Evening, Martin,
author.
Photographers at
work APR 1 4 20

DISCARD

D0117458

PHOTOGRAPHERS AT WORK

Essential Business and Production Skills for
Photographers in Editorial, Design, and Advertising

MARTIN EVENING

New
Riders | VOICES THAT MATTER™

Photographers at Work:
Essential Business and Production Skills for Photographers in Editorial, Design, and Advertising
Martin Evening

New Riders
www.newriders.com

To report errors, please send a note to errata@peachpit.com
New Riders is an imprint of Peachpit, a division of Pearson Education.

Copyright © 2015 by Martin Evening

Acquisitions Editor: Valerie Witte
Developmental and Copy Editor: Peggy Nauts
Proofreader: Bethany Stough
Legal Reviewer: Christopher S. Reed
Composition: Martin Evening
Indexer: Valerie Haynes Perry
Cover Design: Mimi Heft
Interior Design: Mimi Heft, with Martin Evening
Cover Image: Eric Richmond

Notice of Rights

All rights reserved. No part of this book may be reproduced or transmitted in any form by any means, electronic, mechanical, photocopying, recording, or otherwise, without the prior written permission of the publisher. For information on getting permission for reprints and excerpts, contact permissions@peachpit.com.

Notice of Liability

The information in this book is distributed on an "As Is" basis, without warranty. While every precaution has been taken in the preparation of the book, neither the author nor Peachpit shall have any liability to any person or entity with respect to any loss or damage caused or alleged to be caused directly or indirectly by the instructions contained in this book or by the computer software and hardware products described in it.

Trademarks

Many of the designations used by manufacturers and sellers to distinguish their products are claimed as trademarks. Where those designations appear in this book, and Peachpit was aware of a trademark claim, the designations appear as requested by the owner of the trademark. All other product names and services identified throughout this book are used in editorial fashion only and for the benefit of such companies with no intention of infringement of the trademark. No such use, or the use of any trade name, is intended to convey endorsement or other affiliation with this book.

ISBN-13: 978-0-321-99414-1
ISBN-10: 0-321-99414-0

9 8 7 6 5 4 3 2 1
Printed and bound in the United States of America

ACKNOWLEDGMENTS

I would first of all like to thank my wife, Camilla, and daughter, Angelica, for their patience while I was busy researching and writing this book. Next, I want to thank my editor, Valerie Witte, who did a fabulous job helping to guide me from the early planning to the final proof stages, and thank my copy editor, Peggy Nauts, and proof-reader, Bethany Stough, who both helped me look good. Eric Richmond (whom I interview in Chapter 5) was enormously helpful in the early stages of this project, providing me with clarity and useful suggestions, plus a great cover image. I'm also grateful to Dr. Ian Smith and Katrin Eismann for their early feedback.

The following publications were used during my research: *2014 Photographer's Market*, by Mary Burzlaff Bostic (North Light Books); *The ABCD of UK Photographic Copyright* (EPUK); *Beyond the Lens* (Association of Photographers); *The DAM Book*, by Peter Krogh (O'Reilly); *The Digital Print, by Jeff Schewe* (Peachpit); *Dogs/Gods, Equus*, and *More Than Human*, by Tim Flach (Abrams); *Exposed*, by Michael Clark (Voices That Matter); *The Photographer's Guide to Copyright* (PhotoShelter and ASMP); *The Photographer's Right*, by Bert P. Krages II; *Truth & Lies*, by Jillian Edelstein (Granta); *the UK Photographer's Rights Guide*, by Linda Macpherson; and *Why Art Photography?* by Lucy Soutter (Routledge). Chris Reed provided much valuable help with his legal expertise in reviewing the business chapters, and I also want to thank Rod Wynne-Powell for his technical review of Chapter 7.

For helping me to prepare the video interviews, I would like to thank my assistant, Rob Cadman, who worked with me on all the recordings (additional help on some of the videos came from Selina Jones and Radi Konstantinov). Thanks also go to Loft Studios, Tim White Studios, and Tim Edwards at Plough Studios for use of their studio spaces. And thank you to Sean McCormack for his advice on selecting the most appropriate video equipment. Others who helped with the research and supplied photographs are the Association of Photographers, David Hiser, George Jardine, Christopher Nibley, Camilla Pascucci, and Mike St Maur Sheil.

Most of all, I would like to thank all the individual photographers who agreed to be interviewed by me, let me reproduce their photographs in the book, and generously gave up their time. I couldn't have done this book without them.

CONTENTS

3 SETTING UP A BUSINESS. 44

5 PHOTOGRAPHING PEOPLE 114

6 PHOTOGRAPHING ON LOCATION148

10 NEW MEDIA .272

INDEX . 293

INTRODUCTION

In these uncertain times of austerity, the photography industry as a whole has seen a lot of changes, and many photographers are finding it harder than ever to keep their businesses running smoothly. This has been blamed on the recent recession, which has undoubtedly contributed to the problem. But as I found out while researching this book, a lot of what we see going on right now was going to happen anyway. The way technology has popularized photography and brought it into the mainstream has also changed the ways in which images are used and how they are acquired.

I wrote this book because I was interested in exploring the state of the editorial, design, and advertising photography industry as it stands today. I thought the best way to do this would be to talk to experienced photographers who are working in these sectors of the industry and find out how they have managed to maintain successful careers and what advice they would give to those wanting to get started today. I have also drawn upon my own experience as a commercial photographer and summarized here the best ways to set yourself up in business: the stuff that's important, the stuff that's not, and what's best to delegate.

The key points I came across are that professional photographers must be prepared to broaden their skills and that they should specialize. On the face of it, these two statements appear to contradict each other, but the overall message is clear. To have a sustainable career as a photographer you do need to specialize in catering to niche markets that require a high level of knowledge and creative talent, and part of that process will necessarily require you to be skilled in many areas. You need more than a technical knowledge of how to work digitally; you must understand how to market yourself in the digital age as well.

This book has a magazine-style format, which means you can easily dip into any of the different section topics and interviews that take your interest. Ten of the photographer interviews I did have also been recorded as videos. These are around 15 to 20 minutes long, and you can access them via the book website. Or, if you are reading the e-book version, just click on the highlighted links.

ACCESSING THE VIDEO CONTENT PLUS PDF FILE

Ten of the photographer interviews I did have also been recorded as videos. These are around 15 to 25 minutes long, and you can access them online. If you are reading the e-book version, just click on the highlighted links. Along with the videos, you will also find a downloadable PDF called Printing Advice that addresses how to achieve optimal quality for your prints.

To access these files, follow these steps:

1. Go to www.peachpit.com/ photographers_at_work.

2. Here you can download the Printing Advice PDF and all of the video files.

DISCLAIMER

This book is intended for educational purposes only and is not intended to be, nor should it be construed as, legal advice. To obtain guidance relevant to your particular circumstances, you should speak with a qualified, competent lawyer properly licensed in your jurisdiction. Consult your local Bar Association or law society for guidance on finding such a lawyer in your area. The views and opinions expressed in this book are those of the author alone and are not purported to be those of any employer, client, or affiliated entity, past or present.

1

GETTING STARTED

CHOOSING A CAREER AS A PHOTOGRAPHER

IN RECENT YEARS WE HAVE
SEEN A MASSIVE INCREASE
IN THE SUPPLY OF IMAGES
TO A MARKET THAT HAS
REMAINED MORE OR LESS
THE SAME.

This book is about what it's like to work as a photographer for editorial, PR, and advertising clients. You won't find many advertisements for this kind of work, and few qualifications are required other than creative talent and a willingness to work extremely hard against all the odds. Over the last year I have spoken with quite a number of photographers about their particular specialist skills and what advice they would give today to someone wanting to be a photographer. Clearly there's still some pessimism about the state of the photography industry, and all acknowledge how difficult it is right now for established photographers and newcomers alike. Even so, few photographers would choose to do anything else.

I don't think everyone fully appreciates the wide range of skills working photographers bring to each and every job. The aim of this book is to highlight the preparation, services, and skills photographers provide and why being a professional photographer is about so much more than the ability to take a nice picture.

While the core photography and lighting skills may not have changed too much over the past few decades, the technology used to capture images has changed beyond recognition, as have the means by which photographers promote themselves. Print media still exists, but the Internet dominates everything, along with digital signage displays, all of which seek to engage our attention. We are still dealing with the aftereffects of a major global recession, which has certainly had a huge effect on business everywhere, but the change in photography also has to do with the way it has become popularized and now so much more accessible.

It was in the mid-'90s that digital image capture technology came of age. That was the first digital revolution for our art form. What professional photographers didn't take into account was how the same tools that let us capture better-quality images would soon enable others to do the same. This, in turn, has been followed by the advent of smartphone cameras coupled with an explosion in social media use. In recent years we have seen a massive increase in the supply of images to a market that has remained more or less the same. The traditional concept of how a professional photographer earns a living is no longer sustainable, and photographers now need to change to keep up.

Photographer Carl Lyttle (whom I interview later) sums it up by saying, "It's as if a whole midsection of the industry has been decimated." He points out that photographers working in the social sector, covering weddings and PR events, are still doing what they do, as are those at the high end. But those in the middle—the bulk of photographers, who used to service design and PR firms—are finding the commissions just aren't there now. I imagine some wedding photographers will argue that their business, too, has been affected by weekend warriors and the like, but Carl Lyttle's observations about the design and advertising industry are certainly true. For many clients the photographic process is no longer such a mystery. Those photographers who have managed to work steadily despite all these challenges have done so because the photographs they take require a high degree of skill and experience.

I see a parallel here with the film and video industry. The digital revolution has similarly meant almost anyone with a digital camera or smartphone can create video content and post it on YouTube. The quality may not always be great, but these video clips can still generate a huge number of hits. Some YouTube users even earn advertising revenue from them. At the same time the equipment, software, and techniques employed at the high end have resulted in massive improvements to the quality of broadcast TV and film production. While anyone with basic equipment can make an HD movie, there is a big difference between making something that's good enough to go on YouTube and producing a *Lord of the Rings* trilogy or TV drama series. Budgets may be tight and the competition intense, but there's still a market for high-end skills.

That said, this book is not primarily about developing your technique as a maker of images; instead, it's mostly a guide to all the things photographers have to do apart from taking the actual photos. I am going to assume readers already have some idea of how to take a good photograph and the type of photography they wish to do. This book helps fill in the other missing 90 percent of what a working photographer actually does. I chose to interview photographers who specialize in different areas of photography so as to build a general picture of what kind of work is being shot these days and how they run their businesses.

BUDGETS MAY BE TIGHT AND THE COMPETITION INTENSE, BUT THERE'S STILL A MARKET FOR HIGH-END SKILLS.

MAKING MONEY FROM PHOTOGRAPHY

Staff positions are now extremely rare. There was a time when large companies and government organizations ran their own photographic departments. Newspapers, too, used to have large teams of staff photographers, but that's all changed now. In 2013 the Chicago Sun-Times laid off all of its full-time photographers and instructed its journalists to provide photographs for the newspaper using their iPhones. Following this move, it was interesting to see how the Chicago Sun-Times compared pictorially with its competitors (who were still using professional photographers). Eventually 4 of the 28 photographers who had been dismissed by the Sun-Times were rehired, but the drastic slashing of that department is symptomatic

of how this particular industry has been hit by cost-cutting as well as the desire for more video content in place of stills.

Employment opportunities with firms that specialize in social photography still exist, but for the most part you have to make or find your own assignments. With a bit of determination and hard work, most freelance photographers manage to get by. If you want to become wealthy it's best to concentrate on those areas where big fees can be earned, such as advertising, but this won't guarantee you success. The advertising industry is incredibly competitive, and work opportunities for photography are more limited there.

So how do you turn your photography passion into a money-earning career? If you want to specialize in editorial and advertising, the primary way to do this is by gaining freelance commissions. These assignments can be supplemented by selling stock photos and prints and generating income in imaginative ways that include educating others through workshops and seminars. Some successful photographers receive benefits through endorsing products or being associated with a particular brand.

MOST PHOTOGRAPHERS SERVE A LONG APPRENTICESHIP, BUILDING UP THEIR CAREER TO THE POINT WHERE THEY TIP THE BALANCE FROM BREAKING EVEN TO MAKING A SMALL PROFIT.

If you want a true picture of how much a photographer earns, you really need to average out his or her earnings over a lifetime career. Most photographers serve a long apprenticeship, building up their career to the point where they tip the balance from breaking even to making a small profit. This may be followed by a number of years in which they earn decent-sized fees before losing their ability to sustain that level of workload. While things may look rosy during the boom years, over an entire career the good times merely compensate for the bad.

Let's say you want to become a fashion photographer. These days you'll need to accumulate editorial tear sheets, or digital spreads, to show your work has been published. To do this you can try to get work from regular editorial magazines (which pay a small fee plus expenses), or you'll need to work for free to get published by one of the many independent fashion mags. These are published by small groups or individuals (often photographers themselves), and the deal is you work with your chosen team to come up with a fashion shoot story and submit this to the magazine for it to use for free (it is a form of vanity publishing, in which the photographer pays to be seen in print). There is also the expectation that a fashion portfolio should be updated each season with new work. So you'll need to keep shooting fresh editorial throughout the year.

Lots of photographers work as bartenders or waiters or do whatever other work they can find to fund their photography career until they get the chance to land commercial work that pays. With perseverance and talent, a photographer may break through to the big time where high fees can be earned, but career life spans in photography, especially those in fashion photography, are notoriously short.

SHOOT WHAT YOU KNOW

I studied photography at Wiltshire College in Salisbury, England where we were encouraged to have a go at everything. In our first year we learned a lot about working with plate cameras, studio lighting, 16 mm film, and so on. By the second or third year we were encouraged to specialize. As I look back at my own college experience and that of other students, as well as what photographers are producing today, the images that stand out are always those in which the photographer has chosen to concentrate on a particular subject or developed a unique shooting technique. There is nothing wrong with using your camera to record different kinds of subjects. Indeed, any time spent looking through the viewfinder is good experience. However, when it comes to presenting a professional portfolio, what you show has to be tightly focused. More often than not the photography is supported by a keen interest in the subject.

From a commercial perspective it is helpful to specialize and develop a style of photography where it is not just your photographic skills that count but the fact that you understand the subject you are shooting. A food photographer, for example, will know a lot about food preparation and have a food stylist's insight into how particular foods look their best. It is this depth of experience that helps gain commissions. It is all very well to say, "I'll know what I like when I see it." If it were that easy we could all be successful. The trick is knowing how you turn an otherwise ordinary-looking subject into something special. My own specialty has been photographing hair. I have never attempted to cut or style hair, but I've seen great hairdressers at work and had years of experience photographing hair. As a result, I know how to direct hairdressers and spot (and remedy) the kinds of flaws that might otherwise go unnoticed. Plus, it is good to be passionate about what you photograph.

Some years ago I went to a Magnum photography exhibition at the Hayward Gallery, London. Alongside the photographs were biographies of each photographer. I was curious to see where these photographers had studied. What was interesting is that hardly any of them had had a formal photographic training. For example, Sebastião Salgado originally trained as an economist, earning a master's degree at the University of São Paulo, Brazil. Steve McCurry initially wanted to study cinematography and filmmaking but ended up getting a degree in theater arts before he became a photographer. What also struck me was how many had studied unrelated subjects such as chemistry or politics before turning to photography. This highlights how it is important to have interests outside of photography, maintaining that interest and sometimes combining the two.

With anything we buy, we mostly only see and appreciate the end product. Photography clients are the same. They see a nice photograph but don't necessarily appreciate the behind-the-scenes work that went into creating it. This is where some photographers sell themselves short. The photographer is offering a package that includes the skill to produce great-looking images, but that's only part of the overall

THE IMAGES THAT STAND OUT ARE ALWAYS THOSE IN WHICH THE PHOTOGRAPHER HAS CHOSEN TO CONCENTRATE ON A PARTICULAR SUBJECT OR DEVELOPED A UNIQUE SHOOTING TECHNIQUE.

picture. A bigger skill is the know-how that gets you to the point where you are able to point the camera and click. The selection of the team and the props, and all the organization that goes into making the final photograph, are vital. Professional photography is about providing a package of skills in which the actual photography is just one component.

There is, though, a danger in becoming too specialized. Once upon a time photographers who did still-life pack shot photography kept themselves busy photographing boxes and bottles for design and advertising agencies. This type of work has now virtually disappeared, replaced by clients taking the photos themselves or the use of computer generated imaging (CGI). Nor is it a good idea to become too reliant on a single client. It's great to have someone who gives you lots of work, but what happens when that relationship comes to an end? Unless you have some kind of contract that guarantees you a certain amount of work over a period of time, the work you are commissioned to shoot is no more secure than any other freelance assignment.

Photographer-client relationships are vulnerable in lots of ways. The main reason clients may stop using you is they either don't like your photographs or they don't like you. Sometimes, you have already been booked the day they want to shoot with you. This forces them to seek out another photographer, and they may just end up liking that photographer more than you. Sometimes the person commissioning you changes jobs or loses an account. Or, you might just get fed up working with a client and feel it is time to move on. Nothing can be taken for granted in this business, and you therefore always need to have a flexible plan of action that takes these kinds of things into account.

PROFESSIONAL PHOTOGRAPHY IS ABOUT PROVIDING A PACKAGE OF SKILLS IN WHICH THE ACTUAL PHOTOGRAPHY IS JUST ONE COMPONENT.

10,000 HOURS

In Malcolm Gladwell's book *Outliers: The Story of Success*, he explains his 10,000-hour rule and how practicing anything for this length of time is a key to success. For example, before the Beatles became famous, they lived and worked in Hamburg, and over the two years or so they were there, they performed over 1,000 times. By the time the Beatles returned to Liverpool in the early '60s, they were a confident, experienced live band who sounded like no one else. Now whether the Beatles really amassed 10,000 hours, or whether this rule applies to everyone, is debatable, but there is truth in the fact the more you practice at anything, the better you will get. With photography there are so many skills you have to acquire and become good at. This is especially the case with commercial photography. All photographs in this book were captured in an instant but are mostly the culmination of long, careful planning, a detailed background knowledge of the subject, and a second sense for choosing the right moment and angle to shoot. Anything that can go wrong will go wrong, and through experience you learn how to deal with all the different kinds of setbacks you are likely to encounter until they no longer distract you when you are on an assignment.

Even working for a bad photographer can be a positive experience. You can learn just as much from someone else's mistakes as you can from someone's coups. One of the first jobs I worked on was as second assistant to a photographer, shooting a location fashion story for a magazine. The task for me and the first assistant was to source and locate a transit van, a power generator, lighting, and camera equipment. The photographer had no line of credit, and it was mostly left to me and the first assistant to work out how to get hold of everything that was needed. It was late in the day by the time we got all the equipment together, and once everything was set up on location, the photographer managed to capture only six usable frames (it turned out he was unfamiliar with the camera). The shoot was an absolute disaster, but being forced to improvise and work without a budget was a really good education for the first assistant and me—and we learned something about what not to do when setting up our own future shoots.

BEING FORCED TO IMPROVISE AND WORK WITHOUT A BUDGET WAS A REALLY GOOD EDUCATION FOR THE FIRST ASSISTANT AND ME—AND WE LEARNED SOMETHING ABOUT WHAT NOT TO DO WHEN SETTING UP OUR OWN FUTURE SHOOTS.

HOW GOOD ARE YOU, REALLY?

So how good a photographer are you? Probably not as good as you think. In an interview with Michael Reichmann, Jay Maisel mentions that he was asked this question by a psychiatrist. He responded by saying, "I'm probably better than 90 percent of photographers out there." He then asked the same question of other photographers he knew, who all said the same thing. In fact, said Jay, "some thought they were better than 95 percent of other photographers out there." Clearly they couldn't all be right.

So how good are you, really? To begin with, you are most likely to be given small jobs that should be well within your capabilities. As you progress you'll take on more demanding assignments, and that's when you'll start to feel the pressure. Having the ability to self-critique your work and be aware of your limitations is vital. It can save you from biting off more than you can chew too soon. More importantly, it helps you become a better photographer because you find out what your weaknesses are and which areas you need to concentrate on more. You can tell a lot about someone by the way they talk about other people. If everything they say is negative and full of putdowns, you can't help but wonder if they are just being defensive about their own shortcomings. It's the same with photographers when they talk about their photography: if they think they're better than the pack, more times than not, they still have a lot to learn.

HAVING THE ABILITY TO SELF-CRITIQUE YOUR WORK AND BE AWARE OF YOUR LIMITATIONS IS VITAL.

To work as a freelancer you need the confidence to put yourself forward and convince people you are worth hiring. So a little reality distortion about your actual abilities is probably not such a bad thing, especially if this helps you appear confident and get commissioned. But every aspiring professional photographer should take note of what everyone else is doing and not become too complacent about his or her own photographic abilities. Also, you need to recognize there are now lots of amateurs out there who are also producing good work and aiming to be published. There

is a big difference, though, between making a small part-time income and earning a living as a photographer.

Take a look at the photographs opposite, which I shot a few years ago at Monument Valley in Arizona. These are just a few of the images I captured from that particular visit. I like them enough that I have had these published in some of my other books. It's a place I had always wanted to visit, and I enjoyed creating and editing these photographs, but I have no illusions about them being unique—or valuable, even. I say this not out of false modesty or as a critique of the quality of the photographs themselves. I say so because the Mittens rock formations in Monument Valley are now one of the most photographed locations on the planet. Anyone who owns a decent digital camera will have the potential to create images much like these. In one of the photographs you can see how there were lots of other photographers (probably around 30 or 40 in all that evening) shooting the same view at the same time I happened to be there. And if you carry out an image search on the Internet, you'll find umpteen photographs of Monument Valley photographed from the same vantage point.

That wasn't always the case. This remote area, bordering Utah and Arizona, was first popularized by John Ford in the late '30s when he used it as a location for a number of his best-known westerns. It's only in more recent years, with the growth of tourism and better roads, that it has turned into a popular tourist destination spot. Twenty years ago you would have needed a plate or medium-format film camera to photograph this scene and produce an image of professional quality. These days almost any digital SLR can be used to capture an image that is technically good enough for inclusion in a picture library or on a website.

I don't wish to deprecate my own creative efforts. Personally, I reckon the black-and-white image is shot at a fresh angle compared with most other images you'll see of Monument Valley. A fair amount of Lightroom and subtle Photoshop editing was used to achieve the result seen here, which included getting rid of the camera tripod shadow. The point I want to make is that in this day and age, the demand for images like these is the same as it's always been. There are still lots of tourist brochures and websites that will want to show views of Monument Valley. Once upon a time, images like these would have been sourced from one of the main libraries, and the photos purchased would most likely have been shot by a professional photographer. These days such photographs are in plentiful supply, and many can be found and used for little or no money. It's therefore not enough to just take good photographs. To survive in today's market, you need to be able to specialize in creating photographs that go beyond the ordinary. One might argue that this has always been the case and that those who specialize in a particular area of photography will always do well. It's just that now, pushing the envelope is the only way anyone can hope to sustain a career in photography.

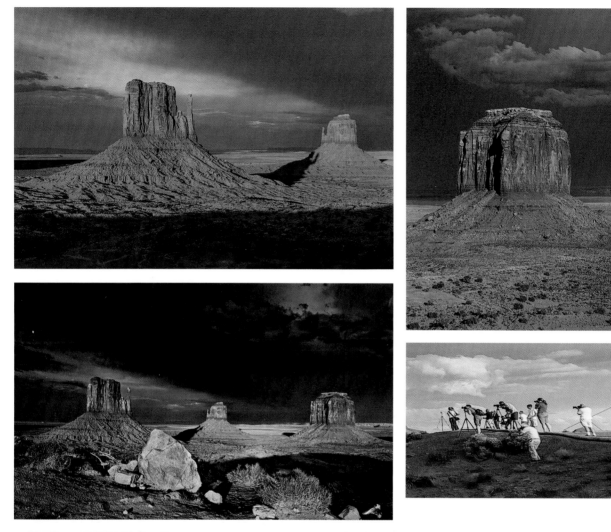

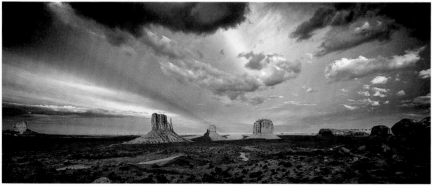

2
FINDING WORK

HOW TO FIND CLIENTS, WORK WITH THEM, AND KEEP THEM

WHOM DO YOU WANT TO WORK FOR?

You first need to work out what kind of photography you are interested in doing and then see how this matches with the types of work that are out there. Some photographers choose to specialize in one area, such as advertising, though most will work for a variety of clients. It's often beneficial to maintain a suitable balance between editorial and advertising work, as good editorial can enhance the look of your portfolio and attract better advertising work.

ADVERTISING AND DESIGN AGENCIES

These agencies offer work that's well paid, but the competition is tough. Advertising agencies handle media coverage for a select number of clients, everything from TV spots to below-the-line trade magazine ads. When an ad is to be used in different media and multiple territories, the fee negotiation is critical and the amounts paid can be quite substantial. Some people regard advertising as purely commercial, which it is, but the creatives who work at these agencies are looking for the best artistic talents. An ideal advertising portfolio should therefore contain a mixture of commissioned advertising as well as current personal work.

Advertising agencies may have an art buyer or team of art buyers, also known as art producers, who are responsible for commissioning photography. You can approach the buyer directly, as it is her job to source new talent. She can give you feedback and advise which art directors or creative teams to approach next (so when you call, you can say you were referred by that person). These days it is difficult to get appointments to show your portfolio directly, so you also need to employ an effective Internet marketing strategy. Personal contact helps, though, because someone who meets you is more likely to remember you, and you get a much better sense of the

people you want to work with when you meet them face to face. Meeting in person is vital when you are likely to be working closely with someone, such as on a long trip. Once you have built a good personal relationship with the art buyer and art directors, it may lead to getting commissioned work.

The position of art buyer is now disappearing from some agencies, though. This may have to do with restructuring as a result of the recession, but even where agencies do have art buyers, the opportunities to drop off portfolios or have face-to-face meetings are more limited. Art buyers are bombarded daily by photographers and illustrators and have only so many hours in the week to see people. Do your research before you contact an agency. While the bigger agencies aim to have a broad sweep of clients, some represent just a few specific clients. To avoid wasting everyone's time, make sure your area of specialization is appropriate for a particular agency before you approach it.

Agencies often represent lots of different clients. If you can prove yourself on a tryout job, the agency may be able to introduce you to plenty of other clients. Initially, you are likely to be given a below-the-line advertising job. The fees aren't as high as for regular advertising, but you'll earn a decent amount and prove yourself to the agency. The biggest challenge is knowing how to cost a job at the bid stage. For argument's sake, let's say the expected fee you can earn is $2,000 for a day's shoot. If the usage is limited to say, a trade magazine ad in a few specialist magazines, then that may be about the right fee for the job. While it's not as much as the fee you would get for a major advertising campaign, $2,000 for the day is still a lot more than you can make on most other jobs. Design agency budgets always tend to be tighter. This is because the fee and expenses you charge have to come out of an overall photography budget, whereas advertising agencies sell your services to their clients and charge a markup in the process.

PUBLIC RELATIONS COMPANIES

Public relations or PR companies work on behalf of clients to manage their business profile and create good press coverage. Most big companies retain a PR company that will handle their press requirements and need to commission photography to accompany press releases. It's a symbiotic relationship in which the PR company provides the newspaper or magazine with free, editorial rights-paid content. In return the client gets free exposure in editorial publications. Magazines and newspapers aren't obliged to use the material they are given, and in fact they don't use the majority of it, so the photography supplied has to be of a sufficiently high quality to merit being used. The budgets for PR shoots are greater than for editorial and more on par with below-the-line advertising rates. From the end clients' perspective, it gives them additional exposure in the press, which complements their existing advertising. This type of photography work is more tightly controlled and art directed than regular editorial,

UNLIKE WITH ADVERTISING CAMPAIGNS, WHICH MAY ENTAIL JUST ONE MAJOR SHOOT A YEAR, PR COMPANIES CONSTANTLY NEED NEW IMAGES TO FEED THEIR PRESS CONTACTS. A GOOD PR CLIENT MAY THEREFORE PROVIDE YOU WITH REGULAR WORK THROUGHOUT THE YEAR.

Example of an editorial photograph for *Delicious* food magazine (photograph: Craig Robertson).

THE EXPOSURE YOU GET FROM PUBLISHED EDITORIAL CAN HELP YOU GET NOTICED AND OBTAIN MORE LUCRATIVE COMMISSIONS FROM PR, DESIGN, AND ADVERTISING AGENCIES.

as the PR agency will need you to meet specific objectives. Unlike with advertising campaigns, which may entail just one major shoot a year, PR companies constantly need new images to feed their press contacts. A good PR client may therefore provide you with regular work throughout the year.

EDITORIAL

A few magazines and newspapers employ their own full-time photographers, but most rely on freelance contributors to supply images. Magazine publishing really peaked in the '80s. This was due to a number of factors including desktop publishing, which made magazines easier and more cost-efficient to produce. There was also plenty of consumer demand, and magazine titles blossomed during this period, with more and more new titles catering to every interest imaginable. Since then the magazine and newspaper market has become a lot harder to work in. This is because there is now more competition within the publishing industry, and titles have to compete harder than ever in a shrinking market. The emphasis now is on digital publishing, as online magazines have to compete with websites that offer free-to-view editorial-style content.

Editorial publishing will continue to survive in some form for the foreseeable future, while advertisers keep their options open to see which media provides them with the best audience. This may mean they continue to advertise in print magazines, online magazines, websites, or even someone's blog. What is clear, though, is that during this transition editorial fees have shrunk. The contributor fees offered to photographers today have barely risen from what they were during the '80s boom. Providing you can get enough regular editorial commissions, it's possible to make enough income from editorial work to cover your overheads. What you really want to do is to make use of the freedom you get on editorial shoots to update your portfolio with good-looking work. The exposure you get from published editorial can help you get noticed and obtain more lucrative commissions from PR, design, and advertising agencies. Also, if you shoot fashion you'll get the opportunity to work with models you might not be able to book normally.

Of course, you will still be limited in choice of models when working for a mum's weekly compared with a Condé Naste title. But if you have the chance to shoot for *Marie Claire*, say, you'll get to work with *Marie Claire*–level models. On an advertising shoot you might get paid well, but you'll get to work with the best models only if you have a really big budget. Good editorial, therefore, provides more opportunities. Again, it helps if you specialize in shooting specific subjects. For example, if you want to work for a car magazine, it helps if you have a keen interest in cars and a good understanding of the things that will interest readers. If you're shooting a text-heavy feature for a publication, always ask for a draft of the story to read before the shoot. Grasping the subject matter will prove invaluable in working with the art director,

who has to satisfy the editor. Editors will sometimes nix your best shots because they don't work with or further the story line, so never forget what the story is about while shooting. Sometimes the art director will give you a list of scenes, locations, or particular shots desired—you can add to them, but don't ignore them.

Magazines tend to offer all photographers the same rates regardless of their level of experience. So while the fee paid may not be great, it will be the same fee as nearly everyone else is getting. Most of the main titles are controlled by just a small group of publishing companies, who are therefore in a strong position to dictate the terms of business to all their freelance contributors. Editorial contracts are invariably one-sided. It's common for magazines to ask for all copyright, and there may well be limits on acceptable expenses. One clause to watch out for is one in which, after assigning all rights (all copyright), you indemnify the publisher against claims that may result from however the images are used. In other words, this means the photographer becomes liable for things like additional model usage fees when the pictures are reused in another publication. It is a good idea to read the contract, look for such clauses, and have these crossed out. In practice, though, I don't know of any photographer who has been sued for such liabilities, and it's probably a case of the lawyers covering themselves as much as possible (because they can).

A number of independent magazines now exist. These date back to the '60s and '70s, with the advent of fanzines and the like. Such publications were always mostly about music and fashion, and by the '80s a number of offshoots had sprung up, such as The Face and I-D magazine. Thanks to desktop publishing, anyone can get into publishing, and that's what a lot of people do, especially young people who are already working in the media industry. They have the advantage of being more directly in touch with what is happening culturally among their own peer group, which gives them more credibility and the ability to attract the right readership.

That said, this end of the market is always going to be a feeding frenzy in which the most you can gain in the short term is exposure and experience. Basically, the independents don't pay contributor fees. If you have an idea for a story you would like to photograph, you might team up with a journalist or a fashion stylist to produce a photo shoot. You can then take it to the various magazines to see if any are interested in publishing it. Some of these magazines take more control over the content, directing the shoots themselves and focusing on a specific theme for each issue. If you are starting out and need tear sheets for your portfolio, independents offer one way to enter the editorial market and get noticed. The problem, of course, is it costs you money to work for them. Even where everyone works for free, you may still have to rent studio space or equipment, and not all model agencies are willing to let you use their models editorially without payment. You therefore need to keep things in perspective and view this work as a means to an end. Otherwise, it's a form of vanity publishing in which you are essentially funding your career as an editorial photographer.

EDITORIAL PHOTO ORGANIZATIONS

If you shoot editorial, you should consider joining an organization that supports the rights of editorial photographers. In the US, the American Photographic Artists/Editorial Photographers (Editorialphoto.com) is a subscription organization. In the UK the EPUK mailing list (Epuk.org) is free for professional editorial photographers only.

ADVERTORIAL

You will notice that magazines highlight promotional features, sometimes referred to as advertorial, which is a cross between editorial and advertising. This is where a company teams up with a magazine to commission an editorial style shoot that promotes a specific product. The result is something that resembles an editorial feature but is in fact a form of advertising. It is usually labeled, in small print, "special advertising section" or a similar term. Advertorial can be done in conjunction with single or multiple products. For example, it could be a food feature about Italian cooking in which the recipes all promote the use of a certain brand of pasta. Or, it could be a fashion shoot that combines a model wearing a collection of clothes posing alongside a new car. For these types of shoots photographers are primarily chosen and commissioned by the magazine rather than the advertising client, and the fees paid all round are higher than regular editorial rates.

DIRECT CLIENTS AND CORPORATE

Some businesses book photographers directly. For example, large companies may have their own marketing department that commissions photographers. Forging a good working relationship with the internal marketing department can easily lead to other commissioned photography such as PR and advertising work. Early on in my career I got an appointment to see a lady called Tina Fotherby, who worked in the marketing department for Elida Gibbs. She booked me on a job, which led me to shoot advertorial assignments for a couple of magazines. These in turn got me introduced to other PR companies as well as more work with other Elida Gibbs brands. Just that one contact set off a whole chain reaction of introductions and further commissions.

A photographer I knew, Mike Russell, ran a photographic business called Mouse in the House. Back in the mid-'90s, his studio was one of the first to go digital, but Mike was finding it difficult to persuade advertising agency clients to accept digital files. His response was to produce a smart-looking brochure that extolled the benefits and cost savings of digital imaging. He sent this directly to all the corporate clients he had been working with through the various advertising agencies. His back door approach worked. By gaining the support of the end clients, he got the advertising agencies he was working with to accept digital capture. This in turn generated more photography work for Mouse in the House. Basically, forging direct relationships with companies can be rewarding as well as persuasive.

BOOK PUBLISHERS

Book publishing companies need photographs to illustrate the covers as well as the inside pages of their books. Most of the book covers you see will have been created in-house by the art department using photographs sourced from picture libraries. However, if the cover features, say, a photograph of the author for an autobiography, the publication will need to commission a photo shoot. Cookery titles usually require custom photography shot specially for the book, which could lead to a block booking of several weeks. Partworks publishers produce magazine series that show things like how to build a model ship over 20 editions: a project like this would mean commissioning someone to photograph all the steps. There is also a market for photography books that have themed content. For example, publishers may sometimes be interested in a book proposal that is photography-led, such as a book of aerial photography.

RECORD COMPANIES

This is a specialized market that attracts photographers who specifically shoot music artists, but it's also one that is open to fashion and still-life photographers. After all, album covers and posters don't always feature the artists and use all kinds of photography. If you think your style of work would be appropriate, then it's definitely worth contacting record company art departments. If you are good enough there are usually opportunities to get yourself noticed. Newer artists have small budgets to spend on photography, so the fees won't be great. Very often they'll have attracted a big enough following of fans who will have taken loads of pictures, and they'll feel they already have enough images to use for their initial publicity. To get commissioned to photograph a major band or music artist, you'll need a portfolio with a strong style. A background shooting fashion or photographing for the music magazines is a good way to gain experience before you approach the record companies.

Another thing to bear in mind here is that most of what you've ever read or heard about the music industry is true. The type of person who chooses to work in management at a record company is very different from the sort who chooses a career in insurance. Music industry people are more fun, but they can also be more ruthless. You need to be extra attentive to the details, like making sure you get an art order in advance of a shoot and checking the terms of your contract.

IMAGE LIBRARIES

For many years image libraries were largely ignored by photographers. The types of photographs the picture library agencies were promoting weren't what most photographers wanted to shoot and were regarded as kind of cheesy. From the end clients' point of view, picture libraries were also cumbersome to deal with. They would put

Example of a book cover image (photograph: Marc Schlossman).

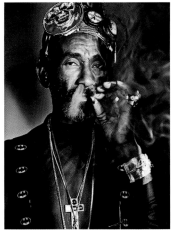

Lee Scratch Perry, musician and producer, who I photographed at Island Records, London.

in a request for a certain type of image and have to pay a researcher to find suitable photographs. These would be sent over by courier as dupe transparencies in sealed transparent bags. If clients found a shot they liked, they could negotiate a price and then break the seal to access the transparency and use it.

Clients who needed to source lifestyle photographs, locations, or still-life concepts would find the options available through the picture libraries quite limited. So clients mostly tended to commission a custom shoot to get exactly what they wanted. Then two things happened, digital technology made it easier for picture libraries to manage and distribute images, and (as a result of this) photographers started to take the stock market business more seriously. Mark Getty, who founded Getty Images, once described intellectual property as the "oil of the 21st century" (The Economist, March 2, 2000). As the image library business took off, he was proved right.

There are essentially two kinds of picture libraries: first, those that deal with news photography, including sports events and celebrities. These serve newspapers, magazines, news channels on TV, and the Web. The other kind handle general subjects such as concepts, landscapes, people in situations, animals, and so on. These sell mainly to advertising and design agencies and publishers. The standard commission rate for stock photography used to be 50 percent, but in recent years the rate paid to photographers by some libraries has been as little as 30 percent. It used to be the case that photographers had to prove themselves worthy before a picture library would represent their work. This was done to maintain high standards and ensure it was worth investing the library's time working in partnership with these photographers. Some photo libraries still work that way, and it's exactly the same as agents deciding which people they wish to represent. However, there are now many other avenues for aspiring stock photographers.

The quality of work available now is so much better than what used to be on offer, and it's easier and quicker to distribute. Consequently, there are now lots of shoots that don't get commissioned because clients can easily source images online and find exactly what they are looking for. Therein lies one of the controversies surrounding the supply of images. In the old days library photographs were made available only by licensed usage, where the price charged per image would reflect the type of usage required and images were made available on an exclusive or nonexclusive basis. More recently we have seen the rise of microstock agencies that sell "royalty-free" images. Clients pay according to the size of image they need and then do whatever they wish with it without restriction. One can blame the picture agencies, but to be honest it's also been the willingness of photographers to contribute their photographs that's led to the success of the microstock and royalty-free concepts. The photo library market is also hampered by the availability of so many free images. If you are a client looking for photographs to use on a website or in print, it is easy enough to carry out a search for images that are legitimately available for free commercial use.

Why does it happen? I suppose because there are photographers for whom photography is a hobby rather than a business, and they are happy enough to share their work for free or for small financial returns. Professional photographers are angry because such people are diluting the market, but also because it has made commissioning clients more inclined to ask for all rights. On the other hand, clients who are prepared to pay proper rates for picture library images are still using the main picture library agencies because they like the exclusivity that comes through buying "rights-protected" photos, licensed for specific usages (which will include shots that are regarded as "similars," i.e., photos taken of the same subject at the same location). Also, some royalty-free images are easy to spot because they are seen so often. After all, clients with money to spend don't want to buy photographs that everyone else is using.

Photographers who are invited to join one of the major picture libraries will get access to information about which kinds of photographs are most needed, indicating current trends in image requests. This is privileged information that can help photographers focus on gaps in the market. The technical criteria for the supply of images will be detailed. Images will need to pass through a quality control inspection as well as be vetted by a picture editor to filter out duplicate shots and ensure that only the best work is added to the library. For the photographer this can mean a lot of hard work as well as having to finance all the photography costs. There can be a long gap between creating the work and seeing a return on that investment, and libraries will expect to see new images submitted on a regular basis. However, where an image is successful a photographer can expect to see continued royalty sales for many years afterward.

Most agencies now work on an image-exclusive type arrangement rather than insist that photographers work solely through them. This gives photographers the freedom to submit different photographs to more than one agency. Images must also be supplied with appropriate clearances. Agencies will require documentation such as model releases and, where appropriate, be able to identify the age of the person or persons in the photograph at the time the picture was taken. This means the photographer will need to acquire an "all usages" signed model release before pictures can be submitted. Some model agencies are willing to enter into such agreements for specific picture library shoots, but at a cost. Some picture libraries may hire a photographer to shoot for them on a funded production shoot. In this scenario the agency agrees to pay the photographer a flat fee plus expenses, but the photographer receives only a small-percentage royalty from future sales.

Experienced stock photo photographers have the benefit of being able to shoot completely for themselves. They aren't tied to when a client calls to offer them work, they can just go out and create their own. As with any area of specialization, to shoot effectively for stock requires experience. It takes time to develop a good sense of what will sell best. Photographer Seth Resnick makes good use of keywords to help his images sell well. Each individual photograph he supplies to his image library may

PHOTOGRAPHERS WHO ARE INVITED TO JOIN ONE OF THE MAJOR PICTURE LIBRARIES WILL GET ACCESS TO INFORMATION ABOUT WHICH KINDS OF PHOTOGRAPHS ARE MOST NEEDED, INDICATING CURRENT TRENDS IN IMAGE REQUESTS. THIS IS PRIVILEGED INFORMATION THAT CAN HELP PHOTOGRAPHERS FOCUS ON GAPS IN THE MARKET.

PHOTOGRAPHER SETH RESNICK MAKES GOOD USE OF KEYWORDS TO HELP HIS IMAGES SELL WELL. EACH INDIVIDUAL PHOTOGRAPH HE SUPPLIES TO HIS IMAGE LIBRARY MAY BE TAGGED WITH AS MANY AS 50 KEYWORDS.

EDITORIAL SYNDICATION

Some editorial publishers now run their own in-house syndication agencies. This is where they sell photographs shot for one of their magazines to another publisher. For example, an architectural magazine may be approached by a magazine in another country, which will ask to reuse an article in its pages. Some publisher contracts include a clause that agrees to provide the photographer with a share of syndication fees. In-house syndication agencies tend to manage requests for usage rather than actively promoting feature work. Photographers who focus on celebrity portraits and the like will usually be better off syndicating their work through a picture library or agency.

be tagged with as many as 50 keywords. Doing this can help the image appear more frequently in prospective image searches. Resnick points out it also helps to investigate what the current hot topics are and find ways to weave the latest buzzwords into your keyword metadata. Most of all, it's important to be original. We have all seen photographs of the Eiffel Tower in Paris, but is there a less commonly used angle you can photograph it from that hasn't been fully explored before?

We can't leave this subject without referring back to Getty, who from the late '90s onward acquired image library businesses from all over the world and turned Getty Images into one of the biggest global libraries (along with Corbis). Once Getty had become a major player in the stock photography business, it started revising the terms of business with its photographers. The UK's Association of Photographers was one organization that managed to successfully renegotiate on photographers' behalf, as did the Stock Artists Alliance in the US, which has now merged with other organizations to create the Alliance of Visual Artists, led by the Professional Photographers of America. Some gains were achieved on behalf of photographers. Even so, it's an ongoing struggle for photographers and their professional organizations, such as the ASMP, to obtain favorable terms with the big agencies as image marketing strategies and the contract terms change. It's probably another reason photographers should consider other ways to self-market their image library photographs.

In 2014 Getty announced it would allow unwatermarked Getty images to be used for free on blog websites providing people use an embedded viewer, which credited Getty Images. The terms of use point out this is allowed only for images posted on a blog or social media platform, but it basically means any Getty photographs can be used for free in such editorial contexts. Why did Getty do this? The official line is that people were using Getty images on their blogs anyway, and this mechanism now allows them to use the photos legally in return for allowing Getty to collect metadata information and place ads within the embedded viewer. Peter Krogh, author of *The DAM Book*, points out that Getty Images was acquired in a $3.3 billion purchase by the Carlyle Group. You don't invest that kind of money to then start giving your assets away for free. Tremendous value is to be had from gaining information about the way photos are used, who looks at them, where, and how often. Secondly, the embedded viewer gives Getty the potential to use this data to stream targeted ads instantly. (For more information, see Krogh's comments on the subject at Thedambook.com/getty-did-what/.)

PHOTOGRAPHERS' AGENTS

A good agent can make a photographer's career by generating new business and helping to manage the preproduction process. Some clients look upon an agent as offering a seal of approval to the photographers he or she represents. This makes them a safe pair of hands to commission, plus they have the backup of the agent liaising as a go-between between the agency and the photographer. But being represented by an agent is a two-way process. It's no good thinking you can sit back while the agent gets you work. You are entering into a partnership in which you need to be prepared to invest time and money to ensure your portfolio and website are updated all the time with new work, and it's the agent's job to sell your services and negotiate on your behalf. If you are serious about working in advertising, it's a big commitment. Working with a bad agent can be costly, too, not least in terms of the damage this might do to your reputation. There's also the risk of an agent going out of business and leaving client photographers with unpaid debts.

If you are looking for an agent, the first thing to do is to carry out some research. Look at the various agents' websites to see which kinds of photographers they represent and what kind of work they are shooting. Does your own photography style blend in with this?

The preferred way to make contact with a photographers' agent is via e-mail, where you should emphasize the successes you have had and how established your business is. Some agents may be willing to take on a relative newcomer who shows outstanding talent, but they also like to see a degree of independence and know a photographer has the experience and resources to just get on with the job. They'll want to know you have the basic tools such as an office base and a network of people, such as assistants and stylists. Above all, they'll want to see talent and be just as interested in seeing your personal photography as your commissioned work. An agent will also be looking to see commitment on your part to keep the portfolio updated with new work.

Some agents just take the portfolios out and pass on work to the photographer for them to produce the shoots themselves. Others provide a more complete production and career management service. All this needs to be formalized so that all parties are clear about the percentage commission taken and each person's responsibilities in this partnership agreement.

A GOOD AGENT CAN MAKE A PHOTOGRAPHER'S CAREER BY GENERATING NEW BUSINESS AND HELPING TO MANAGE THE PREPRODUCTION PROCESS.

MARK GEORGE

SPECIALIZATION: PHOTOGRAPHERS' AGENT

If you want to understand the advertising photography industry, its background, and the changes that have taken place in recent years, there is no better person to talk to than Mark George, who has represented some of the biggest names in photography.

It all began on a tour of Scotland with his motorcycle club when George was asked to share a room with a guy he had never met before. He was an out-of-work food photographer. He and George got to talking, and it turned out he was living in Chelsea just a few streets away from George. When George saw the photographer's work on 10 x 8 transparencies, it blew him away, and so he offered to start representing him. "I didn't know anything about the business. All I knew was that I liked the look of the work." Going out five times a day, seeing various advertising agencies, it was eight months before he landed the photographer's first job. After that he soon took on others—a fashion photographer, then a car photographer. "They were all coming thick and fast. I had no money and was traveling around on my motorbike. I had the portfolios strapped around my neck. God knows what would have happened if I had come off. Probably taken my head off, because they were big old steel boxes in those days that weighed a ton!"

Then he took on Don McCullin. "And when you take on someone like Don McCullin, it starts to open doors to other photographers because he was so well respected, and I ended up with Terence Donovan, Richard Avedon, and people of that ilk. "The story with Richard Avedon is that George was actually recommended to be his agent. "I wouldn't even have dreamed of contacting someone like him. I just wouldn't know how to do it. It was his New York agent, Norma, who contacted Leslie Cobden, who was art buyer at Ogilvy and Mather. She asked who would she recommend to represent Richard Avedon in Europe, and she suggested me. I flew over to America, did the meet, and that was it. I represented him right up until he died. He was a brilliant photographer. I liked representing people like Don McCullin, though. That, to me, is interesting. With Don it was great because he hadn't done any advertising work when I took him on. The first thing we did together was for Cockspur Rum. I got him more money for doing the casting than he'd have got spending three weeks up a jungle river shooting some tribesmen. He couldn't believe it.

"Prior to becoming an agent, my life had been quite colorful and always had an artistic drive to it." An early memory was going to see the film Jazz on a Summer's Day, which was codirected by the photographer Bert Stern. "My mother took me to see that in 1959, when it first came out. I was only about six years old at the time, and it had a big influence on me. It's strange for your mother to take you to see such a film anyway, but strange also that I asked her to take me back to see it again the next day. It is a fantastically well-filmed piece of work." Incidentally, years later he ended up meeting Bert Stern and represented him. "I told him how much I loved that film, and he gave me a signed copy of it, as well as a huge print of Marilyn that I've still got." But along with having an interest in the arts was the desire to have money, which is why George chose to work on the business side and become a photographers' agent. "I had this very astute understanding of what made a good composition. What matters mostly is the emotion and true heart of photography now. The pictures that appeal to me are not about the technique. It doesn't matter about the subject. It is the way he or she treats it that matters to me now."

THE PICTURES THAT APPEAL TO ME ARE NOT ABOUT THE TECHNIQUE. IT DOESN'T MATTER ABOUT THE SUBJECT. IT IS THE WAY HE OR SHE TREATS IT THAT MATTERS TO ME NOW.

THE ROLE OF PHOTOGRAPHERS' AGENTS

Up until the 1960s photographers all worked independently and didn't have agents. As George points out, "Photographers just used to represent themselves. Terence Donovan never had anybody as far as I knew, and when he phoned me up and said I want you to represent me I said, 'What the hell for? You never had an agent?' He said, 'I know, but I've decided I want one now.' I said, 'I've been around a quarter of your time, and you've got a reputation that is huge. You don't need me.' He said, 'I do, I need someone to be in the mix and need someone who is going to come along for the ride with me.' Which is what we did up until he died, and I loved him so much. It was fantastic, actually."

For many years the photography business suffered from the lack of proper copyright legislation. It wasn't till 1989 in the UK that there was a copyright law that benefited photographers and recognized them, along with other creators, as first owners of copyright. "A few people in this country fought hard to get the law for photographers changed because it wasn't right that the commissioner ended up owning the copyright," George says. "I remember the day when the act came into force. A London agency sent round a letter to all the photographers and agents with a pound coin in it, which if you accepted meant they owned the copyright on anything you did with them in future. I sent my coin back. Actually, I spent it and sent another one because I wanted to have a little bit up on them."

AGENTS REALLY STARTED
TO MAKE THE GAME,
BECAUSE PHOTOGRAPHERS
ARE USELESS AT
NEGOTIATING. MOST
CREATIVE PEOPLE ARE.

That was indeed a turning point, and as George says, "You've also got to remember that every photographer out there had got an assistant and those assistants had assistants, and this family tree grew. It grew in quality and it grew in number. And there were now a lot of photographers trying to get work. At the same time the world globalized. This meant projects you got to shoot that were going to appear in the media in the UK only would now get sent to an agency in New York to appear in America, Africa, and Australia. Where once upon a time product advertising shoots would be commissioned in each separate country, there would now be just one shoot carried out. So, in order to compensate for this globalized use, you needed to start getting additional usage fees for such advertising shoots. That's where agents really started to make the game, because photographers are useless at negotiating. Most creative people are."

Despite the hard-won benefits photographers have gained in the US and UK, the situation today is still no better in some parts of the industry. And this is despite harmonization of copyright law throughout the EU and other territories. "In countries like Germany, photographers give away the copyright when they shoot, so it's impossible. Photographers in the UK do the same, too, or they sell it for next to nothing. Quite frankly, unless photographers get their act together the business will just die," he says. "Unless you get compensated for work that's used abroad you will not get enough original commissions to survive. If you get a £30,000 usage fee, that's going to keep your business going for a bit. If you only get £2,500, or £3,000 for a day's shoot, that's not going to keep you going for anything. So you need that £30,000 for usage. If you give that away, do a shoot cheap, and you're quiet for two months, you are going to go under."

THE SHOOT PRODUCTION PROCESS

Over the last few years the agent's job has become a lot more production oriented. "We are really more like film producers now," says George. "Agents don't just take the books out. When you get a job you have to really impress and work with budgets, which quite often are large. And you have to be able to manage that and bring the job in on time under budget and also have an understanding of what the creative requests are." With so many different things to organize on a typical shoot, it is important to have a good understanding of all these related tasks. "I used to set myself tasks. I'd often go out and find a location. I used to do styling. I used to do castings, all just to see how hard it was. For example, I found locations in South Africa and Italy and

would find people on the street for casting sessions. It's very good to do this if you are going to instruct people to do that kind of work, because you need to know how hard it is."

More importantly, the agent is the liaison between the photographer and the agency and sometimes these days between the agency and the client. "I did a shoot recently where the agency would definitely have lost the account had I not been there at the time abroad on a shoot. The business has totally changed now, though," says George. "Art buyers don't really exist anymore. There are great art buyers out there, and I've always laughed about the fact that the art buyer is the most undervalued person in an agency. But they are a dying race and being replaced by project managers, who are good at what they do in terms of production, but they don't necessarily understand photography. You may now have a preproduction meeting for three hours with eight people about a toothbrush shot—I mean, it's ridiculous.

"Also, the management within the agencies is too much on the clients' side, and they are not hiring and training good account executives. You get these kids who come out of Business School. They are suddenly working for a major company as a go-between for a major advertiser and the agency or marketing firm, and they can't handle it. They don't know how to say no to someone. They don't understand photography, filmmaking, or radio recording. They don't understand anything creative. They don't understand the subtle things, like if you keep going to an art director and say rethink this, rethink this, rethink this it's like when you drop a Ping-Pong ball, it bounces high at first and then gets lower and lower till it stops. And that's what happens. Their creative juices run out. I see it every day of the week. It means life is harder because you are fighting battles all the time. Also, these days art directors are more ideas men. They don't understand good photography and are not even really interested in it. So I can't get a reaction from them when I ring them up to go and see them. So I still have to go back to the guys I know. A lot of the time to old school art directors, younger guys who've got it, and, of course, the art buyers."

There is work out there, if you know where to find it, which is easier said than done, of course. "I always say if I could hover above London and have eyes in every single art director's office in London and see what's on their desk, I'd come away with five jobs for each of my guys. I don't know which rooms those jobs are in, but I do know they are out there and suitable for my guys," he says. "My job is to find those jobs the only means I know how, which is to contact art buyers, make sure they are aware of the photographers I represent, and make sure they see their latest work. Then hope they will see a

THEY CAN BE
PHOTOGRAPHERS WITHOUT
AN AGENT, BUT I CAN'T
BE AN AGENT WITHOUT A
PHOTOGRAPHER. I HAVE
ALWAYS KEPT THAT IN MIND.

layout and bang, a connection is made. But I can only see so many of those people in a week as they are swamped with ten calls a day to see photographers. So I'm battling with that, even though I have a reputation and have been around for a long time. I phoned up an art buyer on Monday and asked to see her—she said, 'Come in on Tuesday.' I phoned another art buyer on Monday and she said, 'Come and see me in two months.' I mean, I could be dead by then—that's no good to me. I can't wait another two months before I can get a job out of them."

THE PHOTOGRAPHER RELATIONSHIP

"It's not a case of a photographer coming along who wants me, it is I want them," says George. "Because they can be photographers without an agent, but I can't be an agent without a photographer. I have always kept that in mind. As for what I am looking for, it's simple, really. Individuality, uniqueness, peculiarity. That's all I am looking for. I'm looking for a photographer who can produce something no one else could produce, so that when someone wants to commission them they have to go to them. To find someone that's got that whole feel that's so unique you can't get it anywhere else. That's the ultimate, but those guys are few and far between. Otherwise you will be representing a group of guys where it's just potluck.

I'M LOOKING FOR A
PHOTOGRAPHER WHO CAN
PRODUCE SOMETHING
NO ONE ELSE COULD
PRODUCE, SO THAT WHEN
SOMEONE WANTS TO
COMMISSION THEM THEY
HAVE TO GO TO THEM.

"I call myself a manager, but it never sticks, so I sometimes flick back into the agent side of things. I've managed bands as well and sportsmen and managed all sorts of people. It's no different—they are creative people. All their life they have studied what they do to get to that level where they need a management company. They are focused on that one thing. It's great, but when the rest of the world intrudes it affects their ability to create what it is they trained themselves to do. I like being able to help them. I like being able to pull something out of a hat as well."

The agent's job can also be described as being an intermediary and a buffer. "You don't want the photographer falling out with the art director, who's about to go away to the Galapagos Islands for two weeks. Art buyers are great because you can fall out with them and the next day they'll call up and chat about something else. Because they are like me, they are trained to fall out and fall in straight away again. You know, a photographer won't do that," George says. "They are creative, and he'll be sulking in the corner, or worrying about whether someone is having an attitude when they come into the studio for the shoot day.

"The relationship between the photographer and the agent is very much that you are both working together to try to get the next job, and when you get it, I do my production and the photographer does his creation and that's it. But it's harder now than it's ever been because when they are quiet they start to worry that the only contact that they've got to the business is you, the agent. And if they don't know why they are quiet because they've not got their finger on the pulse like I do, then it's hard for them to accept that. You are more likely to lose someone quickly and they'll go onto someone else because they feel edgy that they're not getting work. But there really isn't the work to give them."

His view is that things work well when the photographers you represent are as driven as you are. "The ammunition they give you is not just work to go in the book, it's projects, meeting people, and their ability to network. To get busy they need to do all that. Other guys just sit on their backsides waiting for the phone to ring and don't even give you new photography for six months. When I lectured at universities I used to ask students, 'Who takes photographs here? And who's got a camera with them?' And no one put their hand up. 'I'd say if you were in music college you would have to play the piano every day. Here you seem to think because you are photographers you don't have to take a picture.' I don't know how they expect themselves to become photographers if they are not really fully trained and looking through a viewfinder. It's even worse if you are a professional and you don't take pictures. How can you do that? How can you think this well-oiled machine, which has to be rolling when someone gives you a job, can be cranked up quick enough to do the job well if you haven't picked up a camera for two months? You can't do it. I think it was the pianist Rubinstein who once said, 'If I don't practice for two weeks, my audience notices. If I don't practice for a day I notice.' That's true with photography as well. You have to keep looking through the viewfinder."

KEEPING UP WITH TECHNOLOGY

The biggest changes to the industry have come about in response to computer technology and digital photography. "You have to change with the times," George says. "These days shoots are captured digitally and stay digital all the way through to the final end use, which nine times out of ten is going to end up as an Internet ad or on a digital signage display. They never ever see a piece of paper. It doesn't exist. You've got to understand that and understand how that then is going to lead to filmmaking. So if you want to exist in this business as a photographer, you've got to be prepared to shoot some moving images as well."

HOW CAN YOU THINK THIS WELL-OILED MACHINE, WHICH HAS TO BE ROLLING WHEN SOMEONE GIVES YOU A JOB, CAN BE CRANKED UP QUICK ENOUGH TO DO THE JOB WELL IF YOU HAVEN'T PICKED UP A CAMERA FOR TWO MONTHS?

THE IDEA YOU CAN
REPRODUCE A PRINT TIME
AND TIME AGAIN IS NO
LONGER A STICKING POINT,
AND PEOPLE ARE WILLING
TO PAY A LOT OF MONEY
FOR A GREAT PRINT EVEN
IF THERE IS A NEGATIVE
STILL LURKING IN THE
BACKGROUND.

At the same time George reckons technology has in a way made our lives harder, such as the way people can contact you easily on the Internet. "You just get fired off things that are ridiculous—it's unbelievable the things you get requested to do because they have the ability to get to you that way." Along with this has been the commoditization of commercial photography to the point where photographs are seen as mere assets (a point that Tim Flach makes in Chapter 9). "When you've got photography managed by agencies and clients in such a way that they view it as a pile of this electronic data they can dip into and use to help sell the service and goods, it's beginning to lose its art form. When the art directors are not capable of understanding composition and balance and color sense and everything else and are just guys who have ideas, you're losing the art form. And when the client is dictating which photographer to use and dictating how they should shoot and dictating which picture they want to choose and how it's to be edited, you're losing the art form," says George. "All this is slowly chipping away at it. Things are changing rapidly even now, and it's very difficult to keep abreast of it because photographic technology has brought about a devaluing of photography. There's been this real flip. It used to be that in the art world, photography was kind of right down there and paintings and sculptures were right up here, but the commercial side of photography, particularly in England and America, was huge. Now it's gone the other way. The art world photography has become very collectible. The idea you can reproduce a print time and time again is no longer a sticking point, and people are willing to pay a lot of money for a great print even if there is a negative still lurking in the background, whereas commercial photography has now kind of lost all its value."

ADVICE TO PHOTOGRAPHERS STARTING OUT TODAY

THE COMPETITION IS SO BIG,
AND IF YOU UNDERSTAND
THAT AND YOU FEEL YOU
CAN BRING SOMETHING
FRESH AND NEW TO IT,
THEN REALLY FOCUS
ON THAT, YOU'LL STAND
A BETTER CHANCE OF
EARNING MONEY.

Finally, I asked George for his advice to photographers trying to find work in advertising. "If I was to advise someone starting in photography today, it would be that you've got to really practice the art form and you have to stick out for usage and owning the copyright. Because slowly all that's going to be clawed away from you. And you really want to see a generation of photographers coming up who value and respect their ability and their experience and all their hard work by wanting to own the copyright in their pictures. Because there is no reason why copyright should be released. Clients don't need to own it—that needs to be kept by the creator of the picture. You can give a license to use in any territories, for any length of time in any media you want.

"The competition is so big, and if you understand that and you feel you can bring something fresh and new to it, then really focus on that, you'll stand a better chance of earning money. Because you can't do this job for love only. You have to be able to live and look after yourself. All the students I ever meet are the same. They just think it's a great groovy thing to do, and it actually comes as a terrible shock when they're sitting there with no food and they've had to go home to live with their parents again, because they haven't planned it well enough."

"In my opinion there are three things in photography that make you stand out. There's what you choose to photograph, how you choose to photograph, and how you choose to edit. So choose a subject and then decide how to photograph it—that's your style coming out, because you are making those decisions. And then there's the editing. 'Which one picture am I going to show people to make them realize why I did those other two things?' That is where photographers fail a lot of the time, because they don't know how to edit. It's like making a good sauce—you cook it, cook it, and cook it to intensify the flavor—and it's no different with photography. Isolate and edit, edit, edit right the way down so you are really showing the cream of the crop that will turn people on. However, most people start off by copying each other. So immediately they've thinned out their ability to become unique."

"Now that the world is so globalized I get calls from India, Paraguay, Australia, Japan... And you can't deal with them all. I look at the websites and most of the time it's rubbish. There's no innovation whatsoever and I see a lot of overuse of Photoshop. Every now and then you get one so mind-blowing it's fantastic. That's a bonus, but it's very rare, I'm afraid."

"It's also about just looking and living. It's an art form, after all. You don't look at Francis Bacon or Freud and go, 'I bet they lived the perfect student life.' They didn't. They were nuts. They were messy and they had passion. They weren't interested in what other people thought about the work they produced. They were just interested in what influenced them and how they took that influence through osmosis and produced their own work. And there are very few photographers doing that."

Video interview with Mark George.

IN MY OPINION THERE ARE THREE THINGS IN PHOTOGRAPHY THAT MAKE YOU STAND OUT. THERE'S WHAT YOU CHOOSE TO PHOTOGRAPH, HOW YOU CHOOSE TO PHOTOGRAPH, AND HOW YOU CHOOSE TO EDIT.

Mark George
Markgeorge.com

PRESENTING YOUR WORK AND GETTING NOTICED

The only way to get work is to let people know you exist and have them remember you the next time they need to commission a photographer. No single method can work on its own, so you need to use all the means at your disposal to get noticed. You have many options these days.

Branding and promotion

Branding is important. We are all susceptible to the power individual brands project and how this affects our buying decisions. For example, why do we value one car over another, or for that matter a particular make of camera? Branding is very much linked to advertising, but brand loyalty is determined by our individual perceptions based on other factors, too. It's everything we know and associate with a particular business or product. Commissioners respond in the same way when purchasing photographic services. The perception they have of you will be based on the sum of everything you present about your business. How you present your work matters almost as much as the quality of the photography itself. You can start by having a logo designed, one that can be used across everything associated with your business, such as letterheads, business cards, and website. It's also important to reach out constantly in the most effective way possible, which is why your photography business plan needs to include a budget for advertising and promotion.

E-MAIL BLASTS ARE MOST EFFECTIVE WHEN THEY ARE SENT OUT REGULARLY BUT WITHOUT BECOMING AN ANNOYANCE.

Photography website

Your photography website is the main shop window for your business and therefore key to everything else you do online. If you have the right skills you can design your own, but ideally, you'll want to hire a professional web designer to create one for you. Another option is to purchase a portfolio template design you can modify, or subscribe to a website hosting service. Whatever method you choose, the website must be formatted so that it works on all computers and devices.

Your website is an important marketing tool. It allows you to present your photography in an attractive form. It should communicate a clear and consistent impression of the kind of photography you do and give you the opportunity to engage with visitors. Each picture you show must be able to stand up on its own as a great example of your work. If you start to include weaker pictures, clients are likely to pick up on this and wonder if that's the kind of work they will get from you. So only show your best photographs. You also have to remember that different people look for different things and, regardless of whether it is a great photograph or not, will look for what's important to them. For example, a fashion editor will mainly be interested in looking at the clothes, choice of model, and hair and makeup, not just the photography.

To market your website, create an e-mail signature that includes a banner graphic with examples of your work and a link that goes to your website. As you make contact with clients you can add them to your personal database. You can also purchase current e-mail lists from companies that specialize in compiling up-to-date listings of potential clients. For example, Bikinilists.com offers packages for Europe, Asia, and USA territories that let you access key purchasers of photography services. E-mail blasts are most effective when they are sent out regularly but without becoming an annoyance. Once every few months should be about right, and always use fresh images. You can use social media to direct people to your site and vice versa, and use the site to get people to follow you on social media. Blogging can be another way to promote yourself and, if incorporated into the website, adds more reason for visitors to make return visits. By providing a blog commentary about projects you have been working on, you allow potential clients to see what you are shooting currently and get a feel for how you operate. It also means you'll be creating more searchable content, which in turn can drive people to your site when they carry out an Internet search.

Obviously, some photographers have been very effective at building an audience around their blogs. For example, The Online Photographer was set up by Mike Johnston and has now grown to become a daily news website for photographers. David Hobby's Strobist site is another successful one. These and others have grown to attract large numbers of visitors and publications in their own right. Photographer Zack Arias turned his Tumblr blog into a successful photography book: Photography Q&A. Those photographers who have created popular blogs have had to devote a lot of time to them. Their blogs have worked because they are genuinely knowledgeable about the business they are writing about and they know how to write for and engage with an audience. All of this may sound intimidating if you are new and starting up your own blog, but you don't have to have lofty ambitions for a blog to be useful. At any level it is a good exercise to publish your photographic activities and build a business profile. If only a handful of clients in a year take the time to visit your blog and work gets generated from that, it will have been worth it.

Search engine optimization

Once you have a website you need to find ways to promote it. This can be done through search engine optimization (SEO). SEO can help boost the profile of your site when someone carries out an Internet search. When the user types certain keywords into the search box, such as fashion photography London, the search engine behind the scenes scours the Internet for sites that best match that search. Well-planned optimization keeps your site listed high up in results the search engine finds for your kind of photography, which in turn generates more hits for your site. One part of SEO is using relevant keywords on your site that describe its content. It may be worth hiring a computer whiz, preferably someone versed in SEO, for a couple of hours to help you with this task.

Another way to promote your site is to encourage others to link to it on their sites. You can do the same for photographers working in other specialties, stylists, and others whose work you admire and is related to your own.

Of course, once you lure the searchers you have to keep them, which means you need to ensure that whenever a visitor arrives anywhere on your site, it is easily navigable and allows them to access the remaining website content.

Website management

I mentioned earlier the possibility of subscribing to a web hosting service. For example, PhotoShelter is a service that allows you to host your photographs online as a photography website and archive. With PhotoShelter you have the tools to sell images online and provide client areas for private viewing, lightbox creation, and print sales. PhotoShelter also provides e-commerce support and client image delivery services—all useful tools for servicing clients. Other web services for photographers can provide features such as online bookings. This can be both a good and bad thing. I did this for quite a few years, and when I was busy it presented a good appearance for my business and helped clients find dates that would fit in with my schedule. However, during seasonally quiet periods the calendar was embarrassingly blank, and I eventually ditched the idea. Apart from anything else, it portrayed a photography salon type of image that was more suited to a photography business dealing with a high turnover of portrait bookings.

To gauge the success of your website you can rely on statistical reports from the service provider hosting your site. Google Analytics is a free service. To enable this you'll need to visit the Google Analytics website and sign up to create a new account. You'll then need to include the individual Analytics tracking ID and code in your website. From there you can log in to your account to get valuable insights into things like who is visiting your website, how long they spend on average viewing it, and where the visits originate from. What's useful about this kind of data is it can help you to refine your website design to see which images are the most popular. It helps you edit the website content and note how such design changes influence visitor viewing responses.

Print portfolio

Print portfolios aren't as central to a photographer's marketing as they used to be, especially as it's always a hassle to manage the practicalities of getting your book to a client and dealing with couriers and the like. But for those times when you are asked to turn up at a client meeting or submit a portfolio for review at the final selection stage, it's vital you have a print book that stands out and looks sharp. At initial client meetings you will usually be expected to bring a print book with you. For jobs that involve print media, it is helpful for clients to see photographs in print and physically hold them.

Photoshelter is a website management service popular with a lot of photographers. This allows you to manage portfolio image collections that can be hosted online. The first image shows the interface for customizing the Photoshelter website interface.

ONE OF THE THINGS YOU
GAIN FROM SHOWING A
PRINT PORTFOLIO IS BEING
THERE WHILE IT'S BEING
LOOKED AT.

There are lots of different ways to present a portfolio, and styles have changed over the years as people have experimented with various formats. The ideal format these days is a bound book of acetate sleeves where the page order doesn't get mixed up by people shuffling the photos about. A print portfolio should ideally contain around 20 to 40 photographs, although you should really be able to say everything a client needs to know about your work in 30 images or less. Any more than that and it may start to look repetitive. The order the pictures are shown in is important, too, and can take a while to work out.

One of the things you gain from showing a print portfolio is being there while it's being looked at. You can gauge from peoples' reactions which is the best order to put the pictures in and which are considered the weaker or least interesting photographs. You might also choose to have more than one type of portfolio and create different books to cover separate areas of specialization.

Mobile media portfolios

There are apps for tablets and mobile devices that can be used to create portfolio presentations. These are useful for keeping a copy of your portfolio on a device such as an iPad or a mobile phone, which is a convenient, useful way to show off your work without having to lug around a heavy print book. When the iPad first came out a number of photographers experimented by using these as replacements for their main print books. Apart from an iPad portfolio being lighter, darker images may show more clearly on a backlit screen compared with when such images are viewed in a print book under poor lighting. However, presentation is key, and photographers choosing this method will want to spend as much money on the case they present the iPad in as on the iPad itself.

Self-analysis and editing your portfolio

It's hard to appraise your own work. The first step is to listen to what others have to say about your photographs and take these comments on board. No one person can be right about everything, but if you start to hear the same negative comments about a particular image you'll know it is time to take it out of the book. The relevance of any criticism should be weighted according to that person's expertise. If someone on Flickr critiques your work, take what's said with a pinch of salt. If a photographers' agent says something about one of your photographs, you should listen very carefully. If an art editor on a magazine thinks your work is too commercial, but your goal is mostly to get advertising commissions, take what he or she says more as an observation rather than as criticism.

When working out how you want to portray your work, consider how other photographers do this. Think of a well-known photographer whose work you admire. Which photographs come to mind? Are you able to spot his or her work before you

look at the credits? If you want to follow in that photographer's footsteps you need to do the same and create a portfolio that is memorable for having a continuity of style. You'll also find that clients, especially advertising clients, like to see work in a portfolio that's exactly like what they want to shoot. For instance, if they want someone to photograph an orange, they often need to see you've photographed an orange (an apple or pear won't do). In the early years of your career, there is not much you can do other than create the one portfolio that shows your best work. As you grow you have the chance to create multiple portfolios that show different styles of photography. For example, a fashion photographer might want to have one portfolio for fashion, another for beauty, and another for swimwear and lingerie.

When I first came to London I was friends with an assistant who had an interesting story to tell about the photographer he'd last worked for, who had left London in disgrace and gone off to Australia. This particular photographer was good at shooting all kinds of subjects and for a while had worked quite consistently. If clients wanted to see something specific, be it still life or beauty, his portfolio could be tailored to show them exactly what they wanted to see. But it was all an illusion. Whenever a potential job came in he would tell his assistant to get hold of some magazines. He'd then cut out the nicest-looking pages to create the perfect portfolio for whatever the client was looking for. This is how he got a lot of his work, and the surprising thing is, he was by all accounts an accomplished photographer. His clients were seemingly happy and none the wiser. That is, until he got to shoot a *Vogue* promotion. Someone at *Vogue* got suspicious when it turned out the image used on his card was actually shot by Irving Penn. More commonly, photographers try to pass off the work of others as their own in a subtler way. For example, a photographer shoots some still-life photographs for a brochure and places pages from the printed brochure, which also contains some rather nice portrait photographs alongside his own, in his portfolio. In this case the photographer is implying he did all the photography, which is wrong and misleading.

Photography directories and advertising

Photography directories are still used by a lot of clients; you can buy page ads in a directory to show examples of your best work. Most are printed annually, while others (such as Spotlight) are published more frequently around specific photography themes. Some have rigid guidelines as to how images should be laid out, while others let you create your own design. In assessing whether these can work well for you, it is a good idea to talk with other photographers and potential clients about their own experiences. Also take note when you visit a magazine or agency—do you see these books being used? Cynics say they generate more calls from students and assistants than genuine clients. Promotion websites, such as those listed in the sidebar, are very popular and more affordable than buying page space in a book.

PROMOTION RESOURCES

Lürzers Archive (Luerzersarchive.net) provides a showcase of the best in international advertising. Production Paradise (Productionparadise.com) has grown from Spotlight magazine and is another popular resource with clients. One Eyeland (Oneeyeland.com) is a relatively new promotional website that celebrates the best in photography by vetting submissions and applies image rankings based on the number of times an image is viewed. The UK company Contact (Contact-creative.com) produces a print annual and offers online directories targeted at creative buyers.

E-MAIL PROMOTIONS

To get started with e-mail marketing you'll find several online services that can help automate the process for you. For example, MailChimp (Mailchimp.com) and Send Emails (Sendemails.com) can be used to design a newsletter layout and send out regular newsletters.

THE NEWSLETTER, FOR ME, HAS BEEN THE MARKETING TOOL THAT HAS REALLY ALLOWED ME TO GET NOTICED. IT IS DIFFERENT FROM ANYTHING ELSE I HAVE SEEN FROM OTHER PHOTOGRAPHERS AND HAS BEEN A KEY TO MY BUSINESS FOR A LONG TIME.

Another option is magazine advertising. Trade magazines for design and advertising are a good place to advertise. It's best to consult with the advertising sales representatives to choose when best to do this. Look out for editorial features that will focus on an area of specialization that links to the kind of things you shoot. If you are already established in a particular field, the chances are the advertising salespeople will already have your number and be chasing you to take out ad space. For any advertising to be cost effective, limit it to the markets you actively wish to work in. Some publications promote the fact they have a global reach, but how useful is that to you if you are selling a photographic service? There's no point in reaching out to art directors all over the world unless you are going to be available to work in other cities. The main priority should be to spend money on advertising that's focused on the markets you are working in.

Newsletters

Another way to connect with clients is to produce a regular newsletter that you can send them. This is a way of self-publishing and promoting your photography and can work for photographers in any area of specialization. Michael Clark (whom I interview later in Chapter 6) has been doing this on a regular basis since 2000. His started out as a printed flyer, with just a few hundred copies made, and was sent out to a select group of art buyers and photo editors. Since 2004 Clark has been producing these newsletters using Adobe InDesign and expanded the size to 36 pages. His newsletter still goes to clients but is available to anyone who wishes to subscribe. Back issues can be downloaded via his website (see link below).

I suppose in this age of short attention spans a newsletter may seem out of place compared with the directness of say, blogging or Twitter, but for Clark it has proven to work well. It does require a lot of work on each issue. He reckons he spends about four full days editing and writing each newsletter, which he produces four times a year. This is quite a commitment. As Clark points out, a number of photographers have experimented with producing newsletters of their own. "Most give up after putting out just one or two, and they aren't quite as well done as the ones I have been putting out for the last 12 years," says Clark. He adds, "While social media is the hot new way to promote yourself, I strongly believe that having a following and creating a buzz around your work is the key to strong marketing. Making this happen is the hard part for any business. The newsletter, for me, has been the marketing tool that has really allowed me to get noticed. It is different from anything else I have seen from other photographers and has been a key to my business for a long time. It is basically a PDF magazine. It goes out to over 2,000 art buyers and photo editors, and there are also around 5,000 subscribers who get the newsletter. They sign up by sending me an e-mail. The newsletter has allowed me to create a following both inside and outside the photography industry, and that following has been key to gaining sponsorships, reaching new clients, and creating new opportunities."

One of the reasons it has been successful is the breadth of content. Clark features equipment reviews alongside editorial content showcasing recent assignment work. It gives him a forum to advertise and promote other things like books, print sales, and workshops. Basically, it has broad appeal to a lot of subscribers. For example, many of his readers are keen photographers themselves and appreciate the equipment reviews. Publishing the newsletter has led to picture sales and equipment and imaging software sponsorship. Also, since the newsletters are linked to the website, they are great for SEO because they all link to the website whenever someone does a search.

A newsletter is an effective way of reminding clients and potential ones of your work because as subscribers, they are choosing to see your work, rather than you having to annoy them every few months, nudging them to check out your website. It doesn't have to be in a PDF form. Some photographers send out newsletters HTML-formatted in an e-mail. These are nice and direct and work well as an alternative to a simple e-mail blast.

Essentially, any form of electronic publishing or social media is there at your disposal to help you build a following and connect with others. It can be used to promote your brand or simply as a means to get your work out there and see what comes from it. Chase Jarvis is a good example of a professional photographer with a

Back issues of Michael Clark's newsletter are available from Michaelclarkphoto.com/NEWSLETTER/BACK-ISSUES/1/.

successful business who has also managed to build a huge Internet following. This is mainly because he is a photographer with interesting things to say, but also because he's mastered the use of the Internet to communicate with others and broaden his audience. There was a time when star status was conferred on the chosen few by industry insiders. With the Internet the process is more democratic. If you are of a certain age you will probably never have heard of Lara Jade or Joey L., yet both have over a quarter million Facebook followers and are probably more influential and inspirational to a younger generation of photographers because they have talent, have become successful at a young age, and are good at promoting themselves and building a following. In fact, some of the people currently regarded as being most influential in photography aren't even professional photographers.

Exhibitions

Holding an exhibition of your work is a good way to get yourself noticed. A solo show will be costly, so a group show might be a more affordable way for young photographers to get started. It is customary for colleges to hold degree shows in mainstream galleries. In the UK, the graduation shows will all take place in London. To be honest, though, I am not sure how much attention is given to degree shows.

To produce an exhibition of your own work you need to find a suitable location first and factor in the cost of producing prints plus framing plus transportation and insurance. If you're exhibiting in a professional gallery, the gallery will take a commission on sales, which is usually around 50 percent.

Gallery view of Peter Hince's Queen Unseen exhibition, held in Sydney, Australia.

Exhibitions don't just have to be in galleries. I heard of one photographer who decided he would exhibit on the London Underground. He figured that the Warren Street tube station (being close to many of the big advertising agencies, such as Saatchi & Saatchi) would be frequented by a lot of art directors each day. So he took out advertising space for all the ad spots on the escalator, effectively turning it into a gallery. Some restaurants are willing to display and sell art that they like, for a lower-key kind of impromptu gallery.

NETWORKING

You also need to concentrate on your networking skills. This can happen by keeping in contact with your fellow workers. Through socializing and building a friendly rapport, you help establish a good name for yourself and find ways to help each other. When a photographer has to say no to a job for whatever reason, who is he or she going to recommend? I've benefited from friends recommending their clients to me, and I've put forward photographer friends for jobs as well. Almost anyone you work with might know someone who is looking for a good photographer, and word-of-mouth contact can just as easily come via fellow colleagues as it can from satisfied clients.

Try to attend industry events, such as exhibitions and trade shows allied to your area of specialization. At industry events I'll inevitably bump into clients who may want to discuss future work. Mostly it's all talk, of course, but it gives you an excuse to follow up afterward, plus it never does any harm to be seen.

Face-to-face meetings are hard to arrange these days, but meeting a potential client in person can do so much to help you become remembered. So while it is tricky to actually meet people and easier to rely on the Internet, you should still aim to make appointments. Such meetings are about how you connect on a personal level and open up the opportunity to talk. This can be about your photography, but can also be about almost anything and therefore an important opportunity to sell yourself. At the end of a successful meeting your work will have been seen and you will have had a chance to talk a little about the pictures and answered any questions. The client will have gotten to know you a bit and formed an opinion as to whether he or she likes you and would want to work with you.

It's good to have interests that are outside of photography. For example, I'm a member of a dinghy sailing club, through which I have gotten to know people from outside work. This isn't a calculated thing—I do it because I enjoy sailing. But your leisure activities add another dimension to your work life. They may bring you into social contact with a potential client or may be a point of common interest when chatting with a future possible client.

It's interesting to note the cultural differences that exist in different markets. Whenever I attend a business social event in the US, I notice how people are much more direct. It's almost a case of "What do you do and how useful are you to me?"

That's not necessarily a bad thing either. In European countries people are more likely to feign politeness and create the impression of interest. When I first started out I worked in Milan, where I shared an apartment with some American male models. They had a notice pinned above the front door that said, "Remember: see you soon means never." It was a reminder as to how Europeans typically respond nicely to everyone at go-see appointments and feel awkward making criticisms. Over time you learn not to take things at face value. For example, I worked with a clothes stylist one year who was endlessly discussing a big shoot he had to organize, for which he wanted me to do the photography. It was hard to tell if this was a genuine job or just a ploy to get me to book him on more shoots. I discovered later he was telling the same story to just about every photographer he worked with.

Networking also happens online. Just about everyone uses Facebook, and here you need to decide whether you are going to use your personal account to promote your business or whether you'd rather have a dedicated business page. A personal profile is one where you can choose to add and accept friend requests and build a personal social network. A business profile is one where you can invite people to 'like' your page (rather than become a friend). The latter offers a more businesslike presence on Facebook but lacks the personal touch. Some photographers are happy to let their personal and work lives mingle, although it can make you more circumspect about what you say online. I knew one photographer who would use his personal Facebook page to promote the photo shoots he had been working on but would then also bitch about every little mishap in his life. He really should have kept his personal profile private and had a separate Facebook business page for his photography. On the other hand, I have photographer friends who manage to combine strong personal views and passions with work-oriented posts. One can argue this embellishes their work profile.

There are other social media sites popular with photographers such as LinkedIn and Google+. LinkedIn has been around for some time now and is a useful place to list your business expertise and establish recommendation links with others. It allows you to join groups where you can network with fellow creatives. Where Facebook has its shortcomings, Google+ is more adaptable as a social media platform. For example, using a single profile you can create circles and use these to organize your friend contacts into relevant groups. You can have a circle for personal activities, one for clients, and another for interacting with other photographers. Google+ also offers Google hangouts. These are live video chat rooms you can use to hold conference calls or to just meet up with friends and colleagues. I have successfully used this service for business meetings quite a few times. Better still, it's simple and free to use. Some people like to control the lighting and camera view to project a more professional presence compared with having a badly lit view of a messy office.

E-mail lists are useful for connecting with fellow professionals and sharing advice, which means if you join you should be willing to offer as well as ask for help. There

are lots to choose from. The Prodig list (Prodig.org) is one I helped establish in the mid-'90s with Ed Horwich. Prodig is aimed at photographers and anyone who is interested in digital imaging issues. I also subscribe to the AoP list, which is a closed list for Association of Photographers members only. Other professional associations have their own lists, such as Pro-Imaging, APA/EP, and EPUK. Less formal are the forums you'll find on websites such as Luminous-landscape.com and DPReview.com.

Now these tips may all seem obvious, but it does amaze me how students don't use online resources to find out more about the industry they hope to work in.

COMMUNICATION

How you present yourself is important. Photographers need to be chameleonlike and adapt to whomever they are with. Eric Richmond (see Chapter 5) told me how one day he photographed a young man who had recently recovered from a terrible industrial injury. Next, he photographed the surgeon who had operated on him and saved his arm, and lastly, an aristocratic lady who was one of the hospital trustees. They were three people from completely different backgrounds, and the nice part about his job was knowing how to put each at ease and make them feel comfortable in front of the camera. As a photographer, you'll have the privilege of working with all sorts of people. Even if your subject matter isn't portraiture, it's still important to have good social skills.

There was a time when you would conduct most of your business by telephone. These days more and more communication is carried out online. Where having a good telephone manner once mattered, it's now just as important to convey a good e-mail persona, and the way you write will say a lot about how you perceive the world and how you are perceived. For ten years or so I edited a magazine column, and readers would send in photographs for me to comment on. Each submission had to be accompanied with some text about themselves and the photograph they had taken. The sloppiness of people's writing was astonishing. You know, if you are in a chat room, texting or e-mailing a friend, it's perfectly acceptable to abbreviate. But if what you are writing is important, such as business correspondence (or something that's destined to appear in a magazine), you'll want to make sure that whatever you say is thoughtfully constructed. When dealing with large numbers of e-mail enquiries, I sometimes find it helps to have prepared answers saved as signatures. So, if someone wants to know about terms of business for a studio shoot, I'll have an e-mail ready to send as a reply, and I can easily modify the standard e-mail as needed.

It's important to appreciate the difference between face-to-face and indirect communication. When you meet people in person you evaluate them not just by what they are saying but how their voice sounds, how they look, how they dress, and their body language. All these factors are taken into account and will lead to an instinctive judgment. When communicating by phone, you have just the voice and how well

someone is able to respond during conversation. Also, when you call someone you'll have no idea of what they are doing. You can't see if the other person is busy or not, so always remember to establish first that it's a good time to talk before you launch into a long monologue.

With Internet communication, or letters, you don't have to worry about whether you are interrupting someone or not—they can read what you have to say at a time that's convenient. What they don't always get is the context of the person who is writing. This applies just as much to the use of social media and Internet forums. Twenty-five years on, these are still relatively new arenas of communication, and the absence of boundaries isn't necessarily all for the good. I know perfectly nice people who sometimes behave like monsters when they are online. I realize they're not really like that, but to others it is all too easy to appear bigheaded and arrogant. It's how flame wars start.

When meeting people in person, in most cases I would say dress how you feel comfortable. That's the freedom of being freelance—you can be yourself. Your choice of clothing can be influenced by the environment you are shooting in, though. If I were to shoot at a formal occasion, I would probably prefer to dress up as I would when going out. If I take photographs in the street, I feel more comfortable wearing casual clothes that blend in with what everyone else is wearing. In fact, it often helps to dress down because you don't want to stand out.

When you are asked to estimate on an advertising shoot the art buyer will usually arrange a meeting with each photographer who's been selected to do the job. This can either be in person or as a conference call with the creative team. How you come across in person can have an important bearing on whether you are eventually selected to do the job. When considering a photographer, talent will be high up on the agenda, as will price, but if you come across as shy or hesitant on the phone or in person, this will have a negative effect. For business meetings to be effective, they need time to enable participants to reach a conclusion. If you don't allow that time, you might as well have not bothered having that meeting in the first place. So set the mobile to silent and put everything else on hold. You don't have to have a written agenda, just sufficient time to discuss everything fully. And for important client meetings, there is nothing worse than cutting it too fine and arriving just in the nick of time. Allow plenty of time to arrive punctually and in a relaxed state.

Building a team

Some photographers work completely on their own, but most rely on a team of some kind. It's one of the big differences between shooting for pleasure and shooting for profit. A professional shoot usually requires the coordination of talent, people who have to be carefully chosen and briefed for the job. So an important skill you must master is the ability to make good judgments about those you choose to work with and how to give direction. The people you recommend or choose for a job should

reflect well on you in terms of how good they are at their work and how well they come across as individuals. To get this balance right takes experience, which comes from trying out new people over the years and finding out who you get on and work with best. Your support contacts are an integral part of your business, and it is important to test out and work with different people so you always have backup people to recommend or try out on jobs. All of us will choose to make career changes at different points in our lives and won't carry on doing the same thing forever. So you need to have team flexibility, which means staying on the lookout for fresh talent.

Early on in my career I secured a nice week's advertising shoot for a high street fashion store, shooting on location in and around London. I should have put forward the regular people I had worked with to do the hair and makeup and styling. Instead, I used this as an opportunity to hire people I couldn't normally afford. The mistake I made here was the people I hired weren't really that interested in my job and were just doing it for the money. Although I had worked with some of them before, the chemistry just wasn't right. In fact, on the first day of shooting the makeup artist walked off set, saying he was going to give up makeup forever. I remember running down the street after him, but his mind was set—he was going. I kicked myself for not choosing people I had been working with regularly and felt stupidly disloyal.

Awards and building on success

There are lots of photography competitions photographers can enter, with the chance to win cash prizes or photo assignments or simply gain prestige. Competitions such as the Sony World Photography Awards offer winners an excellent opportunity to showcase their work. When entering a competition you will often be required to pay an entrance fee, which is fair enough if the chance of winning is deemed worth it. But always watch out for the terms and conditions. In recent years there have been a number of attempted rights grabs, where competition organizers have added clauses that allow them to unfairly exploit photos submitted for competitions. The Pro-Imaging organization campaigns to highlight examples of this via the Artists-bill-of-rights.com website. They maintain a "rights on" and "rights off" list of competitions, helping you see which are OK to enter and which to avoid.

Winning a major competition can bring sudden attention from the press and potential clients. The first big award I won was through the UK Association of Photographers Awards. This was for a photograph that came about as the result of an experiment in which I had projected a negative onto a positive print. It was the first time I had tried this technique out, and I didn't have anything else like it in my portfolio. Shortly after winning the award I got calls from a couple of agencies plus a photographers' agent to see my book. They all made the same comment: "Why haven't you got more pictures like this to show us?" It prompted me to start using this technique more on other shoots that were coming up, but by then it was too late and my brief moment of fame had passed. In an ideal world, if you win an important

AN IMPORTANT SKILL YOU MUST MASTER IS THE ABILITY TO MAKE GOOD JUDGMENTS ABOUT THOSE YOU CHOOSE TO WORK WITH AND HOW TO GIVE DIRECTION.

competition you will want to have a portfolio of photographs ready to show that will meet expectations so you can maximize the publicity potential. The major awards organizations can arrange all this themselves, taking care of the publicity in the press and other media. What you need to do is to make yourself available to help in any way that's needed. If the organizers or press want quotes, for example, be ready to respond quickly.

Just as important as winning awards for yourself is helping your clients win them. When a client wins recognition as a result of your photographs, you get to bask in the reflected glory of a job well done and a happy client. It can also help you get more work. Much of the hair photography I have worked on has been shot specifically for the British Hairdressing Awards. Most years I had at least one client win an award. A knock-on consequence was increased business inquiries, which led to further shoot bookings the following year. To be honest, it is usually more about the client's contribution than the actual photography, but clients like to hire photographers who have helped others win awards.

Lastly, under UK law if you win an award that includes a cash prize, this will be taxable if you chose to enter the competition. If you receive an award without entering a competition, you aren't liable to be taxed on this income.

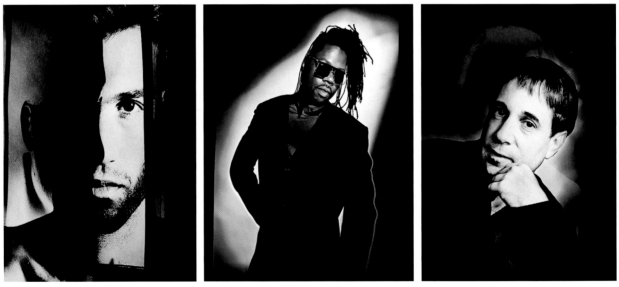

On the left is a photograph with which I won a Silver award at the Association of Photographers Awards. It was only after this win that I used the technique on other shoots, such as Jazzie B (center) and Paul Simon (right).

Self-funded projects

What do you do if you want to initiate a photographic project that's of personal interest to you? While researching this book I asked some of the photographers I interviewed about the kinds of projects they would really like to do if they had time off. Anyone who is passionate about photography will have a dream idea of what they would most like to photograph. If you have the money you can just go out and do it. Otherwise, you'll need to find backers to support you. Maybe you have a client who would be interested in supporting a speculative project, especially if it is one that could lead to a commercial use, such as a published book. Maybe you want to make an exhibition and you can find sponsors who will be prepared to invest in return for the publicity this might generate. Another option is to seek out crowd-source funding using a site like Kickstarter.com on the Internet. If you have a good idea, an established reputation, and examples to show what you can do, ordinary people may be willing to invest for no better reason than they would like to see it happen and be invited to the show. In some cases such projects might even make them a little money. Most self-funded projects will end up costing the photographer money, though, but sponsorship can help alleviate some of the costs. Lastly, there are sometimes bursaries and competition prizes given to photographers who show outstanding talent to support them in photographing a personal project.

3
SETTING UP A BUSINESS
YOUR OPTIONS AND RESPONSIBILITIES

GETTING STARTED

Where did it all go wrong? I had just turned 30, and my photographic career was seemingly in ruins. Up until then I had enjoyed six years of success as a fashion and people photographer and had been getting quite a bit of magazine and advertising work. As I look back now, I would say my creative output had been good up until that point. I don't think it was the quality of my work that was to blame but my lack of business and financial management skills, compounded by a downturn in the economy. One of my clients was a business coach, who once told me, "There are those who make things happen, those who let things happen, and those who wonder what happened." I was left in no doubt which category I fell into but was encouraged to learn how failure is a rite of passage for most businesses.

IF YOU ARE GOING TO CALL YOURSELF A PROFESSIONAL PHOTOGRAPHER, IT'S IMPORTANT TO BE BUSINESSLIKE.

What I found out from this experience is, there are no easy shortcuts. Everyone makes mistakes, and we all become better businesspeople by learning through our failures. In my case I learned that if you are going to call yourself a professional photographer, it's important to be businesslike. I wouldn't say I was by any means an exceptional talent, but through the application of sound business principles I eventually established a sustainable and profitable photography business.

When I went to college to study photography, we had weekly business studies lectures, and these were always poorly attended. We didn't think we needed to be there, and our business studies tutor didn't inspire us much either. All of which is a pity, because we really should have listened more. All too often, people embark on a career as a photographer focusing solely on the creative photographic side—they disregard completely the need to cultivate good business skills. By that I mean the basic principles of how to run a business and manage your affairs. There may be some photographers who do nothing but take pictures and have staff to do everything else, but they are few and far between. In the real world, anyone who sets out to work as a commercial photographer has to be good at photography and business. The two go

hand in hand, kind of like a forced marriage. For example, here are some of the skills you need to run a photography business.

- You need to have a good understanding of how to manage business finances and be aware of your business responsibilities.

- You need to set a career goal and plan how you are going to meet your objectives, such as how to promote yourself.

- You need to be resourceful and have contacts in place who can help you fulfill assignments.

- You need to be good with people, be receptive to what clients want, work as part of a team when required, and be good at giving others directions.

- You need to proof your business against future downturns or changing markets.

- You need to appreciate the value of the work you produce and know why it is important to preserve and protect your copyright.

- Most of all, you need to be self-reliant and be your own boss.

I haven't mentioned things like accounting or spreadsheets. These are important, too, but unless you are comfortable with figures and know how to handle an accounts program, you should rely on the help of a professional bookkeeper. It is more important to focus on the bigger picture first, such as how you present yourself and how the professional photography business works.

FOCUS ON THE BIGGER PICTURE FIRST, SUCH AS HOW YOU PRESENT YOURSELF AND HOW THE PROFESSIONAL PHOTOGRAPHY BUSINESS WORKS.

TYPES OF BUSINESS

According to the Federation of Small Business, it is estimated there are just under 5 million businesses in the UK, while *Business Insider* reveals there are almost 28 million in the US, where over half the working population now works in some kind of small business. Setting up a business is easy, but only a third are likely to remain active after ten years. Here are some of the different types of business structures you can choose from.

SOLE PROPRIETOR/SOLE TRADER

A sole proprietor business is an entity that's owned by an individual in which there is no legal separation between the owner and the business. The business owner owns all the profits (after tax) and has unlimited liability for all debts the business incurs. This is the easiest and least complicated type of setup, especially when you're the only one running the business. There is no need to officially register your business (although you'll likely need a sales tax and possibly a business license). All you have to do is keep accurate records of monthly income and expenditures and file your accounts

promptly with the tax authorities. Ideally, you should have a separate business bank account to process business payments and receipts. Basically, you should file anything to do with your business trading that has a dollar or pound sign on it and keep this information stored somewhere safe.

In the early years your accounting requirements will most likely be relatively simple, but you'll still need to spend some time learning how to correctly file your accounts so your accountant can audit them at the end of each tax year. If accounting is something you feel unsure about, or it is going to consume too much of your creative time, it's best to employ a professional bookkeeper to manage the books for you. This can be done once a week or every other week, depending on how much work needs to be done. Tax is calculated based on annual profits made, and everything after tax belongs to the business owner.

A sole proprietor setup is ideal for small startup photography businesses, because there is only one person involved and it is easy and cheap to establish. A downside of operating as a sole trader is you remain personally liable for all business debts. Because of this some creditors will look more favorably at extending lines of credit to a sole trader. On the other hand, as your business grows it can be harder for a sole trader setup to raise extra capital from banks and investors because the ownership of the company rests with one individual and isn't formalized in a limited company or LLC business structure.

SOME CREDITORS WILL LOOK MORE FAVORABLY AT EXTENDING LINES OF CREDIT TO A SOLE TRADER.

GENERAL PARTNERSHIP

If two or more people are setting up in business together, they can choose to create a general business partnership. Here, you and your business partner (or partners) are personally responsible for running the business. The partners can share all the profits the business makes, where each partner will pay tax on his or her share but also share responsibility for all debts. It is an arrangement that should be entered into carefully, and consideration should be given to how copyright ownership will be decided. For example, it could be a partnership where one partner manages the business and the other takes the photographs. Or, it could be that both partners work together to produce the photography. In either case the copyright ownership will need to be clearly defined at the outset through a joint agreement.

LIMITED COMPANY (UK)

As your profits increase it can be more tax efficient to trade as a limited company. The benefits of doing this are limited personal liability for debts incurred by the business. This is because the company is a separate entity, and the tax affairs of the company are kept separate from your personal finances. Corporation tax is paid on annual profits made by the business, and the company can share profits after tax by paying

dividends to the shareholder owners. With this approach the burden of taxation on surplus profits is much reduced compared with operating as a sole trader. However, tax will have to be paid on dividends, but not at such a high rate as regular income tax.

The downside of setting up a limited company is, there are important legal responsibilities that come with being a director, such as the need to file accounts promptly. Your business will have to be registered with Companies House, where details about your business accounts will be publicly accessible. A company also needs to have at least one shareholder owner plus a company secretary, and these need to be two separate people. Although this structure provides limited liability against debts, some lenders may want to insist on personal guarantees for loans made to a limited company business.

CORPORATIONS (US)

Corporations come in two forms: C corporations and S corporations. C corporations have more complex tax and legal requirements than other types of business structures and also involve costly administrative fees. The advantage of a C corporation structure is the ability to sell ownership shares through an initial public offering (IPO) and attract investors. Most major household-name brands are C corporations. S corporations are more common among small businesses, where the corporation structure limits the financial liability for which the owners are responsible. It provides some liability protection but doesn't shield you from all types of potential litigation. The main difference between this and a C corporation is that profits and losses from the business can pass through to your personal tax return, so it is the shareholders who are taxed and not the company.

LLC (US)

A limited liability company (LLC) is similar to a limited company in the UK and other countries. Essentially, it is a hybrid business entity that combines the characteristics of a sole proprietorship/partnership and a corporation and provides limited liability to its members so they cannot be held personally liable for the company's debts or liabilities. At the same time it offers elective tax status. It can opt to be taxed as a corporation (separately) or as a partnership, in which case it provides pass-through taxation to the members of the LLC. Here, profits or losses are passed through to the individual members, who then report these when making their personal tax declarations. So the LLC itself is not taxed, but the profits passed through to the owner or members are (just as in a sole trader or general partnership setup).

An LLC does not have to pay federal income taxes (unless it's taxed as a separate entity), but some states may impose an annual tax on LLCs. As with a limited company, an LLC provides financial protection to its members. However, whereas a

BUSINESS LICENSES

In some localities it may be necessary to obtain a business license to set up a photography business. This mainly applies to storefront type businesses that deal with the public and seldom applies to things like advertising, design, and photojournalism (though a number of US jurisdictions do require it). In some instances, such as when your work involves public safety, or working with children, a background check will also be required.

corporation can exist in perpetuity, the default position is that an LLC must be dissolved upon the death or bankruptcy of an individual member. This can be circumvented, as an LLC's operating agreement can specify what happens when a member dies or files for bankruptcy. Setting up an LLC may carry more responsibilities in terms of additional paperwork, but it's ultimately a more efficient business structure for most small photographic businesses.

Though the LLC has become a popular form for small businesses, because it lacks some of the formal requirements (e.g., meetings of the shareholders) that corporations have, some have cautioned against the LLC form because the law around LLCs is relatively untested, though in most states, courts will borrow from long-established partnership or corporate law to fill in the gaps in LLC law where necessary. One thing that makes US law tricky is that corporations and LLCs are largely governed by state law, which means it varies across all 50 states. That said, the majority of states have standardized on common laws for most of this stuff, but it's far from uniform.

TAXATION

If you set up a business in the US, you'll be required to pay federal income tax, which you will pay annually or quarterly based on your taxable income. You will need to make a contingency for this by saving up money throughout the year from the business's profits so you're ready to pay the IRS when you are required to do so. You may be liable to make regular estimated tax payments (usually quarterly); this is especially true for self-employed individuals who don't have a regular paycheck from which taxes are withheld throughout the year. US taxpayers are required to file self-assessment tax forms, and April 15 is the last day for individuals to file their tax return.

In addition to this you will have state income tax, which is similar to federal income tax but is collected by the state. The amounts paid vary according to levels of taxable income as well as by individual state.

US STATE SALES TAX

In states that have a state sales tax, businesses that sell products are required to charge state sales tax on all sale items. For photographers this may apply to sales of things like prints but can also apply to fees. Some jurisdictions require that sales tax be applied to photography fees, but not all. The difference with state sales tax is you are collecting this tax on top of the prices you charge to clients and are then required to pass this money on to the state. When setting up a business you'll need to apply for a sales tax permit and submit sales tax returns, which must be completed for each tax period (even if you make zero sales). A local option sales tax (LOST) may also be added to the state sales tax. This is applied in order to raise money to fund local projects. Therefore, the total state sales tax that's levied can vary county by county within an individual state.

UK TAX

In the UK you are required to pay income tax plus National Insurance contributions to the Inland Revenue. When you create a business, tax is collected in January of each year, based on the profits and earnings made in the previous financial year. The financial year for a business will typically go from the beginning of April to April the following year. So, you only start paying tax 9 months after the end of the financial year. This means when setting up a new business, you don't start paying tax till up to 21 months after the start of the first financial year. However, once you do start paying tax you'll have to pay tax on the money that's due for that year in January plus a further amount in July, which will be calculated as 50 percent of your January tax bill, to be paid on account for the following year. The subsequent year's tax is then calculated based on the following year's accounts less the 50 percent already paid, plus 50 percent in July toward the year ahead, and so on. In practice, startup businesses have an easy time in the first year or so of trading. As they start paying tax, the July 50 percent advance payment helps even out a business's tax liability throughout the year. It can also help smooth the ups and downs between profitable and less profitable years.

PROPERTY TAXES

You'll also need to take into account property taxes. In the US, most local governments impose a property tax that is calculated based on the assessed value of a property. The percentage amount varies for each jurisdiction and applies to real estate as well as personal property. In the UK, home owners pay council tax to their local council authority, and businesses have to pay business rates (also referred to as non-domestic rates), while those who work from home may have to pay business rates calculated on the portion of their home that is used for business purposes. So, for example, if you were to use part of your home as a studio, this portion of the property would need to be assessed for business rates and the rest of the space in the house treated as for domestic use.

VAT

Throughout the European Union (EU), value added tax (VAT) must be added to services supplied to customers. VAT registration is compulsory for businesses whose turnover exceeds £79,000 (as of 2014). However, businesses with a turnover below this threshold amount can choose to register voluntarily.

When a business is VAT registered, it must add VAT tax onto all output invoices at whatever is the current rate for each individual member state. In the UK, a VAT declaration must be completed every quarter period where the VAT money you have collected (through charging your clients) is paid to Her Majesty's Revenue and

Customs (HMRC). This can be offset by deducting the amount of VAT the business has paid out on expenses. The chief benefit of being registered for VAT is it doesn't cost you anything to register, and you are able to claim back VAT on all business purchase items. This can improve the profitability of your business through the savings made on purchases. The downside is you have to keep regular accounts and be prepared for an audit inspection at least once in the lifetime of your business. There are penalties for making a late VAT return, and you have to bear in mind that if you ever need to liquidate your assets, VAT must be included in the sale price. For example, if you choose to deregister for VAT, you will be liable for the VAT that would normally be charged on any business assets you purchased through the business. Allowances will be made for equipment that is considered "written off." However, if you bought a digital SLR camera, claimed back the VAT, then deregistered the following year, the HMRC would look to recover the VAT on this purchase. When a business is dissolved this is one of those things that's often overlooked.

There is also a flat-rate VAT scheme that may suit some photographers. Providing your VAT taxable turnover is below £150,000 (as of 2014), you will be eligible. Instead of calculating the difference between output and input invoices and the VAT amount to be paid or repaid, a registered business will add VAT at the current rate as normal to all output invoices and pay a flat rate of VAT to HMRC at the percentage rate for your industry sector (for photography businesses this is currently 11 percent). The advantage of this scheme is it makes the paperwork simpler. Another option is the cash accounting scheme for businesses that have a turnover below £1.35 million (as of 2014). This scheme can be advantageous for cash flow because you only pay VAT based on the input invoices you have paid and output invoices you have received payment for. This can protect small businesses from the burden of paying VAT up front on what might prove to be a bad debt. The downside is the paperwork becomes more complicated to administer.

VAT is only charged on invoices made within member states of the EU. When invoicing within the same member state, VAT is chargeable at the standard rate for that country. When invoicing someone in another country inside the EU, VAT needs to be added, unless the person you are invoicing is registered for VAT in his or her country. In this case you can zero rate the VAT amount, but you will need to obtain the client's VAT number, including the two-letter country code, and include this on the invoice. When invoicing countries outside the EU, VAT is charged at a zero rate. This is important to remember if you are a non-EU citizen buying goods in the EU. For example, if you were to buy an expensive item on a visit to the UK, you will have had to pay VAT at the standard rate at the time of purchase. If you retain the receipt and make time to show this to the UK Customs office prior to departure, you can fill in a form to obtain a refund on the VAT paid. Note that this can only be done when traveling to a country that is outside the EU and applies to goods purchased within the last three months; it excludes the purchase of services and certain other items. To

VAT IS ONLY CHARGED ON INVOICES MADE WITHIN MEMBER STATES OF THE EU. WHEN INVOICING WITHIN THE SAME MEMBER STATE, VAT IS CHARGEABLE AT THE STANDARD RATE FOR THAT COUNTRY.

qualify, check that the store you are purchasing from operates the VAT Retail Export Scheme, where you will need to complete a VAT 407 form. This will have to be shown to Customs on departure, and a refund will be sent to your address.

EMPLOYEE TAXES

There can be tax implications when you start to employ people. If you hire someone on a freelance basis, they will be responsible for their own tax affairs. However, once you employ someone part-time or full-time, you'll become responsible for paying income tax on their wages, plus other taxes. In the UK an employer must additionally make National Insurance contributions calculated based on the amount of wages paid. In the US you have the Federal Insurance Contributions Act (FICA), which includes two taxes: Social Security and Medicare. For Social Security, the employee pays 6.2 percent of his or her wages and the employer pays an additional 6.2 percent. This tax is paid on only the first $117,000 of income (as of 2014). For Medicare, the employee pays 1.45 percent and the employer pays 1.45 percent, and this is paid on all income. Generally, the distinction between freelance and part-time/full-time employment is fairly clear-cut. A stylist or model hired for an individual shoot is obviously working freelance. Assistants are classed as freelancers, too, but if you hire the same assistant on a regular basis and become his or her main or sole hirer, the tax authorities will regard him as an employee and you'll be made responsible for paying his taxes directly.

Allowable deductions

Any purchases you make on photographic equipment and other photography-related expenses can't be claimed against tax unless you have created a separate photography business. There is no reason why you can't do this and still have a part-time or full-time job, but the trading accounts need to be kept separate from the personal accounts.

Anything you register in the purchase ledger has to be a valid item connected with the running of your business. When paying for things like office stationery or business services, it is clear these are necessary work expenses. What you can't do is load the purchases ledger with items that are really personal expenditures. For example, with air travel it is OK to claim for a flight that was necessary as part of your business, but not if it was simply a vacation trip. It may be tempting to bend the rules, but you have to remember that when you file your accounts for tax purposes you will have to make a signed declaration. When preparing the accounts, your accountant may want to check specific items to ensure you have complied correctly. This will be for your own benefit, because if the tax inspectors are at all suspicious you can expect to face a detailed tax audit. And by detailed I mean a forensic inspection of your business and personal activities. Somebody I know once claimed for a trip he made to Australia to

DEPRECIATION OF ASSETS

When you make a capital purchase, such as a new camera, the cost of that purchase can't be deducted as a regular expense item. The tax authorities, such as the IRS, require the use of an elaborate depreciation formula to determine how much you can deduct in each tax year over a number of years. Rental expenses are typically deductible in the tax period in which they're incurred (versus having to capitalize the purchase price). This is why so many businesses choose to lease or rent equipment, not only so they always have the latest models but also for the tax benefits.

IF THE TAX INSPECTORS ARE AT ALL SUSPICIOUS YOU CAN EXPECT TO FACE A DETAILED TAX AUDIT.

Digital cameras and computer equipment needs to be updated every few years. As new technology provides the means to produce better-quality images in challenging conditions, you'll need to invest in new cameras every few years. Lenses less so, since good-quality lenses don't have to be replaced so often. Computers, on the other hand, are constantly being superseded by faster models with greater capacity. At the same time the components used in even the latest computers aren't built to last, and you have to accept the fact that a computer that's put through a lot of hard use will likely need to be replaced after a few years' use.

seek freelance work. Nothing came of it, but he thought it was OK to claim the trip as a business expense. However, because the costs of the trip relative to his gross annual turnover were high, it looked suspicious. The outcome was a lengthy inspection that took over four years to complete. Every little detail of his life was examined. For example, the auditors noted he had purchased Allan Carr's *Quit Smoking* book, which prompted a question as to how much he had spent previously on cigarettes (to establish his personal expenditure). The bottom line is to make sure you are able to defend every item you claim as an expense. If in doubt, check with your accountant, who can best advise you about claiming specific items. You might be able to legitimately claim things as expenses that you would not otherwise have even considered.

Make sure you keep all paperwork for a period of up to seven years (five years in the UK) after the tax return due date for the current year. This is a legal requirement. Should there be the need for a tax inspection you must be able to show records on demand for any time during this period.

ACCOUNTANCY AND RECORD KEEPING

While photographers may be able to take care of the bookkeeping themselves, it is essential to hire an accountant and have him or her advise you fully. A good accountant can help maximize the opportunities to legitimately reduce your business tax liabilities. Be aware that an accountant can only handle your business affairs for where you live and work. If you run a business based abroad, you'll need to hire an accountant who is familiar with the tax laws in that country. In the US it is recommended you choose someone who is a certified public accountant (CPA), as they can best advise you on all your tax and business accounting affairs. It's an important decision, so check with fellow photographers you know for advice when selecting someone to handle your affairs.

RAISING MONEY

As of the year this book is first being printed, it isn't a great time to be starting a business. Following the 2008 banking crisis, it's proven hard for established businesses, let alone new businesses, to secure the money they need to grow. This in turn has created a stagnant economy in many countries, and recovery has been slow. Setting up a new business always requires some expenditure. If you were to set up a retail store you would face the costs of fitting out a shop, purchasing stock, and employing staff before you had even sold a single item. Photographers are fortunate in that all you need to start is a phone, a computer, and a camera. Everything else can be hired in. So while it is nice if a bank is prepared to lend you the money, there is still the potential to grow a photography business from scratch in the early stages without immediately requiring a big business loan. What you will need, though, is access to debit and

credit cards registered to the business, plus an overdraft facility and credit accounts with a number of suppliers such as hire studios and rental companies.

There is an important distinction to be made here between money that's used to buy everyday things and money that's used to invest. You need money to cover regular outgoings such as rent, utilities, and food. For this you need to plan to have a basic income that will cover all these essentials. A part-time job with flexible hours, even if it's unrelated to photography, can help pay for your day-to-day living expenses. You also need money to invest in equipment and test photography expenses and to drive your business forward. For example, it could be used to cover the cost of setting up an office or studio or to finance a photographic project. It's important to keep this distinction in mind whenever you ask to borrow money. A lender won't want to loan money merely to support your living costs, and a business loan in particular will be conditional on you showing that the money is going to be invested properly in the business to help you take better photographs or work more economically. The sensible way to look at finance is as a means to grow at a suitable pace. Without finance few businesses can hope to accelerate forward.

In reality, most people will also have to resolve personal debt—paying it back can start from the moment you leave school. So there is the question of debt management to take into account as well. It can sometimes be advantageous to amalgamate all your current debts into a single loan, especially if it means you pay a lower interest rate, the cost of which can be grouped in with your day-to-day living expenses.

It is possible to start with very little and gradually build up the capital investment needed for camera gear, lighting, and so on. Here's the rub. In the early years the amount of money you are likely to earn in profit from each assignment probably won't even cover the cost of renting all the equipment needed to shoot it with. It makes economic sense to be as self-sufficient as possible, which means choosing wisely which equipment you need for your work. Each bit of equipment you acquire must therefore be able to justify its keep. So, while it might be nice to have a 300 mm f/2.8 lens for your digital SLR, how often will you actually use one on a job? If the answer is "hardly ever," then maybe you should consider renting this lens only when it's needed. You will save yourself money in the long run.

If you figure a piece of equipment is going to be vital to your business, then you need to decide whether it is best to purchase or lease. If the purchase you are about to make requires finance, leasing will be the most cost-effective solution. With a leasing agreement a finance company provides the purchase money and you make regular lease payments, where you effectively rent the item (you don't own it), but these payments are 100 percent tax deductible. At the end of a leasing agreement you will either have the option to return the item and no longer be responsible for it, or purchase it outright for a small sum. With a leasing deal you are paying interest, of course, just as you would with a hire purchase agreement, but of the two leasing is the most tax efficient and therefore more popular. The other benefit is flexibility. Where items

IT MAKES ECONOMIC SENSE TO BE AS SELF-SUFFICIENT AS POSSIBLE, WHICH MEANS CHOOSING WISELY WHICH EQUIPMENT YOU NEED FOR YOUR WORK.

Nikon D700

▶ DxOMark Sensor Scores

Overall Score [?]		80
Portrait (Color Depth) [?]		23.5 bits
Landscape (Dynamic Range) [?]		12.2 Evs
Sports (Low-Light ISO) [?]		2303 ISO

DXO Mark

THE DXO LABS WEBSITE CONTAINS
A DATABASE OF CAMERA SENSORS,
ASSESSING EACH FOR COLOR
DEPTH, DYNAMIC RANGE, AND
LOW-LIGHT ISO PERFORMANCE.

need to be regularly updated, such as with computer equipment, leasing makes sense. If you can afford to buy something outright, it makes sense to purchase because you won't have to pay interest. Capital expenditure items are still tax deductible but will have to be written off over a period of years as depreciation items, so are not immediately tax deductible. Equipment retailers are often keen to promote lease agreements because they will earn commission from the finance companies they recommend. In a competitive market some may even pass on these commissions as savings to the purchaser, so you can end up with a deal with a really low interest rate, or no interest, even, that allows you to spread payments over a year or several years. It is something worth knowing and being aware of when making such a deal.

Another way to save on the financing is to buy secondhand. The market for digital cameras is so fast moving these days that cameras can be considered out-of-date within just a couple of years. As a result such cameras soon depreciate massively and can be purchased for a fraction of their original cost. You can often pick up some pretty good cameras at around, say, a quarter of their original selling price. The sensor may not have as many megapixels as the newest models, or cope so well with low light at high ISO settings, but will still be capable of capturing good images. It can be useful to check out the Dxomark.com website. This is run by DxO labs and contains a camera sensor database where you can compare the sensors in different cameras side by side based on color depth, dynamic range, and high ISO performance. It's also a really useful resource for checking how older models compare with the most recent cameras.

The Internet is awash with good deals, but be careful when you buy online. The cheapest deals will often be for gray imported goods. These aren't illegal, but they won't necessarily include a valid manufacturer's warranty for where you live. Some of the websites that advertise knocked-down prices may take many weeks to deliver the goods, so it's always a good idea to check for feedback from other buyers to see what their reputation is. It's still risky, though. I remember one assistant who lost a huge amount of money purchasing a camera that never materialized. Of course, there is eBay, which is a good place to shop for a lot of things, but in my experience, secondhand camera equipment (especially lenses) tends to fetch inflated prices. You can pick up the occasional bargain, but I mainly use eBay to get rid of unwanted gear because it's often a sellers' market. Stick to the reputable ecommerce sites. A photographer I know sold some equipment, and the person who bought it never paid. It so happened the photographer was driving through the buyer's neighborhood one day. Rather than knock on the door, he took a photo of the house and sent the owner a picture. He got his check.

BUSINESS RESPONSIBILITIES

In Europe, attempts have been made to regulate the photography industry to make it a profession that requires qualifications before you are allowed to practice. It's something that's been strongly resisted by editorial and advertising photographers concerned that such a move would just be government bureaucracy getting in the way of creativity. For example, all of the photographers I feature in this book got into photography without needing to show any qualifications. It also begs the question, which professional bodies would be in charge of setting the examinations, and would they be relevant to all types of photographers? I think one of the concerns is that the idea is attractive to the big professional photography bodies, as it might raise their importance. Not everyone is happy about that. The Association of Photographers, of which I am a member, has long argued such a move would be unnecessary. Having said that, important responsibilities do come with being a professional.

EMPLOYMENT

If you work using a simplified business structure—that is, you're a sole proprietor—the tax implications are fairly simple. Tax is paid based on annual profits, and as a self-employed individual you are responsible for managing your own tax affairs. If you create a limited company in the UK, as director you have to become an employee of the company and pay yourself a salary plus make National Insurance contributions based on what the salary amount is. Also (as I explained earlier), anyone you hire who works for you on a regular basis will have to be contracted as an employee. This means you become responsible for paying your staff's taxes (which will need to be deducted from source income), and your employees have certain legal rights. The law will differ from country to country, but in most places it means you can't just sack an employee without reason. Proper procedures have to be followed. It also means you are responsible for their welfare at work, and they may be entitled to paid leave. They will also be entitled to claim unemployment benefits and insurance. Some photographers prefer to formalize assistant bookings by making clear these are freelance, lest assistants later claim they should in fact have been hired as employees and wish to claim benefits. These are all things to take into account before you expand and take on more staff.

PROTECTING
YOUR ASSETS

It's important to be insured, but it also remains vital to take steps to limit your exposure to theft. It is all very well to replace your equipment at no or little cost should it be stolen, but the inconvenience of losing it can still be significant—especially if you have an important shoot on your card. Chapter 6, "Photographing on Location," suggests some of the ways to protect your gear while traveling.

CONSIDER ANY JOB THAT PUTS YOU IN TOUCH WITH PHOTOGRAPHERS, SUCH AS WORKING IN A RENTAL STUDIO.

ASSISTANTS

One of the best ways to get started in the photography business is to assist established photographers. They need hardworking helpers and you need the experience. The pay may not be great, but the training value is huge. It helps if you can find work with big-name professionals—that way you get to see how things are done at the top, and you have the opportunity to build up contacts that may be useful to you later. If nothing else, you can casually mention that you worked with so-and-so when talking with prospective clients.

When I first started out, most of the top photographers had their own studios, and full-time assisting was the norm. That soon changed as more and more photographers preferred to keep their overheads down by renting and hired in assistants on a freelance basis. A full-time assisting job can bring the benefit of some job security and, if the photographer is busy, the chance to see firsthand how the business is run. You may also be allowed use of the studio on evenings and weekends, which, if you consider the cost of renting, can compensate for a low-wage position. My last full-time assisting job was with a photographer named James Wedge, who at the time was one of the top fashion photographers in London. Through him I got to travel on a lot of exotic trips and worked on a varied mixture of shoots from editorial to high-end advertising. It was a fantastic experience. If you choose to work freelance you'll get to see a wider variety of photographers at work. I know a few photographers who bypassed the assisting route completely, but most have had some assisting experience. I would say this is a vital step if you want to learn how the industry works. Freelance assisting also lets you make a smoother transition from assisting to working solo on your own shoots. Looking back at the four years I spent full-time and freelance assisting, they were a valuable learning experience.

Assisting work can be hard to come by these days, but you can find your way into the industry in other ways. Consider any job that puts you in touch with photographers, such as working in a rental studio, or help out at social events where you are likely to meet photographers. To be a good assistant is all about common sense, really. What you need to do is to be yourself (well, your best self), and you'll soon find that opportunities arise naturally from the people you get to work with.

When you become a photographer and need to employ assistants, it helps having been one once yourself (although so many forget what it was like). A good assistant can be a positive presence and supportive, so it's important to recognize this and treat assistants fairly. It's quite shocking the number of times one hears that an assistant has had to wait months for invoices to be paid.

INSURANCE

While it is great that anyone can pick up a camera and practice being a photographer, it is still important to be aware of the responsibilities that come with being a professional. Failing to do so can be costly and risky. If you shoot as an amateur photographer all you need is appropriate household insurance or extended insurance to cover accidental loss of equipment. If you photograph for profit it's different, and you're commercially responsible for whatever happens to you or what you do to others. The same applies equally to anyone on your crew— it's usually a legal requirement. You'll need to consider several different kinds of insurance.

EQUIPMENT THAT IS NORMALLY KEPT IN THE OFFICE ONLY, SUCH AS A DESKTOP COMPUTER AND PRINTER, WON'T NEED WORLDWIDE TRAVEL COVERAGE.

EQUIPMENT INSURANCE

Photographic equipment must be insured using a policy that covers you when shooting professionally. This is because a working photographer will be using equipment on a regular basis, which will therefore be at more risk than when a hobby photographer uses the same kind of equipment. Look out for exclusion clauses that may limit the type of photography you will be covered for, as well as territorial limits. Actually, you can use this to your advantage to keep the premiums down. Equipment that is normally kept in the office only, such as a desktop computer and printer, won't need worldwide travel coverage. It is also worth checking out the deals professional photography organizations offer their members. Some are able to provide member discounts on professional insurance.

There is also "goods in trust" insurance, which can be used to cover items you are looking after temporarily, such as props, or wardrobe for a shoot. If you hire stylists they should have their own goods in trust policy, so this won't always be necessary. Goods in trust insurance typically provides coverage for most items you are likely to photograph. However, for expensive items such as jewelry or works of art, you'll need separate insurance.

LIABILITY INSURANCE

If you work professionally you need to take out liability insurance that consists of the following types.

It is advisable to have employer's liability insurance. This covers you for any liabilities that arise from someone working for you, full- and part-time employees as well as freelancers. If something bad happens to someone who is working under your control on a shoot, this type of insurance covers the costs of any subsequent action and compensation claims. If you travel abroad, the insurance should cover employees who travel with you, but not ones you employ abroad. For that you will need to arrange separate coverage. In the US, employers are generally required to carry

PHOTOGRAPHERS ARE
ALSO ADVISED TO HAVE A
PUBLIC LIABILITY INSURANCE
POLICY, WHICH COVERS YOU
AGAINST NEGLIGENCE AS
A CONSEQUENCE OF YOUR
DOMESTIC PROFESSIONAL
ACTIVITIES.

workers' compensation insurance, which covers employees if they are injured on the job, and most employers are required to pay unemployment insurance tax that funds a public unemployment insurance system. A handful of states require employers to carry disability insurance.

Professional indemnity insurance isn't a legal requirement, but photographers are advised to consider it. This type of policy can cover a range of things linked to claims that might be made against you for professional negligence, such as dishonest activities of employees or shoots that are ruined as a result of faulty equipment. An example of this would be a corrupt data card that affected the results from a shoot.

Photographers are also advised to have a public liability insurance policy, which covers you against negligence as a consequence of your domestic professional activities. Most the time when you rent a location for photography work you will be required to provide evidence of such a policy before you can make a booking. Coverage will most likely be restricted to working domestically. If you plan to work abroad you may need to arrange separate coverage as needed.

All the above types of insurance can be bundled together in a single business owner's policy package (in the US there is usually just a single package of liability insurance for businesses). Some brokers specialize in doing this for professional photographers. They can also advise how to handle individual claims where the outcome may not always be so obvious. For example, on the way to a shoot in your car you scrape another vehicle. This will be covered by your motor insurance policy, where you need to have declared the use of your car for business as well as domestic use. Let's say you arrive safely and the job is to photograph a car in a car showroom. If the car you are photographing gets damaged by a light scraping against it, this will be covered by goods in trust insurance (because the car is the subject of the shoot and is considered a prop). On the other hand, if a light falls and hits a car in the showroom that isn't part of the shot, goods in trust insurance doesn't do the trick (because the car won't be considered a prop). Liability or public liability (UK) insurance is needed to cover this type of incident.

WEATHER INSURANCE

When shooting on location, you can never completely rely on the weather. You can at least make the assumption that if you go to a particular location at a particular time of year, the weather is most likely going to be good and allow a few days for shooting. If it does rain one day you'll still have time to shoot the next. Weather insurance is an option but is also very expensive. You can include in the terms and conditions a clause that says 50 percent of all fees plus 100 percent of incurred expenses are to be paid out if a shoot has to be postponed due to bad weather.

MEDICAL, INCOME PROTECTION, AND DISABILITY INSURANCE

None of these will be easily affordable in the early years, but if you live in a country like the US, medical insurance is vital. If you want to compare going freelance against a salaried job, you'll need to factor such benefits into the equation. Sure, you may not be able to afford adequate coverage now, but your goal should be to attain the same level of coverage as you would be entitled to in the private sector, working at a similar level. You can buy relatively inexpensive high-deductible insurance that will make you pay for care annually up to a certain point (say, $6,000) and then will cover you after that, in case you have an accident or become seriously ill.

In countries outside the US, like Canada, Australia, and the UK, health care is mostly free at the point of use and funded by the government. Although these services are under increasing budgetary constraint, they do provide a safety net for citizens. Therefore, if you live somewhere like the UK, you don't need to have private health insurance, unless you want the extra coverage (which can be useful, especially since it allows you to fit in any required treatments around a time that suits you).

Income protection and disability insurance isn't absolutely necessary, and opinions about the value of such policies are divided. Individual policies will vary in the details, but the way they work is that should you become incapacitated in some way and unable to earn a living (whether for a short period of time or permanently), such a policy guarantees you continue to receive an income in addition to the other benefits you are entitled to. I recently read about a successful photographer who was forced through illness to stop working completely. Because he had such a policy he has received regular monthly checks ever since. A variation on this is critical illness insurance, which pays out a lump sum on diagnosis of specific conditions. If you take out such a policy while you are young and healthy, you should expect favorable premium rates. If you leave it till you are older, the premiums will rise and exclusion clauses will be added to account for any conditions you might have developed. Naturally, the same applies to health insurance policies. If you initiate these too late in life, they will be more expensive.

Another variant is loss of business insurance. This can be used to insure against illness, but also covers other scenarios that might interrupt the smooth running of a business. It is more suited to photographers who employ full-time staff, as it can cover the cost of paying salaries as well as all the other overheads associated with running a business.

CAREER OBJECTIVES

BEING YOUR OWN BOSS

AIM TO SET YOURSELF A
REGULAR WORK ROUTINE.
IF YOU RENT AN OFFICE OR
STUDIO, THE DAILY COMMUTE
WILL HELP ESTABLISH A TIME
WHEN YOU GO TO WORK AND
A TIME WHEN YOU FINISH.

At some point you need to decide what sort of photography you want to do and have in mind some goals you can work toward. The problem with working for yourself is there's no one but you in charge to set the pace and drive the business forward. It's all too easy to become lazy and settle into a pattern of behavior where you don't really go anywhere and fall into a rut. Being your own boss is just another of those tasks a multitasking freelancer must adopt.

Aim to set yourself a regular work routine. If you rent an office or studio, the daily commute will help establish a time when you go to work and a time when you finish. Working from home is great, but it can be really hard to get into a proper routine. Without the discipline of going to the office, you can end up working sporadic hours throughout the day. At the very least, try to find yourself a space where you can work uninterrupted.

At the end of the day what you're selling is your time, which as we saw earlier is quite expensive if you sit around being idle. Try to structure each week so that you spend enough time on each work activity. This will include office administration, correspondence, preparing invoices, monitoring e-mail, social media activity, and marketing. If you have a weakness for playing Grand Theft Auto and other games (or reading Facebook), just remind yourself how much such a distraction is costing you. If necessary, fit a parental lock on the work computer!

WHAT'S THE PLAN?

Every business needs to have goals and something to strive for. As a photographer you should take time to study how more experienced photographers got to where they are now and learn from their successes and mistakes (as well as your own). Mike Markkula, who was Apple's first big investor and who later became its chairman, said, "You should never start a company with the goal of getting rich. Your goal should be making something you believe in and making it last." I have known photographers who have become incredibly successful, but not all of them are financially well off. But they have all had lives enriched by the experience of doing what they love.

As you immerse yourself in the world of commercial photography, you'll get a better understanding of how the business works and from that determine the various steps you'll need to take in order to do well. So, if your goal is to become a portrait photographer, study those at the top whose photos you most admire and learn what you can from their work. Next, work out how you are going to create your own portfolio and which magazines or newspapers you should contact to get your first

editorial commissions. Once you have gotten established as an editorial photographer, look for bigger assignments such as design, advertising, and better quality editorial. Aim to exhibit your photographs or even publish a book. By setting yourself targets and self-imposed challenges, you keep yourself motivated.

Location

This may seem blindingly obvious, but it's important to decide early on where you are going to be based. Focus on the city you are going to get started in, and concentrate all your efforts on establishing yourself in that market. Basically, it is little use to market yourself to New York clients, unless you are actually going to be based in New York or within easy reach. You just won't be taken seriously unless you are already known internationally or have a New York agent. During my career I have tried working in different countries and had some success in the Netherlands working for a few of the advertising agencies there, but that, too, was tricky, because although Amsterdam isn't too far from London, it mattered a lot to the clients I met whether a photographer was based there permanently or not. Clients like to find photographers they can work with on a regular basis. If they like you and your work they will want to know if you will be around for the long term to build a working relationship.

The other point is, it takes a lot of time and effort to establish yourself, so you might as well do it in a place that offers the kind of work you are most suited for. If you aspire to work in one of the big international cities, move there as soon as you can and build up all your contacts in that location. Once you are established it will then be easier to move to another city. OK, not necessarily easy, because there will be a lot of ground work you'll have to do again from scratch, like meeting new people and sourcing new contacts. My advice is to choose to start out in a city where you can see yourself spending your whole career, rather than start small locally and hope to move up when you are more established. And, if you know what you are doing, building a career in two or more cities can help increase the work opportunities.

PROFESSIONAL ASSOCIATIONS

You owe it to yourself and the industry you work in to become a member of a professional association. These organizations have largely been set up by photographers to unite them and help achieve goals that support the wider interests of professional photographers everywhere, such as challenging unfair contract terms and defending photographers' rights. Organizations like the AoP, ASMP, and PPA have achieved a lot on behalf of photographers over the years and continue to offer advice and shared experience to their members.

YOU OWE IT TO YOURSELF AND THE INDUSTRY YOU WORK IN TO BECOME A MEMBER OF A PROFESSIONAL ASSOCIATION. THESE ORGANIZATIONS HAVE LARGELY BEEN SET UP BY PHOTOGRAPHERS TO UNITE THEM AND HELP ACHIEVE GOALS THAT SUPPORT THE WIDER INTERESTS OF PROFESSIONAL PHOTOGRAPHERS EVERYWHERE.

UNLESS YOU INTEND TO KEEL
OVER BEFORE YOU RETIRE,
A CAREER PLAN SHOULD
INCLUDE WHAT HAPPENS AS
YOU APPROACH RETIREMENT
AGE.

To some it may seem passé to belong to a photography association. Personally, I think it is important to recognize the past gains that have been made by the various associations and appreciate the ongoing need to continue the fight to represent photographers' interests. If you don't give the professional associations your support, who will? The future of the industry is going to rely on photography organizations in some shape or form having a strong voice and the active support of their members.

PLANNING FOR YOUR FUTURE

Nobody likes the prospect of growing old, and none of us can expect to work forever. So, unless you intend to keel over before you retire, a career plan should include what happens as you approach retirement age. There is a saying, "Be nice to your children, because one day they will choose your nursing home." It's something today's political leaders should reflect on as they come to rely on today's students (and future taxpayers) to provide them with a pension. Can a population that's growing (partly because people are now living longer) expect retirements funded by today's younger generation, who, by the way, will have enough problems of their own dealing with student debt and unaffordable housing? There will have to be a solution, and one of the likely outcomes is going to be a later retirement age and fewer government benefits. With this in mind, everyone must think very carefully now about their financial future in an uncertain world.

Retirement savings

The sensible advice is to start putting money into a pension plan or Individual Retirement Account (IRA) as early as you can to allow enough time to build a sizable retirement pot. All this assumes you can afford to make retirement saving contributions in the first place and that the retirement account will grow. This current economic climate isn't a great time for savers. One advantage of making retirement account contributions is you'll normally get tax relief on retirement savings made (but not all savings and IRAs), whereas you won't necessarily with other types of savings and investments. The disadvantage of saving for a retirement account plan is that you can't access the money till you retire without incurring penalties and there is no guarantee your money will grow. You could even see your retirement account savings evaporate as a future financial crash sends the markets into turmoil. What you can do, though, is to get good investment advice in allocating your IRA funds and transfer your retirement account savings to less risky investments as you approach retirement age. This can help safeguard and protect you from sudden market swings.

There are other approaches to preparing for retirement. Some photographers may invest in a studio and use the profits from the sale of such to help fund their pension, although again, there will be tax implications. The rise in property values may compensate for this, but that's assuming that property prices will continue to escalate as

they have often done in the past. Will they? Another option is to invest in a property that can be rented out. Although not as tax efficient as putting money in a retirement savings scheme, this can offer more security, providing the proportion of cash you invest is sufficient to cushion you against future interest rate rises. Also, you can start earning an income now from the difference between the rent received and costs of maintaining the property plus the mortgage repayments.

A qualified financial adviser can help you plan for your future. Consult one about investments and retirement saving plans. Some work within consumer banks and are only able to recommend specific financial products offered by the bank they work for. Others operate independently and can help suggest products from across the market. It's important you feel you can trust the person you are working with and be prepared to take a long view on the investments you make. In the US, brokerage firms are regulated by the Financial Industry Regulatory Authority (FINRA), and investment advisers are regulated by the Securities and Exchange Commission (SEC). Independent financial advisers in the UK are all regulated by the Financial Services Authority (FSA). These government bodies scrutinize the activities of advisers and certify they are qualified. While they have been set up to prevent malpractice, they offer no guarantee about the quality of advice offered, and as you know if you read the papers, many innocent people have been swindled by poorly chosen financial advisers and brokers. You still have to rely on your own judgment when making these important decisions.

Certified Financial Planners

The US financial planning industry also has a well-regarded professional association that certifies individuals as Certified Financial Planners. Members will have reached a bachelor's degree level or higher and have passed the CFP exam. Most good financial planners are CFPs (though not all). You can read a bit more about the program at Cfp.net.

PETER ANDREAS

SPECIALIZATION: ARCHITECTURAL PHOTOGRAPHY

Photograph © Christopher Nibley

ARCHITECT: PAT KILLEN,
STUDIO 9 ONE 2, SOUTH BAY,
CALIFORNIA.

SHOOTING DIGITALLY, THERE
IS THE ADVANTAGE THAT IT'S
EASIER TO BALANCE COLOR
TEMPERATURE AND REGISTER
MULTIPLE EXPOSURES
AFTERWARD ON THE
COMPUTER.

Based in California, Peter Andreas shoots mainly for architectural firms but also for developers, structural engineers, landscape architects, and interior designers. He has always been fascinated by buildings, and his approach is to study different angles and effects of the sun at different times of the day and how it shapes and colors a building. As Andreas puts it, "Why has the architect chosen a certain material and color? What is the psychology behind the person who has created this building? It is the understanding of why the architect designs a building in a certain way which enables me to deliver images that intrigue my client."

When commissioned to photograph a building, the first step is for him to use Google Earth to see where the building is and which way it is facing, and then calculate how the sun will affect the structure at varying times of the day and at different angles. He also uses Sun Earth tools (Sunearthtools.com) to assist with gathering this information. Andreas will then pay a site visit, first to walk around and look for interesting angles, evaluate the feasibility of those, and consider whether or not there is space for the camera, tripod, and a few cases. It may even be necessary to obtain a special permit from the city in order to secure a safe shooting position on public land or in a thoroughfare. Will there be cars in front of the building, will they complement it, and if so, will these cars be available on a specific day? Otherwise it is best to go to the city and ask for no-parking signs to be placed on a specific day and time. Andreas will also use that first visit to decide on equipment, how to get it to the site, and whether he'll need to hire an assistant. Preferred equipment is a view camera, a case of lenses, a heavy duty tripod, sandbags, and a couple of C stands with flags for shading the sun in wide-angle shots.

When shooting interiors, the architect will be interested in the overall lighting of the interior and the harmony of design. A lot of the time architects will be satisfied with an HDR-processed shot that won't need any lighting. Interior designers want to see everything that's been done to the interior. For example, the use of props, furniture, fabrics, and everything that is part of the design. According to Andreas, "They expect to see detail in all the objects and will want the objects to be glamorized extensively." Shooting digitally, there is the advantage that it's easier to balance color temperature and register multiple exposures afterward on the computer.

FIGURE 3.1 The Dieser House, Hermosa Beach photographed from the street.

FIGURE 3.2 The Dieser House from a side angle.

FIGURE 3.3 The Dieser House photographed at dusk.

WORKING WITH CLIENTS

Some clients just give Andreas an address and let him get on with it. Others will draw a layout showing how they may want a certain elevation to be photographed. They may even indicate a specific angle for the shadows, which will depend on the time of year a building is being photographed. This can always be carried out using Photoshop but involves some expensive retouching. Some clients will be present on site and dictate the details of the composition.

When an architect's project is complete, he or she usually likes to see captured at least one image of the project that precisely mirrors an earlier rendering, especially if the images are to be submitted for a professional competition, such as AIA (American Institute of Architects). The photograph in **Figure 3.1** is one that was made to match the architect's plan drawings. "In this instance," says Andreas, "I was asked to shoot from a certain angle and a certain spot. I was up against a tight corner. So much so I couldn't fit my head behind the ground glass to allow me to see what was really going on. The client was absolutely insistent on maintaining this viewpoint. I then shot the same house from a different angle (**Figure 3.2**), which I chose for myself. I felt that this angle intensified the interest in the architectural design and highlighted the truly unique aspects of the building. The image that resulted from this angle delighted the architect and became a sought-after one. This house is in an upscale neighborhood overlooking the Pacific Ocean. Years later, I was asked to do a dusk and dark shot of the same building from a totally different angle, where we wanted to show the seascape and the sunset through the entrance (**Figure 3.3**).

Therefore the angle turned out to be quite low and up close, but thanks to the movements of the view camera, I was able to get the shot with a superwide-angle lens and without cutting off anything of major importance."

The architect or designer usually settles everything with the property owner prior to the photo shoot and obtains the owner's written permission in the form of a property release. Andreas reckons architects are generally good clients when it comes to photographs being properly credited. "There was only one occasion where an interior designer got hold of some digital files and published the images without permission," says Andreas. "I had not even done the work for her. I had shot it for a developer, and he had given the file to the interior designer. Eventually, I was able to collect proper fees from her with the legal help of an attorney friend, but that was the last time I did work for that group."

Digital technology has forced a revolution in the photographic industry. It certainly has affected the way photographers think and handle the flow of work. "In the early '90s, I was having the hardest time trying to transition to digital and master Photoshop," says Andreas. "All the people who knew Photoshop were from a new generation and they could not relate any part of the newer computer program to analog technology, which I understood so intimately. Now, if one has good control of Photoshop, you can accomplish the final goal of the client through proper planning at the time of shooting. Mastery of the skill of Photoshop is like black-and-white printing—no one can print your black and whites better than you; and no one can do the Photoshop editing part of an image better than you."

TRY TO BE DIFFERENT AND CREATIVE AND DEVELOP YOURSELF A STYLE SO THAT YOU WILL BE RECOGNIZABLE IN THE INDUSTRY, AND KEEP A SERVICE-ORIENTED MIND.

Andreas's viewpoint is that digital technology has revolutionized the entire photographic industry. "It has enabled any amateur person, through automation, to do basic photography for basic uses, which, in turn, has taken a big chunk away from the professional," he says. "But not every person can compose and harmonize the photographic composition, and few can meticulously use Photoshop to produce a final image as complex as the example shown in **Figure 3.4**. That alone separates the professional from the Mr. Does It All. I do think there will always be a need for a skilled and talented photographer. If a photographer wants to stay afloat in today's market, they have to keep learning new skills and keep polishing the old ones."

His advice to newcomers is be prepared for a lot of hardship and hard work as a creative mind and a good salesperson. Never overpromise and underdeliver; instead, do the reverse: underpromise and overdeliver. If you have a chance to take some business and fine art classes, by all means do so. Andreas sums this up by saying, "Try to be different and creative and develop yourself a style so that you will be recognizable in the industry, and keep a service-oriented

mind. A photographer should be audacious and passionate, economically wise, and always dream of the impossible and how to reach the impossible dream. Don't put all of your eggs in one basket. In other words, don't invest too much money in cameras and lenses. If you are going to use a piece of equipment once in a blue moon, don't buy it—rent it instead. This is especially true with digital equipment. Never invest in it heavily; it becomes outdated so soon that trying to keeping up would be like chasing your tail; renting is a better choice since the rental agencies will always have the latest gear."

IF YOU ARE GOING TO USE A PIECE OF EQUIPMENT ONCE IN A BLUE MOON, DON'T BUY IT—RENT IT INSTEAD.

FIGURE 3.4 Ettley House, Manhattan Beach.

Peter Andreas Photography
Peterandreas.com

4

BUSINESS SKILLS

DEVELOPING GOOD PRODUCTION SKILLS

Anyone can take a good picture, but it's the steps that precede the moment when you click the shutter that matter most and make the work of a professional photographer special. Imagine you came across a professional photo shoot in progress and you crept up next to the photographer to shoot a snap with your smartphone (I can guarantee the photographer would be pretty pissed off with you if you did). Could you actually call that your own photograph? Even without encroaching on someone else's turf, we all have our moments of glory—like the time you wrote an impressive essay or hit a home run. But can you repeat those successes on demand? This is what professionals are expected to do on each and every assignment.

On certain shoots I've done, the photography part has actually been quite easy. The hard part was organizing and booking the team—the model, the hairstylist, the clothes stylist, and the makeup artist—and briefing them about the job. In situations like this the photography is still important, but the preparation and production are what count most. That, I feel, is the big difference between taking photos for pleasure and being commissioned by a client. For example, do you know how to set up and use an infrared beam trigger device? If a shoot required the use of prosthetics, would you happen to know a makeup artist capable of such work? If the artist was busy, who would you book as an alternative? Would you know who to contact in order to gain access to set up a camera in a lighting rig above a stage? How would you plan and prepare a shoot that involved photographing 100 individuals in one shot? What would you do if a model called in sick on the day of a shoot and urgently needed to be replaced?

Let me briefly provide some answers to the above questions. A quick Internet search will tell you how to work with an infrared trigger, where to buy the necessary equipment, and guidance on how to set it up. But it takes practice and experience

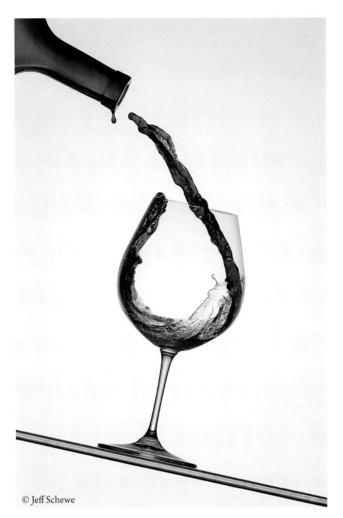

© Jeff Schewe

FIGURE 4.1 This shows a wine pour photograph shot using an infrared trigger positioned to go off when the wine exiting the bottle neck hit a certain spot, combined with a short delay before firing the flash.

to capture shots like the wine pour shown in **Figure 4.1**. Finding a good prosthetic makeup artist would be harder, because here you would need to know how to assess an individual's skills. Booking someone for an important job requires experience with the issues at hand, and it's best if you've worked with that person in the past. To gain access to special vantage points, it helps to know the venue manager or have contacts who do, and it's usually advisable to negotiate well in advance of the shoot. Photographing a large group of people is mostly about planning—working out ahead of time exactly where everyone has to be positioned in order to be seen by the camera and instructing people to get into position. There are technical issues to address such as focusing, choice of lens aperture, and how you would light the scene. As for models not showing up, it helps to maintain friendly business relationship with all the main model agencies where you are so they are able to help out in a crisis. I

THERE'S NO SUBSTITUTE FOR
FACE-TO-FACE NEGOTIATIONS
AND ESTABLISHING GOOD
RELATIONSHIPS WITH THE
PEOPLE WHOSE SERVICES YOU
ARE USING.

usually also have photos of models taken at recent castings. These can be shown to a client and used to help find a suitable replacement at short notice.

Knowing how to solve problems like these comes from experience, which is one reason it is a good idea to spend time assisting as many photographers as possible. This is the best way to learn some of the tricks of the trade and build useful contacts of your own. Thanks to the Internet it's easy to troubleshoot and find expert advice, but there's no substitute for face-to-face negotiations and establishing good relationships with the people whose services you are using.

Preproduction can be a real nightmare sometimes, but the challenges can be stimulating and are all part of the creative process. Also, photographers who immerse themselves in their chosen area of specialization have a competitive advantage over most other photographers, not necessarily because they are better photographers but because they'll know their subject really well and know how to troubleshoot.

What's the day rate?

How much should you charge? Many photographers love to boast about the big fees they have earned, but it is probably more interesting (and more indicative) to find out the lowest fee a photographer is willing to work for. At the beginning of my career an agent once told me that every job should be evaluated by asking yourself, is it for the book or is it for the bank? Ideally, we would like it to be both, and that can happen, especially as you build your reputation, but most of the time we have to weigh whether a prospective job will be good for our business in terms of offering exposure or whether it will just be good for the cash flow.

As for how much your creative fee should be, there is always the chance you will end up undercutting someone else—that's just the nature of how business works. It is through experience that you gain a better sense of what is the right fee to ask for each job. The fact that relative newcomers may be willing to work for less is always going to appeal to clients. Not every photo shoot demands the skills of a top professional, and this is where new opportunities arise for those who are willing to work with lower budgets. However, it's a real problem when photographers severely undercharge and are prepared to shoot for very little or no fee. You could argue this has always been the case. Photography is perceived as a glamorous profession, and there have always been people looking to turn their hobby into a career. In more recent years the advent of digital technology has made it easier for anyone with the right basic equipment to achieve the kinds of results that were once possible only using larger and more expensive film cameras, not to mention the skills to expose correctly and control the lighting. If you add to this the explosion of royalty-free and microstock libraries, it's clear how earning an income from photography has now become a lot harder.

It wasn't always like this. Not so long ago, in the 1960s, photographers would have set day rates, just like any other profession. It didn't matter what they shot,

whether it was editorial or advertising, they aimed to charge roughly the same fee (and if you wanted it shot in color that would be extra). This was the era depicted in the *Mad Men* TV series, when the advertising industry went through a boom period. David Puttnam (now Lord Puttnam) was one of those who saw this as an opportunity to represent photographers such as David Bailey and Brian Duffy and get them higher fees. As a result of this, advertising photography started to become big business. Meanwhile, editorial magazines (which at one point used to spend quite freely on photography) started to cut back on fees and expenses as competition within the publishing industries increased. Also, as the various magazine titles started to merge to form large publishing groups, these companies felt better able to dictate terms and conditions when hiring freelance workers.

As a result, editorial fees have shrunk considerably from the heyday of the '60s and '70s and have barely increased at all since the '80s. There have also been ongoing battles over copyright ownership—many publishers now expect photographers to sign away all rights and work for a low fee. Advertising work can still earn big sums, but the market for direct commissions has been badly affected by economic pressures and easier access to stock photography and digital technology. For example, not so long ago there were studios that specialized in product and pack shot photography for design studios and advertising agencies. These days such work can easily be done in-house using a digital camera or created using 3D programs.

The true cost of running a business

As we slowly emerge from one of the worst financial crises in living memory, it is poignant to reflect on the economic principles of Wilkins Micawber, a fictional character in Charles Dickens's book *David Copperfield*, who said, "Annual income twenty pounds, annual expenditure nineteen pounds nineteen and six, result happiness. Annual income twenty pounds, annual expenditure twenty pounds nought and six, result misery." While the world of finance has changed considerably since the Victorian days, there is something to be said for Micawber's desire for a balanced set of books. The message here is simple. You need to do the math to work out what the real costs of running a business are and how you are going to make a profit.

If you want to become a professional photographer and earn a regular income, you'll need to figure out what your creative fee threshold should be. A good way to do this is to start by considering the number of hours you'll have available for work in any year (and be sure not to overestimate how much you'll be able to and want to work). Photography is not all about taking photos. If you choose to run your own business you will inevitably have to invest time promoting yourself to find work, carry out personal projects to showcase your talents, and do all the boring stuff like administrative paperwork and bookkeeping. There will also be meetings to attend before and after each shoot. Here is a summary of the kinds of tasks a photographer will need to work on (apart from the actual photography).

FOTOQUOTE PRO

FotoQuote Pro is a software program especially designed for photographers that can be used to help calculate an appropriate fee for individual photo assignments as well as stock photography sales.

YOU NEED TO DO THE MATH TO WORK OUT WHAT THE REAL COSTS OF RUNNING A BUSINESS ARE AND HOW YOU ARE GOING TO MAKE A PROFIT.

- Self-promotion: advertising, website social media, and newsletters
- Shoot production: make and receive telephone calls, send e-mails
- Research: reading magazines, books, Internet and e-mail forums
- Office administration: bookkeeping, accounts, and correspondence
- Business meetings: legal sessions, accounts, bank manager
- Seminars and training

If you are prepared to work, say, 50 hours per week, you should be able to devote 20 of those to actual photography. If you multiply that by 50 working weeks in a year, you'll have close to 1,000 working hours to sell. Next, calculate your annual costs. Add to that a modest (at least, at the beginning) income for yourself (remember to allow for taxes), divide by 1,000, and this will tell you what your base hourly rate should be. (Of course, in practice you might not always be working by the hour. If people want you to do a job on a bid, it gets much more complicated, because you have to estimate how long the job will take. Always overestimate how long it will take—it's sure to take longer than you expect.) Here is a list of the business running costs you should include for the year (also review these items with your accountant in terms of what you can write off on taxes to make your final estimations):

- Rent of your business premises (if you own, include property taxes plus service charges)
- Business premises maintenance costs: cleaning and repairs
- Heat and lighting
- Equipment costs (include lease costs, rental and/or depreciation costs)
- Insurance: premises, equipment, public liability, health, and so on
- Telephone: landline and mobile
- Computer, printer, tablet device
- Office supplies: stationery, postage, and so on
- Subscriptions: Internet service provider, server hosting, publications
- Travel costs: running a car, public transport, taxis, airfare, and so on
- Training expenses: books, seminars, subscriptions
- Database contacts list
- Professional fees: accountant, legal, professional association
- Income protection and pension
- Loan repayments: education, car, business loan

The true cost of running a business may come as a shock. It can also be quite intimidating to realize just how much you have to earn in order to stand still, but these are the same problems every other photographer has to face. In fact, all businesses face this same challenge. What can be said in favor of running a photography business is that if you are successful, it is possible to attain a higher profit margin than with most other types of businesses.

Photographers easily undersell themselves unless they have a firm grasp of what their business running costs really are. It is all very well for clients to set the fees they are prepared to pay—they, after all, want to cut costs wherever they can. But it is in your interest to protect your own business model by understanding what it actually costs you to work as a photographer. Being armed with this awareness will make you more surefooted and confident when negotiating fees.

During the first few years you may not make much profit. Most businesses don't until they have operated for a while. You may well be prepared to work more than a regular 40-hour week (although you will still be constrained by the hours clients are willing to work). Also, some types of work will have seasonal gaps. In the fashion industry the model agencies usually close for two weeks or more over the December holidays.

At the very least, I suggest you use this rough formula for figuring your time for the year as a benchmark to help you negotiate fees. It can help you quickly determine whether you will be working below or above the minimum, break-even hourly rate for your business. This is something newcomers find difficult to grasp. They think they are doing well and making good money but fail to take into account the full cost implications of being self-employed.

Typically, a photographer will derive varying levels of income from different types of clients. The aim should be to ensure that when you add up everything at the end of the year, you will have earned enough to cover all your business costs, plus a wage you can live on. If you agree to reduce the rate at which you charge, you need to be clear in your own mind why you are doing this. Is it because the exposure will be particularly good and help boost your profile? If so, it may be worth working on a project, such as an editorial story, for very little money, because it should give you more artistic freedom. Or, it could be work for a startup business that may lead to more profitable bookings in the future. Or, it could just be you need the cash flow. Other types of businesses do this as a way to help keep their overheads covered. It's better to earn 50 percent of something than nothing at all, and if done in moderation can help you keep your head above water. But if you handle it badly, you can end up painting yourself into a corner. The problem is, once you accept a low fee the first time you work with a new client, or lower your fee for an existing client, how do you regain your normal rate? If pushed, the best solution is to make sure your usual full rate is still shown clearly on the invoice and include a special one-off discount. This way clients are reminded of the day rate you normally charge and how you are giving

ONCE YOU ACCEPT A LOW FEE THE FIRST TIME YOU WORK WITH A NEW CLIENT... HOW DO YOU REGAIN YOUR NORMAL RATE?

them a special, discounted rate. Future negotiations should then always start from your usual base rate.

Agreeing to work for less can make the difference between getting a job and not working, but it's not always a good idea. I have tended to find that clients I've agreed to work for more cheaply don't always treat me as respectfully as those who pay the full rate. For instance, I used to shoot with one hairdressing client who was a friend, so I agreed to give him a special rate. The thing is, it was always his company my bookkeeper had to keep chasing for payment, and I would usually have to wait at least three months for a check. To make things worse, in a press interview he claimed to be spending around ten times more on photography than I knew was the case. Apart from being untrue, it made me look ridiculously expensive. Meanwhile, behind the scenes he divulged to another client of mine the special rate he was actually getting, which didn't go down too well (that's one of the risks when you agree to work for below your normal fee). This all went on over a two-year period, during which time I suppose I did get some good photographs, but in the end I had to wonder if it had been worth it. I was reminded of the saying, "No good deed goes unpunished."

AS SOON AS YOU TELL CLIENTS YOU CAN'T WORK WITH THEM BECAUSE YOU ARE BUSY, THEY'LL BE FORCED TO WORK WITH SOMEONE ELSE.

Are clients being completely honest when they offer a low fee? Freelancers can be seen as fair game for exploitation (that's why they are called *free*lancers, right?) It's up to you to decide whether to play that game or not. Focus on your own needs and what a job brings to the table. Will it genuinely offer a good showcase for your work? Will it bring in useful income? Will this job just keep the cash flow ticking over in a quiet month? Be careful about considering the latter. Once you commit to a job you will be obliged to honor that booking. Suppose a better-paid, last-minute shoot comes along and you have to turn it down? It's one thing to have to say you are busy because you'll be working on a lucrative advertising shoot or an interesting editorial story. But what if the prior booking is a poorly paid job that will do nothing for your folio? Good clients are hard to find and easy to lose. As soon as you tell clients you can't work with them because you are busy, they'll be forced to work with someone else. Therefore, the quiet periods you have between jobs should be regarded as a precious resource that shouldn't be given away lightly.

Overall, you need to develop a balance-sheet mentality when costing a job. You can start by looking at the amount of equipment you will be using on a shoot and what the hire cost of that will be. Let's say you'll be unable to do the computer retouching yourself and have to find someone else to do it. How much will it cost? Can you afford to hire a retoucher to replace you and still make a profit? Are all your itemized costings realistic? You might be charging an appropriate photography fee, but are you charging enough for prints? What if the client places a huge print order that ends up consuming much of your time? The extra workload will mean you have to put out a lot of extra effort while making only a small profit. Analyze each aspect of your business carefully to make sure you aren't over- or undercharging. You also need to be confident in all your costings so you can justify these (if necessary) to a client.

ESTIMATING AND QUOTING ON A JOB

With editorial work there is usually a set fee. With most other clients the price will vary according to the specific requirements of each job. If it's a job for a regular client, it will most likely be just you who is contacted and asked to provide an estimate or quote. With advertising agencies it is common practice to short-list several photographers and ask each to provide an estimate. An estimate is just that: an informed guess about how much a job should cost to produce and shoot. Even though it's an approximate figure, be careful not to price a job too quickly over the phone, as this can harm subsequent fee negotiations. Each photographer will be given a chance to provide a cost estimate for the job. The client won't always tell you what the actual allocated budget is, although you can always just ask.

Every job is different and the eventual costs will depend on many factors. The client wants to see a well-researched estimate, one that is also clear and easy to read. For example, clients may often ask for a quote that takes into account various kinds of eventual usages and different shoot approaches, such as shooting with and without variations. Make sure you present this information in a format that is intelligible and clearly shows the options and how much these will cost. Clients don't want to see an estimate that looks like it was put together in a hurry and is just a guess at costs. Major shoots usually involve hiring other talent, and an estimate will need to be backed up with details as the prices are firmed up and a total budget agreed upon. With art buyers you have to bear in mind they have a lot of experience in TV and stills production and will already roughly know what a job should cost. A poor estimate can kill a job stone-dead. For example, if it is ludicrously low, can you be trusted to complete the job to a satisfactory standard? But if you are roughly within the ballpark and art buyers are keen to use you, they'll usually be prepared to work with you to refine the estimate before presenting it to a client.

If you make it through to estimate stage, you are doing well. It doesn't mean you'll get the job, as there can only be one eventual winner, but to be short-listed in this way can be taken as a compliment: you are thought capable of producing the job. At the same time there will be among the final selection one recommended photographer; the others will be there to allow the client some choice. For example, as a brief changes, it is possible one photographer may then become more preferable. Even if you are unsuccessful at the bid stage, your work will have been brought to the attention of the client and the creative teams working at the agency. You will at least have raised your profile and improved your chances of getting short-listed for another job in the future.

With big advertising shoots, you have to bear in mind that the media expenses may easily dwarf the costs of producing the advert. Therefore advertising agency clients aren't so much looking for a good deal as reassurance. They don't necessarily want to spend lots of money on the photography, but the media cost will justify them

EVEN IF YOU ARE UNSUCCESSFUL AT THE BID STAGE, YOUR WORK WILL HAVE BEEN BROUGHT TO THE ATTENTION OF THE CLIENT AND THE CREATIVE TEAMS WORKING AT THE AGENCY.

IF A QUOTE LOOKS TOO CHEAP, THIS MAY CAUSE THE AGENCY OR CLIENT TO WORRY ABOUT WHETHER EVERYTHING WILL RUN SMOOTHLY.

investing properly in the creative services beforehand. If a quote looks too cheap, this may cause the agency or client to worry about whether everything will run smoothly. The fee isn't the only issue; all parts of the quote must appear properly researched and fully accounted for.

Breaking down the costs

Your quote will need to show the creative fee, the costs associated with producing the job, as well as the usage fee (more on the latter to follow). Earlier on in this chapter I highlighted the things you need to consider when working out your day rate, so that bit is fairly easy to deal with. The costs will vary depending on the complexity or unusualness of the job. If it is a straightforward shoot, similar to others you carry out regularly, you can probably compile a quote quite quickly. For example, whenever I am requested to quote for a studio PR shoot, I have a template that's ready to send after some minor editing. When preparing an estimate or quote for advertising jobs, you always need to research the costs carefully, because each job will be different and you have to make sure every detail is accounted for.

The creative fee and costs are all about how much it costs to produce a job. The usage fee reflects how and where the photographs are going to be used and for how long they will be used. This is usually the trickiest part to work out, as the usage requirements can vary enormously from job to job. Also, if the job requires getting quotes from model agencies and stylists plus other freelance suppliers, you need to make sure they are all on the same page regarding expected usage and what is appropriate for them to charge.

For example, let's say you are being asked to photograph an ad for a consumer product. The type of usage might be press advertising in a number of magazines and newspapers, plus packaging and Internet advertising. You will also need to know for how long the photograph will be used, which in this case might be for one year. With photography for packaging, the lifetime can vary. For example, photography to advertise designer swimwear will be usable only for the sales period leading up to summer and for a single season only. Photography for something like high-end underwear is likely to sell for a longer period of time before the products (and photography) need to be renewed. Lastly, you'll need to know which territories the photograph will be used in. Suppose the ad is to be used in two territories. The estimate will need to show your fee, a summary of the costs associated with shooting the job, and a usage fee to reflect the fact that the photographs are to be used for packaging and Internet on top of the magazine usages and will appear in more than one country.

Some photographers incorporate the usage into their creative fee for standard usages, so the basic day rate charged will include, say, up to two media usages in a single country for one year. For any additional usages a usage fee is charged, and this is calculated by multiplying a base usage rate. The base usage rate can be based on your day rate, or it can be higher, depending on your level of expertise. Some professional

photography associations publish guidelines that can be used to calculate such usage fees. These suggest the percentage by which to multiply the base usage fee based on the usage that's required. It must be stressed that these are guidelines for estimating jobs, which will then be subject to negotiation with the client. Using a fee usage calculator can help you pitch a job at a rate that is based on your personal level of expertise and ensures that the usage fee you charge is roughly in line with industry expectations. It in no way guarantees you will get the fee asked and doesn't take into account current economic conditions. It helps photographers gauge what they *should* be charging and adapt accordingly. These things are never straightforward—you might want to take into account how useful a particular job will be in advancing your career, aside from the issue of fees. Or it might be that the photograph you are asked to shoot could be of value to you as a library image after the initial licensed usage has expired.

Before you're hired, there will usually be a period of negotiation over fees plus costs, and the brief might get modified following preproduction meetings. Once everything has been approved, it will then be time to submit a quote. At this stage you need to be absolutely sure of the final required usages and what everything will cost. The client will then be in a position to book you. A verbal agreement over the phone will suffice in order to place a provisional booking. Your acceptance should be seen as a commitment to do the job, and if someone else asks you to do a shoot the same day, you can offer only a second provisional booking till the client who made the provisional booking with you first either confirms or cancels. If you do get a second inquiry for that day, it is always a good idea to let the first client know that someone else is interested in working with you that same day so you don't lose out on the second booking. The same procedure applies when booking other freelance talent. Freelance agencies are adept at managing their clients' diaries in this way and ensuring no work opportunity is lost.

Your aim at this point will be to secure a confirmed booking from the client and to have it in writing, which can be in the form of an art order from the client. At the same time, you should issue your own written confirmation of acceptance in the form of a formal quote, in which costs and usage are confirmed, accompanied by a copy of your terms and conditions. The art order will need to be received prior to the start of the shoot. This is as much in the client's interest as the photographer's, since art orders that are received late, i.e. during the middle of a shoot or afterward, are less likely to be considered legally binding.

TERMS AND CONDITIONS

Most services and suppliers you deal with will have standard terms and conditions that you are required to accept. Photography is no different, and therefore photographers should also have their own terms and conditions to give to clients. These are usually issued prior to the shoot and again when invoicing. The terms and conditions

YOUR ACCEPTANCE SHOULD BE SEEN AS A COMMITMENT TO DO THE JOB, AND IF SOMEONE ELSE ASKS YOU TO DO A SHOOT THE SAME DAY, YOU CAN OFFER ONLY A SECOND PROVISIONAL BOOKING.

CLIENTS MAY ISSUE THEIR OWN
TERMS OF ACCEPTANCE, AND
IT IS IMPORTANT TO CHECK
THERE AREN'T ANY CLAUSES
THAT MAY CONFLICT WITH
YOUR OWN TERMS.

MODIFYING TERMS AND CONDITIONS

If you take a standard terms and conditions form and modify it, make sure you have a lawyer look at the modified version just to confirm everything works together. It is not unknown for people to modify documents and unwittingly introduce internal inconsistencies with a clause that they didn't fully understand. If it ever came to litigation, this would cause a court all sorts of confusion.

may include things that are already covered by trading law or recognized business practices. The document allows you to state your terms of business, especially with regards to payment and copyright. Clients in turn may issue their own terms of acceptance, and it is important to check there aren't any clauses that may conflict with your own terms of service. For example, the clients' contract may include a clause that states their terms supersede yours.

The types of terms and conditions issued by photographers vary from country to country, where, for example, copyright law is not always the same. You can get a lawyer to help draft a form for you to use, but if you belong to a professional photography organization, it probably has a standard form you can adapt and use for your particular location.

The main thing to include is clarification on copyright, where ideally, you will want to assert that you retain all copyright. If clients insist on owning all rights that's fine, but let them know they have to pay for it. It is also a good idea to have a "use" clause, which, among other things, states that copyright is licensed only after payment has been received. This protects you in case the commissioning client goes bust. If this should happen the clause means the end client won't be able to use the photographs until your invoice has been paid, regardless of whether the agency has already been paid.

An exclusivity clause should give the client the right to use the photographs exclusively for the time period of the license but still allow the photographer the right to use the photographs for promotional purposes. A confidentiality clause can guarantee the client that the photographer will be respectful of sensitive data given to him or her in confidence (for instance, if a client is coming out with a new product that hasn't been released yet). Separate to this you will also need to be mindful of advertising agency confidentiality agreements, in which a client may require you to hold back on self-promotion till after the photographs have first been used.

Cancellation fees are payable only after a job has been confirmed. If a client cancels for whatever reason close to the day of a shoot, you should be entitled to a cancellation fee, and this will need to be specified in your terms and conditions. Typically, you might state you charge 100 percent of your fee plus any expenses incurred if canceled within two days of the start of a shoot and 50 percent if canceled between two to four days before. In reality this charge can be discretionary—for example, if it's a regular client, the shoot is being rescheduled for another date, and you haven't lost out on any other work.

The terms and conditions should also include a rejection clause, which states there can be no grounds to reject work on the basis of style and composition (see the section later called "Job Rejection").

PAYING ATTENTION TO THE DETAILS

It is all too easy to let the small details slip through unnoticed. In my experience, once you have negotiated and agreed on a fee there will be no further arguments over how much you are to be paid. But it is always the little extras that can lead to problems down the line. As long as clients are happy with the photos, they will be prepared to pay the agreed-upon fee, but disagreements can easily arise over the expenses that are eventually billed. For example, let's say you allocated a budget for lunch for an estimated number of people, but far more people than expected show up on the day, all needing to be fed. If you can, it's best to include a contingency in the budget that can be used to take care of this, or use your own judgment and swallow the extra expense if necessary. It is usually the petty things that annoy clients most. There was a hire studio that once charged for gas heating on what was one of the hottest days of the year. It was something like 50 pence, and when quizzed it turned out they had measured the gas at the beginning of the day and at the end, and one or two units had been consumed. They had charged for the pilot light gas.

When working on a busy shoot it's easy to miss what's happening around you. One of the ways photography assistants can make themselves useful is to act as an extra pair of eyes and ears to note what's going on, such as recording the arrival and finish times for models and generally checking to see the clients have everything they need.

Ultimately you can't rely on good things to last forever. Great clients can stop using you for all sorts of reasons that are out of your control. They might lose an account, the art buyer might move jobs, the agency or magazine might fold. The lesson here is to never take anything for granted, and even when things seem to be going well, plan ahead for your next move. Sometimes a relationship can end quite unexpectedly. As an assistant I worked with a photographer producing ads for a bicycle company that featured the bicycles being photographed in exotic locations. The first year we went to Kenya and, following the success of that trip, traveled to Martinique in the Caribbean. Apart from the photographer being heavily interrogated on the way out through Paris Charles de Gaulle Airport, everything went smoothly. The art director and the agency were delighted with the results. What none of us paid attention to was the employee from the bicycle company who had accompanied us to help look after the bikes. We could easily have managed them on our own, but her accompanying us on this trip was the company's way of rewarding a key member of staff. We let her relax and enjoy herself while we got on with organizing the shots. However, her perception was that we were all having a lovely holiday at the company's expense—she wasn't around to notice we were up most mornings before dawn checking out locations for the next day's shoot. Anyway, when she got back home she wrote a negative report to her bosses, which put an end to that particular campaign.

CONFIDENTIALITY AGREEMENTS

On advertising shoots or even some editorial shoots, you may be asked to sign a confidentiality agreement. These are designed to protect the client's interests, which can mean you can't release any images prior to the launch of a campaign, or even discuss a job that you have shot prior to the launch date or the newsstand date. As the photographer and person in charge of a production, this means paying careful attention to assistants and others who may take photographs on set that might end up on Twitter or Facebook. It also means making sure all the people who may be involved in handling the image files (such as retouchers) also sign confidentiality agreements. Why is this necessary? For example, from time to time photographs from a celebrity shoot will get leaked that allow people to compare the original images with the retouched versions. It's fun to see what goes on behind the scenes, but it constitutes a major breach of trust for the photographer who was responsible for that shoot.

GOODIES AND EXTRAS

One of the perks that comes with PR and advertising shoots is that items will sometimes be up for grabs after a shoot, such as small props or products. At the same time, photographers have to know their place in the pecking order. A friend of mine who photographed room sets told me how on each job he photographed, just about every prop brought in for a shoot would have to be sent over to the advertising agency at the end of a job. One art director got the nickname "Bonus" because he was always on the lookout for shoot freebies and wasn't averse to a bit of bribery. At the very least, if you like a product on the shoot, the client you are working for might be able to arrange a good discount for you.

INVOICING AND EXPENSES

IT IS ACCEPTABLE TO CHARGE A MARKUP ON ANYTHING YOU HAVE TO BUY FOR A JOB BEYOND YOUR BASIC TOOLS. ALL BUSINESSES DO THIS WHERE THEY HAVE TO MAINTAIN STOCK AND COVER WASTE THROUGH LOSS.

Once a job has been shot it will be time to prepare a sales invoice. If you can, it is advisable to break down the invoicing into stages for the work done and have this agreed upon beforehand. For example, if there is to be a substantial amount of retouching work, you'll want to invoice this separately. Otherwise you may be left waiting ages for final approval of the retouch work before you are able to invoice for the total job, which could harm your cash flow. Make sure you know who the invoice should be sent to, which may well be someone different from the client who briefed you. They may even be located at different addresses.

It is acceptable to charge a markup on anything you have to buy for a job beyond your basic tools. All businesses do this where they have to maintain stock and cover waste through loss (such as printer inks and paper), as well as taking into account the cash flow time gap between purchasing those items and final payment of the invoice. It's worth rehearsing this argument, because it's one you'll come across from time to time in business. Some clients may ask to see receipts as evidence of expenditure. There is no reason why you should be expected to supply these. When you buy a service or product from a company, the invoice they supply you with is all that's needed as proof of purchase. But go ahead and give copies of them if you like. Whatever you do, don't give away your original receipts—you will need to keep these for your own records.

Invoices should remind clients of your terms of payment, and these should be followed up by issuing statements of account at the end of each month. These are an important reminder to clients to pay you; in fact, many companies won't issue payment until they have received a statement reminder. If necessary, follow it up with a telephone call to chase an outstanding amount. You can also help speed up payment by making it easier for clients to pay you. If sending a statement, you can issue one with a tear-off section that makes it easy for the client to attach a check and stick it in a window envelope. You can also include your bank account details so the client has the option to pay you directly online, which is what most people prefer these days. Basically, make the payment process for clients as easy as possible.

In the UK, there is the Late Payment of Commercial Debts Act (1998), which gives businesses the right to charge interest on invoices that are unpaid after 30 days and also defends you from unscrupulous clients who might try to word a contract so as to negate this right. This legislation can be used by your suppliers as well, of course, but since it is based on the Bank of England base rate (which is currently very low), it doesn't provide as much incentive as it did when the act first became law. The overall intention of such legislation is to foster a business culture in which prompt payment benefits everyone. This approach has certainly worked well in some countries; for instance, you can count on German clients to pay swiftly. In other countries payment collection can be a nightmare.

Cash flow crises

They say you spend money three times: first when you get the job, second when you invoice, and lastly when you receive the check, by which time there's no money left. The worst time for any startup business is in the first few years, when cash flow will be the biggest hurdle. But it doesn't always get much easier as you become more established and the up-front expenses are scaled up.

SOME COMPANIES HAVE A DELIBERATE STRATEGY OF DELAYING PAYMENT TO SUPPLIERS. STRETCHING THE TIME BETWEEN THE MONEY COMING IN AND GOING OUT IS ALL PART OF THE WAY THEIR BUSINESSES ARE RUN.

Money collecting can be a frustrating and time-consuming business. Some companies have a deliberate strategy of delaying payment to suppliers. Stretching the time between the money coming in and going out is all part of the way their businesses are run. Rather than take out a line of credit they rely on delaying payments to contributors and other creditors, effectively using them as a free form of finance. What generally happens in a time of recession is bigger clients such as advertisers feel the pinch first and start delaying their payments to the magazines, who in turn may pass on the problem to their contributors. One way or another, it is the freelancers who usually end up bearing the brunt of a crisis situation. Therefore, if it is going to take 90 days or more to get paid, you can at least factor this into the equation when you work out how much you need to charge. Editorial clients tend to be good payers. When I used to shoot for *Time Out* magazine I was paid within 45 days on the dot, although I have heard of one magazine that currently delays its contributor payments by up to 12 months.

With direct clients there is always going to be a degree of uncertainty until you have had a chance to work with them a few times and gauged their payment methods. In my experience you can never tell how good a direct client will be at paying. Most of the people I have worked with have been very good, but every now and then you come across problem clients who will drag their heels for weeks on end before issuing a check. As long as everyone you work with pays eventually and the majority of your clients are good payers, you should be able to weather the storm when one client lets you down. When clients owe you money for too long, it is best to try to talk to them first and wait it out without taking legal action. You don't want to upset a potentially good future client that's just hit a rough patch, and legal fees are expensive.

WHEN ONE CLIENT STARTS TO DOMINATE YOUR BOOKINGS DIARY, YOU NEED TO THINK AHEAD TO ENSURE YOU CAN CARRY ON TRADING WITHOUT THAT BUSINESS IF NECESSARY.

Of course, if that client happens to owe you a lot of money, you have a problem. Even if your biggest client is a regular payer, you still need to be on your guard. What will you do if that client goes bankrupt or switches to another photographer? Nobody would ever want to turn down work on a big project, but when one client starts to dominate your bookings diary, you need to think ahead to ensure you can carry on trading without that business if necessary.

Managing cash flow isn't just a matter of how much you owe and how much you are owed. It is about when money is due to you and when it must be paid. On paper you might be able to show a positive bank balance, but if the bulk of the money owed to you is from jobs carried out in the past few weeks and the money you owe is approaching 60 days or more due, you have a cash flow problem. As long as you have the promise of money coming in, you have a good argument for stalling payment on the money you owe, or you might be able to seek a temporary bank overdraft. An overdraft is something you can have in order to temporarily resolve cash flow delays. Providing you have a good financial history with your bank, there shouldn't be any problem securing an overdraft facility. However, be aware that as soon as you start borrowing money from a bank, it will need to see some kind of financial projections as well as regular cash flow statements.

If you need money to finance other things, such as investment in equipment or business growth, a finance loan will be more appropriate. These used to be fairly easy to arrange, but since the banking crisis it is now much harder for small businesses to secure such loans. You need to be aware of some of the darker practices that have been exposed in recent years. Banks have been in the spotlight over this and urged by governments to clean up their act and also to increase lending to small businesses. Even so, it is wise to pay attention to the financial news and know what kind of questions you need to ask so as to avoid finding yourself with a bad loan agreement. A business loan will usually require some kind of security, such as a property you own or a financial guarantee from a relative. If it all goes wrong and the lender decides to play hardball, the bank will have the power to use that security to make good any debts, which is why you must analyze a loan application very carefully.

To understand your cash flow, you might want to use a spreadsheet program to compare all your monthly outgoing expenses against projected income. You can use a program such as Microsoft Excel to do this. By entering in your current bank balance at the beginning, you can predict what the balance will be at the end of each following month. When you do this for the first time it can be a sobering revelation, one that puts certain expenditure items into perspective. For example, you may find out just how much the cost to run your car and make payments on it are affecting your finances. This exercise lets you take out unnecessary items or modify the budget by using, say, a smaller, less expensive car and see how the projection for six months ahead might slip from a negative to a positive balance. Micawber would be proud.

When the money you owe to suppliers becomes overdue, you have no choice but to deal with this head on. You can ignore your debts only for so long. At some point the debt bubble will burst and the only solution is for your business to fold. But it doesn't have to end like this. There are always ways you can manage debt and bring it under control earlier on. The first step is to recognize you have a problem and forewarn your creditors. For example, you can ring up a supplier, explain you are going through a temporary cash flow problem, and ask the representative to be lenient when chasing your overdue account that month. If you are able to follow through on your promise, the supplier will certainly be more willing to listen if you have to contact it again to make the same request. I went through this whole process myself once. After my sixth year in business, I had built up something like a £30,000 negative balance in my trading accounts, and the economy was about to go into recession. I requested patience from my creditors and the opportunity to pay them back in stages. I made a series of appointments to meet with them face to face and thrash out a deal to repay outstanding debts in manageable installments. I felt terrible going into those meetings but better coming out from them with an agreement in place, and better still when later on I was able to repay everyone. In the meantime, I was able to continue working with my credit rating intact.

Accountants who manage the sales ledger for big companies have to be tough when dealing with outstanding debt. They know to speak firmly with debtors to make sure their outstanding debts are given priority over all other debts you might have. At the end of the day they will also be prepared to take a pragmatic approach to bad debt. Ultimately it is better for them to have some chance of recovering something than nothing at all. If you are in a bullish mood you can press this to your advantage, especially when dealing with credit card debt. An accountant might be able to advise on ways to drastically restructure your personal debts. However, this action comes at a price, though. Your credit score will suffer and your credit limit restricted or made nonexistent. This is the nuclear option, but one that might just save you in a tricky financial crisis.

It is important for any business to fine-tune its day-to-day running costs. There is a saying where I come from: "Watch the pennies and the pounds will look after themselves." This is known as micromanagement, where the goal is to ensure business running costs are kept under control and to maximize profit. It is something all businesses must pay attention to, but at the same time you don't want to lose sight of the bigger picture. It's a useful business exercise, but you don't want to fall into the trap of becoming too obsessed with financial analysis. If you devote too much attention to scrutinizing the budgets, you won't spend enough time being creative and making the business grow. In a flatlining economy this is the predicament many businesses find themselves in. With banks unwilling to lend, many are struggling to find ways to keep their businesses turning over. They are constantly treading water just to stay afloat and not going anywhere. It's good to spend some time minimizing

WHAT YOU MOST NEED TO DO IS TO DEAL WITH THE BIGGER PROBLEMS. YOU NEED TO CONCENTRATE ON WHAT IS GOING TO BRING MORE WORK, WHICH MEANS FOCUSING MOST ON THE PHOTOGRAPHY SIDE OF THE BUSINESS.

your expenditures, but what you most need to do is to deal with the bigger problems. You need to concentrate on what is going to bring more work, which means focusing most on the photography side of the business.

Cash flow problems can be the result of rapid expansion. This is where a sudden influx of new work means you build up short-term debt on expenses associated with each shoot, but the income you are due to receive is going to be delayed. So you may find that as you get busier, you'll struggle to meet the associated shoot expenses as well as being unable to pay your regular outgoing expenses. In a way it's a nice problem to have, because eventually you should be reaping a profit, and it is easier to explain to suppliers why you are having difficulty paying them.

There are ways you can mitigate a cash flow problem. One way is to ask for the up-front expenses to be paid in advance. This is common practice on big productions, such as TV commercials. Advertising agencies understand the need to cover expenses, and agents often negotiate this on behalf of the photographers they represent. With photographers who represent themselves or with other types of clients it doesn't happen so much. I think that's mainly because clients think they are paying you enough money as it is and photographers may like to project an image of not needing up-front finance even though they do. Typically an advance will be 50 to 100 percent of the production costs and may take up to two weeks to be processed. Remember, the agency will need to bill its client first in order to secure the advance amount.

Deflect as many of the big expense liabilities as you can. When quoting for a job you will be expected to list your costs as well as those of everyone else who is working with you. Where a shoot involves hiring models, makeup artists, and other talent, these other fees can easily add up to more than what you yourself will be charging. OK, if you were to incorporate all the shoot costs, this would boost your turnover, but as they say, "Turnover is vanity and profit is sanity." As you negotiate the shoot expenses, ensure such fees are paid directly by the client, so they don't become your added responsibility. Basically, it is standard business practice to charge a markup on all incurred expenses. If you ask the client to pay these expenses directly, you can say they are getting these fees at "cost," rather than you having to mark them up. This can also reassure a client that you aren't just loading the quote. By reducing your liability you also place less stress on the business cash flow.

It's important to get your paperwork in order promptly. Photographers complain about delayed payments, but clients will often point out that suppliers, and especially photographers, make things difficult for themselves by not following through with all the correct paperwork. Having said that, some clients do make a point of holding back on their paperwork requirements and throw them in at a late stage as a deliberate delaying tactic.

As a last resort you can use what is known as a factoring company to handle the debt collection for you. What happens here is you invoice a client as normal for a job,

but instead of sending the invoice to the client you send it to the factoring company instead, which in effect is buying the debt from you. It then pays you the full amount less a small commission and collects the money from the client itself. You'll need to have been trading for a number of years before a factoring company will be willing to work with you. The advantage of this approach is that it protects you from having to ask for an overdraft or a loan from the bank (which is expensive or hard to get), and you can pick and choose which invoices you feel need to be factored. You don't have to do it for every job. Factoring companies can also advise you as to which clients might be bad payers. The downside is, it reveals to clients the state of your finances, which might give the impression you are struggling financially. But hey, lots of people use factoring companies, and it can be a real lifesaver when cash flow is tight.

DEALING WITH CLIENTS

Understanding client expectations and the way clients work can help you figure out how much to charge. From a client's perspective, photography can be seen as a costly luxury, but once clients decide to commit to a photo shoot they will want to be sure they are spending their money wisely. The photography fee may be just one component in a bigger budget that involves design work, printing, and purchasing of advertising space. It can also include the costs of hiring the other talent required to make a shoot happen. When you look at things from the clients' perspective, the pressure is on for them to make the right choices at each stage of the process. While you may view yourself as an artist, clients may simply see you as a means to an end that benefits their business.

Making the wrong choice of photographer can prove to be a hugely expensive mistake. Clients may have already worked out the appropriate amount of money to spend on each component and will have shopped around accordingly. If you have a feel for what the client is expecting to pay, you can tailor the quote to meet those expectations. To win a job you have to reassure clients that they are buying the right talent within the expected budget. In these instances there is the danger you might price yourself too low. An advertising agency art buyer (knowing what the end client's expectations are) may even nudge you in the right direction to modify a quote upward.

A client can also be under pressure to ensure that other important people are kept happy. With a shoot that involves photographing a major celebrity, the pressure will be on to select the right photographer. The safe option will be to use someone who has an established reputation or rapport with the artist. This won't come cheap, of course, but can add more value to the shoot. Many years ago I saw a fashion advertising shoot that featured aristocratic young ladies photographed by Norman Parkinson. I happened to know the art director, Tony Chettle, who devised the campaign and

IF YOU HAVE A FEEL FOR WHAT THE CLIENT IS EXPECTING TO PAY, YOU CAN TAILOR THE QUOTE TO MEET THOSE EXPECTATIONS.

asked him if it had been an expensive shoot to produce. Apparently not. Once Norman Parkinson had been secured as the photographer, the debutante models were all willing to work for more or less the standard rate and were just happy to have had the experience of being photographed by "Parks."

Below-the-line advertising is more competitive. Here everything is about controlling the price and being able to stick to a tight budget. It's also an excellent way for a young photographer to get a first break with an advertising agency. Small advertising jobs, such as trade magazine ads, will be given to the younger art teams. They in turn will know that their budget doesn't allow hiring the biggest names in photography, so they'll look for the best talent available among up-and-coming photographers, especially those that have been recommended by the art buyer. Even if an agency were able to secure a big-name photographer, it may calculate it'll get better value out of a younger, keener photographer working for the same or lower fee.

In fact, being perceived as young and naive can work to your advantage. Younger clients will naturally feel more comfortable working with people who are near their own age. It may also make them feel more in control, whereas working with an established name photographer can be an intimidating experience. This also applies to most sectors of the creative industries, particularly on editorial magazines. Older photographers, like me, may be inclined to whinge that our wisdom and experience has been neglected in favor of inexperienced hotshots. The fact is there are a lot of very good younger photographers out there. Older clients, too, may prefer younger photographers because they are easier to work with, although this could be interpreted as "more gullible and easier to manipulate." Whatever the reason, there is a threshold point where having a certain degree of experience combined with youth can definitely work to your advantage. If you're planning to work into old age as a photographer, just make sure you attain "legendary" status at some point in your career.

Of course, all the above negatives can also be seen as advantages. This is, after all, how most people are given the chance to work with a new client. Nothing remains static forever, and it is the nature of any industry that change leads to new opportunities. Whether this always works to the benefit of photographers, we can't be sure. Above all, remember that whatever struggles you experience when finding work will be similar for every other photographer who's just starting out.

Whatever type of work you end up doing, be it advertising, PR, corporate, or editorial, you'll want to find clients you can bond with. As your career progresses you will find out which type of work and clients suit you best. Building good working relationships will help you and your clients become more relaxed and, as a result, produce better work. If you don't feel at ease with the people you are working with, then maybe you need to re-examine whether you are targeting the right type of market.

BEING PERCEIVED AS YOUNG AND NAIVE CAN WORK TO YOUR ADVANTAGE. YOUNGER CLIENTS WILL NATURALLY FEEL MORE COMFORTABLE WORKING WITH PEOPLE WHO ARE NEAR THEIR OWN AGE.

Knowing when to say no

It's natural to feel slightly nervous before a big shoot. View it as a sign you are taking the job ahead seriously and you are going to give it your all. But it's also important to know your limits and when to say no. It would be crazy to take on an assignment for which you have little, or no experience, such as doing a complex composite or agreeing to shoot video without ever having done so before. It is better to say no in these circumstances than to end up with an upset client and an unpaid invoice. Instead of taking on more than you can chew, find people who can provide the necessary expertise. Film and TV production is all about putting the right teams together. A film director may have a detailed understanding of the technical processes involved in creating a film or video but will still rely on a team of individual experts to turn those ideas into reality. For example, I know of a photographer who was asked to produce a beer TV commercial to be shot in a black-and-white 1950s style. He cleverly chose to hire a crew of old-timers who had actually worked on movies of that era and got them to set up the lighting and camera.

On one occasion I was asked by an agency to replicate a photograph that had been shot by a Spanish photographer. I found out the agency had approached the photographer in question, but the fee asked was too high, hence it was looking for another photographer to re-create the same shot. I thought the project spelled trouble, so I declined to quote.

Working for foreign clients carries extra risk because if you are commissioned by a client from abroad, it will be under the legal jurisdiction of the client's country. This means that if a dispute should arise over payment, you would have to pursue this through the courts in the client's country rather than your own. This can make chasing debt complicated and expensive.

You have to be alert to all kinds of dangers such as Internet fraud, where an unknown client (usually foreign) contacts you with a seemingly genuine job request. What do you do? One way to find out if it's a scam or not is to ask around on one of the photography forums. If it is a scam you will soon find lots of other photographers who have received a similar e-mail that week. However, Michael Clark, whom I interview later, mentions that he has received e-mails that looked like spam because they sounded too good to be true, yet turned out to be genuine, such as when Red Bull asked him to work for it. So you never know.

IS YOUR BUSINESS VIABLE?

Ideally you'll find a successful niche to work in, make a business plan, and see your business grow. But nothing can be taken for granted, and every photographer is likely to experience the effects of a downturn at some point in his or her career. There can be many reasons why this happens. Some things are simply out of your control, such as the economy going into recession or a major client going bust. But you can control

IT WOULD BE CRAZY TO TAKE ON AN ASSIGNMENT FOR WHICH YOU HAVE LITTLE, OR NO EXPERIENCE.

other factors. Is the type of work you do still relevant? Over the last few years, traditional markets such as pack shot photography and stock market library work have eroded, affecting the livelihood of many photographers. There are parallels here with the print industry and what happened to typesetters during the '90s. This was around the time of the desktop publishing revolution, when a little software company called Adobe created Postscript, which revolutionized the way type could be controlled and managed. In the old days designers worked at a large easel and hand-designed their print layouts. These were then passed on to the production department or printer, where pasteup people or typesetters would take the copy that had been supplied by the art department and manually prepare the type for printing. Once desktop computers could be used to carry out the design and type layout, the job of the typesetter was absorbed by the designers, who enjoyed the freedom and control this gave them. So, if the type of photography you produce is no longer in demand, then maybe it's time to change tack and explore new markets.

IDENTITY THEFT

Now more than ever, it is important to protect your personal records. All paperwork that contains personal information needs to be shredded before being recycled. Also bear in mind that discarded packaging of expensive items left outside your business are like an advertisement to would-be thieves.

Online security is a big issue these days. Most Web security revolves around the use of passwords, which is an ongoing vulnerability made worse by recent hacks into major databases, such as RockYou and LinkedIn. These have revealed not just individual passwords but provided insights into how we go about creating them. This information in turn has enabled hackers using the latest hardware and software to hack more successfully. For example, it is estimated that 91 percent of passwords are in a list of the top 1,000 regularly used passwords. Forty percent are in the top 100 list, and 10 percent of us use *password*, or *12345678*. Even 52-character passwords can now be decoded in a matter of minutes. Passwords will continue to be used, as there is no real alternative for managing regular online access. The best advice is to avoid passwords that are obvious, such as names of favorite bands and changing a letter to a symbol. In other words, choosing *@erosmith* as your password isn't going to make your online activities very secure. Solutions suggested by the experts include taking a line or two from a favorite poem or song and using the first letter of each word. To make your password even more secure, substitute numbers or symbols for letters and you can end up with an easy-to-remember 8- or 10-character password that will be hard for anyone else to crack. For example, you could take a phrase like "*The Photographers at Work* book by Martin Evening" and create the following password: *tpawbbme*. To make this password even more secure, substitute a few symbols and use some capitals: *tP@Wbbm3*. Another suggestion is to create a long password by taking two unrelated words and joining them together.

LAWYERS AND HOW TO AVOID THEM

Every aspect of our lives, it seems, is governed by laws and legal responsibilities. As Professor Niall Ferguson once said, "The rule of law has been replaced by the rule of lawyers." Take a wrong step and you could incur civil, or worse, criminal prosecution. The easiest way to avoid dealing with lawyers unnecessarily is to not get into trouble in the first place. The most important service a lawyer can provide you with is contract advice that protects you from harm or doing harm. Contracts are important because they clarify an agreement and are legally binding on both sides. They are vital for all kinds of business activities, from renting or leasing to job assignments. For this reason, it is advisable to hire a lawyer to review your basic paperwork when you first set up in business to make sure everything is in good shape. That way you'll be starting with a solid foundation if something needs to be litigated down the road.

The most common legal problem a photographer will face is bad debt: either money that's owed to you or money you owe someone else. This is always a civil matter, which means if you have a problem with someone who owes you money, you go to a solicitor, or attorney, as a last resort. Before you do this you need to look at all the options that are available to avoid taking unnecessary action. If a client owes you money, first check the terms on any contract you might have. Maybe it stipulates that payment will be made within 90 days? Speak to the client directly if the time limit has passed. You could e-mail first if you prefer, but follow this up with a call, and then send a letter. By this point you should have established there are no contractual reasons for late payment, you have informed the client that you are chasing payment, and you have made every effort to speak to the client directly. If, for example, the client says a check was sent in the post and it went astray, you have given your client the opportunity to provide that as an explanation. If the client doesn't remedy the situation immediately, now is the time to toughen up and write a standard letter to demand payment. If you're in the UK, at the top of the letter write "Without Prejudice." Keep your letter simple and to the point and state that if the letter is ignored, it will be followed up with legal action to recover the debt plus costs. In your terms and conditions you may have stated that interest becomes due on unpaid bills after a certain period of time (this depends on the law in your country regarding late payment). If so, you will also be able to claim interest charges on top of the unpaid amount. In the majority of cases you can expect to receive a swift response. Payment should then follow, or at least a promise to pay in scheduled installments. Or, you may receive a counter letter spelling out the reasons for nonpayment. This will require a further response from you but will at least be a starting point for negotiations.

If you don't get a reply to your original letter, you have the choice of taking the matter further via a solicitor or attorney, doing it yourself, or perhaps doing nothing. The first two options will incur some cost. Doing it yourself is actually very easy, but if you get a solicitor or attorney to handle the debt recovery on your behalf, a letter

CREDIT REPORTS

In the US at least, you can obtain copies of your credit report from each of the three major credit reporting agencies: Equifax, Experian, and TransUnion. Keeping an eye on those once every year can be a good way to ensure nobody has stolen your identity and opened lines of credit in your name. You may also want to check out Annualcreditreport.com. This is a site run by the three credit bureaus to comply with the credit reporting law.

IF YOU HAVE A PROBLEM WITH SOMEONE WHO OWES YOU MONEY, YOU GO TO A SOLICITOR, OR ATTORNEY, AS A LAST RESORT.

CLIENT CHECKS

Before doing serious business with someone, it is worth doing a quick court records check to see if the client regularly sues (or gets sued) and the circumstances surrounding any litigation. Working with someone who sues a lot isn't necessarily a deal-breaker, but it's a red flag. Also, you don't want to get a reputation yourself for being overlitigious.

WHEN YOU ARE FORCED TO CHASE AN UNPAID DEBT, IT IS IMPORTANT TO BE FIRM, BUT ABOVE ALL DON'T MAKE IT PERSONAL.

written on the firm's letterhead paper will usually be enough to get most debtors to swing into action. If not, you then have the option to initiate formal debt recovery proceedings. Now, these are serious. Most outstanding bills are likely to be small enough to be handled via small-claims court procedures instead (the upper limits and rules vary in each country as well as in each state in the US). It doesn't cost a lot to initiate your own small-claims proceedings and it's something anyone can easily do without legal help. In the right circumstances it can be very effective. Providing no counter-claim is made by the defendant, you will have the power to secure a judgment against the individual or company. However, this still won't ensure you receive payment. The defendant may comply willingly, of course. Otherwise, you'll have to actively execute the judgment through the court. You may even be able to potentially bankrupt the client (this can be done in the UK on debts above a certain threshold value).

The question you have to ask yourself before you even consider initiating court proceedings is, is it something worth doing or not? If clients don't pay you, maybe it's not because they didn't like your work but because they can't afford to. If so, who else might they owe money to? Yes, you have the power to pursue a claim and secure a judgment, but that might not help much if you are just another in a long line of angry creditors. There is no sense in throwing good money after bad on a hopeless case. So do your research and find out what the client's financial situation really is. I was once owed a debt from a business and found out later the owner was the boyfriend of someone you really didn't want to mess with. One of his other creditors, who had been persistent in chasing the debt, had the windows of his shop smashed in. In that instance I knew it was time to walk away. Sometimes people will surprise you, though. I can think of a couple of occasions when unpaid debts got paid in full some years later.

When you are forced to chase an unpaid debt, it is important to be firm, but above all don't make it personal. Clients are much more likely to be responsive to a professional approach than an angry, vindictive one. What matters most is the threat of litigation and the impact this may have on a client's business.

I can't confirm if the following is true or not, but I did hear a story about a company called Rent-a-Tramp, which would employ down-and-outs to act as money collectors. The idea was they would give one of their "tramps" a letter of authorization to collect an outstanding invoice. The scruffy collector would then visit the ad agency in person and insist on waiting in reception till receiving a check. It was all perfectly legal, apparently.

When things get ugly, it is all too easy to allow emotions to get the better of you. Where you have two warring factions, two firms of attorneys will happily make money from the disagreement. A cynic might argue it's in the attorneys' best interests to fuel such arguments, and you see this all the time in divorce proceedings. It's best to avoid letting debts get to that stage if at all possible.

But what about being faced with the threat of legal action yourself? You can protect yourself to some extent from litigation through legal insurance, which seems to be vital in this day and age. Whether or not you wish to initiate your own legal actions is up to you. One benefit of being a member of a professional body is that it may be able to provide free or discounted legal advice. Some offer legal services to their members at special rates. If all you need is some advice about what to do in a particular situation, this can help enormously.

It bears repeating: you need to avoid personalizing any business conflicts you have. One of the things you learn over the years is not to let your emotions get the better of you. Either let the issue drop and move on, or if you need to take action, do so dispassionately in a businesslike manner. When conflicts get out of hand they can become all-consuming and a huge distraction. An early business mentor of mine often raged against one of his competitors to the point where the very mention of the chap's name would bring on a fit of fury. A little anger is good if it helps you deal with a problem rather than let it fester, but anger is self-destructive when it gets out of control.

ONE OF THE THINGS YOU LEARN OVER THE YEARS IS NOT TO LET YOUR EMOTIONS GET THE BETTER OF YOU.

If you do have a grievance, how sure are you of the facts? In my experience, whenever I have thought someone has done me wrong, more often than not my first assumptions have proven to be incorrect. You should always step back from a situation and verify the facts before you jump to conclusions. To start with, if there is one thing more unreliable than the postal service, it's e-mail. Many misunderstandings arise simply because a letter, check, or e-mail genuinely got lost in the system. While important business can be conducted this way, you should never rely on it completely. E-mails can be diverted into someone's junk folder, or an attachment you included can result in a failed transmission. When you are sure of something, can you prove it? It always pays to explore all options before you confront someone with an accusation.

Job rejection

It's the call every photographer dreads—to be told there is a problem and the client doesn't like the photographs. It happens, and the outcome can be an expensive reshoot or ongoing litigation. But litigation happens only in extreme cases, when the photographer is clearly at fault or the client is acting unprofessionally.

On a client-paid shoot, the client or client's representative will be present, and his or her job is to direct and approve the work being created on behalf of the client. Photographers like to mock art directors for having an easy time while they do all the work, but the art director is responsible for approving the photographs as they are being shot. It is normal, accepted practice that if the art director OKs the work on a shoot and doesn't ask for any changes, he or she can't then argue the photographer should have shot the subject differently after the fact. Of course, it is easy to reconsider decisions made when viewing the photographs the next day, but the job of the

THE BOTTOM LINE HERE IS
IF CLIENTS DECIDE LATER
THAT THEY DON'T LIKE THE
PHOTOGRAPHS, THEY CAN'T
BLAME THE PHOTOGRAPHER,
ESPECIALLY IF THE
PHOTOGRAPHER WAS CAPABLE
OF MAKING THOSE CHANGES
AT THE TIME.

art director is to direct the photographer and be decisive. The same is true for editorial assignments where the photographer is working with a magazine editor or art director. With direct clients it may be necessary to educate them about their responsibilities. For example, if a client commissions me to carry out an expensive shoot, I always make sure I know who is responsible for signing off on the work and that that person is present on the shoot.

The bottom line here is if clients decide later that they don't like the photographs, they can't blame the photographer, especially if the photographer was capable of making those changes at the time. For example, let's say on a food still life shoot, the photographer is asked to photograph a dessert with cream poured on top. On seeing the photographs the clients point out they needed to see a variation with whipped cream. If the photographer was briefed to do this and forgot, this would be the photographer's fault. If the art director or client forgot to mention this, then it's clearly the client who is to blame.

It gets more complicated if clients simply don't like the photographs. Prior to a shoot the clients will have deliberated over the choice of photographer, and they will have made their decision based on the chosen photographer's style and available budget. Most of the time clients should know what to expect. Allowances should be made for a photographer who fulfills a brief but doesn't necessarily excel by producing the greatest images. In these instances the photographs may be usable, but the photographer probably won't be booked again. Commissioners should reasonably expect results of a similar standard to the photographs that are in the photographer's portfolio. The key here is "fulfilling the brief." As long as the photographer gets all the requested shots done and the work is approved at the time, he or she can't be blamed afterward if someone has a change of mind. But there is still a lot of pressure on photographers to avoid having their work rejected in the first place.

So in a nutshell, if the photographer's creative work falls short of expectations, this should be picked up by the client at the time of the shoot. There is a lot that can go wrong on a job. Crew members can arrive late or fail to show up at all. The people you choose to book may fall short of expectations, which can make you liable for the photographs being rejected. Your worst nightmare is when things go wrong that are out of your control. That said, most problems can be overcome. If a model falls sick, you quickly find a backup. If the clothes aren't looking right, you get the clothes stylist to drape them differently or have something more suitable sent over. If the subject you are photographing has to cut short the amount of time you have to shoot, you make sure you have everything set up beforehand and work at top efficiency. It can be argued that this is what the pros get paid the big bucks for—the ability to keep the show on the road, come what may. This is where your experience comes into play. You should have a list of contacts that you can call upon to recover from any bad situation. If working in an unfamiliar city, you might want to consider hiring the

services of a local production company, or at the very least make sure you hire a local, knowledgeable assistant.

In extreme cases, when the photographs are rejected, this can be resolved in one of three ways. If the photographer agrees to being at fault, he or she may be given the opportunity to reshoot at no cost to the client. This can be costly for photographers but does at least avoid the costs of litigation and enables them to restore their reputation and keep their fee. If the photographer believes he or she shouldn't be held responsible, it can go to arbitration. This will require the consent of the client, though. For example, the Association of Photographers offers arbitration as a service for its members, where an independent photographer and art director examine the work that's been produced and decide whether the brief was met or not. Both parties have to agree beforehand to abide by their decision. Failing that, the case may have to go to court.

Supplier problems

Then there are the confrontations you have to face when you are the client and have a problem with a supplier. The people you rely on working with may let you down and put your shoot at risk. For the most part, you just make the best of a bad deal and work around the problem. Accept that things will go wrong sometimes and factor this into your schedule. It is not a good idea to overcommit on the number of shots you can do in a day. It is better to say you can achieve four finished photographs in a day and have some slack left over in the schedule to achieve this, just in case there is some kind of problem. If you are then able to produce extra photographs on top of what you promised, that can be seen as a bonus for the client.

When dealing with problem suppliers, the same rules apply as when one of your clients has a dispute with you. For example, if you hire a props stylist and decide you don't like the props brought to a shoot, you can only really complain if the brief hasn't been met or you weren't informed beforehand. Let's say your client produced a mood board that has visual references for clothes or props that are no longer available in the shops. A good stylist will inform you and the client before the shoot, maybe at the preproduction meeting. This then allows everyone involved to manage their expectations and consider other options. But if, say, a hairdresser is expected to have arranged for a skin test on a model prior to coloring her hair on a shoot and forgets to do so, that could cause a big problem, and you could justifiably make a claim against him or her.

Be wary of secondhand observations. If an assistant you trust informs you of a problem, that's one thing, but look out for those who tell tales on other crew members. They may mean well, or they might have a private agenda—you never know. Whenever there is a dispute, it is only natural for people to be defensive. Ask people why they have made such a mess of things and you can hardly expect them to agree

IT IS NOT A GOOD IDEA TO OVERCOMMIT ON THE NUMBER OF SHOTS YOU CAN DO IN A DAY. IT IS BETTER TO SAY YOU CAN ACHIEVE FOUR FINISHED PHOTOGRAPHS IN A DAY AND HAVE SOME SLACK LEFT OVER IN THE SCHEDULE TO ACHIEVE THIS, JUST IN CASE THERE IS SOME KIND OF PROBLEM.

with you. Rather than make subjective accusations, focus on the specifics in a matter-of-fact way. For your own sake you need to deal with any problems as quickly as possible as they arise. This is, after all, part of what your client is paying you for. As I have mentioned already, the most common snag is someone who has been booked on a job turning up late. In these instances you need to make a written note of the time the person arrived, and if it affects the schedule, bring it up to the contractor or their agent.

Personality clashes

Personality clashes between you and the people you work with are inevitable. But the benefit of being freelance is everyone is free to pick and choose whom they work with. If things don't work out on a shoot, the easiest remedy is to not book that person again. It is also worth taking a look at yourself to assess your own behavior. None of us are perfect, and when breakdowns in communication occur, it can be just as much our fault as that of others. I'll be the first to admit I have made my own share of mistakes and mishandled shoots—it's a constant learning experience. Above all, it is about treating your clients and coworkers with respect. When I hear people complain about what it is like to work with certain other photographers, the main grumbles are things like a lack of proper catering or sneakily extending the shot list beyond what was discussed. In any town or city there will be a small network of people working and competing in the same industry, and it's easy to make enemies. So be careful whom you upset.

Regarding catering, whether in the studio or on location, my policy has been to provide a decent lunch for everyone along with healthy and vegetarian options. This always goes down well and keeps the team happy. I do advise you make sure the catering expenses are approved beforehand with the client. Some clients like a nice lunch. Others may frown at the shoot being held up while everyone stops to eat a big meal. In the '70s and '80s advertising shoots would usually entail long, boozy lunches. That all changed after the '80s recession. It wasn't just the need to tighten budgets (and waistlines). The new breed of art directors who came in during the '90s were more focused on getting the job done and wanted to disassociate themselves from the Mad Men image that had lingered for so long.

IMAGE LIBRARY SUBMISSIONS

As Peter Hince points out in the following interview, photographers who submit photographs to image libraries need to pay careful attention to getting all their paperwork in order. Image libraries insist on this, as it protects them and those who will be purchasing the images.

IN ANY TOWN OR CITY THERE WILL BE A SMALL NETWORK OF PEOPLE WORKING AND COMPETING IN THE SAME INDUSTRY, AND IT'S EASY TO MAKE ENEMIES.

If the photographs you submit are designated for editorial, news-type usages only, you won't need a model release. But for all other types of usages, if a person appears in a photograph, you will need to provide a signed, all-rights usages model release that will allow the pictures to be used commercially.

Not all model agencies are willing to offer buyout deals for image library photo shoots at a rate that makes an image library shoot affordable to carry out. So when shooting for stock, you will have to find models who will work within your budget for an all-rights usage.

If a building is featured in a photograph, a property release may also be required. With photographs of individual buildings you'll need consent from the owner in the form of a property release if the pictures are to be used for advertising, promotional, or even some editorial purposes. Let's say you photographed someone's mansion and the photo was used to illustrate a feature on how rich people have avoided paying property tax. Another classic example would be a household insurance ad, where the "owner" of the featured property had been refused coverage by that insurance company. In both cases, the real owner would likely be miffed by the implications of the feature or ad. These are all potentially awkward situations, which is why it is important to get a property release for photographs like these. Landmark buildings such as the Leaning Tower of Pisa are in the public domain and don't count, and it is normally OK to take photographs of public buildings. Also, if you photograph a cityscape you don't have to get permission from each and every building owner.

With sculptures and other works of art that are on public display, it is generally OK to include these in a photograph, but if the image is principally of a copyrighted sculpture, then the photographer may run into copyright issues with the sculptor. Also, with works of art that are on someone's private property, you definitely need permission to use a photograph of them, even if the sculpture or other artwork can be seen from the street. Inside buildings the rules are different. What may be a public space on the outside isn't inside. For example, you can photograph the exterior of St Paul's cathedral in London from almost any angle you like, but you won't be allowed to take photographs inside. The same applies to most museums and art galleries. Ultimately, if you can't provide the necessary paperwork your images will be rejected or withdrawn.

Note that the Easy Release model release app by ApplicationGap (see **Figure 4.2**) can be used on location to create model or property releases, which can be output in PDF form and sent by e-mail. According to ApplicationGap, these types of forms will be recognized by the major photo agencies, but you may want to check first with the image libraries you submit to.

FIGURE 4.2 The Easy Release model release app by ApplicationGap.

PETER HINCE

SPECIALIZATION: IMAGE LIBRARY AND
UNDERWATER PHOTOGRAPHY

For many years Peter Hince worked in the music business with artists such
as David Bowie, Mott the Hoople, and Queen, whom he spent ten years with
touring around the world (Hince recently published a book about these experi-
ences: *Queen Unseen*, John Blake Publishing). It was around this time that he
first picked up a camera and became interested in photography. During his
music career he had already learned a lot from photographers who worked
with the band as well as on the video shoots. So after leaving the music busi-
ness, Hince decided to become a professional photographer. The experience
of working in the music business stood him in good stead for producing pho-
tographic shoots: when commissions did start to roll in he was already well
versed in controlling budgets and making sure things got done on time.

QUEEN UNSEEN BOOK COVER

IMAGE LIBRARY WORK

In the early '90s Hince was approached by the Image Bank picture library to
do some shoots. The London office was owned at the time by Mark Cass, who
was quite forward-thinking in commissioning photographers to do shoots and
generally raising the quality of work held by the library. Hince cleverly made
sure he retained his right to a percentage of the royalties, which still to this
day are generating sales. As he became busier, he started financing his own
shoots for Image Bank as well as other libraries. Instead of giving money to
the taxman, he would reinvest it by shooting more library pictures. "When you
are an approved photographer with an image library, you are given access to
information about which types of images are in most demand, and the image
libraries will art-direct shoots as well," says Hince. "If you invest so much, you
should make so much back again. However, things have changed a lot over the
last 15 years. Firstly, with the Internet, and latterly, royalty free. It's gotten to
the point now where it's hard to tell the difference between royalty free and a
commissioned image, and usage fees have gone way down. Clients don't have
to spend so much money to do a commissioned shoot if they can purchase a
ready-made shot for a tenth the cost. Never mind that someone else might be
able to use the same photo. This approach is very cost-effective if it is just for a
one-time brochure usage. But it is just not such a viable business model these
days. My images are still selling, but they are not earning as much money now.
Instead of photographers getting $100 per usage, it's now more like a dollar."

Hince points out if you are going to shoot specifically for image libraries, you need to make sure you have all the paperwork in order. "Twenty years ago there were photographers who would submit to the libraries test shoots and outtakes from commissioned shoots as a way to earn extra money. But this caused all sorts of problems, where models would see photographs of themselves being used without their knowledge. Images had to be pulled, and it all got quite messy, tracing where photographs had been used. It was a wakeup call for the industry that everyone needed to be more careful." These days everything is checked more carefully, and the lawyers want everything to be absolutely watertight. "Submitted images also have to be checked for technical quality," says Hince. "Agencies are now very strict regards digital submissions. Once upon a time, grainy photographs shot on film would be allowed, but they won't be passed now. Everything needs to be shot digitally using approved cameras. They must be correctly exposed, sharp, and of a minimum pixel size."

AGENCIES ARE NOW VERY STRICT REGARDS DIGITAL SUBMISSIONS... EVERYTHING NEEDS TO BE SHOT DIGITALLY USING APPROVED CAMERAS.

WORK WITH QUEEN

Hince worked with the band Queen over a ten-year period. Looking back, it is remarkable that a band as image-conscious as Queen didn't have official photographers working with them. "They would simply ask me if they could use some of my photos inside an album or tour brochure," Hince says.

After leaving the band and starting work as a photographer, Hince didn't want to flaunt his connection with the band or be seen as an ex-Queen roadie. So he never really did anything with them. It was only recently that the Proud gallery contacted him to do an exhibition in Central London, which then went on to Australia. "It was an interesting experience and exciting to see these shots that had been hidden away for so many years in a new light," says Hince. "There were images I found of Fred that I'd never printed before and had gone unnoticed. For example, the one I used for the cover of my book *Queen Unseen*—Fred asked me to make him look mean and moody. This was shot on tour in

Germany in a backstage corridor using basic flash lighting." The photograph of Fred wearing a crown and ermine robe was shot at Hince's London studio. "It was a personal favorite of Fred's," says Hince; "it summed him up as the 'great pretender,' which was what he was, really. In this context, having the nuts and bolts of the studio in the background made sense. It summed him up very well. It was always the show, Freddie the showman, but outside of that he was a very private person."

UNDERWATER PHOTOGRAPHY

Hince learned how to dive during the '80s but wasn't interested in taking photographs underwater because the equipment needed then was rather cumbersome and he just wanted to enjoy the diving. However, one day on a trip to the Middle East, he picked up a Nikonos 5 underwater camera at the duty-free shop. "I bought some fast-speed black-and-white film and started taking pictures underwater using just available light and started to experiment," says Hince. "The thing about photographing in black and white is it's very different, because the colors you see underwater can be camouflaged." He got his favorite printer, Klaus Kalde, to make the toned prints, and the series he produced won an Association of Photographers award. He then went on to have exhibitions at the AoP Gallery in London, and another in Brighton, as well as at several dive shows. Some images did well with the libraries, and he was able to license others directly to clients.

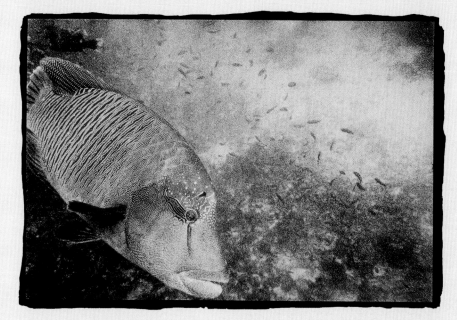

Peter Hince Photography
Peterhince.com

UNDERWATER AD FOR ARALDITE

A few years ago, Hince was commissioned by an agency based in Cambridge, England, to photograph an ad for Araldite, an epoxy resin glue. The intention was to demonstrate the versatility of the product and how it is water-resistant. They wanted a glass fish tank held together with Araldite glue photographed underwater. When Hince was first approached to do this ad, he knew that the best way to handle this would be to photograph the various elements underwater and produce a montage from the best shots. The fish tank would need to be photographed separately in the studio. "There wasn't very much money, and the job had been put on hold because the agency couldn't afford to fly me out to shoot specifically for the job," says Hince. "It so happened I had a trip coming up to the Red Sea, paid for by one of the dive magazines, and I was able to offer this as an opportunity to shoot the stills needed for the ad."

It was quite a challenge shooting in color with an underwater housing and a regular SLR camera. It was necessary to filter quite heavily so as to deal with the blue color cast. Hince knew from his diving experience that the best and easiest dive location to go to would be the southern Red Sea. "This area offers particularly good diving," he says. "There are lots of companies out there that offer first-class diving opportunities, and this location also offers a much greater abundance of tropical fish compared to other popular dive locations." For example, while the Caribbean is a very popular place to dive, you won't get to see quite so many exotic fish. For this particular job, he booked himself to go to Hurghada on a live-aboard dive boat. He used a Nikon SLR camera with a 50 mm lens in a Subal underwater housing. Subal, by the way, mainly makes underwater housings designed to encase the latest Canon and Nikon dSLR cameras, as well as for smaller compact cameras such as those made by Sony and Panasonic. A warming filter was used to help reduce some of the blue color at the time of capture.

He returned from the dive trip with a number of possible images (see **Figure 4.3**). After he showed the photographs to the art director, the shots shown here were chosen to create the final composite. Hince adds, "The tank itself was custom made for the shoot and photographed in a studio. The task then was to combine all these elements."

The biggest challenge was to make the glass tank look realistic within the underwater scene. This was mainly achieved using the Multiply blend mode in Photoshop to merge the studio-shot tank with its underwater surroundings. The fish were cut out using paths and vector masks. These were added to the composite image so the fish appeared to be swimming inside the tank. As you can see, some of these fish were duplicated, or flipped, to make it

FIGURE 4.3 The underwater scene images and studio shot used to create the final composite image.

look like there were lots more fish. The client wanted greater color contrast between the fish and the water, so color adjustment layers were added to the squirrelfish to make them appear more orange. Reflections were added internally, as well as externally, to make the fish look like they really were inside the fish tank and that the tank itself appeared to blend with its underwater environment. It was also necessary to add more shading to some of the fish. For example, the squirrelfish placed at the bottom of the tank needed extra darkening in order to blend in with its shaded surroundings. On the other hand, the two squirrelfish at the top of the tank needed to be kept looking lighter, as they weren't in a shaded area. You will also note that a lid was added to the tank. This was created using the same master aquarium tank image and edited in Photoshop to match the base. Lastly, a duplicate was made of the coral image in the foreground and placed at the top of the layer stack so the tank appeared to be behind it (see **Figure 4.4**). Says Hince, "The client and agency were both very happy in the end."

VIDEO INTERVIEW WITH PETER HINCE.

FIGURE 4.4 The final composite image.

IT'S YOUR COPYRIGHT

COPYRIGHT RESOURCES

The ABCD of UK Photographic Copyright
Epuk.org/files/ABCD_of_copy-right.pdf

ASMP: The Photographers' Guide to Copyright
Asmp.org/free/guide-crcf

Beyond the Lens
The-aop.org/shop

Copyright Workflow for Photographers

Tinyurl.com/jwvwet9

Copyright is a property right that is vested in the works created by an author or artist. Copyright law can be used to protect authors against most unauthorized reproduction of their work, allows them to control how a work is reproduced, and is the lifeblood of our photography industry. In the case of musicians who write a piece of music, if they own the copyright, they control how that music can be used. They can license it to be used in a recording, whether they are the ones playing the music or another artist is. With photographs, copyright ownership puts the photographer in control of how an individual photograph can be seen, whether in print, posters, online, or on TV, and is just as valid and important to photographers as it is to any other artistic creator. While many aspects of national copyright laws have been standardized through international copyright agreements, the copyright laws in most countries do still contain some unique features.

Photographers haven't always been automatically recognized as first holders of copyright. Around the time of the early 20th century, copyright laws were primarily intended to protect the work of writers and painters. Photography was seen as a "technique for copying" (rather like engraving). Because of this, photography wasn't deemed to be deserving of copyright protection status. It's taken a long time for the rights of photographers to be recognized, and almost as soon as this goal was achieved, photographers started being pressured to give these rights up.

COPYRIGHT LAW

US copyright is governed by the federal Copyright Act of 1976. It was this copyright law statute revision that made photographers first holders of copyright, except for what were regarded as "works for hire" (more to follow on that). In the UK it is governed by the Copyright, Designs & Patents Act 1988. This, too, automatically recognizes photographers as first copyright holders. Because of the need to harmonize European law, this act was later amended in 1996 to fit in with European-wide legislation on copyright. South African copyright law has been largely based on British law, and the 1978 Copyright Act is the one currently in force there. It differs from European law in that commissioned photographs are owned by the commissioner (client). The default position is therefore a work made for hire, although this can be overridden by mutual agreement, even one that is made verbally.

Copyright law has also been determined by international treaties, such as the 1886 Berne Convention, which set out minimum standards for legislation and has been widely adopted by countries all around the world. However, it has only been in the last few decades that these principles have been fully implemented in copyright legislation for all types of creators.

COPYRIGHT DURATION

Copyright typically lasts the duration of an author's lifetime, plus somewhere between 50 to 100 years beyond his or her death. The exact number of years varies from country to country. In the UK and European Union, the period is 70 years beyond death and is currently the same in the US, but there are some exceptions. In the US, copyright held by corporations lasts 95 years from the publication date or 120 years from when the item was first made, whichever happens to be shorter. Also, the copyright duration has changed several times in the US, and in a couple instances Congress has retroactively extended copyright. For works created prior to January 1, 1978, figuring out the duration is enormously complicated and very fact specific. In the UK the time limit is 50 years after creation for computer-generated works, which are images created by a computer directed by an author, such as a fractal-rendered image. In the UK, at least, it is not a good idea to describe your computer-edited photographs as being "computer generated."

For works by unknown photographers, the duration of copyright is 70 years from the time the photograph was first made available to the public or published. For photographs that have not been previously published, the copyright expires 70 years after the photograph was taken. So, with photographs that date back to the mid-Victorian era, there will be no problem reproducing them because their creators (known or unknown) will all be long dead and the photographs therefore out of copyright. With more recent works, from the 20th century, it's less clear what can and can't be used. With a photograph taken during the early part of the second World War, the copyright would last 70 years after the death of the creator. If the photographer happened to have been killed during the war the copyright would only just have expired. If, on the other hand, the photographer survived the war and is still alive, the copyright might well still be in force and won't expire till 70 years after death. If you think the photographer who took the picture was unknown, then the copyright may have recently expired, but if you don't know who the author is, how can you be sure?

Digital Millennium Copyright Act (DMCA)

The US's Digital Millennium Copyright Act (1998) implements two 1996 treaties of the World Intellectual Property Organization and was brought about to help clarify the law regarding online social media website and image usages. It exempts Internet Service Providers directly and indirectly from liability (subject to certain procedural requirements) and also renders it unlawful for anyone to produce technology, devices, or services designed to circumvent copyright protection systems that control access to copyrighted works. It essentially protects companies such as Flickr and Facebook from being sued for secondary copyright infringement. At the same time it provides a mechanism for copyright holders to complain about unauthorized use and for such images to be removed. For example, if someone infringes copyright

STRICTLY SPEAKING, PHOTOGRAPHERS ARE ONLY "EMPLOYED" IF THEIR EMPLOYER HAS THEM ON THEIR PAYROLL AND DEDUCTS THEIR TAXES.

on the Pinterest website, it absolves Pinterest of responsibility, but there is a page on the website that allows you to file a takedown notice. In response to this, Pinterest is required to take down the infringing content in a timely manner.

Who qualifies?

Interestingly, in the US a photograph must be regarded as being "original" for it to have copyright. What this means exactly is unclear and has yet to be tested in court. However, the Supreme Court has said that the originality requirement is not particularly stringent and requires only that a work displays some minimal level of creativity. Copyright ownership does not apply to employed photographers, who do not own copyright for the work created during their employment. Strictly speaking, photographers are only "employed" if their employer has them on their payroll and deducts their taxes (in the US what they produce on the job is known as work for hire). Where appropriate, photographers working on a short-term contract should make sure the terms and conditions don't class them as an employee and thereby take away their copyright.

The author needs to be identifiable, which means if you intend on using a fancy pseudonym or brand name for your photography, people should know who the real you is. It's a safe bet most people interested in photography know who Rankin, aka John Rankin Waddell, is, but if your working identity remains unclear, this may mean copyright lasts just 70 years from the time a photograph was taken.

Work for hire

In an employer-employee relationship, if the photographer is a true freelancer, then the copyright is owned by the photographer, unless there is an agreement to the contrary. However, if the photographer is an employee, and creating photographs is part of the job, then the copyright is owned by the employer and the art is regarded as a work for hire (WFH). The only exceptions are when the work created by the freelancer falls into one of several categories specifically enumerated in the Copyright Act of 1976. In these cases the photographer and client can agree beforehand to deem this a WFH. The specific categories include things like a contribution to a collective work as part of a motion picture or other audiovisual work, as well as what are described as supplementary works.

WFH agreements were originally designed with specific scenarios in mind, such as wedding photography where several photographers might be working for one photographer who has been hired by a couple to cover their wedding. This would allow the collective work (in this case the wedding album) to easily be licensed to the couple. Otherwise, if you had one or more other photographers covering the event without WFH agreements, they would individually be able to make claims for copyright ownership. What isn't intended is for companies to try to apply WFH agreements to regular, freelance contractor commissions. For example, a WFH can

be created if it is agreed upon by the photographer and client before the assignment starts and signed in writing (but only if it falls into one of the specific enumerated categories described in the statute). This can serve to pass the freelance worker's copyright to the client as though he or she were an employee, but without the usual employee benefits, of course. It can even be enacted after the work is finished, which has allowed some clients to sneakily include WFH agreements in the endorsement areas of payment checks.

Freelancers also need to watch out for the conditions of work on a long-term project. Such work should be done under a contract for services rather than a regular employment contract, because the latter could be interpreted as a WFH.

Another important point to realize here is that if photographers set their business up as a limited company, or LLC, they become an employee of the business and the company (the employer) will own all the company assets. Should the company ever be sold or go into liquidation, the copyright would be regarded as being part of the company assets. There are ways to circumvent this. You can ask a solicitor or attorney to draw up a document that transfers the rights in the photographs shot for the company to you personally and then relicense these back to the company. A simpler solution is to keep the income from royalties separate to the company, although this requires managing two sets of accounts. In either case, you should always seek legal advice.

Copyright registration

In the US, it's not necessary to register your photographs in order to retain copyright because the copyright belongs to you regardless (unless you choose to sign it away, of course, or unless you take the photos for a company while you're its permanent employee). However, in order to successfully file a copyright suit you will need to register your images. This is because with unregistered images, damages are limited to actual losses. Registration is a requirement to file suit and get into court to sue for actual plus punitive damages. Basically, it is still required for US domestic copyright owners if they wish to receive the full benefits copyright protection can give them and bring a suit for copyright infringement in a federal court. As long as you register before the infringement, or 90 days before publication, then you're eligible for statutory damages and attorney fees. To register you need to use the Copyright Office's online registration system, Electronic Copyright Office (eCO). This can be accessed by going to the Copyright.gov page: click on the eCO link and follow the instructions on how to register your images and what file format and size they need to be, and then upload them via the site. A payment will be required for each registration, which varies slightly depending on which type of form is used. However, groups of published photographs, for example, still require paper forms.

COPYRIGHT INFRINGEMENTS

Copyright infringement is often worth pursuing, providing your case is strong. In the US the only place that can hear a copyright claim is a US federal court, because US copyright law is exclusively federal. Sometimes it pays to bring your small claim along with a copyright claim, and take it all to federal court, as the potential damages awards from copyright infringement are usually higher than simple breach of contract claims. Alas, there's no one size fits all answer to this issue, so this is one of those cases where it's a good idea to consult with a lawyer to get a sense of what your options are.

Moral rights

Moral rights were included in the Berne Convention and are partly implemented in UK and Canadian copyright law. Under UK law, moral rights are granted automatically and cannot be sold or assigned (surrendered) in the way copyright can be assigned. They give photographers the right to be correctly identified as the author and have their work properly credited when published (but this has to be asserted). The rights also allow you to object to derogatory treatment, such as poor Photoshop retouching being carried out on a photograph without your permission. Also included is a clause that safeguards the commissioner's privacy. This means with commissioned photographs taken of social events such as weddings or family portraits, the photographer owns the copyright but cannot publish those photos or exploit them for financial gain without seeking permission from the commissioner. In the US, Section 106A of copyright law provides specific rights of attribution and integrity for visual artists.

Client negotiations

IF YOU SHOOT FOR COMMISSION YOU MAY BE ASKED TO ASSIGN YOUR COPYRIGHT. IT HELPS TO KNOW THAT THE ONLY WAY YOU CAN DO THIS IS BY WRITTEN AGREEMENT. UNLESS OTHERWISE SPECIFIED, THE COPYRIGHT IS YOURS AUTOMATICALLY, AND IT CAN'T BE NEGOTIATED AFTER THE EVENT.

The reality is, many clients haven't liked the copyright law changes that have benefited photographers. Prior to 1976 (US) or 1988 (UK), whoever commissioned and bought the photography (or more specifically, paid for the film used) owned the copyright. Photographers could (and did) negotiate to keep their copyright but had to assert this right prior to agreeing to each job as part of their terms and conditions of business. With prints you could put a stamp on the back to say, "This photograph is subject to copyright." With transparency slides these would need to be mounted and the copyright owner's details written onto the slide mount.

With the advent of digital, it's now much easier to assert copyright. You can mark a photograph as being copyright-protected and include your name, contact info, and other relevant details in the IPTC metadata. None of this is foolproof and you can argue it is just as easy to copy and paste an image to remove all the metadata as it was to remove a slide and put it in a new slide mount. There is a provision in the DMCA that makes it unlawful for someone to knowingly and intentionally remove copyright management information from copyrighted works.

If you shoot for commission you may be asked to assign (give up) your copyright. It helps to know that the only way you can do this is by written agreement. Unless otherwise specified, the copyright is yours automatically, and it can't be negotiated after the event, either. However, you will inevitably meet clients who'll demand all copyright. The main reason for this is that their lawyers have advised them to get blanket waivers from everyone they deal with. Such demands aren't always transparent—the waiver may be contained in a clause on the back of an art order. Worse still are one-time agreements in which the photographer agrees to assign copyright to that client for everything he or she shoots now and into the future. Shortly after the 1988 Copyright, Design & Patents Act became law, a London agency sent letters to

photographers with a pound coin attached stating this letter was a copyright assignment and acceptance of this payment would assign rights for all future work commissioned by that agency. Of course, to be valid, such an agreement needed to be signed by the photographer, but it showed the desperation of some clients to secure all rights, even if it cost them a pound to do so.

Instead of assigning full copyright, you can grant a license specified by usage type (i.e., media usage), time period, and territory, and it is possible to make this an exclusive right. This appeals to clients because it guarantees only they will be able to use the pictures. From the photographers' point of view, an exclusive license agreement assures them the photos can be used only for the requested usages and time period. So it can be fair to both sides. An exclusive license, signed by the copyright owner, also gives the client the right to sue third parties directly for any copyright infringement. Exclusive license agreements are commonly used in advertising photography.

A nonexclusive agreement is one that would mainly be used where the source image was not shot for a particular client but most likely self-commissioned, and the photographer wished to maximize potential sales. The best way to visualize this is to imagine a cake being divided up into lots of different slices. One slice would be to sell a photograph for press advertising in the US for a period of six months. Unless it's made exclusive, that same slice can then be sold again to someone else. Each slice can have a calculated value based on the type of usage, where it is to be used, the time period, plus requests for exclusivity.

As much as clients might like to negotiate to have the whole cake to themselves, it is the photographer's or agent's job to explain why they won't always need it. Photographer Seth Resnick offers some good advice here: "Asking you for a price for unlimited usage is a little like asking for the price of a car but not knowing if you want a Ford or a Ferrari. I tell clients that unlimited usage means usage in every media type in every language, and the cost would be far greater than they need to spend. Are they doing television? If not, they can exclude television rights. Are they going to have usage on the sides of buses? Are they going to use billboards? For example, if a regional magazine charges $5,000 for a full-page ad, it would make an enormous difference in the price if the ad is run once or six times. Also, there may be one regional magazine or there could be 20. Again, the price would vary greatly."

Where a photographic shoot involves models or incorporates elements that are themselves subject to copyright, this actually strengthens the argument to insist on the need to sell limited rights. After all, if the model booking agreement signed by the client limits the picture usage, then the photographer's agreement should do so, too. In other words, the model agreement already limits the types of usage, and the photographer can't be made liable for extra usages that go beyond the original shoot agreement. This also highlights the problem of losing control of your work when you assign copyright. Your work can then be used anywhere in any context, but the models featured in a photograph may not like the products or concepts they'll be associated with. That can be a problem.

PUBLISHING RIGHTS EXPLAINED

Photographs can be licensed in a number of ways. One-time rights are where a photograph is offered for publication one time only. First rights are where you offer a publisher the opportunity to publish a photograph before anyone else, again on a one-time basis. Serial rights are where a photograph appears repeatedly in a publication, such as a portrait taken of a columnist who writes a regular column for a magazine. Electronic rights covers usage in electronic media, such as apps and websites, which these days are an important part of magazine publishing. Then there are promotion rights, which cover use of a photo in promoting a publication. For example, if your photograph is used for a magazine cover, the magazine cover design may end up being used in press, poster, and TV ads. While magazines pressure commissioned photographers to assign full copyright, it is important to be aware of these terms when selling self-commissioned work.

Even when the photographer
owns the copyright of an image,
there is still the opportunity for
the work to be appropriated
using a fair use defense. This is
an exception allowed in copy-
right law that permits the use of
copyrighted material by others
without requiring permission
from the creator. This particular
defense was made use of in Pat-
rick Cariou vs. Richard Prince.
In this court case Prince was
accused of having used photo-
graphs taken by Cariou to create
new works of art. Prince justified
this using a fair use defense,
arguing that the treatment
applied was "transformative." At
a sitting of the appellate court,
two out of three judges agreed
and found in favor of Prince. The
court of appeals did send the
case back to the district court
regarding five of Prince's works,
because the judges thought
the case required more fact-
finding. However, that part of
the case was ultimately settled
privately between the parties. In
some other notable cases, a fair
use defense for photographic
images has been rejected, and it
remains a gray area.

Copyright ownership also gives the photographer some control when collecting payment. As I mentioned earlier, as part of your terms and conditions you can state that the copyright license only comes into effect once payment has been received. It wouldn't go down well to enforce this to the letter of the contract, but such clauses are useful should you find yourself in a situation where an advertising agency goes bust and the photographs continue to be used by the end client. In such situations you could make a claim against the client for usage of the photographs (even if the agency had already been paid).

As mentioned earlier in the book, be careful when entering competitions or agreeing to license an image. Always read the terms and conditions carefully. For example, it is common for photography competitions to include onerous clauses that are essentially a rights grab (see "Awards and Building on Success" in Chapter 2). Students who enroll in a photography course should read their agreements carefully to make sure the work they will be producing for that course remains theirs and that their copyright is not automatically assigned to the college.

ORPHAN WORKS

Images with missing metadata information are typically described as "orphan works." A lot of photographs and other artistic works in existence have no indication of copyright ownership, and there's no way to tell who the author is. Orphan works photos are a problem for picture editors because they can't use them (except when a photograph is clearly old enough for the copyright to have expired), and photographers who omit their contact details won't benefit from potential sales. As a result, there are, as you can imagine, a lot of rather interesting historical photographs held in libraries that can't be published because of the uncertainty surrounding their ownership. The fact that a prospective user cannot identify the owner does not make the work anonymous or pseudonymous.

Some businesses would like to see legislation introduced that would allow them to avoid liability when publishing or using orphan works. This is also being strongly supported by public institutions, as well as vested interests that would like to administer schemes to oversee the use of orphan works. However, if done right, orphan works legislation could offer a fairer deal to photographers. One US proposal would limit damages to a reasonable license fee, so that the photographer would be out no more or less than in an ordinary commercial transaction situation. In the absence of legislation to deal with orphan works, courts in the US have also been more willing to expand the contours of fair use, which has been used as a shield.

The overall situation is not helped by photographers who fail to safeguard their images and who are not taking care to mark their photos as being copyrighted or adding their contact details to the IPTC metadata. At the same time, uploading photographs to social media sites can cause them to lose such metadata and thereby create

orphan works during the process. If you haven't heard about proposed orphan works legislation, I urge you to read up on this.

There was the recent, well-publicized case of Morel vs. Agence France-Presse (AFP)/Getty Images. The story here is that Daniel Morel, a Haitian photojournalist, took photographs of the earthquake disaster in January 2010 in Haiti, and within hours of the event happening, posted these on TwitPic, a website that allows users to put pictures on Twitter. However, another Twitter user took the photos from Morel's TwitPic and posted them on his own. AFP ended up using the photographs from this account without following its own guidelines to check the true ownership of the photographs. AFP then forwarded the images to Getty Images and as a result, both became embroiled in a Southern District of New York court case in which the two agencies were found liable of multiple violations of the Digital Millennium Copyright Act and found to have altered the copyright management information and added false, misleading data. Part of AFP's defense was that the Twitter website allows for the fair use of photographs. At one point AFP even brought counter claims, one of which sought a judicial decree that it hadn't infringed anything, and another for commercial defamation. The judge saw things differently. Twitter allows users to post and retweet but doesn't allow for the commercial use of photographs posted by other users. The jury found that AFP and its American distributor Getty Images had willfully infringed Daniel Morel's copyright and awarded him $1.22 million. This was a significant victory for an individual photographer who had fought a long battle with the picture library agencies.

I think the main culprit here was the Twitter user who effectively stole Morel's photographs and thereby allowed them to be used by AFP without the original creator's knowledge or permission. AFP had indeed issued guidelines to its editors to avoid using photographs found on social media sites without checking, and its picture editor was clearly at fault. Getty Images was also found liable by association for its role in the infringement, and it is reckoned it may well sue AFP for the legal costs Getty Images incurred. The important thing about this case is that it clarifies how photographers have the right to maintain ownership of their images when photographs are posted on social media. Where picture editors have been inclined to use photographs without properly checking, this case serves notice to them to act more responsibly in the future.

SECONDARY RIGHTS

When retouching is carried out by someone other than the photographer, this implies dual copyright ownership and permission must be granted before the original copyright owner can exploit that image and license it for other usages. It is all a question of how much retouching is done. Basically, retouching that extends to simply cleaning up an image doesn't qualify. But if the retouching work substantially changes the appearance of an image, or includes photographs created by another photographer, then more than one copyright will be associated with that work. For example, the image in **Figure 4.5** is one that I worked on for Makebelieve Beauty through Nude Brand Creation. I took the photograph of the model featured in the design and carried out the preliminary retouching. The Henri Rousseau–inspired jungle foliage was illustrated by Derek Bacon and the final image composition assembled by Allen Luther at Nude. Permission was sought by each of those people in order to reproduce this image in the book.

FIGURE 4.5 Client: Makebelieve Beauty, illustration: Derek Bacon, design. Mike Parsonson @ Nude, image composition: Allen Luther @ Nude, model: Tess @ MOT.

Adding copyright information

You can identify a photograph as being copyrighted in a number of ways. You can add a copyright notice watermark to it, which clearly tells people, "This is a protected photograph." Be careful when uploading images to social media or image-sharing websites. If you care about the picture you are uploading, be sure to add a watermark that indicates it's copyrighted. Not all sites strip the metadata, but with those that do, this will be your only means of defense. A watermark will survive metadata

FIGURE 4.6 In Lightroom you can create a custom metadata preset (left) and use this to apply essential copyright information and contact details to photos in the catalog. The Metadata panel (right) lists the IPTC information, including copyright.

FIGURE 4.7 In Photoshop you can inspect the file metadata by choosing File > File Info... Here you can inspect and edit the metadata information. If a photograph is marked as copyrighted, a © symbol will appear in the document window title bar when it is opened in Photoshop.

stripping but has the disadvantage of defacing your work. You can select the "copy-righted" item from the Copyright Status section of the IPTC metadata. This can be done using a program such as Photoshop, Lightroom, or Phase One Media Pro. This alerts a potential user to the fact that the image is copyrighted and is not available for general use, and copyrighted images opened in Photoshop will display a copyright symbol in the image document window title bar. While you are about it, you can add more information about the picture, such as your name and contact details, your e-mail address, and your website URL (see **Figure 4.6** and **Figure 4.7**). You can also use special plug-ins that are able to embed an invisible, robust watermark. Examples of this are Digimarc and Signum SureSign.

PICTURE LICENSING UNIVERSAL SYSTEM (PLUS)

The PLUS Coalition is an international nonprofit organization (Useplus.com). To quote from its website, its aim is to simplify and facilitate the communication and management of image rights. The PLUS Picture Licensing Glossary helps educate people about the language used to form a license. The main impetus has been to work with the International Press Telecommunications Council (IPTC) to have extended IPTC metadata entries that make use of machine-readable code to define media categories for image usage. The online License Generator can be used to create a PLUS Universal License Statement, which describes the rights information you have granted to a licensee. This creates an XMP file that can be used to embed your license in an image or collection of images. The PLUS Registry at Plusregistry.org allows photographers from all over the world to register their contact details for free, enabling purchasers of images to more easily locate photographers. All of these services are provided as free tools and will offer a vital defense against future orphan works legislation. For a small annual fee you can become a supporting member and receive a unique PLUS Member ID that can be used by your business in images and image-licensing documents.

CREATIVE COMMONS

Creative Commons (Creativecommons.org) is a nonprofit organization that enables the sharing and use of creativity and knowledge through free legal tools. Creative Commons tools allow creators to retain copyright, while allowing others to access and use their work in limited ways. It offers a "some rights reserved" approach to copyright licensing as opposed to the traditional "all rights reserved" restrictions. It allows creators to retain copyright while enabling others to copy, distribute, and make some uses of their work. It supplies various levels of licensing, all built upon copyright law, that permit different levels of specific usages. Using tools that are

available on the website, users can specify and generate custom XMP metadata templates. Instructions on the site show how you can then use these to edit the metadata in image files to add a Creative Commons license notice.

THE GROWTH OF THE INTERNET HAS FUELED APPETITES FOR FREE CONTENT. THE UNDERLYING ETHOS OF THE INTERNET IS OPEN-ACCESS PUBLISHING.

The growth of the Internet has fueled appetites for free content. The underlying ethos of the Internet is open-access publishing, and few publishing sites require an entry fee other than Rupert Murdoch publications and pornography sites. With this has come the problem of people expecting everything to be free; it has spawned a "freetard" mentality. I should explain here that freetard is a slang term for someone who thinks all digital content should be available at no charge, regardless of the fact that the people who create this stuff need to earn a living. It is neatly summed up by the slogan "Everything should be free, all the time (except for the things I am selling)." Giving content away can work for some publishing media and creative endeavors, but photography is different. An established band might calculate that allowing people to download some of their music for free will help promote future tours, which will make them money. With photography the photograph is everything. You can't offer a seven-day trial (like you can with software). The only thing you can do with a photograph is to embed a visible watermark that allows people to view the image before deciding to buy it or not. But the freetards want everything to be free on the Internet. It's become commonplace to accept that that's the way things should be, and it accounts for why so many of the images you see being used on the Internet are published illegally.

COLLECTING SOCIETIES

Collecting societies are bodies that have the authority to collect royalty payments from users of copyrighted works and distribute royalties to copyright owner members. Rather than manage primary usages (such as where a client contacts the photographer to enquire about usage in, say, a book), they manage secondary copyright usages, such as photocopying and TV broadcasting of photographs. End users are able to pay a fee in return for a blanket license indemnity that grants them permission to use images in this way. There are collecting societies in each of the European countries (the Design and Artists Copyright Society [DACS] is the collecting society for UK visual artists). However, Canada and the US have less restricting rules about how these types of societies should be run. There isn't really a collecting society for visual art such as photographs. The Copyright Clearance Center (Copyright.com) operates as an opt-in clearinghouse for certain types of content, mostly book chapters and journal articles, but it does offer some image-licensing services.

5

PHOTOGRAPHING PEOPLE

PHOTOGRAPHING MODELS, CELEBRITIES, AND PEOPLE ON THE STREET

STREET PHOTOGRAPHY

There are many approaches to photographing people on the fly. These depend on the environment you are in and what type of photography you are after. The following tips are based on my own experience, plus advice from other photographers. With candid street photography, the goal is to be as unobtrusive as possible. For example, one of the reasons Leica film cameras proved so popular with photojournalists was because they were small, lightweight, and quiet (being range-finder cameras, they have only the sound of the shutter and no mirror). Leica now makes digital cameras, too, and Fuji has come up with the similar-looking X-Pro series, which has also proved popular with professionals. Some pretty decent compact cameras are also available, such as the Ricoh GR or Sony RX100, which can be used to photograph discreetly. These are relatively inexpensive. They are able to shoot in raw mode and can work silently, and autofocus lets you shoot discreetly without lifting the camera to your eye.

LEGALITY OF PHOTOGRAPHING IN PUBLIC

ALL TOO OFTEN PHOTOGRAPHERS ARE BEING STOPPED BY POLICE OR HARASSED BY PRIVATE SECURITY STAFF.

We are now working in a climate where photographers, especially those who look like pros, are regarded with more suspicion. Everyone can be seen now taking photos with mobile phones, but if you carry around an expensive-looking kit, you'll certainly attract more attention. I find wariness of photographers to be more of a problem in the UK than in other countries, and indeed, a recent campaign highlights this. The "I am a photographer, not a terrorist" campaign saw photographers assemble en masse at Trafalgar Square, London, to assert their right to take pictures in public. All too often photographers are being stopped by police or harassed by private security staff, and while police officials in the UK have stated publicly that photographers should be free to photograph lawfully, the message hasn't got through to everyone. It

is therefore worth familiarizing yourself with the law, so that you know your rights when out photographing in a particular locality.

Generally speaking, a distinction needs to be made between public and private spaces. Almost anywhere outdoors is regarded as a public space, except when you are on someone's private property (which isn't always obvious). The general rule is you can photograph freely in the street in a public space, but commercial photography for business use is still restricted in some public spaces. For example, parts of London appear to be public thoroughfares but are in fact privately owned. The section of the Embankment by the London Eye looking out over the Houses of Parliament is privately owned, as is the pedestrian area in front of the London mayor's office by Tower Bridge. To shoot commercially at these locations, you will need a permit. The same goes for shooting commercially in the Royal Parks, which are owned by the Crown.

So, as long as you are not breaking the law and not obstructing a public right of way, the police shouldn't stop you from taking photographs. In some instances they may ask for your name and address, and if you refuse, that could lead to problems, but generally the police are OK. In the US, the police do not usually have the power to confiscate equipment, demand to view your work, or force you to delete pictures without a warrant. However, you are not allowed to photograph military installations or areas deemed off-limits to protect national security. The US Department of Energy also has prohibitions on photographing nuclear facilities except for those areas that are normally visible to the public.

In the UK, you are allowed to photograph in public places, and the police have no power to stop you from photographing incidents or police personnel. However, under Section 43 of the Terrorism Act 2000, officers do have the power to stop people they reasonably suspect to be terrorists and search for anything in their possession or on their person that may constitute evidence they are a terrorist. In these specific circumstances, officers have the power to view digital images on mobile phones or cameras and seize any article that might possibly constitute evidence of terrorist activity. Officers do not have the power to delete images at any point during a search, as this can only be done following seizure and a court order. When covering a news event, your photography mustn't get in the way of what the police are doing. If the police ask you to move on and you refuse, you could be arrested for obstruction.

Most of the problems photographers encounter tend to come from private security guards who argue that you can't take photographs of the building they are responsible for because of security reasons. They actually have no legal right to stop you photographing a building that is in public view, as long as you are shooting from public land, such as from the street. They can legitimately stop you from taking photographs inside a building, because then you are on private property. Of course, asserting your rights in public spaces is easier said than done. Some private security people can be quite bullying. You do also need to be sure of your facts, because

Magnum photographer Ian Berry, shot as part of a series of advertisements for Leica. The cameras were small enough that he could carry a couple of bodies tucked discreetly in his jacket.

If stopped by the police, it is best to respond by being polite and answer any reasonable questions. The police are legally allowed to stop you, but ultimately they can't detain you unless they have reason to suspect you have committed a crime. The question to ask is: "Am I free to go now?" If the officer says no, then you should ask why you are being detained and what the crime you are suspected of committing is. In situations like this you need to have your legal arguments rehearsed to remind officers of your rights. The police authorities do train their officers and update them on most recent changes to the law, but instances are still reported where individual officers have misinterpreted the law and wrongfully detained photographers. In the US, police authorities need to ensure individuals' First, Fourth, and Fourteenth Amendment rights are protected whenever members of the public or professionals record police officers discharging their duties.

sometimes where you are standing may look like a public right of way but is in fact private property. What the owners of a building can control are the property rights, which means you don't have the right to publish for commercial gain an exterior photograph that features a building without securing a property release.

Photographers must not obstruct a right of way, which means you need to be careful when setting up a tripod to not block the street or pose a risk to pedestrians. If your shoot requires the use of a tripod, it is usually simply a matter of contacting the local police in advance and informing them. As long as you do this and take care that you and your crew don't get in people's way, you should be left undisturbed.

There are nearly always limitations when photographing indoors, where the owners will be within their rights to restrict photography (such as in an art gallery or a restaurant). Where photography is permitted, you'll still need to arrange a permit if you wish to shoot commercially.

In most countries there are no laws to prevent you from photographing people in public. However, you still need to be in tune with local customs. If your style requires the discreet approach, use an appropriate lightweight, quiet camera. If you work as a news photographer in public spaces using a bulky dSLR, it is no good trying to hide the camera. It's better to be up front about it and let people see you are a photographer and, where necessary, to also obtain proper accreditation to cover specific events. In social situations, wearing a camera around your neck makes those around you get used to seeing you with a camera and thinking of you as a photographer. For example, my daughter's school friends and parents are all used to me having a camera and taking photographs of them. It's inevitable, though, that some people will still jump to conclusions. Let's say you are taking photographs in a park and a parent accuses you of acting suspiciously. In a situation like this, you can always calmly explain who you are and why you are taking photographs. These days everyone will have a mobile phone with a camera, so you can even suggest they take a photograph of you to show you have nothing to hide. But if the parent is still upset, it might be safest to back off and photograph a different scene.

There are still boundaries to consider, such as whether it is appropriate to photograph someone or not. When shooting an informal portrait, try to engage with your subject and get his or her permission first. You can ask directly, or if there is a language barrier, simply lift up your camera and point at it to show that you want to take a photograph and see how the person responds. Don't necessarily dive in and take pictures straight away. When you are in a new environment, take a few moments to blend in first to let people get used to you being around before taking photographs.

PRIVACY ISSUES

Whether it is OK to push the boundaries or not comes down to personal choice. For example, in a recent court case, New York photographer Arne Svenson surreptitiously photographed his neighbors in the Tribeca tower block opposite where he lived. The resulting photo series The Neighbors came in for a lot of criticism, and two of the neighbors actually sued after noticing their children were featured in the series. However, as the Guardian newspaper reported in August 2013, a court did rule that Svenson's actions were defensible under the First Amendment's guarantee of free speech, and that such art needs no consent to be made or sold. A case like this highlights how the freedom to take photographs is one that will be upheld regardless of questions of privacy, taste, and decency. The concern will always be that once there is a legal precedent that prevents people from photographing freely, it's the thin end of a wedge.

For paparazzi-style photography, the bigger the better—bigger lenses to photograph from a distance, and just having a bigger presence in order to get where the action is and grab the shots. While the rich and famous may wish to avoid photographers spying on their private lives, they do want to be seen when they are on display. To cover a celebrity event you need the right camera, lenses, and flash so you can work fast in low-light conditions. Also, having the latest Nikon or Canon dSLR around your neck (plus a press pass) gives you credibility and says, "The photographs I take will be published." Otherwise you look like a regular fan trying to get a photo for Facebook.

It is illegal to harass somebody, though. This doesn't mean that simply photographing someone is an act of harassment. You have to cause someone genuine harm or distress and do so persistently, rather than on a single occasion. Essentially, a person has a right to privacy in places they would expect to be private, so photographs shot with a long lens pointing inside someone's house are usually an invasion of privacy (yet the Arne Svenson case suggests this may not now always be the case). Meanwhile, the European Court of Human Rights has determined that protection of privacy may in some cases apply to certain public spaces as well. The main concern here seems to be with photographing children. It's a controversial area, because while Article 8 provides the right to a private and family life, Article 10 provides the right to freedom of expression (including artistic expression). The courts will have to balance these two rights when deciding a particular case.

It should be OK to take photographs of people at public events and publish these editorially. But if such photos are to be used for commercial purposes, you'll need to obtain a model release whenever a person or people featured in a photograph will be recognizable. With image library shots, model releases are essential, and advertisers in particular have to be really wary about people featured in a scene being recognizable.

LAW OF CONFIDENCE

Photographers working in the UK need to be aware of the law of confidence. This is a law designed to protect confidential agreements, such as when a magazine arranges an exclusivity agreement with a celebrity and has sole rights to photograph his or her wedding. If a paparazzo takes unauthorized photographs and these are published, the client (who has the contract with the celebrity) can get an injunction against the offending publisher. This also applies to shoots where the photographer has to sign a confidentiality agreement not to disclose details of a shoot prior to publication. In these instances you have to be careful not to inadvertently show off the results of a shoot before your work is published or reveal any privileged information you learn.

WORKING WITH MODELS

Organizing a test shoot should be treated like any other shoot, where if you want to get the best results you need to work with a creative team including a hair-dresser, makeup artist, and clothes stylist.

Working with professional models can make all the difference whenever you need someone who is experienced at being in front of the camera or you are after a specific look: either a beautiful face or a character image. There are model agencies that represent all kinds of models, not just the young and good-looking. If the work you do is going to rely on the use of models, then you'll first need to establish a relationship with the agencies you would like to work with in your area. Model agencies aren't likely to send models to work with someone they have never heard of before. If you are new to the business or local area, you'll need to introduce yourself first and make face-to-face contact. Be prepared to show your portfolio, and if they like your work get into a discussion about doing test shots of some of their models.

Test shots are a way both the photographer and the model can build their portfolios. This can be regarded as a reciprocal arrangement where everyone gains, where a new photographer and new model can both get experience. As you become more proficient you will want to assert your status. If your test shoot involves renting a studio space plus getting a hairstylist and makeup artist to test for free, you will want to make sure you are able to work with a model who will also bring something extra to the test shoot. You basically have to find the right balance, where everyone involved with the shoot feels they are working with the right level of talent all around. It isn't going to work if you persuade, say, a top clothes stylist to source clothes for a test shoot and the model you choose to work with isn't suitable for the look you want to create or is totally inexperienced. You have to bear in mind that all the model agencies are interested in doing is finding the most talented photographers to work with their newest models and get them photos, so it will be in their interests to push you toward using the models they most need new photos for.

More experienced photographers charge to shoot test shots of models. For a set fee they shoot a variety of images that can help a young model build her first portfolio. Here, model agencies will want to approve the photographer first before recommending him or her, and there are always stories of unscrupulous studios that specialize in tapping into the dreams of youngsters looking for fame and fortune in a glamorous profession. For budding fashion photographers, test shots can provide some pocket money, useful experience, and the opportunity to get paid to test. Everyone who is involved in a test shoot must know not to abuse the implicit trust involved. The hairstylist can't then use the photos to promote a salon, nor can the photographer go and sell the photographs without negotiating with everyone involved.

Keep the relationships you have with the model agencies professional. One of my first assisting jobs involved organizing model castings and shooting schedules, and I once advised a model who was with a small agency to switch to one of the majors. Her agent was furious and complained to the photographer I was working for at the time. It happened because I was showing off, but I learned a good lesson from that

experience: to be more respectful and not interfere in other people's business. Unless you happen to know models really well, you can let them work out for themselves whether they are happy with their agent or not. And remember, in any city the number of talent agencies will be fairly small. What might be a small startup agency today could soon become the next big thing. In my experience it has always been important to have a good, reciprocal relationship between yourself and the model agencies. When you find yourself in a tight situation it helps to have friendly model agency contacts, who will be ready to help out at a minute's notice.

FINDING AND CHOOSING MODELS

Selecting a model or models for a shoot can be done via an agency website or through recommendations by the agent, but the best way is to make time for "go-sees"—appointments for models to see clients and photographers, to introduce themselves and show their books. Agencies arrange these on behalf of their models to help them meet new potential clients and, I suppose, to keep them busy and show that they are working hard for them. Even if the agency knows a photographer doesn't have any shoots coming up, it can still be beneficial for everyone, because the photographer will have more time free to look at books and be inspired to arrange to do a test shot.

The best way to select a model for a job is to hold a dedicated model casting and have the client attend. It is all very well looking at websites and referring to recent go-sees, but a model's look can change in a short space of time, and having face-to-face meetings between models, the photographer, and the client is so important.

Model agencies might offer to send over a model package prior to a casting. This will be an e-mail link showing a custom selection of models that you can expect to see. For important jobs and especially ones where there is a lot of money at stake, it does help to filter out the models who will be sent to the casting. You otherwise risk being besieged with models, not all of whom the client will be interested in seeing or who will be right for the job. You can hire casting agents to take on this work for you, but even then it can involve too much time. In one case, a client needed to find a mother and daughter for a TV ad and decided to have the "mum" who matched the "daughter" present themselves at the same time. It was a nightmare for the casting agent to organize, took up a lot of the models' time, and was completely unnecessary.

Castings can also serve as a preshoot meeting with the client, enabling you to spend some time together ahead of the project and focus on the creative objectives. It may be the first and only time you get to meet clients before a job, so this is a good opportunity to bond beforehand. I usually ask the clients to arrive at least half an hour before the casting is due to begin so we have time to chat first. This also gives you a chance to work out the dynamics within a team and weigh who is most in charge of the creative decision making. For example, you might learn that while the

At model castings I always have a small studio setup that allows either me or my assistant to photograph each model as they arrive.

IF AN EXPERIENCED AND IN-DEMAND MODEL ARRIVES AT A CASTING AND SEES A LONG QUEUE THAT ISN'T MOVING VERY FAST, HE OR SHE WILL VERY LIKELY SKIP WAITING AND HEAD OFF TO THE NEXT CASTING INSTEAD.

owner of the business is in charge of the money, it's actually someone lower down the pecking order who calls the shots when it comes to the creative decisions. Things like this are good to find out in advance.

The key thing is to keep the model casting moving. As much as you might like to plan for an even distribution of models to arrive throughout the afternoon, you can't efficiently organize a casting this way. All you can do is to ensure that each model is interviewed as quickly as possible and not allow a big queue to build up. It is a good idea to brief clients at the beginning of a casting to spend the least time possible looking through the portfolios of models who clearly don't fit the bill. This way the casting flows quickly and you won't miss meeting the most suitable models. If an experienced and in-demand model arrives at a casting and sees a long queue that isn't moving very fast, he or she will very likely skip waiting and head off to the next casting instead.

It is important to select the right casting location. Ideally, the casting studio should be easily accessible and near other photography studios. If you set up a casting at an address that's miles out from the center of the city, you'll immediately restrict the number of models likely to attend. It doesn't matter so much for the final studio shoot location, but for model castings a central location is best, such as a photographic studio or hotel suite. Just bear in mind that you need somewhere with room to accommodate yourself, the client, and, say, a dozen or more models who will be waiting to show their books. Models tend not to be early risers. If you cast in the morning they won't start rolling in till around 11:00, but if the casting time starts just after lunch and runs throughout the afternoon, you can expect to see a steady stream of models.

In the old days photographers might have shot Polaroid photos of each model. Now, of course, it is easy to capture digital photos instead, and it can help to hire an assistant to do this. With the camera setup tethered to a laptop, you can get your assistant to add the model's name and agency details to the caption metadata as each model is photographed. Nearly always the models should arrive with little or no makeup, which makes it easier to judge who's right for the job when reviewing the photos. The composite cards models leave are all very nice, but clients usually find it easiest to compare the photos that have been taken on the day of the casting.

Booking models

When you organize a casting, begin by sending out a casting brief. The agencies will expect this, and it should list all the obvious information, such as who the shoot is for, where it's going on, the dates and times of the shoot, and so on. This can conveniently be done by sending an e-mail, but it's always a good idea to follow up with a call to make sure the e-mail has been noted and read. A lot of the time e-mails go unnoticed unless you tell someone at the agency to look out for yours. It's also a good idea to

build a personal rapport with the model bookers. Having a friendly business relationship will go a long way, especially when you need cooperation with a tight budget or need to find a replacement model at short notice.

The casting brief should specify the desired usage and what the proposed fee will be. Establishing from the outset what the booking terms will be helps guide the model agencies to send only models who are available for that usage and budget. It might be that a model has already worked for a skin care line and is precluded from advertising a competing product. The model budget you have may only allow you to see and choose from an agency's newest models. Being clear from the beginning makes life easier when you book the models, because by sending a model to the casting, the agency has already implied that the fee you propose is acceptable.

This approach works well with shoots where the budget is tight and all the models will be expected to work for the same rate. With advertising commissions the model fees are far more open to negotiation. At the time you put a quote together, you will need to speak to each agency individually to explain what you are looking for and ask them to quote a range of prices for their models. From this you will be able to determine what the final model fee is likely to be. The quotes you get back will be varied. It depends on whether the booker sees this as a job that demands a high fee or not, and fees also vary from model to model within each agency. So depending on which model is selected from the casting, the final model fee might vary a lot. One way to manage this better is to gather a few sample quotes from agencies big and small and from that narrow down the fee range you present to the client. Exclude the agencies who are asking for too much money or call them back to propose a more acceptable limit.

For example, let's say the response you get from one agency is that they'll expect a flat rate of $150 per hour for any model on their books. Three other agencies all request an hourly rate that ranges from $200 to $300, and the fifth agency you contact asks for a fee that ranges between $300 to $500 per hour. Now, you could go to the client and say the model fee will cost anything between $150 and $500 per hour, but this will look weak and like you weren't trying your best to manage the shoot budget. A better approach would be to work in the midrange quotes and barter to get these lowered so that you cap the limit at say, $250 per hour. You might as well offer this to the most expensive agency as well—you'll be surprised how often they'll say yes. You can then indicate to the client that the model fee budget will be up to $250 per hour for the job. This will give you room to negotiate a better fee depending on which model is finally chosen. If you can save the client some money, it makes you look good. The model fee negotiation stage also allows you to cross-check to see if your own fee is within the right range. For high-end work, model fees will be high wherever the usage includes things like poster and show card advertising. If you are clear about usage at the briefing stage, the agencies will add an appropriate usage fee to the quote.

If you aspire to become a successful fashion photographer, you will want to get commissions with the prestige or budget that enables you to work with the best models. Model agencies mostly view a job the same way you do. Is it a well-paid opportunity, or will it look good in the model's portfolio and get him or her more work? Your personal reputation will also come into play. Photographers who have proven themselves to be successful creatively gain kudos and receive favorable treatment. Model agencies are willing to supply their star models for an ordinary shoot with a name photographer because it is seen as a useful introduction and, if the photographer likes the model, could lead to more lucrative jobs.

Bookings need to be formalized with a call to the agency followed by an e-mail. The agency in turn will send you a "confirmation of booking" form, which either you or the client will need to sign. In an ideal world this should get sent out after you've made the confirmation. In reality, agencies tend to send these out in a last-minute panic at the end of the day before the shoot. This document should clearly state the agreed usage and fee, so always remember to check that the details are correct before signing or submitting to the client to sign.

Exclusive bookings

Whether a client requests exclusivity or not, shooting for a major brand may have an adverse effect on future bookings working for a competing brand. If a model has an advertising or even a PR photograph in her book shot for a client similar to the one she is seeing, it often means she won't get the job. It is something agencies take into account when pricing a job and why they're reluctant to quote too low and would rather lose a job than undersell their models. Therefore, a model with gorgeous hair might only be chosen to advertise one brand of hair product, whereas a photographer who specializes in hair and beauty won't always be restricted from shooting for competing product companies.

Model agency booking fee

When negotiating prices you'll need to take into account the model agency booking fee that will be added to the model's pay. Just about all model agencies charge a 20 percent booking fee on top of the rate agreed upon for the model. They typically take another 20 percent from the model's earnings, so in all, a third of what you charge the client for the model goes to the agent. The rate varies from country to country, with Asian markets taking between 20 and 35 percent and most Milan agencies 50 percent.

Street castings

If you can't find what you are looking for going through the main model agencies, you can always cast regular people instead to act as models. Many of the hairdressing salons I photographed liked to cast models themselves by selecting their own clients or advertising at local colleges where they would offer free hair makeovers and pictures in return for modeling for a photo shoot. On other jobs I have found it necessary to cast a wider net, especially when looking for something that's very specific or out of the ordinary. Some photographers find they prefer working with people who aren't professional models, and indeed, there are clients who claim that advertising on social media works best for them if they photograph ordinary-looking models (while also saving themselves money on regular model fees, of course).

Planning a model shoot schedule

For an all-day shoot you need most of the crew to arrive at the same time in the morning. If you are working with more than one model, you'll want them to arrive at staggered times throughout the shoot day. That way you end up paying only for the number of hours each model is actually needed. I don't know about other countries, but in London model lateness is a constant problem and not helped by the model agencies, who seem to take the view "heads we win, tails you lose." If a model turning up late causes overruns, it is assumed the photographer will absorb these costs. If a model ends up going into overtime because of lateness, they expect to be paid overtime. We constantly have to be on our guard about this, and I get my assistants to make notes of the times models arrive and leave.

To be on the safe side, it is best to start with the most experienced model first, who is more likely to arrive at the studio on time. More importantly, he or she can help get the day's shoot off to a flying start. If you are working with a new client, or a substantial amount of money is riding on a job, there can be a lot of nervousness at the beginning of the day. The last thing you want is to kick off with a model who is relatively inexperienced and consequently find yourself struggling to establish a good start for the shoot. Once you are able to show clients a strong image on the computer display, you can feel the tension lighten all round and the rest of the shoot is far more relaxed. The ideas that evolve from the first sets of photos you create can also be used to inspire and direct the models you shoot with later.

For this shot I arranged things so I could work with the model without the lighting set getting in the way and communicate more easily.

IT HELPS TO HAVE AN ASSISTANT TO ADJUST THE LIGHTING, BUT I KEEP SHOOTING EVEN IF I SENSE THE LIGHTING MAY HAVE FALLEN OFF SLIGHTLY.

SHOOTING TIPS

When you photograph a model, it can be like recording a performance. Most will have a repertoire of moves and poses they like to use, and a good photographer will be able to direct them to create the looks he or she is after. On a typical shoot a model may get into position for you ready to shoot, and once the shutter goes off switch to a new pose. A rhythm can quickly become established, where the photographer should ideally keep up with whatever the model is doing. If necessary, you may need to slow things down sometimes, but I believe it helps to maintain a synchronized flow of communication, verbal or otherwise, between you and the model. That's true not just with fashion photography but with portraits, too.

Complex lighting setups are necessary on some shoots but can be overwhelming. If you stick your subject in front of a huge array of lights and tell her she can't move an inch this way or that, it is all too easy to kill any spontaneity. Furthermore, if your subject is able to provide you with a great pose but you aren't ready or able to shoot, the moment is soon lost and the shoot will suffer. I mostly like to keep the lighting simple and flexible so that the model is free to move about. It helps to have an assistant to adjust the lighting, but I keep shooting even if I sense the lighting may have fallen off slightly. Doing so means the rhythm is maintained, and you can always fix such images later if the exposure has dropped off.

WORKING WITH CHILD MODELS

Child photography is an area photographers tend to specialize in. It goes without saying that you need to actually like kids to do this kind of work. You will need to have clearance such as a criminal record check, just as you would if applying for a job as a teacher, or any kind of work that involves young children. You also need to appreciate the constraints that apply to child photography. For example, a child model has to be accompanied by a guardian, and this applies to the casting as well as the shoot. You will be expected to pay a small fee to each child who turns up at a child casting in order to cover the guardian's expenses. There are also limits as to how many hours a child model is allowed to work. In the UK, a child performance license will be required from the local authority where that child lives, to allow him or her to work on a specific photo shoot. This is designed to safeguard the child's well-being. The license takes time to obtain, typically five to ten working days (depending on the local UK authority). Getting the license is the responsibility of whoever organizes the shoot, which can be the photographer or the client. Some child model agencies may be able to organize this for you for a small fee. Also, some local authorities are able to offer six-month work licenses to child models in their borough.

Legal definitions vary from country to country as to when a child officially becomes an adult. Whatever the law is where you live, you need to be aware of what

your responsibilities are when photographing young people. Typically, the law prohibits you from taking photographs of a minor that are deemed to be sexually exploitative. In the UK this will be age 16 or younger; in other countries as old as 18. So when a UK tabloid newspaper recently published a topless photo of a young woman with the caption "Sweet Sixteen today!" it was fairly clear an offense had been committed.

Many of the mainstream model agencies like recruiting girls as young as 14 to work as fashion models. In these situations a parent or guardian should be present, but in reality this doesn't always happen. With children, and especially teenagers, it is important to note their age at the time a photo was taken. With older teenagers you may be asked to prove that a person was over 16 or 18 years old at the time a photo was shot, and this information can also be added via the IPTC metadata. As a case in point, I know a photographer who on the opening night of an exhibition had a police officer threaten to close the gallery because he suspected one of the nude photos to be of an underage model. The photographer rang his personal assistant and got her to fax over a copy of the model release to prove the model in question wasn't a minor at the time the photos were taken. He showed this to the officer and the gallery opening was allowed to proceed.

Age restrictions apply to older age groups as well. With drinks advertising, there are industry codes of conduct not to target under-21 age groups, so the models used need to be 21 or older. Where tobacco advertising is allowed, the minimum age can be higher. If a product or service is aimed at a specific age group, the model used should be the same age. So, if you are asked to advertise a health care plan for the 50-plus age group, you would need to find nice-looking models who were in their 50s.

The Committee of Advertising Practice (CAP) is a self-regulatory body that enforces a code of conduct for UK advertisers, more specifically, nonbroadcast advertising, sales promotion, and direct marketing. The Cap.org.uk website provides information about the rules governing various kinds of photography and filming. For example, one of the rules in the section on children states: "Children must not be shown in hazardous situations or behaving dangerously except to promote safety." The US equivalent is the Federal Trade Commission, which is an independent agency of the United States government. It is responsible for consumer protection to ensure the rights of consumers as well as to promote free trade competition.

Child labor laws

A number of states in the US, in particular, California, have relatively strict laws about child labor, which govern the number of hours per day a minor can be on a set and so forth. However, the specifics vary by state.

ERIC RICHMOND

SPECIALIZATION: PERFORMING ARTS

In the current economic climate of tight budgets and arts funding cuts, it is proving harder than ever for photographers to find work and keep busy in this competitive niche market. Over the last 30 years Eric Richmond has worked as a portrait photographer mainly photographing music, theater, circus, and various other performance artists, establishing himself as one of the leading photographers in London for theater and dance photography. He was born in the US but has mostly lived and worked in Europe and currently has a studio base in Bethnal Green in the East End of London. Having assisted a number of high-profile fashion photographers in New York, he originally specialized in fashion. One day he came across an advertisement for a tattooists' convention, which inspired him to contact the organizers and arrange to take some setup portrait photos. After that he carried out a similar project where he set up a studio to photograph some of the costumes being prepared for the Notting Hill carnival. From these two personal projects he was able to build a brand-new portfolio, which got him a commission with *Time Out* magazine, which then led to him getting more regular jobs.

The good thing about *Time Out* was that it was a weekly entertainment listings magazine, and the subjects Richmond was asked to photograph were many and varied. "It gave me the opportunity to photograph lots of well-known and talented people and build a diverse portfolio," says Richmond. "It also gave me experience shooting on location and working 'on the hoof,' so to speak. Around this time I also had my own darkroom, and that allowed me to make useful cost savings and the freedom to experiment, and it meant I could turn around work very quickly. At that time I also had more of a passion for black and white, which made my work become more austere and graphic."

These days Richmond's subjects are typically music, theater, and dance. He photographs big-name artists in these fields, as well as lesser-known performers. Some shoots, such as theater posters, pay decent money, but the bulk of the work is done on an all-inclusive fee. So while advertising photographers may be able to load up their invoices with extras, Richmond is usually given a fixed amount of money to work with and has to absorb all expenditure costs. It's given him the opportunity to make a living doing what he loves best, traveling to exciting locations and working with some amazing people.

The studio he works from now is a converted ballroom that dates back to the 18th century and still retains many of the original features. It took a few years for him to get his own studio space, but the effect this has had on his standing

FIGURE 5.1 *The Wrong Size* photographed on Millennium Bridge, London.

MOST PHOTOGRAPHERS
DREAM OF HAVING THEIR
OWN STUDIO SPACE, BUT
THE REALITY IS WITH THIS
COMES THE RESPONSIBILITY
AND COSTS OF RUNNING IT.

as a photographer has been significant. "It's an impressive space to work from, and that alone makes a big difference compared to shooting in a standard rental studio," says Richmond. "I actually found it oddly intimidating at first. Most photographers dream of having their own studio space, but the reality is with this comes the responsibility and costs of running it. Overall, the best bit is the feeling of being in total control. When people arrive on a job they know they are entering your personal domain, and this immediately helps you establish your authority."

WORKING ON LOCATION

Even so, Richmond still does a number of location shoots. His early experience working for *Time Out* taught him all he needed to know about preparing for location shoots. "Location work requires good organization and the ability to work fast and deal with the unpredictable," says Richmond. "It grieves me bitterly that my assistants don't always remember to use the equipment checklist! I treat each job like a campaign—it's like a war each time you go on location. Assume that something will go wrong, double up on things, and hire extra stuff in." For example, the photograph in **Figure 5.1** was shot on the Millennium Bridge by the Tate Modern. This particular shot required a lot of coordination—getting all the artists to the location, setting up, dealing with passing tourists, planning to get the timing right to capture the scene at dusk, and most of all good luck with the weather.

Dane Hurst/Rambert Dance

Foreign travel requires even more preparation. On a trip to Cuba to photograph a record cover, Richmond visited the Cuban Consulate in London, whose staff members were extremely helpful in sorting out permissions and the like. On arrival in Havana he had prearranged to hire a local person as his guide, who, as it turned out, was a doctor needing to earn some foreign currency. As Richmond says, "If you don't know the country you are visiting or don't speak the language, it is really helpful to hire someone local on your behalf. On a trip to India I decided to hire the lighting from a local studio, which included a team of assistants. However, sometimes you can have too much help, and I felt it best to pay most of them off to keep everything more manageable." Such trips are in decline now. The current global economic situation has resulted in

clients tightening their budgets. In addition, technology has led to photographers everywhere getting attention. Richmond says, "Some really interesting photography is now coming out of China, which would previously have gone unnoticed. Whereas once I might have been commissioned to travel to say, Buenos Aires, to do a shoot, there is now, thanks to the Internet, more chance of finding suitably talented photographers who work locally. So they are now getting the jobs instead."

Of all the clients Richmond shoots, he has the most respect for the dancers (dance photography is a good third of his work). "It's because of their dedication and ability to endure a lot of pain, work long hours and total lack of vanity. From the early days it was interesting to note the response dancers have when looking at a Polaroid or a screen image. Most people will look with a critical eye. Dancers, on the other hand, are invariably less concerned with how the lighting looks and are only interested in getting the line to look right. They are better able to critique themselves and trust the photographer to do their job."

PREPRODUCTION WORK

When preparing for a portrait session, Richmond's advice is to appreciate that it's all about the person you are shooting. Subjects will always be flattered if you can show you've done your homework and are able to talk about things that interest them. "Wikipedia and Google are the photographers' friend," says Richmond. "A quick online check should provide you with enough information about the person you are photographing to initiate a conversation that can help build a rapport. People are always flattered—it doesn't matter how big you are. It can make someone totally accessible. Even well-known people can be inhibited. My job is to deinhibit and relax them—that's key. It also makes a difference when I am shooting in my studio, I am the boss, I'm older and more confident, and it grants me a certain amount of authority. On location you don't always have that."

With the exception of theater work, Richmond is either art directing or collaborating in the art direction with a designer or art director. With the dance and music, he does most of the art direction. "A dance piece may not even have been conceived of yet, let alone rehearsed," says Richmond. "You have to come up with a visual representation and often an iconographic approach to represent the idea. So often they get something they weren't expecting at all. The magic can happen on the day from the collaboration. Other times I'll approach a client with an idea."

So how does Richmond keep control of his work? "A good tip is to Google yourself to check for unauthorized usages," says Richmond. For example,

A QUICK ONLINE CHECK SHOULD PROVIDE YOU WITH ENOUGH INFORMATION ABOUT THE PERSON YOU ARE PHOTOGRAPHING TO INITIATE A CONVERSATION THAT CAN HELP BUILD A RAPPORT.

you can go to the Google website and upload one of your images. This kind of search will show any photos used on the Internet that match your image. Richmond adds, "You might be surprised at what you'll find. Possibly umpteen unauthorized usages of your photographs. In most cases these aren't commercial usages. Some people may be using them on their blogs, but even so it would be nice for them to at least ask permission." Where the usage is commercial you can push for a fee payment. Richmond cites an example of a client who commissioned him to shoot a picture for a dance festival in Torino. The design company then used the same image when designing the cover of a catalog for the Cultural Olympiad. In that instance, his agent helped secure a compensatory fee payment.

Angelina Treva

The Gogmagogs

Richmond is surprised that commissioners are not better tutored about image usage. "Predigital this was not such a problem," says Richmond. "Now everything has expanded to such a degree, and it is surprising that commissioners in London don't always understand copyright ownership. The very ubiquity of images is a problem now, and in terms of commercial use it happens all the time. The digital technology does make it easier these days to shoot under trickier environments on location—there are no horrible surprises. But you can't go back. The only time to shoot film now is for nostalgic reasons, such as when I was on a recent holiday trip to Egypt. But digital throws up problems of authenticity and what is a true photo now. With the work I produce, it is usually just cleaning something up rather than introducing something into a shot."

Richmond's advice to young photographers is to be culturally aware of what is going on around you. "We live in a world saturated with images. They should ground themselves in other art forms. Look at paintings, read, look at the culture at large. Photography is meaningless without a context. I freely acknowledge it's very difficult, given the number of choices there are right now."

Video interview with Eric Richmond.

Eric Richmond Photography
Ericrichmond.net

In the UK, "personality rights" exist, which are the rights of individuals to control how their likeness is used commercially. These are considered property rights that can survive the death of an individual. For example, you can't take a photograph of someone (well-known or not) and use it without permission for commercial purposes, such as a product endorsement. In the US there is a "right of publicity," although this is governed by state law and varies throughout America. In most states the right dies with the person (that is, the estate of a deceased individual has no rights to the likeness of the individual), but there are notable exceptions, such as California (where there are lots of celebrities) and Tennessee (where there will forever be Elvis). In the UK, photographs of well-known people can sometimes be used in an advertising context, if used humorously and in a way that does not imply they are actually endorsing a product.

These laws are knowingly flouted in political campaigns, although in instances where an ad is regarded as distasteful, it will be in breach of advertising guidelines. In the US, commercial use almost always requires permission.

PHOTOGRAPHING CELEBRITIES

The insatiable public demand for celebrity news means there is also a strong demand for photographs. However, most of these are sourced from paparazzi stock to fill the magazine intro pages, gossip columns, and online magazine sites, plus there are celebrities who are putting their own photographs up on social media. Meanwhile, in the music industry, the latest dSLR cameras can capture high-quality photographs using stage lighting to the point where photos captured at a concert are replacing the need for studio-commissioned shoots. Elsewhere, professional setup shoots are still commissioned, and it is one area of specialization where only those with the right experience and the necessary skills will get commissioned. It's not a market that amateurs and newcomers can readily infiltrate.

EDITORIAL INTERVIEWS

If you are starting out as a portrait photographer, you'll find picture editors who try out new photographers on profile interviews, most likely on small jobs at first. Some picture editors use a regular column like the "A Life in the Day" feature at the back of the *Sunday Times* magazine as a testing ground for new photographers before deciding to try them out on bigger jobs. In recent years, the celebrity interview has become something of a cliché. The thing to bear in mind here is that editorial magazine interviews usually happen only when the celebrity in question has a new film, album, TV show, or book out and their publicity team requires them to be available for PR promotional work. Stills shoots are an obligation that some embrace willingly and enjoy, while others do so grudgingly. For example, whenever a major new film is released, the actors and director will be contracted to do a worldwide promotional tour to promote the movie. This will mean doing one red carpet event after another in different countries, preceded by a press call where selected magazines and TV and radio stations are each given their slot with the stars to do an interview and take photographs. In such situations the photographer is left with whatever time is available after the interview to get the shot before the next interview is about to begin.

So the celebrity is often a reluctant participant. While celebrities may be inclined to give a journalist a tough time, they are usually more easygoing when it comes to being photographed. Most of them will be concerned enough about their image to make sure the photographer gets a good shot. The challenge is to break away from the standard PR shot and to create something more distinctive. The good celebrity photographers will be on the lookout for something that gives the photo an edge, through the photo technique they use, a particular location, or the use of props.

The easiest people to photograph are either those who are just starting out or established artists. The most difficult are usually those who've had a small taste of fame and it has gone to their head. And then there is the entourage accompanying

the celebrity you sometimes have to deal with. Or, there may just be a press handler accompanying the star. Either way, you'll often have to negotiate your way past the in-between people in order to do your job. On a regular promotional shoot you may be told you have just ten minutes, because your allotted time will ultimately be limited by the fact there are other photographers and journalists waiting their turn to inter-view and take pictures. Therefore, if you intend using a portable studio, you'll need to have everything set up, have done a lighting test, and be ready to start shooting the moment the artist arrives. If you are given a decent space to set up in, such as a hotel room, and allowed time to prepare, you'll be able to do something more elaborate. Otherwise, keep it simple and don't let technical considerations hold up the limited opportunity you have to shoot. Plan A should be to capture something reasonably safe in case you really don't have any time. Plan B should be to push the boundaries to get that special shot.

COMMISSIONED SHOOTS

Portrait photography can be commissioned directly for magazine features, film, TV, theater, or record company clients. You'll need to have established a reputation for doing portraits or have worked as a fashion photographer to be considered for these kinds of jobs. Here, the artist will often come to a studio or hired location, rather than you having to work out of a hotel suite or conference room. For these types of jobs you can usually expect to have more time to spend with your subject and more opportunity to fine-tune all the important details like hair, makeup, and wardrobe and not be so rushed taking the actual shots. That's not to say these types of shoots are any easier to do than interview call setups, but they do usually give photographers more opportunity to work with the talent and get the shots they are after.

These types of commissions carry more responsibility. With some subjects it's tricky for clients to get access to the subject, which may be limited, so clients have to feel comfortable that they are making the right choice when they hire a photographer to do a shoot, especially for something like a film poster, where there is a lot riding on the outcome. So it is an area you have to specialize in to be taken seriously and given the chance to carry out such jobs. The person who is being photographed may have an opinion, too, about who they want to be photographed by and might veto being photographed by a relative newcomer. The top portrait and fashion photographers can be regarded as celebrities in their own right—consider *Vanity Fair* contributor Annie Leibovitz. Building that kind of reputation can certainly help in getting access to the best jobs. However, the industry is now dominated by publicists, which is making it ever harder for the photographers (and their subjects) to work together creatively. Despite these restrictions, there are still photographers out there who are producing strong work.

KEEPING COPYRIGHT

When photographing celebri-ties, it is important to keep your copyright of the photographs. If you care about your reputa-tion, this gives you full control over how the images are subse-quently used. If this right is used responsibly, it also allows you to build trust with your subjects. If you sign away the copyright to a magazine or newspaper, then it will be free to use your images in any context it likes, including negative stories about the per-son you photographed.

KEEP IT SIMPLE AND DON'T LET TECHNICAL CONSIDERATIONS HOLD UP THE LIMITED OPPORTUNITY YOU HAVE TO SHOOT.

JILLIAN EDELSTEIN

SPECIALIZATION: PORTRAITS AND REPORTAGE

Jillian Edelstein is a London-based portrait and reportage photographer. Her home country, though, is South Africa, where she initially trained in sociology and worked in social services for the National Institute for Crime and Rehabilitation of Offenders. This took her into townships where she would work with offenders, ex-offenders, gang members, and people evicted from their homes affected by the group areas act. The people she encountered through her work were also her first subjects. Edelstein went on to become a press photographer, working under phenomenally stressful conditions. "The work was very varied. I would go from fashion shows to townships to nighttime cricket events to photographing somebody arriving at the airport. Fitting all that in within the press photography model proved to be an incredibly tough training ground," says Edelstein. She also assisted a commercial photographer and a fashion photographer, which taught her lighting and working with medium-format and large-format cameras, plus darkroom printing.

Edelstein decided she needed to study photography properly and chose to attend the London College of Printing (now known as the LCC), which had just started to run a photojournalism course. Given that she had already won local awards, plus an honorable mention in the World Press awards, the transition of going back to college was difficult. "The thing is," says Edelstein, "once I

I WOULD GO FROM FASHION SHOWS TO TOWNSHIPS TO NIGHTTIME CRICKET EVENTS, TO PHOTOGRAPHING SOMEBODY ARRIVING AT THE AIRPORT... FITTING ALL THAT IN WITH THE PRESS PHOTOGRAPHY MODEL PROVED TO BE AN INCREDIBLY TOUGH TRAINING GROUND.

Rand Agricultural Show, photographed for the *Rand Daily Mail*, 1982.

Picture Post photographer Bert Hardy, with editor Anne Scott James.

had already been working as a press photographer, to suddenly go back into studying was very hard. I almost had to come off the adrenaline rush I had been addicted to."

The work of David Goldblatt was a big influence, as well as that of Robert Frank, Richard Avedon, and Irving Penn. Her own approach to portraiture depends on a number of circumstances. "I try to read quite a bit. If I can do a recce [reconnaissance] I do that," says Edelstein, "and if I can talk to the person I will. If you have a relationship with someone before the shoot, you may pick up on something that they can bring to the shoot—maybe a prop or something that sparks their imagination and which then becomes mutually cooperative and so much a two-way process." Edelstein is most interested in team projects and has never been formulaic. "I work very much with that person and what it is that interests them," says Edelstein. "With celebrities it's more of a minefield. They may want to check you won't use an image in a way afterwards that is going to reflect badly on them. I have been on a shoot and unexpectedly been asked to sign something. Mostly that happens with high-end portraits."

IF YOU HAVE A RELATIONSHIP WITH SOMEONE BEFORE THE SHOOT, YOU MAY PICK UP ON SOMETHING THAT THEY CAN BRING TO THE SHOOT—MAYBE A PROP OR SOMETHING THAT SPARKS THEIR IMAGINATION AND WHICH THEN BECOMES MUTUALLY COOPERATIVE AND SO MUCH A TWO-WAY PROCESS.

Publicists often set boundaries that a star might choose to break. When photographing Daniel Day-Lewis in Dublin for the *New York Times* Magazine, Edelstein was told she would have only one hour at the most and would definitely not be able to go to his house. Says Edelstein, "Instead, the session went on for seven hours, and I ended up doing an incredible portrait of him on the grounds of his home. He was very relaxed and defied the publicity thing; it was a completely more relaxed experience than I thought it would be. He was very generous and delightful. Also, when photographing Woody Allen at the Gritti Palace hotel in Venice, Woody was chilled and would have gone on longer, but for the press person who cut the time she had with him to take photographs. That has happened a number of times." An example of this was when Edelstein photographed Leonard Cohen with Sharon Robinson, his collaborating songwriter. Cohen's agent was furious with her coming along not just once in London, but again in Paris, to photograph his client. Says Edelstein, "Leonard Cohen is a

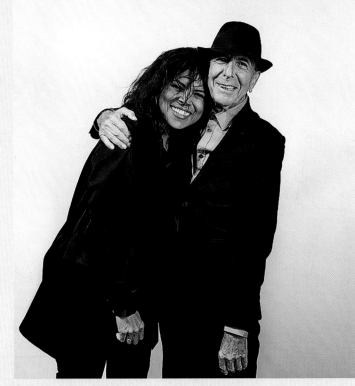

Sharon Robinson with Leonard Cohen, shot for the *FT Weekend* magazine.

man almost in his 80s and about to give a major performance. So it was under-standable—the agent was just being protective."

Most of her experiences have been very positive. "At worst I'll get a credit that says Julian instead of Jillian. That's happened fairly regularly," Edelstein says. "Fan sites are a problem, especially with the photographs I have taken of high-profile actors, such as Helena Bonham Carter. People just download and use them on their sites, which is upsetting."

TRUTH AND RECONCILIATION HEARINGS

In 1996 Edelstein returned to South Africa for a family wedding. While there she watched scenes from the Truth and Reconciliation Commission, which was set up to help remedy the effects of apartheid and which was covered every Sunday evening on South African television. On her return to London she put together a proposal to Kathy Ryan at the *New York Times* Magazine, who agreed to send her out there to cover events. On that first trip she was com-missioned to photograph Nelson Mandela (who at that time was president). She also took photographs at commission hearings and was assigned another trip from which the *New York Times* ran a huge spread. From that point on Edelstein was gripped and decided to make further visits to cover more of the hearings. These later trips, which were made between 1997 and 2001, were mostly funded by her. "I was going back and forth about four to five times a year," says Edelstein, "returning to London to carry out commissioned work." The hearings took place all over South Africa. She was allowed to set up make-shift studios in rooms next door to where the hearings were being held. Other times she visited people at home, from white suburban areas to the townships.

"There were omissions, but I managed to get most of the important people," says Edelstein. "Some of the experiences I had were filled with poignancy, pathos, peculiar and strange." In the case of white supremacist Eugène Terre'Blanche, Edelstein knew he was due to appear in Mafeking in the Northern Cape. She set up a makeshift studio outside and tried to find someone con-nected with him. "He was actually very difficult. The night before I had been talking to a set of media people from the South African Broadcasting Corpora-tion, and we discussed how Terre'Blanche would brush his hair over the top of his head because he was balding. So I had this idea in my head that I would ask Terre'Blanche to let me photograph him from behind. The next day I did these very strong portraits of him, and there was one on 5 x 4 Polaroid where it literally looked like the Polaroid had started to burn at the edge. And later I said to him 'So, Mr. Terre'Blanche, do you think you could turn around?' And it was quite terrifying the way he looked at me and said (in Afrikaans), 'Ek is

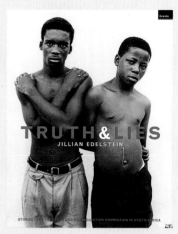

Truth & Lies, published by Granta.

SOME OF THE EXPERIENCES I HAD WERE FILLED WITH POIGNANCY, PATHOS, PECULIAR AND STRANGE.

TRUTH AND LIES VIDEO

On the book website is an extract from the video interview I did with Jillian Edelstein, in which she discusses photo-graphing the Truth and Recon-ciliation Commission hearings.

nie moffie!' which is hard to translate, but the literal translation is, 'I am not a homosexual.' I had no idea what he was thinking; it was such a mad response. Some experiences were very scary. There were five members of the security police who as a group had a power, but as individuals they were weak. They were called in to the Pretoria hearing. They had gone into a suspected African National Congress member's house and killed him and his wife and left their child alone overnight with the parents' bodies. That was a very tough story.

Nelson Mandela, photographed on his veranda at Tuynhuis, Cape Town for the cover of the *New York Times* in 1997. The use of flash was strictly forbidden because of retina damage to his eyes from working in the quarry on Robben Island.

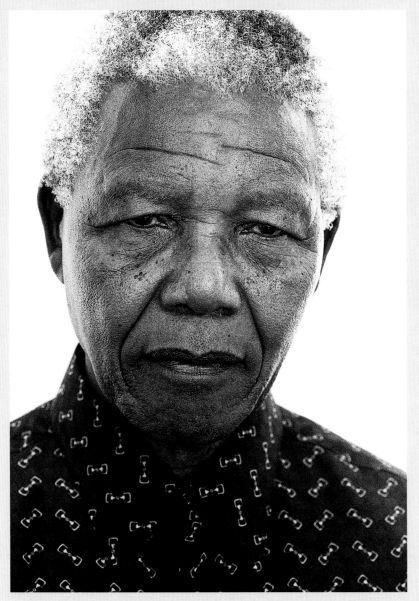

Some very close colleagues were beset with all kinds of medical conditions. One had double pneumonia, another a breakdown, another two heart attacks. But I was lucky. I could leave and could go away and come back again."

Edelstein worked with her editor, Liz Jobey at Granta, who got her to write for the book as well and suggested she return to South Africa to capture some contextually based images. When these were placed alongside the portraits of the perpetrators, victims, and exhumations, they made it a more rounded project. The book, *Truth & Lies*, was published by Granta in 2002 and accompanied by an exhibition held at the AOP Gallery, London. The photographs have more recently been shown at exhibition spaces and galleries in France, Cape Town, China, New York, and Germany.

Video interview with Jillian Edelstein.

NEW TECHNOLOGY

Digital technology has had a huge effect on the way Edelstein works. "For the last five years I have been sort of on this giant learning curve," she says. "I think we all have, and there has been some form of osmosis to match this new digital world. My old world was film, loading 4 x 5 film in a darkroom bag. Projects where I would use black and white positive/negative Polaroid, wash the negatives in a bucket and hang them up to dry. It's very different and challenging and I'm mostly concerned about how to make the digital work not look digital—that's been my big ambition. I still shoot with film. Not a lot, but I still feel it's important to keep a handle on it."

In this fast-changing world there is much that established photographers have to keep up with in order to stay ahead. I asked whether she uses social media. "I do, I think it's essential," says Edelstein. "I have to do Twitter and Facebook, and I am mindful of the fact this is an era that commands and demands self-publicity. I've never been good at that, but you have to, you have no choice. Somewhere, somehow if you want to have some kind of profile, you have to keep up. Those of us who are more versed in the film world have to take on the fact it's fair play now, so we've got to take the social media world on. What I like about social media is you have a chance to write and comment on your work, and I enjoy writing."

"Where photography is headed is a very good question," says Edelstein. "I think the good thing is photography will continue to be sought after—alongside painting—and people will always want to buy original photography. Since we've got to the point where photography has been commodified, it's become much more competitive. Everyone has a camera now. It's harder to have your voice heard because you are under pressure to keep producing the goods, and I think that's the biggest challenge."

IN THIS FAST-CHANGING WORLD THERE IS MUCH THAT ESTABLISHED PHOTOGRAPHERS HAVE TO KEEP UP WITH IN ORDER TO STAY AHEAD.

Jillian Edelstein Photography
Jillianedelstein.co.uk

© David Hiser

GREG GORMAN

SPECIALIZATION: CELEBRITY PORTRAITS

For as long as Hollywood has had a movie industry, it has attracted talent—not just future movie stars but creative artists such as photographers. Greg Gorman's career as a celebrity photographer has entailed photographing just about every famous movie star you can think of. He has had exhibitions all over the world and published books that feature his commercial and personal work. One of the most recent, *Framed*, features the best of his photographic work for the l.a. Eyeworks company. Gorman's early years were spent in Kansas City, Kansas, a place far removed from all the glitz and glamour of Hollywood. He first became interested in photography when in 1968 he borrowed a friend's camera to take photographs at a Jimi Hendrix concert. Knowing nothing about photography or lighting, Gorman was told if he shot Tri-X with the camera set at 1/60th second at f/5.6, he'd probably get something. The following morning he went to his friend's home, where they processed the film. "When I saw that first print come up in the developer on this white piece of paper, I was pretty much hooked," says Gorman.

Soon after he studied photojournalism at the University of Kansas, where he spent two years. A friend then suggested he study film. "My parents divorced when I was quite young," says Gorman. "My father had moved to LA and I really quite liked LA, after Kansas City, which was kind of a big jump. So I decided to pursue my education at the University of Southern California and ended up getting a master of fine arts degree in cinematography. However, I soon realized I was too much of a control freak to work in the motion picture business. I liked being in control of my subjects and having the one-on-one communication with the people I was photographing. At the same time a lot of my neighbors were television actors and movie people who always needed pictures taken. So that is how it kind of all got started. I was doing head shots for $35 per day, including film and processing, and I printed everything in a tiny darkroom using the kitchen of my single apartment."

Music was a big influence. "I spent the first summer in Los Angeles going to rock and roll concerts every single night," says Gorman. "And for a kid from Kansas City, seeing every major group you had ever listened to in your life, live in small venues, was pretty extraordinary." His early work consisted of photographing album covers, such as Leon Russell and his wife, Mary (*The Wedding Album*) and the Byrds. He was also lucky enough to get some big movies under his wings, such as *Scarface* with Al Pacino and *The Big Chill*. "*Scarface* kind of established me in a certain niche that few other photographers had back then," says Gorman, "and

I WAS DOING HEAD SHOTS FOR $35 PER DAY, INCLUDING FILM AND PROCESSING, AND I PRINTED EVERYTHING IN A TINY DARKROOM USING THE KITCHEN OF MY APARTMENT.

that was my ability to get along with difficult talent and big stars who can often-times chew you up and spit you out. A lot of what came out of those early days was the recognition factor that I could get in there, get the pictures, get along with the talent without disrupting the production of the movies, and deliver the goods. I would say my big break came when I was hired to shoot the motion picture campaign for *Tootsie*. It so happened that Dustin Hoffman, in his role as Dorothy, had been promised by the director Sydney Pollack a day where he could become famous and do whatever he wanted. Dustin said he wanted to do a day where he shot magazine covers with me [Gorman appears in the movie playing himself] and asked, 'Who do you know that could come down and do a maga-zine cover with me as Dorothy?' So I called Andy Warhol, who was right down the street from where we were filming in Union Square. And Andy, being a true

Michael Jackson, photographed in Los Angeles, 1987.

celebrity monger, agreed to come down and pose with Dustin. At the same time, in his diaries, I was mentioned as having cheated Andy out of his day rate, which is kind of hysterical, because it was never even discussed."

We probably all have certain preconceptions about Los Angeles and how the Hollywood movie industry works. As Gorman points out, "Most people, unless they are complete fools, can learn the technical part. How you apply it and how your style evolves, that's another story. I think a lot has to do with being a good shrink or psychologist. That combined with a good sense of lighting and direction. In my own case it's really my propensity to deal with people—to come up or down to their level. To make them feel comfortable and confident in front of the camera. Being able to garner and win people's trust has been a huge part of my success." However, the industry has changed massively in recent years. The opportunities to build intimate partnerships between talent and photographer are challenged by the rise of publicists who increasingly control shoots.

Kim Basinger, photographed in Los Angeles, 1986 for *Interview* magazine.

Says Gorman, "It's tenfold worse. I mean, it's hideous now, and one of the reasons why I don't shoot so much now in that realm. You've got makeup artists and stylist and hairdressers, even sometimes a nutritionist, who will travel with the talent. This is in addition to managers and sometimes the directors and producers. In some cases the talent have even relinquished photo approval to their agent or publicist to make the kills. And what do they know about the photo session, what my intentions are, what's in my mind, or how I perceive what I want to see published on a page as an interpretation of my vision? You've now got a whole wagon train of people that follow these celebrities around basically making all the decisions for them, plus someone sitting at the sidelines letting you know what the talent will and will not subject themselves to. It takes a lot of the creativity and fun out of it—they are like catalog shoots. I shot once with Steven Seagal for a *GQ* cover. He came in, we had lunch and everything. We went down to the studio and there was this person with him and I couldn't figure out who he was. Finally, I turned to Steven and asked, 'Who is this guy?' And he said, 'Oh, he's my lighting director.' I said, 'Really?' and handed him my camera. Steven said, 'What is that for?' I said, 'Well, if he's going to light the picture, he might as well take the picture.' Steven was cool with that and got the message. The only relationships that really last today are those where there is trust between the talent and the photographer, and which exclude all the periphery."

All this is in sharp contrast to the kind of work that helped Gorman first establish his name and career. As Gorman explains, "*Interview* magazine would call me up and ask if I wanted to shoot Kim Basinger and I'd say, 'Yeah, I think she is great.' 'Well, here's her phone number, give her a call and organize a date and take some pictures. We'll need a cover and six pages.' I would book the makeup, the hairdresser, the wardrobe stylist, find a home or location where we could shoot, and go out and take the pictures. I'd pick five or six photos and send them to the magazine. That's how it worked."

A big difference between shooting fashion and shooting portraits is that unlike with models, when you photograph a celebrity they generally aren't being paid to be there. Says Gorman, "On an editorial shoot they'll only want to wear the clothes by designers they like, or work with their hair and makeup people. I think once you've established a relationship with talent, one that breaks through that comfort zone and that level at which you have better communication, they trust you. You know what their better angles are and you know what sort of light to shoot them in and what sort of lenses to use. So you come into the shoot with a lot of the checklist already checked off and start off up the ladder quite a bit higher than you would do just walking in blank. If we're dealing with an image change and the artist wants to go in a different direction than they've been perceived before, we'll have meetings beforehand.

YOU'VE NOW GOT A WHOLE WAGON TRAIN OF PEOPLE THAT FOLLOW THESE CELEBRITIES AROUND BASICALLY MAKING ALL THE DECISIONS FOR THEM, PLUS SOMEONE SITTING AT THE SIDELINES LETTING YOU KNOW WHAT THE TALENT WILL AND WILL NOT SUBJECT THEMSELVES TO.

IT'S NOT JUST ABOUT A
GREAT PHOTOGRAPHER, OR
ABOUT GREAT TALENT AND
A LOUSY PHOTOGRAPHER. IT
IS A TWO-WAY STREET AND
TAKES BOTH PARTIES TO
MAKE A GOOD PICTURE.

If I don't know the talent I do spend time during the hair and makeup process, sitting in there, studying their face while I am having a conversation with them. Kind of looking at what I might want to play up with the highlights, what I might want to play down in the shadows. Ultimately, I will have a better understanding and assessment when I get them in the studio, to know where I want to begin so we have a reference point. It also allows them to chill with me, so that we get a bit of a rapport going before we do the shoot.

"I have always made a point to try not to formulate any opinions before going into the studio to shoot and just kind of let everything unfold on its own. Sometimes you will have heard this and that about a person, but you don't know if that person got laid the night before, or had a fight with their wife or partner. You just don't know their frame of reference. You know, we've all been in situations where we've been agitated, or something weird has happened and then we have had to go to that next level to do something outside the realm of where our mental state is at that point. It's not a given when somebody walks in what they are going to be like." Other times, the publicist can hold a shoot back, or it may be simply nervousness on the part of the talent. Says Gorman, "The worst moments are when you either realize the person has an extremely false sense of reality in terms of who they are and what the hell you can possibly do. Or, they see themselves in another light, meaning they won't give you what you want and won't open up. You know, they can sometimes be very closed down. Then it gets difficult. I share my vision with the people I shoot—they always get to see the pictures I take. So it's not like I am withholding. But you know, it's not just about a great photographer, or about great talent and a lousy photographer. It is a two-way street and takes both parties to make a good picture."

BOOKS AND WORKSHOPS

Gorman describes the books he has produced as being a labor of love. "It's always been nice to have a current project. I think if anything, it leaves a legacy and also pushes your credibility to a certain degree. I am currently finishing a new book about Southeast Asia. This originally started when I did an Epson Stylus Pro tour for the Epson Print Academy with Dan Steinhardt. The deal was that we would have time off where we could both go out and take photographs. Dano would photograph the more colorful, iconic scenes and I would go out and shoot the horror stories, because I am always more interested in the down and dirty. So it was kind of wild. We would go to strange places throughout India, China, and Malaysia, and I'd be shooting the eunuchs, drug addicts, and street stuff and have an amazing time. I was very nervous doing it, because ironically, you can put me in the studio with the most famous people in the world and I'm

right at home. But put me on the street with a camera in a foreign country with foreign people and I'm a nervous wreck. It took me a long time to get semi-comfortable. Like anything, the more you do it the little bit more relaxed you get. The kickboxing stuff came a little bit later and was a lot easier, because this was an organized project Steve McCurry got me involved in. For that, we had organized producers, a driver, and a fixer who would go with us on location plus a translator. So it was a challenge to me. I'm not sure I would do another photojournalism book, but I feel it was an important one to publish."

The Mendocino photography workshops Gorman runs all started after he attended a digital printing workshop given by R. Mac Holbert and Jonathan Singer at Anderson Ranch in Aspen, Colorado. Gorman loved the format and hands-on approach and was inspired to do something similar himself. "I thought if I could impart what wisdom I had learned over my 45 years as a photographer and couple it with some digital stuff, food, and wine, then I could create my own workshops. Also, doing them up in Northern California would give people a kind of unique experience with me in the Mendocino highlands for a week. It's amazing. I love it and have been doing them for a long time now."

Outside the Studio book published by Damiani editore, Bologna, Italy.

Buddhist, Angkor Wat (2007).

DIGITAL TECHNOLOGY

Gorman has long been involved in digital technology and evangelized the benefits of digital. From a very early stage he forged friendships with the software engineers who were creating these tools and various digital imaging experts. As Gorman explains, "It was great when I started in the digital world, because I was not sure how that would all go. They all kind of wanted to be Greg Gorman and I wanted to kind of be like them and learn how to do all that stuff, so the mutual admiration society worked very well for me. It's changed a lot now, though—it's gotten so advanced. In the early days everybody kind of helped each other and it wasn't as cutthroat as it's getting now."

Johnny Depp, photographed for the *Pirates of the Caribbean* movie (2003).

It is certainly all very different from the early years, where the negatives would come back from the lab and you'd mark the contact sheets up and were at the mercy of how dark the lab wanted to print and what contrast paper it would print them on. "Today, all that is in my hands," says Gorman. "I make all the prints myself on the paper and substrates I choose to use."

On the other hand, digital technology has also created more problems. "They still haven't been able to figure out the storage issues," says Gorman. "There are just no solid storage solutions. I've been through three different setups, and none of them have worked. It just keeps going on and on, with me trying to find a good system that will last forever. And who can afford to buy another $20,000 system every time you've got to upgrade your archive of files?

"Digital has also consumed my life completely. Everybody enjoys that instant gratification and at the same time takes it for granted they can have everything in 15 minutes. It's really created a tremendous tie-up in terms of the communication and time it takes to get things done and how much more time has to be devoted to this incessant, instant need." As for what can now be done digitally, here, too, Gorman reckons there are pros and cons. "I think it is incredible. What we can do today is extraordinary, and it's so exciting to see the face of traditional photography change. By the same token, you go to photo shows and see these big, boring pieces on the wall that are medium format, that are sharp, but say, mean, and deliver nothing. They're no longer photographs because they've been manipulated so much. You can't even put it in the realm of photography. I think the world of photography is in many ways looking up and in many ways looking down, because with the onset of eBooks and all the online options, the magazine and book industry is dying. I mean, I don't want to look at someone's photographic book online. I don't want to look at a book on a computer. Maybe to read a book, but not to look at somebody's art. I want to hold the book or magazine. I want to turn the pages and see the photographs. Maybe I am old school, but that's really how I feel. I think from that point of view the world of digital and the world of photography is suffering.

"However, the world of the gallery and fine art photography is still very much alive, and the big galleries will argue their business is thriving. In my classes I teach how important it is to maintain control, plus how important layout and design are and how this influences how your work is perceived. This is true with my work, which a lot of times can be considered controversial, especially some of the male nudes. If it's not handled and exposed properly in terms of how it's given its life through a continuous set of images and how they are laid out, it can be misinterpreted or shown in the wrong light. It's so critical. You don't realize how everybody is going to have a different vision of who you are and what you are all about. It's your job as an artist to see it finalized from start to finish so that it represents exactly who you are."

YOU GO TO PHOTO SHOWS AND SEE THESE BIG, BORING PIECES ON THE WALL THAT ARE MEDIUM FORMAT, THAT ARE SHARP, BUT SAY, MEAN, AND DELIVER NOTHING.

Greg Gorman Photography and Mendocino Workshops
Gormanphotography.com

6
PHOTOGRAPHING ON LOCATION

TRAVEL PLANNING

Most of us like to travel, and to have the opportunity to combine this with work is one of the benefits of being a photographer. What can be better than to travel the world with all expenses paid? The travel aspect can be fun, but once you leave the studio or home ground, there is always a greater chance of things going wrong as you attempt to work in unknown territories. For those who aren't fully prepared, it's all too easy for problems to spiral out of control. Maybe the best way to look at it is, exploring new environments is all part of the adventure.

The key thing you need to realize is that different places will have different levels of risk (and opportunities), and you need to at least be aware of what those are before you set off to take photographs. If you are a photojournalist covering world news events, your travel itinerary is unlikely to meet the approval of government travel advice websites—visiting risky or dangerous locations is all part of the job. Photojournalists are undoubtedly very brave doing the work that they do, but such bravery is based on accumulated knowledge and experience to reduce, where possible, the level of risk to themselves as well as their fellow journalists.

Photographing certain types of subject matter, such as covering extreme sports, also entails risk. But for all types of location photography, it makes sense to measure the pros and cons of any particular assignment and to do your homework.

Looking back over my own career and that of my colleagues, I have seen clients choose unnecessarily tricky locations to do quite basic catalog-style photo shoots. As nice as it has been to travel to these interesting and exotic locations, on some jobs it would have been more productive to have gone to a location more accommodating for such types of work, such as Cape Town or Miami.

IF YOU ARE A PHOTOJOURNALIST COVERING WORLD NEWS EVENTS, VISITING RISKY OR DANGEROUS LOCATIONS IS ALL PART OF THE JOB.

ROAD TRAVEL

For any road travel that's connected with your business, you are allowed to deduct the cost of running a car by calculating the mileage used for business purposes. You will find there are standard mileage rates that are applicable for business use, and these apply to all cars regardless of make. There is an app called Mileage Log+ that can be used to track your mileage over time and is IRS compliant in the US when used to record expenses. If you're not going to deduct your mileage costs on taxes, you'll want to make a note of mileage associated directly with any jobs so that you are able to charge the client for mileage expenses.

AIR TRAVEL

With air travel one of your main concerns will be how to transport your photographic equipment. Most airlines allow you to carry at least one baggage item, big enough to stow a limited range of cameras and lenses. Providing the bag fits the maximum allowed dimensions and you are able to lift it into the overhead bin, you'll be fine. However, if you economize and choose to fly using a budget airline, your options will be strictly limited. The rules regarding how much luggage and weight you can carry individually may make this impractical. With some budget airlines, there is not even an option to pay for excess luggage; you may be restricted to just 18 kilograms (a little less than 40 pounds) in total, which, when you consider the weight of a typical suitcase is 6 kg (around 13 pounds), doesn't let you carry much. If you are traveling with an assistant, or other members of a team, you can always split the camera equipment transported as carry-on luggage between you.

There is also the question of insurance and whether your luggage is fully covered. On a recent trip to South Africa, I took all my cameras and lenses as carry-on luggage, but the less expensive items, like battery rechargers and lens filters, went in the main hold. On the return leg of the journey some of these items went missing. It was only then that I found out I wasn't insured, as these were only covered as carry-on items. So check to make sure your travel insurance covers any equipment that's not carried by you personally. You also need to make sure you have adequate coverage for the type of traveling you are doing and the specific countries you intend to visit. When you renew your insurance, separate the photo equipment items you are likely to carry with you on trips and insure just these items on a continual worldwide policy. Items that never leave the office or studio, like the office computer, can be grouped separately and need premises insurance only.

Most of the main airline companies offer reasonable carry-on baggage limits as well as decent checked luggage allowances, and if need be you can pay for extra items. To transport items like stands and tripods, you might want to consider carrying them in a golf bag or some other type of sports bag. This is because sports luggage items sometimes have lower excess rates compared with regular luggage. If you travel

Mileage Log+ app
(Contrast.co/mileage-log/).

ATA CARNETS

Use the following links to find out more about ATA carnets.
Merchandisepassport.org

Iccwbo.org/chamber-services/
trade-facilitation/ata-carnets/.

business class you'll usually be given a more generous baggage allowance, plus flexibility with your choice of flight times. When you are working on an unpredictable schedule with the possibility of overruns, this is something to consider.

ACCOMMODATION

Fare aggregator websites such as Expedia and Travelocity can make hotel booking easy, and review websites such as TripAdvisor provide useful information based on customer experiences, which can help you find suitable accommodations. Prices will vary depending on how prebooked a hotel is, whether there are any special discount offers available, and when you wish to book. With editorial shoots the magazine will most likely organize the flights and accommodations and take advantage of reduced-price deals in return for a credit.

CUSTOMS AND CARNETS

When traveling abroad you'll need to clear customs each time you enter a new country, as well as when you return home. If you are carrying a lot of expensive equipment, think about whether you'll need to create an ATA carnet or not. An ATA carnet is an international customs document, which acts as a financial guarantee that the person who holds it meets all the required customs conditions and procedures. Once issued it can be used as many times as you like for up to 12 months. It proves the items you are carrying are all duty-paid and therefore not subject to duty payments when you bring them back home again.

A carnet is only really necessary when you are carrying a large amount of equipment, or traveling to a country where the rules won't be relaxed and it is in your best interest to produce one. There are downsides to having one. First, there is the time you'll have to spend creating a carnet, and the process can be quite expensive. You have to allow time at arrivals to seek out the customs office to present your carnet and make check-in staff aware of this. You then need to do the same at the customs office at the other end when you arrive, when in transit between other countries as well as on your return journey home.

A simpler option for photographers based in the UK is to produce what is known as a duplicate list, for which there is no charge. A duplicate list is a letter prepared by you on headed business paper that itemizes the equipment you are carrying. It should contain a brief description of each item and the serial number (if applicable), plus its value. A duplicate list can be used only to cover professional items, works of art, trade samples, or trophies. In the UK, you will also need to complete in advance a C&E 1246 Returned Goods Relief form (which you can get on the Internet from HMRC or at your departure port). Basically, a duplicate list allows you to export goods temporarily without penalty. However, it doesn't simplify the customs procedures in the destination country, where you may still be required to fill in foreign customs

import and re-export documentation. For example, on a trip to Morocco our crew had a duplicate plus a letter from the Moroccan Embassy in London. Unfortunately, none of this was sufficient, and the customs officer impounded all the equipment and directed us to the owner of an import/export company who, as luck would have it, was his brother. I can't remember how much it cost to get all the cameras back, but it came with a ticking-off for not following the proper channels. This was all some years ago, and the situation with customs in Morocco today may be easier, plus Morocco does accept ATA carnets. You may need to make special allowances when planning a trip to certain countries, because not all third world countries are members of the ATA carnet system, and you will need to check what the customs situation is before you travel.

US-based photographers traveling out of and back to the US can use Form 4457 to do the same kind of thing as a duplicate list. This, too, is a free service. You'll need to download the form as a PDF and make copies for each piece of equipment you intend to carry and fill out each individually. Just prior to departure you will need to get a customs agent to sign each form and verify ownership prior to leaving the country.

If you travel with a laptop, a camera body, and a few lenses, you won't be carrying anything more than a typical tourist, especially when traveling between most Westernized countries. No customs officer is going to quiz you over a small amount of gear, or customs would be stopping just about everyone. Customs officers will mainly be suspicious of someone who is importing equipment that looks brand-new (especially if it is still boxed). If you tag your equipment with labels, or some other form of permanent identification, like a sprayed-on logo, this will help make it clear it's your personal kit. Maybe it's a good idea not to be too fussy about letting your kit get the odd few scratches. Carry business cards with you, too, so a customs officer can, if necessary, check out your website to see you are a professional. None of this guarantees you won't be stopped and surcharged with import duties, as customs officers have that right. A number of other factors might also trigger a red-flag response and cause you to be stopped, such as an unusual flight pattern or a short stay in a country.

RESEARCH

Find out as much as you can about a country before you head there. I remember a young New York student who came to stay in the London apartment I was sharing at the time. He had brought a machete with him (this was before 9/11), because he assumed that while he was in London he might need it to cut his way through the forest. Before you leave, buy a guidebook of where you are going and carry out a few Internet searches to get an idea of what to expect. You can find out a lot on your own, but you should also try to make contact with others who have visited before to get their personal accounts and tips on where best to stay and so on. First thing, check out government websites for travel advice (in the US, Travel.state.gov; in the UK, Gov.uk/foreign-travel-advice). These will warn you of any dangers or other problems

A NUMBER OF OTHER FACTORS MIGHT TRIGGER A RED-FLAG RESPONSE AND CAUSE YOU TO BE STOPPED, SUCH AS AN UNUSUAL FLIGHT PATTERN OR A SHORT STAY IN A COUNTRY.

HAVING GOOD PEOPLE ON
THE GROUND WILL PROVIDE
YOU WITH VALUABLE
SUPPORT AND HELP AVERT
UNWANTED ATTENTION, OR
TROUBLE.

associated with a particular country. They may also prove useful should you have to abandon a trip. I was once due to travel to Venezuela and had my tickets booked. However, a national strike meant the whole country got closed down, and the UK Foreign Office declared Venezuela a no-go zone for all but essential travel. When I consequently had to cancel, this government travel warning entitled me to a full refund of my airfare.

In a lot of countries you'll be fine just turning up and finding your own way around. Most people speak English, especially in hotels, restaurants, and shops, and getting around shouldn't be a problem. If venturing to areas that are off the tourist track, you need to make some preparations in advance. At the very least it might help to have a driver who can get you around, who speaks a little English, and who can introduce you to the local culture. If you intend on driving yourself, a regular driver's license will be valid in most countries, but you will want to check with the local hire companies to find out if any additional driver documents might be required or if there are age restrictions. A translator can help, as can a fixer, maybe someone who can do both. Having good people on the ground will provide you with valuable support and help avert unwanted attention or trouble. They can also advise how much things should cost as well as being travel companions.

Google Earth can be used to get an idea of what a place looks like. If Google street views are available you can get a good sense of the look of a specific location. Although it can be slow and awkward to navigate, it is still quicker than driving around all day on a scouting mission. You can also see photograph views provided by other Google Earth users, but the accuracy of these is variable, so don't place too much trust in them when trying to work out where to be to get the best angle of view. Pashadelic is a free app that can be used for inspiration about places to photograph at a particular destination. As you search by a location, you'll see photographs taken in that city or town and a map view of where each was taken. In conjunction with this you can use other location services such as the Photographer's Ephemeris. This is a smartphone app that can be used to calculate the angle of the sun at a given time in a particular location. The screenshots in **Figure 6.1** show how it can be used to work out the sun angles at a specific time of the day as well as calculate shadow lengths. You can also determine the sun's path at different times of the year. It's an invaluable tool for location photography and working out optimum shoot angles to capture, say, the light hitting a building just before sunset. If you are looking for an alternative, LightTrac, by Rivolu Pte Ltd, is similar in function.

While online tools can help prepare for a trip, you may still need to carry out a proper reconnaissance once you get to the location. What a satellite map view can't show you is what the ground terrain is like. How accessible is it? What are the roads like, and how long will it take to get there from your base? Also, what will the weather conditions be like at the time of travel? Peter Hince (whom I interviewed in Chapter 4) described a car shoot in the South of France carried out in February. The

FIGURE 6.1 The screen shot on the left shows how you can track the angle of the sun from sunrise to sunset, in the Photographer's Ephemeris app (Photoephemeris.com). The screen shot on the right shows how you can work out the shadows.

client was expecting sunlit beaches, but the reality was that it snowed. Prior research will give some indication of what the weather patterns are like at a given time, but you can't guarantee perfect weather on a specific day.

One option is to take out weather insurance to cover the cost of a reshoot, which is expensive and not always practical if you need to put together a specific crew. Another option, which can also be expensive, is to allow for a few days to get the shots done so that while you are on location you have more shooting opportunities. One photographer I worked with went to the Caribbean to shoot a swimwear story, and the entire week was a washout with poor weather. The day he was due to travel home the sun came out, and he shot the entire magazine feature on the drive back to the airport, stopping every now and then along the way. (This is also a lesson in why being flexible is important in photography.)

What is the environment like? What can't be seen in landscape photographs of Scotland are the midge insects, which can be a real pest in late spring and late summer (in fact, they are a problem in all northern territories, such as Finland and Alaska). In hotter climates you are at risk of all sorts of diseases, and the larger the crew the more likely someone is going to be laid low. People may carry on working even when ill, but in some countries you really can't afford to take risks. The main thing is to ensure you have all necessary vaccinations up-to-date before you travel and access to bottled drinking water. Failing that, chlorine-based water purification tablets dissolved in water kill off water-borne organisms.

Also, what might be easily accessible by car may be difficult to reach using a location van. On a trip to the southern parts of the state of Georgia, our Winnebago van had a hard time coping with the country tracks and was just too big to access certain locations.

LOCATION SERVICES

You can research locations on your own. The online tools certainly do make it easier, but if it fits in your budget, you can hire a location company to help find locations for you that match a specific brief or act as intermediaries for private property owners. If you need help finding something specific and working out the logistics of where everyone will stay, such companies can help a lot. Property owners prefer having the reassurance of a location company acting as an agent, which in turn will vet photographers and film crews wanting to use a location to make sure they are adequately insured and held responsible for any breakages or damage. Location hire fees are generally at least the same as renting a posh studio. Some, though, cost a lot more, plus the whole package will also need to include the costs of transportation and accommodation.

Full-service production companies provide everything you need to carry out a shoot. For example, if you have a shoot to do in Ibiza or Cape Town, companies based in these locations can provide photographers and filmmakers with a complete package, from sourcing local talent to studio hire and postproduction facilities. Obviously, this all comes at a price, but it allows you to immediately tap into local knowledge and have a smooth production experience. Such services are generally more relevant for big-budget jobs, where you can look upon using them as an insurance policy that ensures you can work effectively within a budget, where going it alone on a big job in an unknown territory could prove really expensive.

GAINING ACCESS

As was discussed earlier, in Chapter 4, you generally don't need permission to photograph in public spaces, providing you don't cause an obstruction or nuisance to other members of the public. When photographing a commercial shoot on busy streets, it is a good idea to notify the local police in advance. Some city police departments have special departments that can help with photography and filming, but this only applies to bigger cities like Miami and New York. You'll also find that within the US, many cities provide support services for film and stills productions and can assist production companies that intend to shoot there. If covering news events, a press pass can allow you access to restricted areas. There are different types: a police pass will allow the holder to cross police lines but is only issued to accredited news journalists. Other types of press cards do not provide any rights of access and are more a means of identification to say that the holder is a practicing journalist. Although limited in authority, they can help bearers show they are professional photographers and enable them to work unobstructed. They can sometimes even get you a discount at your hotel. Lastly, there are passes issued by the organizers of closed events such as sporting events and concerts, which you will absolutely need in order to get access to the best vantage points (and which might also get you free access to the events).

YOU'LL ALSO FIND THAT WITHIN THE US, MANY CITIES PROVIDE SUPPORT SERVICES FOR FILM AND STILLS PRODUCTIONS AND CAN ASSIST PRODUCTION COMPANIES THAT INTEND TO SHOOT THERE.

KEEPING SAFE

When traveling with professional equipment, your main priority is security. When traveling to exotic locations you can't afford to take risks and need to exercise common sense when on location. For a start, it doesn't help if the camera strap shouts "Nikon" or "Canon." Look for something more nondescript, ideally one that incorporates neoprene to help spread the camera's weight. As for camera cases, the plainer the better. A silver camera case is an obvious target for thieves. Alternatively, you could adapt a regular hard shell case to carry certain items of equipment so that it doesn't appear to be that different from everyone else's luggage. How you dress is important, too—you want to blend in as much as possible with those around you, so as not to stand out as a tourist.

Many years ago I was chatting with advertising photographer Alan Brooking and he told me how he would shoot simultaneously to two camera bodies using a split cable release. The rolls of film would be numbered and, before traveling home, divided up so that he, the photographer, had one set of film and his assistant carried another. They also took separate flights. "Well, you never know," he said. While that might sound a little over-the-top, on an important job it could be a good idea.

These days we have the luxury of being able to check digital files while on location, but on a commercial shoot the data stored on the memory cards can be more valuable than the cameras. It is tempting to buy just a few high-capacity cards and not have to bother switching cards all day, but I suggest it is better to have lots of smaller cards so that you can keep removing them from the camera as they fill up and then keep these stored in your hotel safe, or some other secure location, in case your camera gets stolen (with everything from the day's shoot with it). It goes without saying to back up your card data at the earliest opportunity. Some cameras also have dual card slots so that data is backed up as you shoot.

Data cards are said to be fairly indestructible, though. Many years ago I read a report of how these were tested to destruction. A card was boiled in water and given to a seven-year-old boy to play with—the testers even banged a nail through it to see what would happen, and still, the data could be read. Even so, data failure does happen, which doesn't have to be the end of the world, because with data recovery software it still may be possible to recover image files from a corrupt card.

The hotel room is your sanctuary and home away from home, where you will want your equipment to be safe and you'll have the space and facilities to work. While your hotel room can feel like a safe haven, room service will always compromise your security. Bob Marchant told me a story about how a photographer he knew once had to carry out an emergency repair on a Hasselblad lens. He carefully disassembled it and placed all the unscrewed bits carefully on the bed so that he would know which order to put them back in. Before finishing the job he went off to dinner, only to come back and find his bed had been turned down for the night with all the lens bits tidied away in the bedside table and a couple of nice chocolates on the pillow.

WHILE YOUR HOTEL ROOM CAN FEEL LIKE A SAFE HAVEN, ROOM SERVICE WILL ALWAYS COMPROMISE YOUR SECURITY.

IF HAVE TO LEAVE YOUR EQUIPMENT UNATTENDED IN THE BACK OF A CAR OR IN A HOTEL ROOM, RUN A THICK CABLE THROUGH ALL YOUR BAGS AND PADLOCK THEM TOGETHER.

Photographer Mike St. Maur Sheil points out that you should think of the camera bag you carry around with you as being the equivalent of a bag full of bank notes. Just as you wouldn't leave a bag of money unattended, you should never do the same with your camera gear. If people see you packing equipment into the back of your car, don't then leave it to take care of something else. For example, check out of a hotel first, then pack your camera in the car, not the other way round. Even if you feel relaxed enough to trust the staff at a hotel, when rooms are being made up you will notice how doors are often left open so that anyone can easily slip into your room while you are out. If the room has a safe, then use it, or make sure your cameras stay with you at all times. If you have valuable items that are too big to lug around, leave the Do Not Disturb sign up on the hotel door. Better to come back to an unmade bed than an emptied room.

You can seldom stop a determined thief, but you can at least try to make his job difficult enough that he doesn't bother to rob you and chooses another victim instead. When traveling in some countries, thieves may try to slash open a bag with a knife in order to quickly get hold of the contents. With a backpack this can even be done while the person is wearing it. One way to prevent this is to reinforce the interior of soft bags with wire mesh. Another St. Maur Sheil tip is to padlock your cases together. Camera cases are designed to be carried easily. But if you have to leave your equipment unattended in a hotel room, run a thick cable through all your bags and padlock them together. This presents a would-be thief with a great enough challenge to be something of a deterrent.

You can tag your equipment by having a company logo sprayed onto everything. Or, you can use tamperproof asset tags. These steps can reduce the resale value of equipment, so they do help act as deterrents and may aid in the recovery of stolen items.

PREPARING FOR THE UNPREDICTABLE

Good planning includes making contingencies for things that don't go as planned and, more importantly, things that may cost the client more money. You won't know in advance what these may be, of course, but adding 10 percent to a budget should be enough to cover unexpected problems.

Several of the photographers I interviewed have mentioned the steps they take to avoid things going wrong. The most important one is to double up on your kit. You should always take two camera bodies with you on assignment in case one fails or gets stolen. Take enough lenses so that between the primes and zooms you have enough to carry on shooting should one fail. You can always rent additional items, but if traveling abroad you may need to check to see if the hirer allows its kit to be taken out of the country. Some may preclude this in case items are detained at customs due to carnet problems. Also, if you are shooting away from home and away from nearby rental centers, you'll want to be sure of the kit you are using and know it can be trusted to work.

GETTING ON WITH YOUR CREW

On lengthy journeys it helps to be around people you can trust. Even on relatively stress-free trips in your own country, a reliable assistant can be a nice travel companion and help make a trip run smoother.

Larger groups of people can be a mixed blessing. If the group gets on, you have a better experience. The reality is that apart from your choice of assistant, you generally have little control over who you'll be traveling with, and it's all too easy to end up with the dysfunctional family from hell. You are likely to be spending a lot of time in close proximity to people you've never worked with before or people you have worked with but have never gotten to know properly. You often hear stories from people who'll sum up a bad trip by saying, "I don't know why they ever chose to book me in the first place if they hated me that much." You are seldom going to find it easy to work closely with people over extended periods of time, even among the best of friends. The key thing here is, every team needs a leader. That person might be the photographer or it might be the client. Whoever it is, he or she needs to know how to manage and deal with people.

They say "an army marches on its stomach," and it's well worth remembering, as there is nothing like depriving people of food and drink to create an unhappy team. That may sound obvious, but I hear a lot of horror stories of how photographers simply neglect to look after their crew. One model told me how she and another girl were instructed to meet up with the photographer at his studio in Milan at 7:00 a.m. As she arrived, the photographer and his assistant were eating breakfast, but they didn't offer the models anything to eat. They then drove off to the location still with nothing to eat or drink, and at around midday, the photographer got out a packed lunch for himself and his assistant. There were no shops or restaurants in the area, so the model called a cab to take her to somewhere where she could eat and rang her agent to say she wouldn't be returning to the shoot.

When producing a shoot, you need to allow for catering expenses. On some trips you or the client will be responsible for providing catering, which can be included in the hotel booking, or as expenses incurred as you dine out. Some productions budget for what is known as a per diem expense. This is a fixed-rate allowance that's given to each crew member, which allows crew to spend as they please. It is usually intended to cover food expenses, though it can sometimes include travel expenses. On most of the trips I have worked on, the catering is taken care of by the photographer or client, who will assume responsibility for picking up the tab at restaurants.

YOU GENERALLY HAVE LITTLE CONTROL OVER WHO YOU'LL BE TRAVELING WITH, AND IT'S ALL TOO EASY TO END UP WITH THE DYSFUNCTIONAL FAMILY FROM HELL.

THOMAS FAHEY

SPECIALIZATION: LOCATION FASHION PHOTOGRAPHY

Thomas Fahey grew up in Oklahoma, where he worked as a photojournalist to help pay for his college tuition. He photographed for the school newspaper and the city newspaper in Oklahoma City. Back then it was quite a different craft, with darkrooms, process cameras, and ortho/litho halftones. During this time he developed a small client base and niche for photographing people. After that, he moved to Atlanta, Georgia, where there were more people doing more things. Says Fahey, "It was a great meeting of business and attractive lifestyle. Over the years I shot a lot of editorial for *Atlanta* magazine, including covers and features. I also developed a large client base of commercial bridal clients including After Hours Formalwear, Men's Wearhouse, Johanna Hehir, and Tommy Hilfiger."

ON LOCATION

For each project, Fahey works with his main assistant to produce a custom checklist of gear. He normally likes to travel with a basic camera kit: two dSLR bodies and an assortment of lenses from superwide zooms to prime lenses ranging from 16 mm to 200 mm, a laptop computer, and various accessories. He works with the rental houses that are available locally to obtain anything that's bulky or heavy, especially when working away from home in other cities.

A good location must first have the right feel for the shoot in question and work with the clothes. "I like working with ambient light and manipulating that," says Fahey. "So the quality of the natural light is important. Locations must generally have power or I'll have to figure out how to get power in—either using portable batteries or a generator. I also look for amenities like changing areas and secure areas where we can base our gear. Prep areas can be created, though, using brought-in tables and clothes hangers. Having a good, local food source is important, as is parking. On some shoots you can have a large crew, plus you can never know exactly how many people are going to show up. Clients do often invite extra people to come along to a shoot without informing me first."

As for gaining permission to shoot on location, Fahey reckons it's best to clear all shooting areas in advance. "I always minimize any chance of surprises by keeping everyone on the same page and being compliant," says Fahey. "You don't always need permits to shoot locally, but sometimes you do, and it's my

responsibility to find out a definitive answer beforehand. Shooting out on the street in Atlanta without a permit isn't a big problem—it's not like Miami or London. However, with our rapidly growing movie industry, here in Atlanta that is beginning to change."

It is sometimes a producer's or client's job to maintain an efficient schedule, but it is often the photographer's. Says Fahey, "That means when one segment of the drive train becomes unhinged for any reason, it must get realigned so

everyone is pointing in the same direction. Hiring professionals and working with people you trust will take care of almost all the wrangling issues. You want the production crew to all be working from the same script." Fahey's approach to shooting fashion on location is to keep things fairly minimal and choose locations carefully, so that he can accomplish as many different types of shots as possible within a single spot, rather than have to drive all over the place.

Fahey adds, "Whenever you shoot on location with models and a large crew, it's always going to be tricky and unpredictable. The biggest thing that can set a location shoot back is the weather. A stormy day puts everyone in slow motion, and if shooting indoors it radically changes the quality of the ambient light. Just recently I was carrying out a large commercial shoot at the beach and we were hit by stormy weather. In situations like that you sometimes have to go forward despite the adverse conditions and persevere." And then there is the problem of working with unknown talent. "There is always the occasional person you hire who completely brings [things] to a grinding halt because of attitude, incompetence, or both. It happens."

SELF-PROMOTION

Public relations experts will tell you to use every available means to get your work out, including advertising in trade books, list buying, and social media. According to Fahey, "Having worked many years as a photographer, I am able to rely a lot on word-of-mouth contacts and recommendations. I suppose I'm an anomaly in that way, but I do use an e-mail list to keep in touch with clients and find that social media is now crucial."

A lot of industry people believe that photographers need to learn how to shoot video. "I feel this also will be a matter of degree," says Fahey. "I think print stills will be around for a long time. As a photographer who already directs large still photography productions, it's not such a reach to consider directing a moving picture. But it does mean investing in a steep learning curve to do this."

As for the future of photography, Fahey says, "I see two roads ahead for commercial photography: digital capture technician and interpretive visual capture artist. Everyone will find their balance between the two, depending on whether they want to become a craftsman or an artist. There will always be a healthy demand for both, but the artist will probably command more money depending on their uniqueness and business savvy. Distilled down, photographers take photographs. Shoot all the time, shoot everything, shoot frame after frame after frame until you find your visual voice."

FAHEY'S APPROACH IS TO KEEP THINGS FAIRLY MINIMAL, SO HE CAN ACCOMPLISH AS MANY DIFFERENT TYPES OF SHOTS AS POSSIBLE WITHIN A SINGLE SPOT, RATHER THAN HAVE TO DRIVE ALL OVER THE PLACE.

Thomas Fahey Photography
Thomasfahey.com

WORKING ABROAD AS A PHOTOGRAPHER

In some countries, such as in Europe, it may be necessary to register your business, or register as a professional photographer, to work there long term. It may even be necessary to become a member of a professional association. However, this applies only to setting up a permanent business in another country. Most people will choose to base themselves in their home country, file taxes there, and work abroad for foreign clients as requested.

Are you permitted to work abroad? An assistant I knew once flew to New York to find work as a photographer, taking a photographic portfolio case with him. He was detained at JFK airport, where he was asked what his intentions were. He admitted he was traveling to New York to find work as a photographer and was sent home on the next available return flight. I suppose you could say he made himself an obvious target. I have on occasion traveled to the US to photograph professionally myself, but this has been permissible because the paying client was based outside (and the images were to be used outside) the US. But if you travel to a country to work for a client within that country, you may first have to obtain a work visa.

If a shoot for a foreign client involves travel abroad, a number of things will affect the way you work, as well as legal obligations, which may well differ from those where you live. For example, the privacy laws differ from country to country, so it is best to acquaint yourself with these and know your rights. And there are all sorts of other laws and customs you may need to observe.

Liability insurance

As was mentioned in Chapter 3, when you work abroad you will need to look at your liability insurance as an employer. If you are traveling with an assistant who is employed in your home country, your assistant will probably be covered, but if you employ someone while you are in another country, you'll probably need to take out separate liability insurance. This is because your domestic public liability insurance won't be valid either. So, if you wish to rent a location while working abroad, you'll have to take out separate insurance that covers you in that specific country. Given the litigious climate today, this is vital and will protect you from any mishap that occurs while you are working.

WORKING FOR FOREIGN CLIENTS

You have to be extra careful when taking on the responsibility of working for a client who's outside your jurisdiction, even if the shoot takes place on your home ground. With a foreign client, you need to ensure the contract you work under is made under the law of the country where you live. This can help protect you regarding copyright, since copyright law varies by country. Otherwise, if there is a dispute regarding payment or another matter, you will be forced to chase through the courts of the client's country. If you don't speak the language and are unfamiliar with its legal system, that may prove problematic. Every now and then I've received emails asking me to quote on a job for a foreign client promising interesting work. These always seem to be spam messages, and you'll see other photographers discussing these on the various photography forums. Basically, you have to be very wary of working for a client outside your own country.

Processing payments

When working for foreign clients, payment terms will need to be agreed upon. Usually, clients will expect to be invoiced in their own currency, which means carrying out a currency conversion, so make sure the amount quoted and invoiced is the correct equivalent of what your domestic prices would be. When receiving money from abroad, always try to arrange for a direct payment via electronic transfer. This is the fastest and most economical method, although it will be subject to the bank's exchange rate on the date of transfer. In the UK, this is calculated based on the interbank rate plus the bank's margin. These will vary from bank to bank and can make quite a dent in the amount of money effectively received due to the commission charged by the bank. It is worth having a PayPal account for general business use and to offer this as a way that foreign clients can pay you. PayPal also charges a fee on top of the interbank base rate, but this may still be more competitive than your bank's. For big transactions, investigate what your best options are at the time you need to actually transfer the money.

Payment by check can be done by negotiation with recourse. In the UK, for example, the bank will credit your account on receipt of foreign funds but charge a substantial handling fee. This is to cover the handling period during which the funds are actually cleared. It will take longer than a regular domestic bank transaction. Ultimately, if the funds can't be cleared, you will have to return the money to the bank, but this does still give you fairly swift access to the money. However, with countries that are regarded by the banks as high risk, check payments can only be sent for collection and the funds only credited once a check has cleared.

IT IS WORTH HAVING A PAYPAL ACCOUNT FOR GENERAL BUSINESS USE AND TO OFFER THIS AS A WAY THAT FOREIGN CLIENTS CAN PAY YOU.

MARC SCHLOSSMAN

SPECIALIZATION: TRAVEL PHOTOGRAPHY

Anyone can take a nice travel photograph, but it takes a lot of skill and experience to be able to fulfill the types of commissions that require specialist knowledge of working in remote territories and the problems one is likely to encounter when shooting in hot and sometimes unfriendly environments. Marc Schlossman has traveled extensively across Africa and the Far East photographing for non-governmental organizations (NGOs), as well as corporate clients such as *BBC Books*.

He first became interested in photography while studying wildlife biology at university in Iowa, where he took a black-and-white printing course. Early in 1985, the partner he was with had a fellowship to study and chose to go to London. Wanting to take his photography further, Schlossman looked into applying to do a photography course and ended up studying photojournalism at the London College of Printing. At the end of that year he had to go back to the United States, where he worked for various newspapers in the Boston suburbs and cut his teeth shooting everything from features to sports to portraits. This taught him how to relate to subjects and deal with people. On his return to London in the late '80s, there were suddenly a lot of new magazine titles. Says Schlossman, "This was a boom time in magazine publishing, and plenty of magazines were willing to give assignments to newcomers, which allowed me to get my first editorial and contract publishing commissions. I was later able to add corporate work, which helped support shooting the kind of work I liked doing best."

SHOOTING ON LOCATION

It is extremely important to do your research and read up beforehand. "Talk to other colleagues and find out as much you can before you go," says Schlossman. "It is also good to cultivate good lines of communication, where you can be introduced to people who know something about the place you are heading to and can offer useful advice. In African countries things usually happen very slowly. There can be a lot of sitting around, where you just have to wait and be patient. However, when something does happen you have to be ready to work very quickly at short notice." He usually travels on his own but does also like working with journalists. Having two people work together can help you make contacts more quickly. You can share ideas and watch out for each other. With clients now asking for video, it works well to have the journalist taking care of recording the sound and the photographer concentrating on the video.

Says Schlossman, "When covering any story, it is important to be neutral when listening to subjects from all sides of the story and gathering images. Stating your opinions at that stage can influence what people say or what they show you and give you access to. Even in situations where you might think being a US citizen would be a barrier to being liked, if you present yourself as being a professional, you will be more easily accepted. Sometimes it's hard not to take a side, and the subjects you shoot will affect you. When I was sent to cover the first intifada and its effect on the relationship between Israelis and Palestinians, it was the most tense place I had ever worked in and I couldn't wait to leave.

"When I went out a second time to photograph in the occupied territories, I booked an El Al flight to Israel from Heathrow. However, I made the mistake of carrying some books and papers, which contained examples of what I had shot on the first trip. As a result, I was taken to a tiny room and a thorough search was carried out on all my bags. The grilling lasted so long I missed my plane and had to catch a later flight. Once I was there it was a very sensitive time. At checkpoints guns would be pointed at you, which, even though the safety catches were probably on, was still very intimidating. All in all, a very difficult place to work."

WHEN COVERING ANY STORY, IT IS IMPORTANT TO BE NEUTRAL WHEN LISTENING TO SUBJECTS FROM ALL SIDES OF THE STORY AND GATHERING IMAGES.

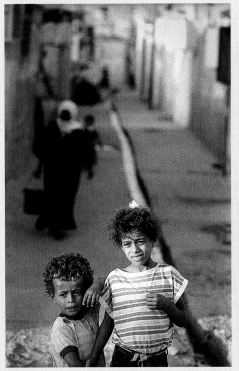

A boy and girl in Rafah, Gaza.

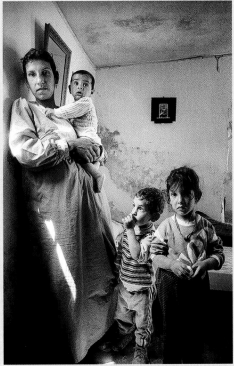

A mother and her children at home in Jalazone refugee camp, Ramallah, West Bank.

A boy peering from behind a tree, village of N'dobo, Equateur Province, Congo River, DRC.

Schlossman likes to take two dSLRs, some short zooms, plus longer fixed-length lenses up to 180 mm. He carries a couple of portable flashlights with a TTL cord for low-light shooting plus a small soft box. He's a big fan of maps and likes to know where he is and also takes water purification tablets and iodine, although he's rarely needed to use them. Says Schlossman, "There has usually been good drinking water wherever I've traveled to. The biggest precaution you can take is to make sure you have good people on the ground as well as back home. NGOs may not be able to give you money, but they can offer good advice, which is invaluable. Fixers can be expensive, but along with a local driver they're possibly the most important things you can arrange, as

you immediately get access to useful local knowledge. On a recent trip to Cameroon the driver was able to blag us into the port area to shoot the trucks lined up waiting to unload. In that instance the photos had to be shot using an iPhone, and even that was really risky."

When photographing the people he comes across on his travels, Schlossman usually enlists help from whomever he has working with him as a translator or guide. "People turn you down a lot less than you might think," says Schlossman. "They have a look at the big sweaty guy and just shrug their shoulders or laugh and think yes, why not? Women are often more modest and if they say no, I'll never press them and will look for another possibility instead. Sometimes it helps just to sit down in a place, and by the time the novelty value of the visitor wears off you can start shooting. It always helps to buy something nearby to be seen adding to the local economy. Or, you can share what you buy with their kids, and then you'll quickly make friends." Another piece of advice is to "always know how you are going to get from the airport to the hotel and how much that will cost," says Schlossman. "When you arrive at an airport there will often be a sea of people offering taxi rides. Always make sure there is someone there to meet you who you can trust. Once you are at the hotel you'll have a base to work from, and you can start making plans from there. The hotel itself must be secure. It's difficult to know what secure is, of course, so do some research ahead to find out which ones are the best where you are heading."

Cover for *Facing the Congo* that uses photographs shot by Schlossman on a trip to the DRC.

BUSINESS SETUP

Schlossman works mostly now in Lightroom and uses Photoshop less and less. This is because he finds Lightroom quicker to edit in and it's easier to apply keywords. Here, he'll enter as many as possible at the import stage, but then sends photos off to a company in India to apply even more keywords. Says Schlossman, "This saves time and is essential to raise the profile and value of photos submitted to image libraries."

He now also offers a video service to his clients. "There will always be a market for stills," says Schlossman, "but as image makers we need to look at all the different ways we can use our skills to add content. Plus, content on the Web is going very much to motion. A couple of friends of mine can't understand why a stills photographer should want to shoot video. It surprises me, really, because it's all photography, and it's what you put in the viewfinder that counts. When shooting video there are so many more factors to consider, and shooting stills now seems quite simple by comparison. There is definitely a demand coming from clients now. For example, on a recent shoot to Cameroon, I recorded video as well as stills to create a multimedia film that told

BAKA PEOPLE VIDEO

The Baka people video mentioned in the main text can be seen at: vimeo.com/74927913.

a complete story about how logging in the rain forest is affecting the Baka people. If a client asks for something that's a little beyond what I can do, I'll still say 'yes' but enlist people with the right skills to put together a team that will make it work."

When I went to interview Schlossman it seemed a bit over-the-top that he is based in the large studio complex at Plough Studios, especially when most of his work is shot on location. However, an advantage of having a studio there is that there are a lot of other people working close by such as video technicians. "It is like a community," says Schlossman, "where everyone can share knowledge, share equipment, and give each other work. It makes it easier to put teams of people together for corporate clients as well as produce personal work together. Over the years I have always come to learn and understand the latest technology by learning from those around me."

PERSONAL WORK

Schlossman is currently working on a project about the loss of biodiversity. After all these years, it feels good to him to incorporate his studies in wildlife biology into his photography. He has so far taken photographs of a number of different species held in various museums and started to build a body of work around this subject. There was a project he shot for *BBC Books* in 2003 that took him to Sossusvlei in Namibia. "I would go back tomorrow and spend more time there if I could," says Schlossman. "Wherever you go, you have got to find

A man bathing in river water at the stern of a barge, Congo River, DRC.

the best in a place and the people. Above all, you've got to bring back material that will make others excited about it as well."

Aside from the commercial work, Schlossman has been involved in a number of charities, one of which was Inside Eye, a prison photography project. This began in 1991 when photographer Jason Shenai arranged for a group of free-lance photographers, including Schlossman, to give up their time to work with prisoners. They were given a disused cell for a darkroom and set about teaching a group of prisoners how to take photographs and print their own pictures. Says Schlossman, "It was quite an experience managing to do all this with limited resources. Everything had to be submitted to security officers for censorship, and contact sheets would often come back with big red crosses. However, the funding lasted for over four years, which was enough to produce a book and hold an exhibition at the Photographers' Gallery, London."

After that Schlossman became involved with PhotoVoice, which puts cameras in the hands of disadvantaged and marginalized communities. "It allows them to tell their own stories, to represent themselves and work for change and provide the tools for self-advocacy," says Schlossman. "One good example of the way PhotoVoice has helped is in Kinshasa, where PhotoVoice has given cameras to HIV-positive women. At home they have done the same with young asylum seekers in the East End of London. The organization manages to place work in newspapers. There are exhibitions and an annual print auction and talks to raise funds, and it is supported by well-known photographers such as Sarah Moon [who is a patron], as well as *Times* picture editor Nick Danziger."

Video interview with Marc Schlossman.

COMMERCIALLY IT IS GETTING TO A POINT WHERE THE INDUSTRY IS GOING TO BE MADE UP OF PEOPLE WHO DON'T NEED TO MAKE MONEY FROM IT.

ADVICE FOR NEWCOMERS

There have been so many huge changes over the last decade or so. Schlossman summarizes the situation by saying, "Anybody can have a good idea for a good project. When you have a great idea that's well executed, you don't need experience to have something catch hold. You may need experience to tell you what will work well commercially and what might have longevity, but there has to be a lot of you in whatever you produce. If you are going to eat, breathe, dream photography 24 hours a day, you can definitely get started in this business, but it's going to be tough. Overall, the photography industry is doing fine and the tools we now have at our disposal are incredible. I can't wait to see what is going to happen in two, five, or ten years' time—everything is evolving so fast. Commercially it is getting to a point where the industry is going to be made up of people who don't need to make money from it. There has always been an element of that, but for people to have the time and freedom to pursue the big stories—the ones that need time—it is very difficult right now to find the kind of commercial work that can support that."

Marc Schlossman Photography
Marcschlossman.com

PhotoVoice
Photovoice.org

MICHAEL CLARK

SPECIALIZATION: ADVENTURE SPORTS PHOTOGRAPHY

One formula for becoming a successful photographer these days is to find a niche market that few others are operating in and specialize in doing innovative work within that genre. Michael Clark's career perfectly embodies these principles, although nobody ever said it would be easy. Clark originally studied to be a physicist, but during his graduate courses realized he wanted to find work that would take him outdoors, rather than be stuck in a lab for the rest of his life. After leaving university he worked as a rock climbing and backpacking guide, and it was on an eight-month trip through Europe he realized he might be suited for a career as a climbing photographer.

On his return to the United States, he started sending images to magazines and saw his first three submissions published. He then worked at an outdoor store for a few more years, during which he was able to work part-time as an adventure photographer. His job at the store also allowed him to meet athletes he could photograph and build up enough steady photography clients to work full time. Says Clark, "My skills as a climber are a big part of how I could actually become a full-time pro photographer. When I started there were maybe only 25 climbing photographers worldwide. Because there weren't so many of us out there, I could get my foot in the door. I basically combined two passions and created a career, but once I went full time I realized I needed to shoot a wider variety of sports to diversify my client base and images."

ONCE I WENT FULL TIME I REALIZED I NEEDED TO SHOOT A WIDER VARIETY OF SPORTS TO DIVERSIFY MY CLIENT BASE AND IMAGES.

WORKING ON LOCATION

Prior to each job Clark researches the location he is going to as much as possible. If it is a rock climbing shoot, he will already know most of the popular locations. If he's shooting a sport he doesn't know so well, he'll rely on the athletes a bit more as to what they can do and how close he can be without getting in the way. He'll look at other images that have been shot at that location and talk with the athletes to see what they are thinking. If possible, he will do a location scout, but sometimes the areas he goes to are so remote this isn't possible. For example, for the Red Bull paragliding shoot (**Figure 6.2**), he and the athletes discussed some possible locations, what they were capable of, and how they could set up shots he had thought about capturing. For this photograph he strobed the paragliders as they flew by his position. "That had never been done before and it was difficult, but we got some shots that were completely different than anything else that had ever been shot before of paragliders."

FIGURE 6.2 World-class paraglider Honza Rejmanek floats above Sandy, Utah, while training for the 2011 X-Alps Competition, which takes place in Europe every July.

Sun Seeker app By ozPDA (Ozpda.com).

Clark usually writes out a shot list of all the kinds of shots he would like to get if possible. Once on location, for one reason or another, some of those ideas may have to be thrown out. The location might not allow for it, or the athlete may not be able to pull off what he had in mind. If he knows he will have a limited time in an area, Clark will use Google Earth or the Sun Seeker app to figure out when the best light will hit a certain feature, or whether strobe lights will be necessary. Generally, he is able to shoot at least 70 percent of his ideas. "Sometimes," says Clark, "an athlete offers up something I had not thought of. Adventure photography is basically documentary photography, but because there are no strict rules I am able on location to manipulate the shot to get what I want."

Sometimes clients have a fixed idea of the type of image they are after. Usually Clark works with athletes to determine where they will go, based on experience and what they are comfortable doing. He mostly relies on his subjects as the best source of information about the route they are going to climb, the wave they are going to surf, or the terrain they are going to explore. When on location, the amount of photo gear that's taken varies depending on the assignment. "I usually have twice as much outdoor gear as I do photo gear," says Clark. "The outdoor gear never gets flagged—I just have to pay more to get it there. Often the outdoor gear dwarfs all my photo gear, so it isn't even noticed. For big-budget location shoots outside of the USA I will get a car-net, as customs officials seem to be drawn to the odd luggage photographers carry, especially Pelican cases and lighting cases. If I am only carrying a few camera bodies and five or six lenses and no lights, then I don't usually bother. I

can usually get all of my camera gear into a carry-on bag and take that on the plane with me. If I have to check camera gear it goes into a Pelican hard-shell case, and I have beefy Lightware cases for all my lighting gear."

A big problem when working in remote locations is having no electricity. With this in mind, Clark packs lots of backup batteries. For extended trips, such as when he might be on a glacier for a month, he uses a Goal Zero Escape 150 solar-powered recharger. It's a heavy item to carry, but the only way to keep things powered when you are out in the wilderness.

Security is always an issue, especially getting to a location and coming back. "Having so much gear in a third world country makes a huge impression, and people tend to follow you to figure out what is happening," says Clark. "Mostly it's a question of keeping the gear from getting banged up. But early on in my career, I had my entire camera kit stolen along with a lot of climbing gear while climbing a huge formation in northern New Mexico known as Shiprock. We literally watched the thieves drive around to see where we were on the rock formation (they were 2,000 feet off the ground at the time), and then drive around to our car and take pretty much everything out of it. At that point my gear was uninsured. From then on I have always had business insurance for all my outdoor gear and photo equipment. A few cameras have died when they were submerged in salt water accidentally, and I have dropped a few lenses while rock climbing. My Lowepro fanny pack camera bag once came unclipped and fell 200 feet during a rock climb. The 70–200 mm lens in that bag literally exploded."

Adventure sports photography is not without its dangers. As Clark says, "I have used up six or seven of my nine lives, it seems. I have had my rope cut down to a few strands of the core—that was probably my closest call. I have been hit by a car while training on my road bike. I have been hit by a beach ball–size rock falling off the top of a 450-foot cliff (it was a glancing blow). I have also been in a small avalanche, fallen into quicksand, and suffered cerebral edema at high altitude." Being an athlete himself, he is prepared to be there no matter what the sport. "Swimming in the ocean shooting at Pipeline, the world's most dangerous wave, is quite a thrill and extremely scary—especially since I am not a surfer. For the Tahiti surf shots, we go out in a 20-foot fishing boat and the fishermen there are very adept at staying out of trouble. The engines in these boats are gigantic, which allows the drivers to get into and out of trouble quickly. These days there might be five or six of these open-top fishing boats jockeying for position next to Teahupo'o, the main wave in Tahiti that photographers fly in from all over the world to shoot. Teahupo'o always breaks in a certain spot and is fairly predictable. An occasional wave might come in at a funky angle, but that is rare. Hence, the boat driver basically puts us in as close as possible, about 100 feet away from the action, and we go over the shoulder of the wave as it goes by.

Jacopo Alaimo climbing El Matador on the Devil's Tower in Devil's Tower National Monument, Wyoming.

"As a photographer you get to know the boat drivers and figure out who has the best skills," he explains. "Boats have been known to flip over on that wave, and I have been in one that has caught air. I went with a different driver after that. Since the fishermen don't want to destroy their boats, they are usually a safe bet. I have also flown in a lot of helicopters and been in some scary situations where I have had to completely rely on the pilots. I have now learned which helicopters are safer and prefer those that have at least three blades, as they are safer and steadier, especially in high winds."

There are some sports that go beyond his abilities. There was one time when an athlete wanted to do something so risky that Clark declined to shoot it, but mostly there are ways you can work out how to photograph a sport. For example, you can use remote cameras, and on days when it is too huge to go out with the surfers, you can always shoot from the shore. Although an expert rock climber, Clark wouldn't consider photographing a cutting-edge mountaineering trip. In fact, there are probably only two photographers in the world who could realistically do that type of work.

The biggest unknown is the weather. With certain sports too much wind can bring a job to a halt. For example, when photographing a mountain bike shoot for Adobe, the wind couldn't be any more than a few knots. If it was any stronger than that the cyclists would be blown off course and wouldn't have been able to hit their marks. Clark has shot some ridiculously risky activities, but these were when photographing world-class athletes, who knew what they were doing (as with the BASE jumping shot shown in **Figure 6.3**). Clark says, "I

FIGURE 6.3 Jon DeVore, a member of the Red Bull Air Force team and a world-class BASE jumper, leaping off the edge of a 3,200-foot cliff in southwestern Utah. At this point he was just seconds away from flying at speeds of over 140 mph in his wingsuit.

used to have athletes sign a statement to say they wouldn't sue me if they got injured and that they would take full responsibility for their actions. After talking with a few lawyers I stopped using it. I was told that any lawyer worth their salt could get past a signed agreement like that in a heartbeat."

The only really embarrassing incident was in 2009 on a ten-day exploration for the Patagonia Expedition Race. "I was shooting for Wenger [which makes Swiss army watches and knives]," says Clark, "and halfway through our remote trek in uncharted and unmapped terrain, I injured my knee and had to bail at the only possible exit point near a road. Over the last few miles the CEO of Wenger, who was on the expedition, carried my backpack as I limped out to the road in quite a bit of pain. That was embarrassing, but even so, in the first part of the trip I was still able to get some stunning images for the client, one of which is still in my portfolio."

IMAGE LIBRARY WORK

With photographers reporting reduced sales income from stock libraries, I was interested to know if this had been the case with Clark's own work. "I, too, have seen declining sales from the stock agencies since 2008 or so," says Clark. "My images do stand out, but these days there are over 250 adventure photographers worldwide, so there is a lot more competition than when I started out way back in 1996. Most of the best images adventure photographers take are not with a stock agency. The hard-core stuff doesn't sell that well, because few can really understand it. The more generic images end up in stock libraries, and those clients that are looking for the extreme stuff usually contact the photographers directly. I am still with Getty Images but see very little money from them now—just the occasional sale. For me, the good news is I can market my work more effectively myself. I still get a lot of clients contacting me directly who want to get pricing for images they have selected from the website."

MOST OF THE BEST IMAGES ADVENTURE PHOTOGRAPHERS TAKE ARE NOT WITH A STOCK AGENCY. THE HARD-CORE STUFF DOESN'T SELL THAT WELL, BECAUSE FEW CAN REALLY UNDERSTAND IT.

VIDEO

If still photographers want to stay in business, it's proving a necessity these days to produce video. Clients expect it and seem to think it is just as easy to produce as stills. "I see video as a natural progression from stills," says Clark. "But it is massively more complicated than just changing a few settings on your dSLR. Good video and good audio takes a highly skilled team. I have found that I need at least three people to capture really solid video content."

"Of course, it depends on the project and how the footage is being shot," he says. "If I am hanging from a cliff, then there will only be me shooting footage from that vantage point and the audio will be captured from an on-camera

Timy Fairfield hanging from the tip of the Crystal Cave on "Super-Dope", near Jemez Springs, New Mexico.

IN-PERSON MEETINGS ARE STILL THE BEST AND MOST EFFECTIVE FORM OF MARKETING. THERE IS NOTHING LIKE MEETING A POTENTIAL CLIENT FACE-TO-FACE, SHOWING THEM YOUR PRINT PORTFOLIO AND DISCUSSING POSSIBLE PROJECTS.

external microphone. Producing motion content is also a totally different animal for still photographers who are used to working without an assistant or with just one assistant. For the photographer who wants to control every aspect of a shoot, I think they will find video very difficult because you need a team and you have to trust them to do their part in the process. As motion/still cameras become easier to use and offer higher resolutions, I think video will play a bigger role. For the pro, I don't think there is an option anymore. You must be able to do both stills and video if you want to make a living."

Learning how to produce video content is another massive hurdle. Shooting the video is often the easy part. Preproduction and postproduction can easily take significantly more time than the actual shoot. Add to that the learning curve to understand basic audio and video editing, and it becomes clear why a team is necessary. Says Clark, "I have basic audio and video editing skills, but that doesn't mean I should be the one working with those elements when creating video content if I want it to be top-notch."

BUSINESS AND PROMOTION

Clark markets his photography in a number of ways, relying mainly on e-mail promotions, direct mail, his website, which makes use of well-made search engine optimization, books he has written, and last but not least, his newsletter, which he sends out every quarter (see Chapter 2). In-person meetings are very important, and he usually tries to tag these onto jobs and other client appointments. Clark says, "I think in-person meetings are still the best and most effective form of

marketing I do. There is nothing like meeting a potential client face to face, showing them your print portfolio, and discussing possible projects."

For social media Clark uses Facebook, Google +, Twitter, Instagram, LinkedIn, Vimeo, and Behance, plus he blogs, but to a lesser extent these days. "As far as I know I have never really gotten a job because of any of these social media channels," says Clark. "But they allow my clients to keep track of what I am working on and are all good venues for bringing people to my website. The website is home base for all of my marketing. All of my e-promos and direct mail pieces are sent out to get folks to look at new work or to read the latest newsletter."

No matter how well-known or busy you are, cash flow will be an issue. "When I started out I thought ten years in, I would have it made," says Clark. "But the reality is the assignments keep getting bigger and bigger, and more money is needed to fund them. Sometimes you have to front expenses for a major assignment before the client's deposit has shown up." To limit cash flow issues, Clark will usually ask clients to pay for all expenses up front and half of the creative fee.

The gear he uses is mostly stuff he owns. He prefers not to rent because if you are out in the middle of nowhere you need to know the gear will work. He occasionally needs to rent lighting gear, as well as items like large booms, dolly tracks, and continuous video lighting for the video shoots.

The top, cutting-edge adventure photographers tend to be young and in their 20s or 30s. To create images like the ones shown here means being able to maintain a high level of fitness. So I suppose as you get older it is only natural to have an eye to the future and consider how you will be able to continue working in a field like this. From Clark's perspective, adventure sports and exploration in general are his passion, but he does realize that at some point he won't be able to be there like he is now. He plans to continue shooting for at least the next 15 years or so. After that he'll see what happens. "Talking to other adventure photographers," Clark says, "most seem to go into mainstream advertising photography or continue shooting adventure sports until they can't any longer. As I get older, I will still shoot adventurous activities, they just may not be as adventurous as those I shoot now and have shot in the past."

To survive, professional freelance photographers must be prepared to keep reinventing themselves. Many, such as Clark, have chosen to tap into the education market. He teaches workshops and has so far written four books, including *Exposed* (published by New Riders). He has also found fine art print sales have started to pick up, and being based in Santa Fe, he is in a perfect location for this. Clark adds, "There is nothing like seeing one of your best images framed up and hanging on the wall. Hopefully, print making and selling fine art prints will be a part of my business for the rest of my career."

All the photographs seen here are discussed in Michael Clark's book, *Exposed*, published by New Riders.

MY PERSONAL PROJECTS
ARE TO KEEP PUSHING AND
IMPROVING ON ALL FRONTS
AND TO PURSUE OTHER
ADVENTURE SPORTS I HAVE
NOT PHOTOGRAPHED.

Photographing surfers has been a personal project for the last five or six years, and his next step is to get out and swim in the bigger waves in Hawaii and Tahiti. He tries to have at least one or two personal projects each year and right now is working on a time-lapse project. "My personal projects are to keep pushing and improving on all fronts and to pursue other adventure sports I have not photographed."

LOOKING TO THE FUTURE

The current economic climate has affected many working photographers, and the adventure sports sector is no different. Clark is fortunate in that the last three years have been his busiest ever, bucking the trend experienced by other photographers. At the same time, it seems likely technology will continue to force radical changes upon the photography business. "In terms of where the photography industry is headed," Clark says, "technology is going to keep changing the industry radically for quite some time. The last 10 years have seen more changes in the photo industry than the last 50 years. It is already becoming clear that the majority of photographers creating images for editorial and

Professional surfer Josh Kerr surfing a sizeable wave at the legendary surf break Teahupo'o in Tahiti.

advertising clients will probably be working part time as photographers in the future. Only the very top photographers will be able to afford to work full time at their craft. I am already seeing that trend among some of my peers. Digital has taken the genie out of the bottle. There is no more mystery in terms of how an image is created, now that you can see the image instantly on the back of the camera. Hence, photography has exploded as a hobby and as a profession like never before. There is now a massive supply of images, yet the demand is the same, or less than what it was before 2008."

With the introduction of 4K video cameras, there has been much talk about the possibility of being able to shoot video and print quality stills at the same time. Will this become a reality, though? It's hard to say. Clark points out that one of the point-and-shoot cameras he owns can do this already. But the thing is, shooting professional quality video and stills requires very different approaches.

"I think this convergence of video and stills is more myth than reality," says Clark. "I think we will be able to shoot video and stills at the same time, but I don't ever see taking stills (of action at least) out of video as being possible or a good thing. I might be wrong on that one, but the thing I have learned by shooting both stills and video is they are massively different mediums and require different approaches. I remember talking to a Nikon representative a few years ago, and he told me their strategy is to make it so that what you see with your eyes is exactly what the camera captures. We are still a ways off in that respect, but that tells you where this is all headed, especially with Google Glass. As with any revolution, things usually get worse before they get better. The quality of digital images for a while was horrendous, but we are now at the point where digital technology has long left film in the dust. The main problem is, the public has accepted low-quality images for so long that high-end photographers have a lot to overcome. With 4K video on the horizon for 2014, I am hoping that quality will start to stand out again and be appreciated."

Aspiring photographers will find Clark's books full of useful insights. Clark's main advice to would-be photographers is as follows: "Keep your overhead as low as possible and avoid getting into debt. Understand that you are going to have to work insanely hard to make it in this business. Make sure you are passionate about your work. You are going to have to want a career as a pro photographer above almost everything else in life if you want to actually be successful in this business. If you aren't obsessed, you probably won't make it. Perfect your craft. You will have to create new and different images than are currently out there to really stand out from the crowd. Lastly, I would say that anyone pursuing photography as a career has to have the long view early on. It isn't going to happen overnight. Expect that it will be a bumpy road and you will be better off."

DIGITAL HAS TAKEN THE GENIE OUT OF THE BOTTLE. IF YOU AREN'T OBSESSED, YOU PROBABLY WON'T MAKE IT. EXPECT THAT IT WILL BE A BUMPY ROAD AND YOU WILL BE BETTER OFF.

Michael Clark Photography
Michaelclarkphoto.com

7

TECHNICAL REQUIREMENTS

CAMERA SYSTEMS

Having worked as a writer for *What Digital Camera* magazine for over ten years, this is a subject I should know something about, yet I am loath to be too prescriptive as to which cameras are best. It depends foremost on what kind of photography you wish to do and is also subjective, where preferences at times border more on the theological than on practical analysis. Only you can decide if a camera looks and feels right for you. What I would say is don't become too obsessed with the kit—it's the photographs you take with your camera that matter most. As Jay Maisel once said, "I generally find it's easier to be a photographer when I am carrying a camera than when I am not." (Maisel, by the way, always carries a camera with him wherever he goes.) With the photographers I interviewed I deliberately chose not to inquire too deeply as to which specific cameras they used other than to find out if they were using dSLRs or medium-format systems. Basically, I was more interested in discussing their photography. But in this section it is perhaps more appropriate to look at the types of camera systems that are available to professional photographers and discuss their relative merits.

You need to have confidence in the kit you use and to some extent the impression it creates. For example, for my personal work I often shoot with a lightweight compact dSLR because it uses the same lenses as my full-frame SLR but is much lighter to carry. However, on jobs I always use a full-frame camera or rent a medium-format system. These types of cameras are more able to withstand punishing use. They also create the impression you are working with a serious, professional-looking kit. This is, after all, what most clients expect to see. Let's now look at some of the pros and cons of the different kinds of digital cameras designed to meet the needs of professional photographers.

MEDIUM-FORMAT SYSTEMS

Medium-format systems are the first choice for studio photography. These are digital backs that can attach to cameras that are based on the 6 x 4.5 cm 120 roll film format. Some digital back sensors are just slightly smaller than 6 x 4.5 cm and therefore provide an equivalent view magnification when using system lenses. So, a 50 mm lens on a Hasselblad H5D-60 camera will provide almost the same angle of view when used with a digital back compared with shooting with 120 roll film. Because the sensor in a medium-format camera is bigger than a full-frame dSLR, this means you can achieve a nice shallow focus, which is desirable for some styles of shooting. The other benefits are increased pixel size and sharpness. For example, the Phase One P65 back captures 60 megapixel images. That's a huge file size and more than enough for most jobs I can think of.

Unlike dSLRs, medium-format sensors generally don't have a high pass, anti-aliasing filter covering the sensor. This results in sharper captures. The downside is that such sensors are more prone to picking up moiré patterns, though where this happens it can be corrected in the software processing. CCD medium-format sensors usually work best at the lowest ISO setting. This is fine for studio work or where the camera is used outdoors, mounted on a tripod. But once you start raising the ISO setting, noise can become an issue. This isn't necessarily the case with all medium-format backs. For example, the latest Phase One backs allow you to shoot high ISO captures at a quarter the maximum pixel resolution. Also, since early 2014, a Sony 50 megapixel CMOS sensor has been adopted in Phase One, Hasselblad, and Pentax models. Although smaller than all the medium-format CCD sensors, this now allows you to shoot high-quality medium-format captures at up to ISO 204,800. I have reviewed both the Hasselblad H5D-50c and Pentax 645z cameras that use the Sony CMOS sensor and been impressed with them.

DIGITAL SLRS

When the 35 mm camera manufacturers started making digital cameras, they looked at ways to adapt their established 35 mm film camera designs. Initially, the sensors used in these cameras were smaller than the 35 mm camera film format size. Over the years sensors have been developed specially for dSLRs that are now the same size as the full-frame 35 mm film format. First came CCD sensors that were similar in design to those used in medium-format digital cameras, but these tended to suffer from noise. Most dSLRs these days now use CMOS-type sensors. Sensor design has now improved to the point where the latest dSLRs are capable of capturing files to almost rival medium-format cameras in terms of megapixel size, while offering better noise characteristics. Most dSLRs offer greater flexibility for location work and access to a wide range of system lenses.

CCD AND CMOS SENSORS

For a long time CCD (charge-coupled device) sensors were thought to offer the best image quality, which is why all the early dSLR cameras used CCD sensors and medium-format backs have continued to stick with CCD. About 12 years ago manufacturers of compact and dSLR cameras migrated to using CMOS (complementary metal-oxide-semiconductor) sensors. There were a number of reasons for this. CMOS sensors are generally cheaper to manufacture, consume less power, and therefore generate less heat. Because the capture data can be read and processed more quickly, they have been able to offer faster capture rates and high speed video recording. On the other hand, the image quality from CMOS sensors has not always been as good as that you can get from a CCD, but as CMOS sensor designs have improved, they can now potentially offer image quality to rival CCD, plus have the added benefit of offering fast capture and higher ISO speeds.

The transition from film to digital has presented camera manufacturers with a number of challenges. In the days of film capture, optimum sharpness could be achieved only by shooting with low ISO black and white or Kodachrome film emulsions. These days the detail that can be captured using a dSLR easily exceeds that of traditional 35 mm films. The megapixel race has driven the need to build better lenses that can match the capture quality of the latest sensors. To get optimum quality from a large megapixel dSLR you really need to use the best optics. This mostly means using prime lenses, though there are some impressive zoom lens designs that have wide apertures. Basically, you get what you pay for, and if you are going to splash out on a dSLR kit, you'll also want to invest in decent optics.

COMPACT AND MIRRORLESS CAMERAS

Compact system cameras are a lightweight alternative to dSLR cameras. Some systems are compatible with dSLR system lenses, while others come with their own range of lenses. These are favored by some photographers who specialize in street photography because they are less obtrusive than regular dSLRs and can work in a silent mode (since there is no internal mirror). The downside is you have to rely on an LCD screen or rangefinder to focus. However, the latest electronic viewfinders are making mirrorless cameras more appealing. In the future we may see large sensor mirrorless cameras being used in place of traditional dSLR camera designs. I know several photographers who shoot landscape who have been seduced by the latest Sony A7r camera, which has the same 36.4 megapixel sensor as the one used in the Nikon D800 and D810 cameras. Some photographers are even choosing to work with fixed zoom compacts. A number of such models are capable of shooting in raw mode, and their compactness makes them suitably discreet for candid photography. They also come in special sports models to capture fast action; you can attach these to, say, the tiller of a sailboat, or to a quadcopter to capture aerial stills.

COMPUTER SOFTWARE

IMAGE EDITING

It was during the '90s that digital imaging first became possible on a personal computer. Most photographers were using Photoshop, but a number of other popular systems were in use, such as Imaginator and Live Picture. Photographers who wanted to provide digital retouching services faced quite a struggle, though. Within the publishing industry there was quite a bit of resistance because prepress operators were being asked to accept externally created files rather than transparencies or prints, which they could scan themselves (and charge the client for). To be fair, this was all

prior to ICC color management being implemented in Photoshop (see the section "File Submission Standards"). There was a fairly cozy relationship between advertising agencies and those who were providing the computer retouching services. I remember once receiving an invoice from my photo processing lab that was meant to have been sent to an advertising agency; I was shocked to see a bill for tens of thousands of pounds in computer retouching fees, which was then going to be passed on to the client. From the mid-'80s onward, computer retouching was almost exclusively carried out by a handful of studios. When photographers began to provide computer retouching services, this undermined the relationship between the studios and the agencies, who were doing quite nicely from the markup they were able to add to the retouching fees. One art buyer told me about the pressure she was under to have the retouching outsourced to dedicated retouching houses. There were rumors, too, of underhanded dealings to maintain lucrative contracts.

DIGITAL CAPTURE UPSET THE MAJOR RETOUCHING HOUSES AND PREPRESS COMPANIES, WHO IN TURN WERE SUPPORTED BY THE PUBLISHERS AND ADVERTISING AGENCIES, WHO WEREN'T KEEN EITHER ON A CHANGE TO THE STATUS QUO.

For these same reasons it was difficult to promote the benefits of digital capture. It upset the major retouching houses and prepress companies, who in turn were supported by the publishers and advertising agencies, who weren't keen either on a change to the status quo. During the '90s a small number of professional photographers began to explore the potential of digital imaging and invested in expensive digital cameras and computer equipment. At first, it was a struggle for photographers who worked digitally to be taken seriously. It has to be said, the computer hardware at that time was primitive compared to the equipment we have access to these days. For example, my first serious computer for image editing had a 33 MHz processor, 16 MB of RAM, and a 320 MB hard drive. Yet this machine was able to run Photoshop 2.5 and I could just about edit 8 megapixel images. Meanwhile, high-end retouching for advertising was carried out on dedicated systems like Scitex, Barco Creator, and Quantel Paintbox XL systems, and software programs designed to run on personal computers (like Photoshop) were considered toys. It was the dawning of a new era, and to be honest, photographers like me were all learning from scratch how to become digital retouchers using severely underpowered equipment. Resistance came from fellow photographers, too. As one colleague scoffed, "Photoshop is turning good photographers into bad surrealists" (he may have had a point). Another suggested photographs entered into the Association of Photographers awards that had been digitally processed should carry a red dot to indicate they weren't real photographs. There was even a "campaign for real photography."

AS ONE COLLEAGUE SCOFFED, "PHOTOSHOP IS TURNING GOOD PHOTOGRAPHERS INTO BAD SURREALISTS" (HE MAY HAVE HAD A POINT).

Digital capture comes of age

The turning point came as the quality of medium-format digital sensors improved and became popular among more and more still-life photographers. Meanwhile, Nikon and Kodak were developing 35 mm body cameras for the professional market. The DCS Pro14n, a 14 megapixel full frame dSLR, was announced at Phototkina in 2002, around the same time as Canon was about to introduce the 11 megapixel EOS

1Ds. Although smaller in pixel size than the Kodak, Canon's entry stole the lead for a number of years with its full-frame sensor and fast capture rate. The main contenders now are Nikon and Canon, both of whom have helped open up the market for digital photography and inspire photographers (amateur and pro) to go digital. The 35 mm dSLR revolution has helped establish digital photography and with it an increased interest in the software that can be used to manipulate images.

There was also a demand to develop improved tools that could manage the raw image processing. Camera Raw evolved from Thomas Knoll's disenchantment with the software that came with his newly acquired EOS 1Ds camera. Apparently, Knoll spent his holiday time in Italy that year working out how to devise a raw processor of his own making. Phase One also worked on developing its very successful Capture One software for the dSLR market and established itself as a leading raw converter program for professional and amateur users. Professional photographers I've spoken with recently say they now use Photoshop less and less and rely more on raw processing programs such as Capture One or Lightroom to do all the main image-editing work. This makes sense, because raw software has matured to the point where you only really need to use Photoshop to carry out the advanced retouching, which many images may never need. Consequently, it is now more important to concentrate your image-editing software skills on the raw processing stage. If your style of photography requires something more than that, you'll need to learn how to use Photoshop, which is still a valuable skill to have. If you know what you are doing and are good at retouching, this may also help you to generate extra income.

How much is it OK to retouch?

A hot topic right now is the degree to which retouching is permissible (or desirable) in professional photography. Much depends on the context and expectations of the viewer. In the case of advertising photography, retouching is perfectly OK. Heavy use of manipulation in advertising imagery is acceptable because viewers understand and expect to see this kind of treatment in advertising. At the same time, industry guidelines dictate what is OK and not OK to show in an advertisement. For example, food photographs must portray the advertised item. Food can be presented to look its best, but you can't cheat by preparing something that's not the actual product. Advertisements are of course designed to seduce us into buying a product or service, but we are all savvy enough to interpret these photographs as perfections of reality and not object to the extensive use of computer effects. In fact, we sometimes rather enjoy it, in the same way that we marvel at the use of special effects in movies. It's fun to look at, and we all understand it's hyperreality, not true reality.

With documentary photography the use of computer retouching is a major issue; a number of recent examples have cropped up of news photographs having been proven to have been manipulated. News photographs shouldn't be retouched, because each time a news photograph is proven to be a fake, this undermines the

work of every other photojournalist. This is why photojournalists themselves are so keen to make sure this type of practice is curtailed. The thing is, where do you draw the line between what is acceptable tone and color editing and unacceptable manipulation? Here, photojournalists seem to be at odds with what is allowable when editing digital images. If we step back a bit and look at the work of classic film documentary photographers, such as Sebastião Salgado, there are well-documented examples that show how the original negative images were transformed in the darkroom to produce the final desired print. The situation with digital is no different, really. A raw file is like a digital negative. There may be less dynamic range in a raw image, but it is still possible to dodge and burn to achieve an improved tonal balance. Likewise, you can alter the color and mimic the look of classic film emulsions, or create something completely different.

The Pictures of the Year International contest (POYi) is one of the most prestigious photojournalism competitions in the world. In 2009, the POYi jury made the controversial decision to disqualify a photograph submitted by Klavs Bo Christensen. It argued that the edits made to the raw original breached competition rules regarding color and tone enhancement. In this instance the tone contrast manipulation was arguably a bit heavy-handed, but it's clear from looking at the original raw version that nothing had been factually altered in the photograph. Was the contrast manipulation carried out by Bo Christensen any less ethical than what film documentary photographers had been doing for years before in the darkroom working from their negatives? Tools available today can help clarify such disputes. Fourandsix.com offers digital imaging forensic services, and you'll see interesting case examples on its website where it offers a verdict on the validity of various digital images and explains how its conclusions were reached. Izitru.com is another, where you can upload a photo to have it analyzed automatically.

A public and political debate about photographs of models being retouched, which the media erroneously describes as airbrushing, wages on. This, too, is nothing new. For many years fashion magazines like *Vogue* have made use of chemical, and later digital, retouching, especially with its cover images. The current controversy is more about the degree of retouching that's being used and is a reaction to the fact that just about every fashion and celebrity portrait image you see now is retouched. In the old days access to such tools was limited, and retouchers really did use airbrushes to paint out the blemishes. Then, as programs like Photoshop became more accessible and the tools became more sophisticated, almost anybody could become a retoucher. As a result, standards have perhaps declined. Anyone who spends time looking through model portfolios will tell you how among the many great examples of fashion photography and good retouching, you'll see a lot of photographs that are let down by being overly touched up.

Clients can also be to blame, especially those who push for photographs to be more retouched: sometimes they request the photographer to smooth or reshape

EACH TIME A NEWS PHOTOGRAPH IS PROVEN TO BE A FAKE, THIS UNDERMINES THE WORK OF EVERY OTHER PHOTOJOURNALIST.

WHETHER PHOTOGRAPHERS DO
THE RETOUCHING THEMSELVES OR
GET OTHERS TO DO IT FOR THEM,
THEY NEED TO HAVE A SAY AND
SOME CONTROL OVER WHAT IS
DONE TO THEIR WORK.

further, or they hire a retoucher to work on the photographs independently and the images are taken out of the photographer's control. Photographers should be aware of and pay attention to this. Fashion photography images will always depend on the use of manipulation—there is nothing new about that. The point to bear in mind here is that the debate about excessive retouching has caused magazines and advertisers to reconsider how much their images should be manipulated. Whether photographers do the retouching themselves or get others to do it for them, they need to have a say and some control over what is done to their work.

IMAGE MANAGEMENT

When digital imaging was in its infancy, nobody gave much thought to how and where they would store all their digital files. Over time photographers have looked for ways to efficiently organize their collections of images. But it still amazes me the number of photographers I meet who rely on a traditional folder hierarchy to manage their images, where only they seem to know where particular images are stored (see **Figure 7.1**). Adobe Bridge on the other hand allows you to view all types of files, not just images, so it offers all the features of a system browser but with added controls to inspect and manage metadata (see **Figure 7.2**). However, there still remains the problem that you need to be familiar with the way the folders are organized. Another drawback to Bridge is the fact that the metadata information has to be stored locally

FIGURE 7.1 The problem with browser-style management is that the person doing the searching needs to know clearly how the files and folders are organized on his or her system. When using an operating system like OS X, you can only preview a single image at a time as you browse.

in the files themselves—file searches are therefore not as fast as they can be when using a cataloging program. Also, to work efficiently in Bridge, previews need to be cached for each folder you intend to inspect. This can take some time to carry out when managing a large collection of images. Or, you can adopt a Lightroom work-flow (see **Figure 7.3**). The key difference here is that the files have to be explicitly imported into Lightroom first and the program limits the types of files that can be imported. Only the PSD, TIFF, JPEG, PNG, DNG, and specific proprietary raw for-mats are supported in Lightroom, along with specific types of video files. Imported images are cached automatically and the cache and metadata information archived

FIGURE 7.2 A browser program like Adobe Bridge can make the task of searching for images somewhat easier. This is because it allows you to view multiple images at once inside the folders you select and create ad hoc collections.

FIGURE 7.3 A cataloging program like Lightroom bears some similarities to Adobe Bridge. Files can still be navigated via a folder hierarchy based on the system level folder organization.

inside a single catalog folder. This makes metadata searches faster with fewer holdups waiting for previews to generate. As with Bridge, images can be grouped together into collections. Lightroom also encourages the use of keywording, which ultimately makes a catalog of images more accessible. When this is done well, it can be as easy as carrying out an Internet search to locate a specific image. Lightroom discourages redundancy by giving you the option to limit the import of duplicate images yet the freedom to add virtual copies where different treatments have been applied, such as black-and-white conversion, vignette, alternative cropping, or sepia toning.

The reasons you should practice good image management are as follows. Having your image files cataloged allows you to work more efficiently because you can find images more quickly and your image library becomes more easily accessible to others. If you are consistent with your keywording and archiving methods, anyone who has a rudimentary knowledge of the software that's used to manage your image library will be able to access your images on your behalf. Keywording makes your images more discoverable and can also help generate more image library sales.

One of the first and most successful image-cataloging solutions designed for photographers was iView, created by a small UK company and later sold to Microsoft, where it became Expression Media. It is currently owned by Phase One and now known as Media Pro. This is probably the most comprehensive database solution for managing stills and video file resources. Media Pro supports photo and video files from more than 100 cameras and is designed to manage large photo libraries. It also integrates neatly with Phase One's Capture One software.

Apple released Aperture in 2005, offering Macintosh users a combined image database and raw processing program in one. The main drawback to this system was that it was for the Mac platform only. It evolved over the years and became popular with some Mac-based photographers, but in 2014 Apple announced it intends to discontinue development of Aperture beyond the current version 3. In 2015 Apple will be releasing its Photos for OS X program as a replacement for iPhoto and Aperture. Aperture users will be able to migrate their existing Aperture libraries to Photos, but it's unknown as of yet whether Photos will continue to offer the pro level features found in Aperture.

Shortly after the release of Aperture, Adobe released Lightroom, which runs on both Mac and PC systems and, like Aperture, provides combined image database and raw processing features. Its cross-platform flexibility and use of the same raw image processing engine as in Camera Raw for Photoshop, where over 400 raw formats are now supported, helped ensure its success.

Whichever software program you choose to use, you'll need to import files into the catalog before they can be managed. Programs like Lightroom restrict you to working with image and video files only, which can be a positive thing in that it simplifies your system. The other alternative is to use browser software to access your images. A browser is like the operating system navigation window; it sees everything that's on the system, not just image files but Word documents and PDFs. It can lead to a more cluttered view when browsing, but if you're navigating through folders specifically dedicated to holding images, this is less of a problem. An example of a browser is Adobe Bridge, which comes as part of the Creative Cloud.

It's funny how the issue of whether to catalog or browse has become so divisive. Some photographers hate the idea of working with Lightroom and insist that the Bridge method is the only one that makes sense to them. Personally, I like using Bridge for its browser features whenever I am working on a movie project or a book,

and I prefer using Lightroom when I just need to search for and edit my images. These two methods work nicely side by side, and in my view there is a place for both. Browser software such as Bridge offers a better interface and editing environment than Finder, Explorer, and the like, and cataloging software is faster and more focused and efficient at managing your images.

BUSINESS SOFTWARE

If you are going to set up in business, you'll need to invest in some standard programs. Microsoft software is the standard for business, and you'll regularly need to open files created in programs such as Word, Excel, and PowerPoint. These are all part of the Microsoft Office suite, which you can buy as a bundled package that includes Entourage, Microsoft's e-mail program. You don't necessarily need Microsoft software to open, say, a Word document, as there are Microsoft Office–compatible programs such as Libre Office and the iWork Suite, but if you are collaborating on a document it helps to be using the same software as your client or other work colleagues. Similarly, you don't need to have Photoshop to open a raster image, but if you are working with other Photoshop users you ideally should be using the same version of Photoshop that they are.

Are you going to process your own accounts? If so, think carefully about which software program you are going to use because it can be a real pain to transfer the accounting data from one system to another if you decide to switch (it's often bad enough to have to update to a new version of the same software). If you are going to have a bookkeeper manage your weekly accounts, find out which software he or she is using so you can run the same program on your system and thereby easily access reports. If you choose to do the bookkeeping yourself, your accountant will also be able to advise you (Sage accounts software is very popular). When all goes smoothly you can expect to keep your finance management costs to a reasonable level, but as I have found out myself, if you have a problem with the software this can be a costly problem to iron out manually.

Contact information can be stored using a database. A simple program like Address Book that comes as part of the Apple operating system is effective for the way it integrates neatly with other components such as Apple Mail (allowing you to quickly add contact details without having to re-enter them), as well as synchronizes with contacts on an iPhone. FileMaker Pro is a professional-level database program that can be used to store client details and manage contacts data more comprehensively; it also integrates with tablet and smartphone devices. It can be used to manage projects, such as the progress of a shoot, as well as job quotes.

An electronic diary helps keep track of appointments and activities. The basic ones are probably all that most photographers need. For the work I do, all I need to note down is when and where to turn up. Google Calendar integrates with iPhones

and Microsoft products and has the benefit of being free. For more complex shoots one can use time management programs (a techie term for what are essentially digital diaries) to organize large numbers of people and produce monitored call sheets for everyone. Some programs offer a range of tools for managing a studio business, but these are most useful for portrait studios where there may be a lot of client bookings to manage each day.

Setting up Internet accounts

Having an Internet account and your own website is a key part of your business. The first step should be to register a personalized domain name. This can be done via a domain registration service, but if you are checking to see if a specific domain name is available, carry out your initial investigations via a regular search engine, such as Bing or Google. Do not search a domain register website until you have a fairly good idea your choice is not already taken. The reason for this is if you do not buy a vacant one reasonably speedily, you may find someone else will grab it and offer it back to you at an inflated price (after spotting your choice). I have heard of this happening to colleagues, all because they were too hesitant.

Once you've decided on the name for your business's site, go to a domain registration service and enter the name to confirm it is free or what other options are available. Even if you have a very common name you should be able to find something unique you can register—sometimes just by adding "photography" to the end of your own name. Remember that you want your site name to be easy to remember and find. US Internet accounts all end in ".com," but anybody anywhere can register a ".com" address. There are umpteen variants including ".net," ".biz," plus regional domains. It's important for big businesses to ensure they have these variants covered in order to prevent competitors or others from snapping them up; you may not choose to do this.

Just bear in mind you'll have to pay an annual registration fee for each domain name you do register. Once you have done this you can arrange for all e-mail to be redirected via your chosen domain name and similarly have your personal web address diverted to whoever hosts the website. This allows you to freely change Internet service providers without having to change your e-mail and website address each time you do so.

Next find an Internet service provider (ISP) that can provide web server space plus an e-mail account. There are a lot to choose from these days, and it is best to check online first to see who offers the fastest Internet speeds in your local area. Domestic and business ISPs will usually offer complete packages for e-mail and Web hosting. If you want cloud storage, that will cost extra. This will allow you to automatically synchronize files from your computer to a remote server and allow synchronized access to other computers with the owners' permission.

IF YOU ARE CHECKING TO SEE IF A SPECIFIC DOMAIN NAME IS AVAILABLE, CARRY OUT YOUR INITIAL INVESTIGATIONS VIA A REGULAR SEARCH ENGINE. DO NOT SEARCH A DOMAIN REGISTER WEBSITE UNTIL YOU HAVE A FAIRLY GOOD IDEA YOUR CHOICE IS NOT ALREADY TAKEN.

E-mail

It is best not to place complete reliance on e-mail communications, as you can't always guarantee an e-mail will be received and recipients will often have restrictions in place to block large attachments. Some e-mail systems reject attachments that are bigger than 5 MB in size. Even when it is possible to send large attachments, the recipient may be on the road with poor Internet access and won't thank you for clogging up his or her in-box. Apart from anything else, it's poor netiquette to send large unsolicited attachments. A better way to send image files is to use the File Transfer Protocol (FTP) method. There are two ways you can do this. Your ISP may very well offer online storage space and an FTP address you can use to store files online. To use this you'll need FTP client software, such as Fetch for the Mac (Fetchsoftworks.com) or IPSwitch for PC (Ipswitchft.com). Another option is to make use of a web-based FTP service such as Hightail (Hightail.com), or Dropbox (Dropbox.com). I mainly use Hightail and subscribe to the Pro account plan, which allows me to send documents that are up to 2 GB in size. With this FTP method you don't have to use your own server space at all. An e-mail is sent to the intended recipient and all they have to do is click on the link to access the file or files you have sent them.

DATA SECURITY AND BACKUP STRATEGIES

All businesses need to keep their data secure. The first line of defense is a firewall to prevent network access to all except authorized users. Beyond that you'll need to make sure the data on your computer is kept secure when accessed directly. This can be done by enabling password protection. Sensitive data, such as banking information and password codes, can be further protected using a password database. For example, I use SOHO Notes to store password information, where access to each note is also password protected.

The information you create as a result of your business activities will be personal to you, but it includes other people's information, too, so keep in mind your responsibilities as a professional to protect such data from being seen or stolen by others. In the UK, the Data Protection Act needs to be considered whenever you store client details. In the course of your work you will gain access to telephone numbers and address information, plus other details that are not for general distribution. If the photographs you take are licensed exclusively to a client, you need to be responsible for their safekeeping, and you certainly don't want to be the one who's responsible for an unauthorized usage. For example, if you choose to supply images to clients for download via your website, you need to make sure you have proper security in place. Website hosting service providers should be able to offer suitable password security so that only selected people you choose to inform can gain access to specific image collections.

As I explained earlier, it is a good idea to tag your images with keywords and IPTC metadata, as this will make them easier to locate and add value. However, you may not want to share all information. Some keywords may be fine for personal reference, such as "heavy manipulation," but you might not want a client to see them. Location information can also be very sensitive. If you were to photograph someone's children and happened to record GPS data, that, along with an autofill of the IPTC metadata, might reveal the home address of those children. When releasing photographs for external use you may in some cases need to ensure all location metadata is removed first.

As the saying goes, "There are only two types of computer users: those who have suffered a crucial loss of data and those who are about to." Technology can seem daunting, but it behooves you to learn about it to run your business effectively. Evaluate your storage media (you might also want to hire a computer consultant to check it out). This can be done by looking at the media type used, its age, how it is formatted, who has access to it, and where it is stored. Traditional hard disk drives (HDDs) use a mechanical mechanism, where a number of disk platters coated with a magnetic medium spin at high speed and actuator arms travel across the platters reading and writing data. This design has been around for several decades and improved upon over the years so that very large-capacity drives are now available at low cost. As long as you stick to trusted makes, these types of drives are reasonably reliable, if a little slow compared to the newer solid state drives (SSDs). These use integrated circuit assemblies as memory to store the data. SSDs are significantly faster than just about any regular HDD, but at the time of writing are still newish technology, and the cost per megabyte is a lot more than with HDDs. Most modern HDDs incorporate SMART (Self-Monitoring Analysis and Reporting Technology System), which means when a hard drive starts to show signs of failure, you'll see an "imminent failure" message that will warn you the drive is on its last legs. SSD drives are reputed to have longer life spans than HDDs and lower failure rates. Because there are no moving parts they are more robust, but when they fail it is more likely to be catastrophic. Drives of any kind will lose performance over the years. Mechanical HDDs become slower as more data is stored on them. Also, as the data becomes more fragmented, the read-write times become slower. Ideally, you don't want to push an HDD beyond say, 85 percent capacity. SSDs can accumulate bad blocks, which can also eventually lead to drive failure. When a mechanical hard drive goes bad, certain procedures can be used to rescue and salvage data from the platters. In the case of SSDs, when it's gone, it's gone.

Hard drives can be configured in a number of ways. A RAID system (Redundant Array of Independent Disks) can be configured to provide extra speed or added security. Faster drive performance can be achieved by striping two or more drives together (this is known as RAID 0). Striping two drives together doubles the speed, and

SSD RELIABILITY

The first generation of SSD drives had a comparatively low number of read/write actions before failure. Subsequent versions have improved, but their lifetimes are nevertheless finite, and they are thus best used for transactions (such as launching applications and scratch disk usage) in preference to storage, as speed is the main benefit. This is the theory behind Apple's Fusion drives, where an SSD is coupled with a mechanical HDD and the OS has in-built caching and analysis of data handling to decide what is stored on the SSD and what is stored on the associated HDD.

striking four drives together quadruples it. Or, you can have two or more drives mirror each other (this is known as RAID 1). Should one drive fail, the mirrored copy on the second drive will continue working seamlessly. You can then swap out the failed drive and replace it with a new one, which the RAID 1 controller will start copying to, thereby restoring the duplicate. There are also other flavors, such as RAID 5, that use a four-drive setup and provide security, though this approach isn't infallible.

If you want to ensure you don't lose any data, the simplest system is JBOD (just a bunch of disks), where data is stored on single drives. This is an uncomplicated setup and one favored by a lot of photographers, in which you carry out regular, scheduled backups of data from your master disks to a backup set of disks. This can be done using special software configured to back up, say, every night in the early hours of the morning, or it could be a task that you carry out manually every week or so. It gives you the security of having a complete, updated backup of all your data. But where will the backup disks be stored? If they are permanently connected to the computer, then your backup disks are just as vulnerable to fire and theft as the computer itself. In 2007, film director Francis Ford Coppola's laptop and backup drive were stolen from his house in Argentina. He claimed to have lost 15 years of personal data, including writing and family photographs. To prevent this kind of thing happening to you, you can store all the backup drives in a fire safe, or better still, implement a triple backup plan. For each master drive you have two extra backup drives. Keep one backup drive connected to the main computer at your office, ready to back up your most recent data, and keep the other backup disk in a separate location, such as at home. Then keep swapping the drives over between home and office so that should anything catastrophic happen at the office, there will always be a second set of backup disks you can access.

KEEP ONE BACKUP DRIVE CONNECTED TO THE MAIN COMPUTER AT YOUR OFFICE, READY TO BACK UP YOUR MOST RECENT DATA, AND KEEP THE OTHER BACKUP DISK IN A SEPARATE LOCATION, SUCH AS AT HOME.

Another option is to make use of a remote server, where important data is copied to an FTP site, thereby keeping a complete updated copy on a server. In my office I use the triple disk backup strategy to keep my data secure, but on important projects, such as this book, I also upload all the latest modified production files to a remote server at the end of each day. Another alternative is to make use of cloud storage, where the process of backing up data is seamless and allows shared access to data across multiple devices. For example, Apple customers with an iCloud account can use this service to synchronize personal data between their iPhone, iPad, and Macintosh computers. Calendar, e-mail, and other information is synchronized automatically. However, I would currently find this approach impractical to keep a complete backup archive of all my images. It is not just a matter of the time it would take to upload a large number of image files, but how long it would take to read all that data. Whenever I suffer a drive failure or lose data, it's always much quicker to restore that data from a fast hard drive, or simply replace the faulty drive with the most recent backup.

Data can be archived to read-only media. This was popular back in the days when hard disk storage was expensive, but it fell out of favor as hard drive space became

cheaper. Data can still be backed up to CD, DVD, or Blu-ray media, but it is a slower process compared with backing up to regular hard drive media. However, there are still advantages in doing so. Data backed up in this way is locked to the media it is stored on and can't be overwritten. Files backed up on hard drives may regularly get updated and be overwritten, which implies more potential for data loss, while files stored on read-only media are also safe from future virus attacks (something that can't be guaranteed using hard drive backups). Read-only media offers reasonable longevity for the safe storage of data, but it's not that long. Manufacturer's estimates are in the region of 20 to 100 years for CD and DVD read-only media. Even so, this is still longer than the lifetime of hard drives that have been subjected to continuous use.

Backup software

When managing large amounts of data, you want software that can intelligently back up that data for you to separate hard drives. You can buy various products to do this, but they mostly offer similar key features. Essentially backup software checks the modification dates between the files on your system and copies and replaces the newer files only. You can customize the software to inform you of data changes before it does so, or build an archive of older files that have subsequently been modified so you have something to revert to. The backing up process can also be made to be two-way, which can be useful when you need to merge data on two separate source drives. Ideally the backup process needs to be scheduled to occur at regular

WHO HAS ACCESS?

If more than one person has access to a computer, the potential for human error is increased. Where your computer data is kept matters, too. A laptop computer that's on the move with you is more likely to become lost or damaged, compared with a hard drive in a static tower system, kept in a room that's locked when not occupied.

FIGURE 7.4 This screenshot shows the Carbon Copy Cloner program interface for the Mac OS that can be used to back up data onto backup hard drives.

WHILE EVERYTHING YOU WORK
WITH CURRENTLY MAY APPEAR
TO BE OPERATING JUST FINE
AS IT IS, AT SOME POINT ONE
OR MORE COMPONENTS WILL
REQUIRE UPGRADING, AND
THIS IN TURN WILL HAVE
A KNOCK-ON EFFECT FOR
EVERYTHING ELSE YOU USE.

intervals, so most software will allow you to setup a suitable schedule for this to take place automatically.

Retrospect is one of the market leaders in backup software and is available for both Mac and PC. As a Mac user, I have used ChronoSync by Econ Technologies but now mainly use Carbon Copy Cloner by Bombich Software (see **Figure 7.4**). One of the key features of Carbon Copy Cloner is that it allows you to create a bootable system hard drive. This means when you clone the system hard drive, the copy you make can be used as a substitute boot drive. If your system drive fails, you can be up and running in a matter of minutes by designating the copy drive as the boot drive.

RELIANCE ON TECHNOLOGY

I can remember the days when the closest a photographer got to digital technology was a fax machine and computers were only used to do word processing and accounts. Equipment was expected to last forever, and classic cameras like the Hasselblad 500C had remained virtually unchanged since the 1950s. These days digital equipment is updated at such a pace that it is often necessary for photographers to upgrade the digital camera/digital back and computer equipment they use every three to four years. While everything you work with currently may appear to be operating just fine as it is, at some point one or more components will require upgrading, and this in turn will have a knock-on effect for everything else you use. Let me give you an example. In 2008 I upgraded to shooting with the Canon EOS 1Ds MkIII camera. I had been happy enough shooting with the EOS 1Ds MkII but was attracted by the increased megapixel size of the newer camera. As a consequence of this I also needed to make sure I was running the latest version of Lightroom and Photoshop in order to be able to access the latest Camera Raw update that would allow me to read the raw files from the MkIII camera. At the same time, the iMac computer I had been using to process the files was struggling to cope with the increased raw file sizes, especially when shooting tethered. So, I had to buy a new iMac, but I then found out that I needed to install a Windows operating system in order to achieve the fastest USB download speeds.

In short, upgrading a single item such as a camera or an operating system is likely to mean other upgrades. In the example I just gave, this led to a lot of added expense beyond the cost of the camera itself. Once you have established a digital workflow and setup that works, you can always try to keep everything ticking over as is on the theory, "If it ain't broke don't fix it." But sadly, digital equipment, especially computer equipment, is not designed to last that many years. Another problem is the fact that the other people you work with or are competing against will themselves be upgrading. So the expectation is that you, too, will be using the latest camera technology and software. This is especially the case if providing creative services for designers and other photographers; you'll need to be able to read the latest file format specifications.

I have been involved with digital imaging technology for almost 20 years now, and in that time I have seen a great many changes. I have managed to salvage files from those early days from Syquest discs and transferred them to DVD and hard drive backups, yet these still won't open because they need dedicated software to read the raw formats. People often point out that big companies such as Adobe are no different. Can we guarantee they will be in business in 50 years' time? No, we can't. People thought Kodak would be around forever, but ironically, a company that led the way in digital imaging ended up becoming bankrupted by one of its own innovations, as Kenny Suleimanagich pointed out on PetaPixel.com in 2013.

In the case of Adobe, I don't think one should panic about files not being able to open in the future. One thing Adobe has been good about is providing the industry with open standard formats. For example, the TIFF format has been around from the early days of digital imaging, and TIFF files that I created 20 years ago still open fine today, as do JPEGs of a similar vintage. Some variations of TIFF won't be compatible for some readers, but essentially, the TIFF file format has never been at risk of becoming obsolete. With the native Photoshop PSD file format, things are a little less certain. Any PSD file will open in the latest version of Photoshop, but not all PSDs created in Photoshop will be able to open completely in older versions of the program. This has been one of the concerns about the Adobe Creative Cloud. If you were to save files as PSDs in Photoshop CC and then stopped subscribing, would you be able to open those PSDs in whatever imaging software you had left to work with? At the very least you would be able to read the composite image data (providing backward compatibility had been enabled in the Photoshop File Handling preferences), but you wouldn't necessarily always be able to edit the layered content. The same would be true of TIFF. You would definitely be able to access the merged composite data and see all of an image but might not be able to edit all the layers. In short, you wouldn't be completely prevented from being able to view and access your files, but you might face some restrictions. And if there were no more Adobe? There will probably be some continued support for PSD, but I would say the TIFF format is more likely to survive the test of time.

Proprietary raw formats are more vulnerable because there are so many varieties out there. For example, the Canon CR2 format may share similarities across the range of cameras that use CR2, but the raw files from each Canon camera are distinctly different and only the latest software is able to read the newest variants. A number of different programs can read and interpret different raw formats, but as the number of digital cameras continues to grow, there must come a point where there will no longer be support for a specific raw format unless you are able to keep a computer system frozen in time. About 16 years ago I worked with another photographer, Adam Woolfitt, to review a number of high-end digital camera backs. These included products from manufacturers such as MegaVision and Jenoptik. However, to access the raw digital files today would require the proprietary software that was supplied

at the time, none of which would be able to run today on a modern operating system (although I do believe MegaVision still supplies the PhotoShoot software for Windows). This highlights the great weakness of proprietary systems.

The Adobe DNG raw format is essentially a subset of the TIFF standard and intentionally open source, meaning it is fully, publicly documented and adopted by more programs than just Adobe software. Here, I think it's more likely DNG will continue to be supported as a raw format, whether Adobe survives or not. Imagine a scenario in which Adobe went the way of Kodak, and let's say 50 years from now someone wanted to open a raw image shot using a Kodak DCS Pro14N camera: which would they be more likely to open, the proprietary DCR raw original or a DCR that had been converted to DNG?

Is it wise to upgrade immediately? It's a good idea to hold off upgrading until you are sure of all the ramifications. For example, the Mac OS update from 10.6 to 10.7 saw the end of support for all PowerPC (Carbon) applications. Anyone who at the time was still running Photoshop CS2 would have found their software would no longer open using the latest Mac operating system. At the same time, new operating system releases will inevitably have bugs that will have to be addressed in future releases. It is therefore always best to monitor the professional user forums for confirmation that a new system version is OK to upgrade to before switching.

SHOULD YOU RENT OR BUY?

When deciding whether it is better to rent or buy, you need to work out what is the most expedient solution. To work as a professional photographer you don't really need to own that much equipment, since everything can be rented as required. The downside, of course, is that renting can be expensive. If the equipment hire costs have to come out of your fee, there won't be much left over in the way of a profit on some jobs.

It is good to be disciplined when buying equipment. Purchase just those items you'll be using on a regular basis such as the camera bodies and your main lenses. Equipment you use infrequently is best rented on an "as needed" basis. You can look at it this way: a piece of equipment will incur a capital cost that comes out of your business profits. For as long as you own that equipment it will depreciate in value, as opposed to that money being invested—money that could otherwise be earning interest, or burning less of a hole in your overdraft, or spent producing more test shoots or promoting your business. In addition, you have to pay to insure the equipment you own and with bigger items, sometimes even pay for storage. So owning equipment you don't use often can work out to be quite expensive. Fortunately, it is very easy these days to sell equipment online via sites such as eBay, where the trade in photographic equipment is quite buoyant. Whenever I have looked at buying secondhand equipment on eBay, I've noticed that the eventual sale price is often not that

IT IS GOOD TO BE DISCIPLINED WHEN BUYING EQUIPMENT. PURCHASE JUST THOSE ITEMS YOU'LL BE USING ON A REGULAR BASIS.

much less than if I had purchased the same item new. For this reason, I have always been pleased with the prices I have achieved when selling online.

Renting on-site is a viable option only if you are based in a major city or are renting a studio where equipment hire is available. Having said that, the Borrowlenses.com website offers an equipment hire service from lots of locations on the East and West Coast in the US and can ship items to you. You'll need to factor in shipping cost and any insurance surcharges that are applicable. Another option is to lease equipment for a longer period, which, as was explained earlier, can be a tax-efficient way to recoup your costs, plus you have the option to buy at the end. Leasing also makes it easier to upgrade as the equipment you use is surpassed by newer technology. This can make sense on items such as a medium-format digital camera back or computer. By setting aside a regular amount to cover the lease cost of, say, a digital back, you can easily upgrade every three or four years without the hurdle of having to find a buyer for your old back to obtain the capital to buy a new one.

TRAINING

To get the most out of your equipment you need to spend time and money on training. The last 15 years or so have entailed a steep learning curve for photographers as we have all been forced to make the transition from film to digital. Some adjustments have seemed quite natural, but there are a lot of hidden features and bits of information photographers need to be aware of in order to make the most of the latest technology. New features are being added to cameras and software all the time, so it's a good idea to keep abreast of what is going on and find out if new tools can help you work more productively. To stay abreast of technology and techniques, if you have never had any kind of formal training you could enroll in a course or seminar program. If you make the effort to attend a photo event you are likely to focus on attending sessions and concentrate on learning. Not every seminar will be informative, but you should still pick up some useful tips. Books can be helpful, of course, as are websites that offer advice and movie tutorials. Webinars are very popular these days, too: online content is immediately available and the quality of online movie presentations is much better than it used to be. Another option is one-to-one training, where an expert teaches you what you need to know directly. This is great for people who mostly know what they are doing but need a pro to review their working methods and advise how they might do things better. Mail lists are a good source of tips and advice, too. Online communities such as these are often the best place to turn to when you have a specific problem, but they work best when everyone contributes. So, when you join a group you should be prepared to participate and help others as well. It's not good netiquette to ask for free advice but not be prepared to reciprocate.

IMPORTANCE OF DIRECTED TUITION

One of the arguments you hear these days is how the sales of books, both print and e-books, have declined because of the immediacy of being able to find answers to your questions online. No doubt this is true and Google searches can be very effective, providing you know which questions to ask. Discovering the answers to the questions you want to ask is one thing. Learning along the way the answers to the questions you hadn't thought to ask is equally as valuable. While the search engine is a terrific research tool, one shouldn't ignore the importance of directed teaching, whether this be in the form of planned coursework, a seminar, or a book or video series.

FILE SUBMISSION STANDARDS

In the early years of digital imaging photographers struggled to get their digital files approved by the prepress companies. It was assumed photographers knew nothing about the file standards required to meet prepress requirements. More specifically, photographers were mostly working in RGB and if they did edit in CMYK were using a generic CMYK space rather than a CMYK space specific to a particular press. Most of all, the prepress companies didn't like the fact that digital photographers were taking away their scanning business.

To be fair, the prepress companies were right to be concerned about maintaining quality. In a closed loop system the client would supply transparencies or prints, the prepress company would then scan these, and its internal scanner would generate prepress-ready CMYK files with colors the company knew were printable and that had the correct amount of print sharpening. By doing everything in-house, prepress had full control over the CMYK conversion process and could maintain quality control all the way through to the press. Once photographers started scanning their own photographs and were shooting digitally, the problem of how to integrate externally generated digital files of unknown provenance into a traditional, closed-loop system arose. A mistake made at the prepress stage could be very costly to resolve once the presses had started rolling. So it is understandable that the prepress companies were reluctant to accept files that could cause problems down the line. For many years this was a source of friction between photographers, prepress companies, and their mutual clients.

Color management

The fact is the whole situation was a bit of a mess. As much as photographers, designers, and their clients wanted to embrace digital, they couldn't always get it to work successfully because of the color management issues. A colleague of mine, Mike Laye, once achieved the dubious honor of the "most out-of-gamut color of the month" award from a prepress company for choosing a particularly bright green background color in one of his photographs. Then, during the '90s the International Color Consortium (ICC) participated in the development of the ICC specification, which led to the introduction of ICC profiles to describe the color characteristics of any color device. A Color Management Module (CMM) could then make use of ICC profiles to transform the color information between different native device color spaces.

Photoshop 5 was the first version to feature an ICC-based color management system, and it transformed the way photographers could work with color. Instead of editing photographs using a device-specific monitor RGB color space, Photoshop users could implement a device-independent full ICC color management system. This meant photographers could scan or capture in RGB and continue to edit in RGB mode while previewing and outputting to any desired CMYK standard. The

tools were there to make color management work outside a closed-loop system, but it took a while for this workflow to gain acceptance. If photographers were to be taken seriously they needed to train themselves to become prepress savvy. These days responsibility lies with the designer who works on the layout to ensure the work he or she supplies is properly color managed. But responsibility lies with photographers to make sure the photographs they supply are properly color managed, too.

Meeting press standards

You need to come to understand several things about color management. First, appreciate the nature of the problem. Why is it the colors you perceive in the original scene are not always the same as those you see on the computer display, in an inkjet print, or in what is eventually reproduced in the final print? Furthermore, you need to understand the importance of soft proofing in an ICC profile color-managed workflow, without which the colors you see on a calibrated display won't necessarily match the printed output. Whole books have been written on this subject, but here are the basic steps you need to take to achieve a good color-managed workflow.

WHY IS IT THE COLORS YOU PERCEIVE IN THE ORIGINAL SCENE ARE NOT ALWAYS THE SAME AS THOSE YOU SEE ON THE COMPUTER DISPLAY?

- Purchase a good-quality computer display capable of displaying a gamut that's close to Adobe RGB. Most standard LCD displays have a color gamut not that much different from the universal sRGB space. This is a constrained color gamut that won't be able to display all the colors that can be achieved in print.

- Get a decent display calibration device. This doesn't have to be an expensive purchase; these days a good display plus calibrator is really quite affordable. Use the software that comes with it to calibrate your display (or purchase a separate dedicated program such as basICColor).

- In Photoshop, select a prepress Color Setting (see **Figure 7.5**). You will see three different kinds: US, European, and Asian. Choose the one that matches where your work will be sent. Any of the Photoshop prepress color settings will configure Photoshop for prepress production work and embed and recognize ICC-profiled images. The only difference is the profile that is selected as the CMYK default. For example, the European Pre-press setting selects the Coated FOGRA 39 profile, which is the one typically used to match to on European presses.

- Get profiles for all the different media you intend printing to for your printer. This is a slightly more tricky step. When you buy an inkjet printer it may well come with canned profiles for a limited range of paper media. If you are going to use other papers, do an Internet search for profiles that work with that printer. Most inkjet paper manufacturers supply high-quality profiles for their products free of charge. All you have to do is download these and follow the installation instructions.

FIGURE 7.5 To ensure color management is enabled in Photoshop for prepress work, go to the Color Settings and select a prepress setting that matches the geographical location you are supplying the output images to.

- Appreciate the importance of soft proofing, as mentioned at the beginning of this section. If you follow all the preceding steps you should have a reasonably good color-managed setup. The colors you see on the display will allow you to work with a fair degree of confidence knowing that neutral grays will indeed reproduce as neutral gray and the luminance of the display should be correct for a good match when making prints viewed in a standard print viewing environment. Problems may arise when trying to match specific colors between what you see on the display and what you see in print. The reason for this is, the RGB display you are viewing the photos on will be capable of showing colors that cannot print and the inkjet printer you are working with may be capable of printing colors that can't be shown on the display.

- Following on from the last point, learn how to actually implement a soft proofing workflow and how to previsualize the expected output on the computer display before you make a print.

The first four bullet points are fairly essential and easy enough to grasp. Do these and you will be most of the way there to working with color photographs and preparing your images for client approval. The last two points are things you should at the very least be aware of. Understanding the relationship between the information shown on the computer display and what the printer is capable of printing will help you manage your expectations and understand why you shouldn't place too much confidence in what you see on the computer display as a representation of your final print output (even when you think you have everything calibrated). You can learn more about soft proofing from a PDF that's on this book's website (go to: Peachpit.com/photographers_at_work). If you are going to be responsible for the color files that will be supplied to your clients, you need to learn these skills.

Sharpening

All digital images require some degree of capture sharpening. When shooting in JPEG mode this happens automatically. If shooting in raw mode you need to let the software apply some default sharpening (which all raw processors will do), or modify the capture sharpening manually if the software will allow. Basically, all digital capture images and scans need some level of sharpening to look acceptably sharp on the display. You may not have even noticed this was going on because so often it is done by default, but you would certainly notice if the capture sharpening were disabled.

The other important factor you have to take into account is the loss of sharpness that occurs during the print output process. This is a separate issue from capture sharpening. Any time you are required to supply files for print, you'll need to sharpen again for output. A good example of this is where an image is destined to be printed in a magazine. Here, a photograph will need a fairly aggressive amount of output sharpening to prepare it for print, the objective being for the printed image to appear as sharp as it did on the computer display before you applied any output sharpening. The same is true when outputting a file to an inkjet printer or sending it off to a photographic printing service. The method and degree of sharpening is not exactly the same as that required for halftone magazine printing, but the principle remains the same. Basically, what you see on the display isn't a true representation of how the final printed image will look. The objective of output sharpening is to add an extra amount of sharpening to take into account the softening that occurs when printing so that the output image looks the same as the image on the display before output sharpening.

ANY TIME YOU ARE REQUIRED TO SUPPLY FILES FOR PRINT, YOU'LL NEED TO SHARPEN AGAIN FOR OUTPUT.

Automating the process

These considerations may seem complicated to newcomers, but the good news is these tasks can easily be automated. As I mentioned earlier, the color management system in Photoshop has been refined to make it a simple matter of selecting a prepress Color setting and you are all done. Most display calibration hardware devices

are affordable and easy to set up. Adobe programs like Camera Raw for Photoshop and Lightroom have a database of color profiles for most of the professional digital cameras in use today, and these are constantly being added to as new cameras are released. The Lightroom program contains print sharpening options to be used when outputting to a printer, to a printing service, or to a website. If you are looking for more guidance I can recommend two books written by my colleague Jeff Schewe: *Real World Image Sharpening with Adobe Photoshop, Camera Raw, and Lightroom* and *The Digital Print: Preparing Images in Lightroom and Photoshop for Printing*.

Supplying digital files that are acceptable for print

Much has changed over the last two decades. As I mentioned earlier, when digital capture was in its infancy and few photographers were working on digital images, there was a significant problem dealing with the repro and prepress companies. Digital imaging has become so accepted now that there has been no alternative but for the prepress business to adapt to photographers supplying digital files. The problem of RGB files of questionable origin and color space has largely been resolved through ICC color management systems being commonly implemented in programs such as Photoshop. It is now rare for a digital file to be received that doesn't have an ICC profile embedded to say "this is what the numbers mean" and therefore allow recipients to open these and view them the way the sender intended. It was a huge breakthrough but is now just accepted as how things should be. As a result many photographers send their files into a magazine without much thought, expecting the art department will know how to handle everything.

When I spoke to one of the leading photography magazines at Time Inc in London, staffers told me how the art department now checks everything that is supplied for print and they have the right equipment and know-how to manage submitted files and ensure these are all handled correctly. Fifteen years ago that just didn't happen. The onus then was on photographers to take total responsibility for the files they supplied. With advertising clients it is also the photographer's responsibility to supply a profiled RGB image at sufficient resolution for the art department to process. The end advertising usages will vary a lot from magazines to billboards to the Internet, so there is no way the photographer can tailor the file supplied for every kind of usage. With other kinds of jobs in which there is a single end product, such as a printed brochure, it is more likely the photographer will be required to supply press-ready files. When I handle these types of jobs, the first thing I want to know is where it's going to be printed and which CMYK profile the press is matching to. For European jobs this typically means using FOGRA 39. So in this instance I will then use the FOGRA 39 CMYK profile to create a soft proof preview of the RGB original. This is like a filter that lets you see onscreen what the RGB photograph will look like as a printed CMYK image. Soft proofing allows you to use a CMYK preview and adjust the image tone and color settings accordingly.

WITH ADVERTISING CLIENTS IT IS THE PHOTOGRAPHER'S RESPONSIBILITY TO SUPPLY A PROFILED RGB IMAGE AT SUFFICIENT RESOLUTION FOR THE ART DEPARTMENT TO PROCESS.

I will find out the size the final images need to be printed at and resize copies of the RGB originals accordingly using a resolution of between 220 to 300 pixels per inch. After doing this it is a good idea to sharpen the copy image for repro output. How much you sharpen can depend on the final line screen of the press and whether the paper stock will be coated or uncoated. There are sharpening plug-ins for Photoshop that can help you automate this process and apply the exact amount of sharpening required. One such is PhotoKit Sharpener from Pixel Genius. I should declare here an interest in this company, but PhotoKit Sharpener has proved very popular with other photographers working on press-ready files.

Lastly, I will convert the resized, print sharpened file to the requested CMYK color profile and supply this with a hard-proofed inkjet print. This is an inkjet print that's made from the soft-proofed version of the RGB image data printed using the correct media profile for the paper used, where, in the Hard Proofing section of the Photoshop Print dialog, the desired color matching CMYK profile is selected. Basically, this process reads the RGB source data, filters it through the selected CMYK proofing profile, and renders the RGB data using the known profile for the RGB inkjet printer. The result is an RGB inkjet print printed within the color gamut of the selected CMYK profile. So, the printer will receive a CMYK-converted image that's ready to print at the correct print size as specified in the designer's layout and will also receive a proof image printed using the CMYK profile that has been specified as the CMYK proofing space. This is generally known as an aim print, and most printers will be happy enough to receive something like this as a target to match to. This isn't the same as a certified match print, but for all intents and purposes near enough the same. If a client does request a certified match print, then this can be done by arranging for a proof print to be made from the CMYK press-ready file. This can get expensive, though, if you have a lot of images to print.

Some photographic studios are able to create their own certified proofs. This can be done by using a professional-quality inkjet printer running what is known as a Raster Image Processor (RIP), which is software that takes the image data and translates it to print data. It's an alternative method for printing photographs where you use the RIP software rather than the Photoshop and operating system print dialogs. Essentially, a RIP speaks directly to the printer, bypassing the regular operating system print pipeline. It converts the pixel image data into print data and provides a direct print head control using its own dithering routines. RIPs come with their own sets of high-quality profiles for most of the popular professional printers and papers. Some photographers swear by them for creating certified proofs as well as for making regular exhibition-quality prints.

File naming

It is also important that you name your files correctly. It matters that you are consistent in your naming approach and, if choosing to rename your file captures, do this early on in the production process. When renaming you should avoid introducing illegal, or nonregular, characters, such as a period within the filename. (While the file may still open, on some computers it might not.) It is also advisable to exclude spaces and use an underscore instead. One reason for this is that filenames that don't follow this strict convention may trip up an FTP server and prevent your files from being uploaded.

CHARGING FOR DIGITAL SERVICES

UPDATING EQUIPMENT, TRAINING, AND MAINTENANCE ARE ALL ADDED COSTS THAT PHOTOGRAPHY BUSINESSES NOW INCUR WHEN PRODUCING DIGITAL CAPTURES.

This is a difficult area for some people. To quote Jeff Schewe, "With the advent of digital capture, clients are under the delusion that everything should be cheaper, right? Hey, pixels are free once, of course, you've bought that $8K camera and that $5K computer system and all the other stuff you have to have in order to capture those free pixels." By rights you should be entitled to charge a digital capture fee, and there are good reasons why you should do so. For example, you have to take into account the cost of updating equipment, training, and maintenance. These are all added costs that photography businesses now incur when producing digital captures. Consider adding to this the cost and time that's involved when postprocessing and archiving the images you have shot plus the maintenance of a reliable backup system to make sure the files don't get lost. If you have no option but to accept an all-in fee, then fair enough, but know that you will struggle to keep up with the latest technical demands unless you are able to incorporate a digital capture fee as an added expense.

You can at the very least break down your digital services so that you are able to charge for making CMYK conversions, transferring files via FTP, burning discs, and, of course, doing any computer retouching work. I know photographers who have calculated the cost of supplying services like retouching by making sure the hourly rate they charge works out to be the same as what they would normally charge to do the photography. Since most jobs are likely to involve a fair amount of postprocessing computer work, you'll want to make sure your time is being paid for adequately, especially if these tasks are likely to take up a lot of your time. Not all clients accept the argument that digital capture is a legitimate expense, but I strongly urge photographers to factor this into their shoot budget when quoting for a job.

JEFF SCHEWE

SPECIALIZATION: ADVERTISING PHOTOGRAPHY
AND PIONEER IN DIGITAL IMAGING

In the mid-'80s, few could have grasped the significance digital imaging technology would have on the photography industry and the popularization of digital photography through the development of smartphones and social media. By the early '90s just a handful of professionals were testing the limits of what could be done digitally with home PC computers using, what was then, pretty elementary software, such as the first versions of Photoshop and Live Picture. Jeff Schewe was one of those who, out of necessity, got drawn into the world of digital imaging as a means to process his complex studio shots.

Schewe's first interest in photography began when, as a kid, his parents bought him a Kodak Box Brownie to keep him occupied while being dragged along with them on business trips. However, he soon got yelled at by his dad for using up too much film, which was expensive back then. Photography remained a hobby until he went to art college, where a lack of drawing skills drew him toward three-dimensional art. For a production of *One Flew Over the Cuckoo's Nest*, the teacher asked if anyone had a good camera and would like to take photographs at the dress rehearsal. At the time Schewe had a pretty decent Canon 35 mm camera and enjoyed directing the cast and lighting. Says Schewe, "I thought that was pretty cool. So maybe if I couldn't draw, I could photograph for a living?"

He dropped out of college for a year and worked at Fox Photo in Springfield, Illinois, selling photographic gear, where a customer suggested if he really wanted to learn about photography, he should go to Rochester Institute of Technology (RIT). "So I spent three years there and graduated with the highest honors and a bachelor's in science in photography," says Schewe. "The common thing after leaving RIT was to go to New York City and become a big famous photographer, but I decided instead to go back to my hometown of Chicago. Advertising in New York was in decline, but throughout the country it was on the uptake and secondary markets were becoming the leading edge in creativity. Rather than assist I got hired as a second photographer at a studio in Chicago, shooting for titles like *Better Homes and Gardens*, Sears, and a few of the ad agencies. As I got to know more people in the industry, I decided to become an independent freelance advertising photographer."

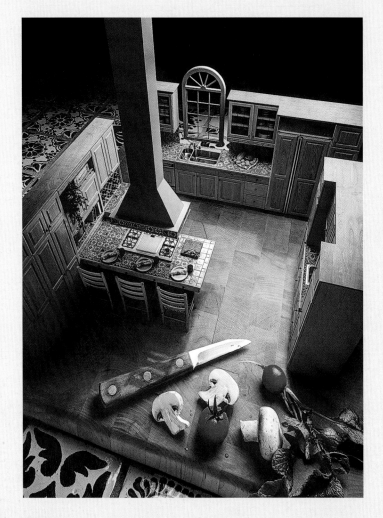

In the '80s there was pressure to specialize. You had to shoot fashion, or food, or still life, which was something Schewe rebelled against because he enjoyed all kinds of photography. But he had worked out how to create multiimage combinations either in camera or in the darkroom and ended up specializing in responding to tricky briefs. "Then, in 1984, an art director wanted to do a shot of a full-size kitchen positioned on a cutting block, so it looked like a bird's-eye view of a miniaturized kitchen," says Schewe. "We used a retouching company, Raphael Digital Transparencies Inc in Austin, Texas. I sent down the mocked-up layout with two 8 x 10 transparencies and she sent me back an 11 x 14 transparency. Part of it was retouched digitally and part of it chemically retouched, and I sat there looking at it with a loupe and thought to myself, well, this changes everything." For the rest of the '80s Schewe used digital imaging

as part of his arsenal of services, leveraging his experience and knowledge to shoot the individual elements and knowing how these could be put together on computer. But it was rather frustrating not being able to do the imaging himself. "I've never been great at delegating authority or responsibility," says Schewe. "It was also getting very expensive. One ad I worked on was for Budweiser and had four people rafting down the foam of a beer being poured into a glass. The whole thing cost $60,000 to produce, and about half of that was in computer retouching costs. There was a place in town where you could rent computers, which at the time came with Photoshop 2. I rented a IICi Macintosh on a Friday to do my first basic retouching job and worked straight through the weekend. There was one selection I had made 20 or 30 times and it wasn't until Saturday night I worked out you could save your selection work as a channel! By the time I was done with that job, I realized I had a lot to learn to really know how to use Photoshop, so I attended a Photoshop for photographers workshop up in Camden, Maine, at the Center for Creative Imaging, my first Photoshop class. For four or five days we had 24-hour access to workstations working nonstop. When I got back I told my wife, Becky, 'I need to buy a computer for a lot of money we don't have.'" So Schewe bought a Quadra 950 and ended up getting a big job, which actually paid for it before he had even gotten the computer. He very quickly improved with Photoshop and described himself as an image maker/assembler.

ONE AD I WORKED ON WAS FOR BUDWEISER AND HAD FOUR PEOPLE RAFTING DOWN THE FOAM OF A BEER BEING POURED INTO A GLASS. THE WHOLE THING COST $60,000 TO PRODUCE, AND ABOUT HALF OF THAT WAS IN COMPUTER RETOUCHING COSTS.

I CONSIDER MYSELF AN
'ARTISTE' AND HAVE NEVER
MET A PIXEL I HAVEN'T
WANTED TO MANGLE.

Meanwhile, the technological developments in digital imaging were all happening on the West Coast. Schewe had been online since about 1984, and every Tuesday night there was the Photoshop chat, hosted by a fellow called Kai Krause (who had developed plug-ins like Kai's Power Tools). It was here where all the "cool" people such as John Knoll, David Biedny, and Mark Hamburg would show up. Says Schewe, "That was the start of me getting to know the actual engineers and learning how to deal with them. I think in those early years of Photoshop, people like myself, Katrin Eismann, and others had an amazing amount of undue influence over the development of Photoshop as a tool set for us photographers."

Debates continue over what are acceptable levels of Photoshop retouching. "Personally, I consider myself an 'artiste' and have never met a pixel I haven't wanted to mangle," says Schewe. "In fact, my nickname used to be 'the chief pixel wrangler.' There is no limit to what I am prepared to do, because I am trying to create a hyper-realistic image that meets the attributes I dictate. I never felt any constraint. I do believe those fakey-looking Photoshop jobs suck. You look at it and it's like, 'What the hell were they thinking?' Well, clearly they weren't thinking. Human nature is such that with men and women, body awareness, self-loving (and loathing), there is a natural rejection of the synthetic appearance. On the other hand, it doesn't keep those people from buying those magazines, does it?

IT'S A VERY FINE-LINED
JUDGMENT IN AESTHETICS AND
ETHICS.

"It's a very fine-lined judgment in aesthetics and ethics. Part of it is that clients don't spend a lot of money on Photoshop retouching any more, and part of it is the great commoditization of digital imaging. When I first started, digital imaging machines cost millions of dollars. Now, you can get a Macbook Pro plus Photoshop for less than five grand. It's put digital imaging in the hands of almost anyone who wants it, and that's not always a good thing. If you are working in the sphere of photojournalism, there should be clear lines of demarcation about what you can and can't do. Unfortunately, photojournalists have done a very bad job of defining what those limits are. Anything that could be done previously in the darkroom should be allowed to be done digitally. You know there are photojournalists who seem to have rejected any kind of digital imaging. With some of the press photo competitions you have to submit a raw file so the veracity of the image can be checked. I am at the stage in my career where, because I am not a photojournalist or scientist, I don't need to worry about that stuff. But I am a member of the industry, so it concerns me. I have friends who are photojournalists and they are constantly frustrated by the fact the technology enables them to make images that in essence could never have been done on film, but now there are technocrats in charge that are trying to dictate with a very heavy hand what they can and can't do."

We have definitely now reached a plateau for sensor technology. "As new cam-
eras come out they are incrementally better in some manner," says Schewe,
"but the revolution is over and we are into evolution. Now that digital is in the
hands of more amateurs, I have a greater appreciation and respect for amateur
photographers at the moment, because if you look at the root of the word
'amateur' it's love (amore), and I see doing photography for the love of the art
as being more noble than doing it for money." Regarding the raw processing,
a lot has been accomplished, especially by Adobe, says Schewe. "Every time I
chat with Eric Chan and Thomas Knoll, they keep coming up with new things
to do for raw processing that extract even more information out of the raw
capture," says Schewe. "It's amazing what they have been able to accomplish
since 2003, but the rate of change is now going to slow down. Cameras have
made things so easy, there is a tendency to ignore the tech aspects. But if you

want to improve the quality further with the current technology you really need to go back to the fundamentals—things like what does an f-stop do in terms of depth of field? How fast a shutter speed do you really need? Newcomers coming into the business should pay attention to that."

The question then becomes, what do you need the images for? Says Schewe, "On the high-end I've got Canon SLRs and a Phase One. So I pick the camera best suited for the task at hand. For our 40th-wedding anniversary we went to Italy, where I took a little Sony RX100, rather than take my big camera (because I figured I wanted to have a 41st anniversary). And I've got really good shots from that, which could be used quite large. If it's merely for remembrance and snapshots, camera phones work just fine. In fact, it's amazing the image quality I can get with my iPhone 5s. If you want anything more you've got to invest in appropriate equipment. Yes, some smartphones can now shoot raw, but optics are still a limiting factor. For the vast majority of people who are not photographers, the camera phone's great. I do see people do the iPhone-a-day shots. And I look at that and think, 'That's great. Too bad it wasn't done with a real camera.'"

EACH PERSON WILL HAVE THEIR OWN COMFORT LEVEL IN TERMS OF HOW MUCH THEY DO IN CAMERA AND HOW MUCH IN POSTPRODUCTION.

Fundamentally, photography has always been this odd blend of art and science, and you can't have one without the other. "If you want to exert control over the final image, you have to exert control over the camera," says Schewe. "There is an awful lot of intellectual activity that goes on in creating a photograph. In the postprocessing there's an aesthetic that some people prefer to get right in camera, which is fine, but does that mean they don't do something in postprocessing? What's important to understand is, each individual person will have their own comfort level in terms of how much they do in camera and how much in postproduction. Don't let your panties get into a bunch about what you do when and where and for what purpose. The ultimate thing is not the camera or the process. The ultimate thing is the final image. What you had to go through and how you processed it: whether you spent one minute or ten hours working in Photoshop makes no difference to the viewer who doesn't know anything about the photograph. They don't care how hard it was or wasn't to do. All they care about is whether the photograph works at the final stage."

BUSINESS ADVICE

ONE OF THE HARDEST THINGS PHOTOGRAPHERS HAVE TO LEARN IS THAT THE VALUE OF AN IMAGE TO THE CLIENT REALLY DOESN'T HAVE MUCH TO DO WITH HOW DIFFICULT OR EASY THE IMAGE WAS TO CREATE.

Schewe's business advice to newcomers is simple. "Unless you are a government, the bottom line is to take more money in than you spend. You have to control your costs while maximizing your revenue. One of the hardest things photographers have to learn is that the value of an image to the client really doesn't have much to do with how difficult or easy the image was to create.

Photographers need to get past the fact it's fun and easy to do. They need to arrive at working out what the value of the image is to the client, and that's when you can really negotiate. I'm fine doing the estimates and negotiations and got to the point where I didn't need a representative. I'm not shy about demanding a high price. One of the biggest things I learned was knowing when and how to say no. For example, when clients are overly demanding, you can politely tell them you wouldn't be appropriate because the budget won't allow you to produce a job with acceptable production values in the turn-around time given to do a professional job. That always kind of freaks them out. So if they do go ahead and use someone else and something goes wrong, they'll remember that. And when they do have the budget, they'll come back to someone who is professional and handles things in a professional way.

"There are some areas of photography that constantly need refreshing, such as fashion, because every season there are new fashions and a need for new photographs. Same is true for food photography. Making people and food look good is a skill set that is in demand. It is important to have the willingness to be creative. Do things that are different from what other people are doing. If you can do that in such a way that your vision, style, and viewpoint happen to be attractive and in demand, you'll find you'll be hired for the right reason, because the client wants you to do the job, not because you happen to be the cheapest person on their list. So find out what you want to do and understand that as a professional you by definition, need to have professional standards and be businesslike in your dealings with people."

MAKING PEOPLE AND FOOD LOOK GOOD IS A SKILL SET THAT IS IN DEMAND.

Jeff Schewe Photography
Schewephoto.com

8

IN THE STUDIO

EQUIPMENT AND ALTERNATIVES

RUNNING YOUR OWN STUDIO

Virtually all photographers dream of owning their own studio—to have somewhere that's designed to meet all their needs that they can call home. However, over the last few decades fewer of us have felt able to justify the expense and running costs. Times are changing, yet some photographers still manage to run their own studio bases. These days you have to use your imagination and consider all the different ways you can meet the costs of maintaining a studio.

SHOULD YOU RENT OR BUY?

When setting up a studio, you need to take lots of costs into account. First, it depends on whether you are going to rent, lease, or buy. If you choose to rent you can rent a sublet studio space that belongs to someone else, such as a studio share or an office attached to a studio complex. This is the easiest and least risky way to get started, because you'll have the option to exit from the agreement and move out without having direct responsibility for the studio lease.

If you are looking for a studio space solely for yourself, commercial real estate companies list spaces you can lease. This implies more commitment because a lease will lock you into a specific time period regardless of whether your photography venture works out or not. As with renting, the property belongs to the leasehold or freehold owner. A studio space may typically require modifications in order to create a suitable working area. The cost of those renovations will therefore have to be recouped over the period of the lease, which may typically last just a few years. After that you may have the opportunity to renew the lease, but at what price? A client of mine took out a lease on a shop in Covent Garden, London, at a time when the rent seemed reasonable. However, at the end of the two-year lease he was asked to pay triple the rent he'd paid previously and had no choice but to close the business. When he took into account all the setup costs against the profit the business had made, he had only just managed to break even.

FINANCING A STUDIO PURCHASE

Buying a studio can be a good move, but only if you can afford to do so and you are able to buy in the right area at the right time and at the right price. While it's nice to own your own studio space, it should primarily be regarded as a business that has to pay for itself. Do it right and you might end up making a nice profit, as purchasing a studio can be a good investment for the future. I know a number of photographers who in the past were able to invest in rundown properties and renovate them. This step can be advantageous if you reckon you will be receiving enough income to make the studio pay for itself and the amount you have to pay to service the mortgage is about the same as what you would otherwise be paying in rent. If you are confident the property market will rise in your local area, this might be a good investment. However, there are two snags to this plan. First, you have to take into account the tax that may become due on the profit when you come to sell a business property. In the UK, you have to pay capital gains tax on profits made from a property that is not your main residence. This also assumes that the property market will continue to rise. As I mentioned earlier in Chapter 3, there is no guarantee that the current situation, where property values are outstripping inflation, can carry on forever.

The lending criteria when purchasing a commercial property are not the same as when purchasing an apartment or house. This is because the minimum loan to value (LTV) rates are usually lower compared with a residential mortgage, and the entry qualifications for buying are therefore restricted to those who can offer large down payments. However, there is the possibility you can use your pension or 401(k) savings to fund the deposit; consult your accountant if you're interested in that idea.

The hidden costs

The actual cost of the rent, lease, or mortgage may be the least of your concerns once you take into account things like business taxes, building insurance, and maintenance costs. In Chapter 4, I mentioned just some of the costs that will need to be taken into account when running a business. It is important to do a proper analysis of what the full running costs will eventually be before you take on a studio. Remember, you will be committed to a purchase or fixed lease contract period throughout which you'll be responsible for the mortgage repayments or rent. You also have to be aware that unless you are purchasing a designated live/work space, you won't be able to legally live in the studio, so you'll still need to be able to cover your regular household running costs on top of the costs of managing the studio.

CRAIG ROBERTSON

SPECIALIZATION: FOOD PHOTOGRAPHY

TABLETOP SETS

One area of photography that is thought to be doing well still is food photography. As with fashion photography, it is unlikely to be overtaken by computer-generated imagery. Also, so many people are interested in food these days, with lots of magazines, books, and TV programs on the subject. Craig Robertson is an established food photographer, based in Manchester, England. He specializes in shooting editorial, although he does do some advertising work. His view is that the food photography industry is currently doing OK. Says Robertson, "Like other areas of photography, the work is easily affected by the economic climate as you are seen as being at the luxury end of the market. When the '90s recession hit I had five book projects pulled all at the same time, which resulted in me losing about six months of prebooked work. This time around, the recession hasn't affected me as badly, fortunately."

A lot of Robertson's work is studio-based. As Robertson explains, "On a typical food shoot there will be around three to four people working on a job. A props stylist will bring props to the studio, but because they will have done all their work the day beforehand, once they have dropped everything off they won't need to stay around for the shoot. Most importantly, there will be a food stylist to create the food dishes, who may also have an assistant, and lastly, the client, of course." Robertson may also have an assistant, but it depends on the size of the job. "On big shoots it is important, especially when there are clients to take care of as well. Food stylists need a kitchen to work from, of course, so the studio must at least have that, but not all hire studios are as well equipped as one would like. Hence, food stylists tend to turn up with cars full of a lot of their own kit just to be on the safe side."

EVERYONE WHO SAW THESE PHOTOS KIND OF FELL IN LOVE WITH THE DROP FOCUS AND BLUE DAYLIGHT TINT.

A professional team will understand better how to pace everything on a shoot when working with a photographer, and as with fashion, food photographers have tended to follow certain shooting styles. Says Robertson, "For some time now the dominant request has been for the natural daylight look using a shallow depth of focus. This style was influenced a lot by the food photography in *Vogue Australia Entertaining and Travel*, which at one time preferred to commission reportage photographers to accompany the journalists and photograph the food served in a restaurant. Everyone who saw these photos kind of fell in love with the drop focus and blue daylight tint, and this seems to have

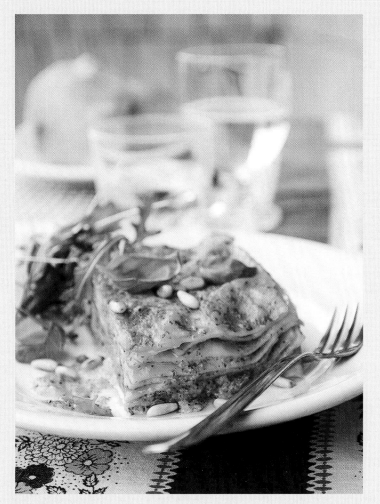

I SUPPOSE YOU DO BECOME
A BIT OF A FOODIE AND
KNOW MORE ABOUT THE
DIFFERENCE BETWEEN
WHAT'S GOOD AND BAD. IT IS
BOUND TO RUB OFF ON YOU.

stuck. Of course, it is easier to find lovely daylight in Australia, so when shooting in more unpredictable climates, such as the UK, the same look is reproduced using a combination of flash, tungsten, and fluorescent lighting."

Seeing lovely food being prepared every day must offer a lot of temptation, and it is quite remarkable that all the food photographers I've known (including Robertson) seem to have kept their waistlines under control. As Robertson says, "I suppose you do become a bit of a foodie and know more about the difference between what's good and bad. It is bound to rub off on you. With regards to waistlines, after you've stared at your subject for half an hour or more you really don't want to eat it."

His work does now include shooting people, which wasn't always the case. "Not so long ago a client would book a food photographer to shoot the food

IT CAN MAKE A DIFFERENCE WHEN PHOTOGRAPHING CHEFS—BEING A FOOD PHOTOGRAPHER YOU HAVE A COMMON CONNECTION BECAUSE YOU ARE BOTH IN THE SAME INDUSTRY.

and a lifestyle photographer to shoot the people, whereas now, because of budgets, or whatever, clients are more inclined to give everything to the one photographer," says Robertson. "And for me it makes a nice challenge to photograph portraits. The food industry has changed a lot over the last decade. Thanks to TV programs a lot of chefs have become celebrities. Being photographed for publicity shots is all part of their roll call, and they are used to it." This in turn has led to more opportunities to photograph chefs. One such example was when Robertson was asked to shoot Marco Pierre White for P&O Cruises (he has a restaurant onboard). "He was tough to photograph," says Robertson, "and clearly didn't like being there. But it can make a difference when photographing chefs—being a food photographer you have a common connection because you are both working in the same industry."

TECHNICAL REQUIREMENTS

BASICALLY, IF IT CAN ALL FIT ONTO MY SCOOTER, THAT'S ABOUT THE RIGHT AMOUNT OF GEAR TO TAKE.

For the studio shots Robertson uses a Phase One camera plus Capture One software. For location work the kit is far more minimal. He prefers to use a Nikon dSLR with a portable flash kit that has its own battery pack for ease of use. Says Robertson, "I'll take a tripod, but I prefer not to if possible. Basically, if it can all fit onto my scooter, that's about the right amount of gear to take. There is the temptation to upgrade because the quality just keeps getting better and better. However, at the same time, budget constraints are tempering everyone's ability to upgrade for the sake of it, and the camera technology has matured quite nicely now."

Robertson's initial interest in photography was in the photographic printing side, and having the computer is now quite exciting because you have again that opportunity to tweak and adjust, which you didn't have so much when

shooting with transparency. "Capture One is a program I have grown accustomed to," Robertson says, "and I find I use Photoshop less and less now. Capture One obviously plays an important role in making fine-tuned adjustments to get the desired result. Also, magazines don't pay anything extra for retouching work. The ability to make basic edits to the raw files at the capture stage is great because it doesn't add to the workload."

Robertson feels there is still work out there to be had, although clients have cut back on what they pay for photography and the fees are going down and have done consistently for the last few years. "They all want more for less," says Robertson, "which is hard to justify when everything else has gone up in price, such as the studio rent and equipment costs. Video is playing an increasing important role. To some extent it seems people just want to know you are ready and prepared to shoot video. There is a well-trodden path of food still-life photographers becoming directors for food commercials. Clients are now asking for video, as well as offering opportunities for food photographers like myself to direct."

Pie, written by Angela Boggiano and photographs by Craig Robertson, published by Mitchell Beazley.

Video interview with Craig Robertson.

Craig Robertson Photography
Craigrobertsonphotography.com

EQUIPPING A STUDIO

Assuming you already have a basic camera and lighting kit, the main things to focus on are getting the shell of the studio working. Most importantly, a studio space needs to be comfortable enough to work in and have all the main services such as electricity, water, and telephone. A studio will have to be comfortable enough for clients to work in, so it shouldn't be freezing cold in the winter or boiling hot in the summer. In the beginning you might rent a studio where the heating doesn't work, figuring you can always rent somewhere different next time and keep everyone happy. But if the studio you are permanently based in fails to impress, you'll risk losing clients. Basically, the space you create will need to have facilities that are comparable to those offered by regular hire studios.

Safety

You'll be legally required to ensure the studio space is safe to work in. The state of the electrical system must meet required minimum standards. If you plan to use high-powered cinema lights to shoot moving image work, you'll need to make sure the power supply is adequate and that you have installed an approved and fully tested electrical system. If the space hasn't been renovated for a number of years, you'll also need to do research to ensure it meets current fire, health, and safety standards. Are there adequate fire doors? Does the building require a sprinkler system? I remember shortly after the Association of Photographers took over new premises in Smithfield, London, they were informed double fire doors had to be installed on each of the four floor levels. It was a tall, narrow building, and the addition of these doors took up a lot of the available floor space.

Making a studio work

Separate the studio business from your photography business so that it becomes a rental service you can rent to yourself as well as other photographers. The downside of this is you may end up in a situation where the studio gets booked by someone else when you need to use it yourself and you'll have to hire another studio. But if this can bring in additional income, why not? Note that hire studio rental income can be classed as "other income," separate from the income you generate trading as a photographer. In the UK, such income does not attract National Insurance contributions.

A studio space can be more than just a place to shoot photographs. Consider alternative revenue streams and look at all other ways it can be used, such as for music or dance rehearsals, launch events, seminars, an exhibition space, or parties. I know one studio that used to rent its space out for after-gig parties, which worked well for them until it got booked by the Happy Mondays. All the above will be subject to conditions in the rental agreement, not to mention consideration for your neighbors.

There is no need to restrict the work you do to photography only. For example, with appropriate equipment you could run a custom printing business. If you have the right skills you could also offer retouching services, although this is getting harder now that photographers and clients have the choice of using cheap overseas services. But if you have the skills, and the equipment you use to do your own work is otherwise sitting idle, look at ways to extend the services you offer. For example, if you know how to do desktop publishing, you could offer a package deal that includes the photography and design. Now, in saying that, gone are the days when one could impress with a little knowledge of InDesign. If you are going to do this seriously I would recommend hiring a professional designer, but having a studio space to work from will make it easier to produce and oversee more ambitious projects. I've done this myself where I once produced a small advertising campaign for a major hair product company. I shot all the photography. I did the retouching myself and hired a professional designer to work on the layout. I then had to personally oversee the press proofs for each of the magazines where the ads were to be published and was able to charge for these additional services.

Another option is to share a studio space with another photographer. You can either share responsibility 50/50 and split the costs evenly, or one person can take on the lease and sublet to the other. In these situations it is best to ensure each photographer has his or her own office, ideally separated from the main studio area. Another common setup is for photographers to rent an office that's part of a photographic studio development. The benefit of doing this is you only have to pay for the office space, and renting the studio is convenient because you'll have all your personal equipment at hand. Working alongside other photographers can be a good thing because you'll be able to offer each other support, whether you need to urgently borrow some extra equipment or simply share advice. On the other hand, it is also good to be working alongside people whose work complements what you do rather than competes with it. So, if moving into commercial premises with several offices, it would work well to have say, a designer or video editor based next door to you.

THE HIRE STUDIO ALTERNATIVE

If you can't afford to run your own studio, a good alternative is to rent on a short-term, daily basis. The benefits are that you don't have the full-time financial responsibility of maintaining a studio. You are not tied down to one geographic location and can freely move about from one city to another. Most clients are willing to pick up the studio hire fee costs, and these can be charged out like any other expense or billed directly to the client. You can also choose different studio locations according to what your shoot needs are. One may have great daylight shooting potential, another offer lots of space, another a good budget rate. Hire studios can provide you with that flexibility.

On the other hand, not having a permanent home can be a drag, especially if you get busy. You will forever have to move your own personal equipment back and forth between different hire studios. You won't be able to personalize the studio space with your own props and other items, and you will have to pay hire fees every time you want to shoot, which can make shooting test shots and carrying out personal project work quite expensive. Also, like rental cars, hire studios come in for a fair degree of punishment. I used to hire a place in North London and on one occasion arrived to find the floor of the studio I had booked was ruined. The photographer the day before me had let off Catherine wheel fireworks as a background effect for the band he was shooting. Needless to say, he wasn't allowed back after that.

Hire studio policies vary, but you'll mostly find everything is chargeable, even the loan of a stepladder. In fact, the degree to which some studio businesses charge for extras can be quite offputting. For example, it's nice to have a biscuit to go with your coffee without being charged for a whole packet each time.

The main downside is the uncertainty of not having a permanent base. Last-minute jobs are always going to be demanding, especially if all your favorite rental studios are booked on that day. There is also the uncertainty of not knowing what to expect. These are usually busy places where there may be several studio spaces within a single complex, and you never know from one day to the next who will be shooting in the studio next door to you. Often that's the fun part because you may get to meet up with friends working on other shoots or meet new contacts. But you never know when you'll have disruptive neighbors. On one shoot I did, a photographer in the same studio complex was working on a "back to school" clothing shoot for kids. But it so happened that in the studio next door to his, a pornographic video production company was holding a noisy casting session, and the only thing that separated the two was a canvas backdrop. Another time a TV commercial was being shot in the studio below the one I had hired. The studios in this case were in an old warehouse complex where the slightest movement would disrupt the sound recording. It didn't help that the main star of the ad was Oliver Reed. In the end we obliged and kept quiet long enough for them to record the dialogue, but they really should have booked a proper sound stage.

Efficient usage

When using hire studios, every hour is chargeable. Therefore it is crucial to get the day started swiftly. It helps to make the studio hire company aware in advance of any special items you need—even down to basic things like mains extension leads. You can otherwise waste a lot of time at the beginning of a shoot day requesting specific items. You ideally want everything you need to be there in place ready to set up and get the shoot rolling. Studios will usually send out a booking confirmation sheet beforehand that you can use to clarify which equipment you'll be requiring. The larger studio complexes tend to have everything in store, so if there is an unusual bit

of lighting or a special photographic accessory you need, you can get it at a moment's notice. The smaller, independent studios may be cheaper, but I find you tend to have to order in more equipment than you actually need, because the studio will be unable to provide instant support.

THE SMALLER, INDEPENDENT STUDIOS MAY BE CHEAPER, BUT I FIND YOU TEND TO HAVE TO ORDER IN MORE EQUIPMENT THAN YOU ACTUALLY NEED.

If you have to go into overtime you will be penalized, as the hourly rate will increase once you go beyond the normal booking period. It's not unreasonable to be charged overtime, and it can also be a disciplining factor that prevents studio shoots from running late unnecessarily. If this is down to the client adding on extra shots to a job, you can legitimately pass these charges on to that client. You will most likely also have to pass on the overtime costs for other crew members as well as for your own fee. If the delay is down to you, then you have a problem. The client won't want to incur overtime costs, and because everything gets more expensive after 6:00 p.m., every half hour extra will eat into your profit margin.

One way to protect yourself is to add a contingency to the budget that can cover you for such eventualities. The other thing you can do is learn how to plan your shoots so they all run smoothly and don't overcommit on the number of shots you have to produce in a day. Clients will pay the contingency money if they have to, but it looks more professional if you don't need to use it. It looks even better if your final shoot invoice shows you were able to make a few small savings. Say you budget so much for lunch and other extras and the final expenses come in under, you can afford to charge the client a lesser amount on the final bill. When you work with a client regularly, little things like this help build trust.

CLIENTS WILL PAY THE CONTINGENCY MONEY IF THEY HAVE TO, BUT IT LOOKS MORE PROFESSIONAL IF YOU DON'T NEED TO USE IT.

SPECIAL EFFECTS

Around the time that digital image retouching first became readily available, there was a lot of interest in computer generated images (CGI). Studios that used high-end systems started to produce some very interesting CGI work (this was back in the late '90s). As with image retouching, the software and technology are now within reach of many and are put to regular use, especially in film and advertising. In the early years there were concerns that this technology might signal the death knell of traditional photography. CGI work has come a long way. It won't ever replace all types of commissioned photography, but there are certainly times where it allows you to achieve what would otherwise be extremely expensive, if not impossible to create in real life.

I know a few photographers who have gotten involved in CGI work and developed this as a sideline to their regular photography careers. It makes sense that photographers should be getting into this, because we understand better than anyone how to control lighting and make such images look photorealistic. In the following interview with Carl Lyttle and the accompanying video, he explains in detail some of the techniques he uses in his automotive photography, which includes CGI.

CARL LYTTLE

SPECIALIZATION: AUTOMOTIVE, CGI, AND
LANDSCAPE PHOTOGRAPHY

EARLY CAREER

In a fast-changing industry, few of us can predict how our career trajectories
will be mapped out. In the case of Carl Lyttle, he came to specialize in automo-
tive photography as a result of a combination of his digital imaging skills and a
passion for landscape photography.

Lyttle grew up in Belfast, where as a teenager during the '70s he was heavily
into the punk music scene, following bands like the Undertones and Stiff Little
Fingers. He would have liked to have been part of the music scene himself, but
realizing he wasn't going to be able to do so as a musician, got interested in
photographing gigs and soon became known as "the kid who has the cam-
era." After finishing A-levels, he took up an apprenticeship at Anderson Meakin
Photography, where he acquired a lot of technical skills and had the chance to
shoot a few PR jobs himself. After a while Lyttle longed to do something more
creative. Says Lyttle, "I couldn't see that happening if I stayed in Belfast, where,
apart from anything else, I was fed up with the whole political situation, which
I couldn't see changing any time soon."

Lyttle chose to go to Bournemouth because of its strong reputation, and it
was there during his third year that he did an internship working with Chris-
topher Joyce, who fortunately happened to need a new assistant. Says Lyttle,
"He was a very funny character and so lighthearted about everything. I think
that's what endeared him to everyone. His passion was huge. He also taught
me a lot about archival black-and-white darkroom printing, such as how to
make cyanotypes, salt prints, and calotypes." Joyce's approach to photog-
raphy taught him a lot about the business. As Lyttle says, "One of the things
I took from Chris is that on a job the work comes first, but you have to get
along with everyone on the team. If you don't surround that commercial envi-
ronment with a bit of lighthearted fun or distractions, like restaurant dinners or
going to a show, it can become quite monotonous and intense sometimes."

When Lyttle set up on his own he initially photographed still-life subjects,
working out of his studio in Soho, London, where he was also an early adopter
of digital. As he explains, "I thought then it was expensive, but if I don't do it
somebody else will and I'll start to lose out commercially. I started looking at

IF YOU DON'T SURROUND
THAT COMMERCIAL
ENVIRONMENT WITH A
BIT OF LIGHTHEARTED
FUN OR DISTRACTIONS,
IT CAN BECOME QUITE
MONOTONOUS AND INTENSE
SOMETIMES.

the digital cameras that were around then and got involved with the Digital Imaging Group. I remember we were all thought of at the time as being nerds, and a lot of the agencies didn't want to touch us. They didn't think photographers had the ability to understand the digital processes, or color gamuts. They didn't think that was the photographers' job. Now look where we are now as an industry. Personally, I think if you don't take any risks in this business you can't move forward. Sometimes the risks are stupid, but you learn by your mistakes. Ultimately it's by taking risks you get from that point to this point."

I THINK IF YOU DON'T TAKE ANY RISKS IN THIS BUSINESS YOU CAN'T MOVE FORWARD.

AUTOMOTIVE PHOTOGRAPHY

The car photography came about because an art director liked his landscapes and wanted to stick a car in one of them. This was back in the days of cut and paste. The result was crude, but it was a job that led to him getting out of the studio more. These days his work is mostly all car photography. "I do a few little side projects for Fender guitars," says Lyttle, "which takes me back to the Belfast legacy of my music days, but it's now almost entirely automotive and CGI. The golden word these days is 'budget', because everyone decides what they can do with the money they have. Compared to six years ago, clients now want twice as much in half the time for 75 percent of the budget. That puts huge pressure on everybody through the whole process—how I and my staff have to work and have our timelines absolutely in sync with each other."

There are still some commissions where a photographer will be given a car (or "piece of metal," as Lyttle likes to call it) and shoot for real, but those instances are increasingly rare. "It's also very expensive," he says. "You have to get a prototype sent out to the location, plus there are all the security issues. The last time I shot a real car was two years ago. I'm quite sad that it's all changing, as it's good to do some of those traditional shoots. It pushes you back to basics as a photographer because you have to use your skill sets and your intuition to see things like watching out for the reflections on the side of the car. I really used to enjoy those kinds of jobs."

CGI WORK

TO MAKE THINGS APPEAR REAL IN CGI LAND YOU HAVE TO HAVE THE PHOTOREALISM AND YOU CANNOT DO THAT UNLESS YOU HAVE THE MEANS TO PUT THE REFLECTIONS OF THE SCENE BACK INTO THE CAR.

As Lyttle explains, "These days what typically happens is you get a brief to shoot on location and shoot as normal, but without the car in the shot. I'll find a scene that I would normally put a car into and then imagine the space around that, using my experience as to how a car would fit in that scene regards the location, time of day, and light. The clients will then send over canned data of the car. This is a 3D model that arrives as a wire frame and is usually the same data that's used to manufacture the car. However, this will be repurposed for commercial use, which means they take out all the tiny details like the nuts, bolts, washers that are hidden in the door panels and strip it down to just those assets you can see externally and internally. When photographing on location, three-dimensional target frames have to be placed in the middle of the scene, where the car is meant to go. It is then a case of waiting for the right light and shooting as you would do normally. The reason for having the target in the frame is because at the postproduction stage you have to reimagine that scene in 3D space.

"I will later be able to take the lens information and the distance from the camera (which will already have been noted), and use this to align the wire frame data from the car with the target. The target allows us to take the 3D version of that target and exactly align it on top of the 2D version of the 2D traditional target plate. The next stage is to shoot a light map. Basically we shoot a 360-degree HDR image within the same space where the target was [where the car would be] to produce a light dome image. To make things appear real in CGI land, you have to have the photorealism and you cannot do that unless you have the means to put the reflections of the scene back into the car. It's not a case of, 'Let's make the car a mirror and reflect the background.' It's much more detailed and deep than that because it takes into account the ambient light settings and allows for ray bounces between the object and the background and works out how the shadows should look. 3D programs cannot work without this information, as it would otherwise make everything look like a cartoon.

"The final step is to texture and shade the car to make it look as close to the real thing as possible. In theory it should be quicker to shoot just the location scenes without the car. Clients do tend to think, 'We've got this 3D object, so let's just send a photographer wherever they are going, get them to shoot lots of things, and we'll make the pictures at the end.' The reality is that the constraints of the location shoot process are exactly the same as when shooting a scene with the car. You still have to wait for the optimum light, which limits shooting to early morning or late evening. There's no point trying to cram extra shots in because the light won't be in the right place. If there are people involved and it's complex, then it will be just one shot a day like the old times. If we are in an interior warehouse type of scene, say, we won't be dependent on the daylight and we'll be able to control the lighting. Clients will want you to shoot as much as you can get out of that location. There are even some commissions where everything is a studio CGI build and no photography is involved at all."

The equipment Lyttle uses depends on whether he needs to shoot a car for real or the location only. A lot of the time he'll go to Barcelona, primarily because of the weather. For a regular car shoot a car rig will need to be transported there in a van along with a whole digital setup including computers and monitors, plus lots of tripods and extension poles for shooting high

IF YOU DON'T GET ON
WITH THE PERSON YOU
ARE GOING TO SPEND TWO
WEEKS WITH IN THE MIDDLE
OF A DESERT, THERE IS
ABSOLUTELY NO POINT IN
THEM COMMISSIONING YOU.

up in the air. If it's location only, he and his crew take just the computer gear, cameras, and tripods and mainly shoot using a 60 megapixel Hasselbad H4D plus a Canon 5D MkII to capture the light dome images. For long-distance trips where everyone has to fly, it's not economical to travel with too much kit. This isn't usually a problem since most of the places you go have pretty much everything available to hire. Says Lyttle, "I have a very strict process, and my assistant, Dan, has been with me for an untold number of years. He takes the whole process out of my hands now and I don't need to double-check because he is on it, so I have that great trust. That's an important issue: you need to have an assistant who totally knows what you are about and vice versa." The relationship between the photographer and the art buyer and art director is also vital. As Lyttle points out, "If you don't get on with the person you are going to spend two weeks with in the middle of a desert, there is absolutely no point in them commissioning you, no matter how much they like your work. If there is an open dialog and sharing of knowledge it's like building blocks of an image. I think if photographers are too insular, then their shots will reflect that."

MOOFE

As Lyttle developed the skills necessary to create car images using CGI techniques, this highlighted the fact there was a gap in the image library market for landscape plus high dynamic range dome images to produce product shots, such as car images set in photographed landscapes. This is where the idea to form Moofe, which he cofounded with photographer Douglas Fisher, came from. "We both noticed how people were trying to get into CGI but didn't have the right assets, so we came up with this out-of-the-box solution," says Lyttle.

"It's come of age as we have got people to know what we are about and build a reputation. Because we are both photographers we know how to deliver a really high-end product that clients want. We have now maybe 30,000 to 40,000 locations, and each of those can have anything from 10 to 100 images. We approach each location as if it were a shoot for an agency and cover every possible angle a car could sit in that scene." Some of Moofe's clients want exclusive terms and are prepared to pay for them because they can't afford their competitors to have that image running at the same time. Most clients, though, choose set terms, set territory, and a set media usage.

LANDSCAPE WORK

The landscapes are all personal photographs, yet play an important role in supporting the commissioned work. As Lyttle explains, "I find the landscapes are for me more an expression of how I feel. I love the big open landscapes of America. There is a definite crossover, though, between this and the paid work. When you go to an agency to get some work, if you have a book full of landscapes, nobody is going to touch you. If you have a book full of cars, nobody is going to touch you. But if you have half beautiful landscapes and half car shots, it works. For me it is a momentum process. The commissioned pictures allow me to take the personal pictures, which are what art directors want to see, because they want to see your expression."

WE APPROACH EACH LOCATION AS IF IT WERE A SHOOT FOR AN AGENCY AND COVER EVERY POSSIBLE ANGLE A CAR COULD SIT IN THAT SCENE.

Each year Lyttle also produces a nice midsize coffee table book of landscape photos he has taken that year and sends these out as Christmas presents. "Clients love to receive them," he says. "They are good from a commercial point of view, and it's good for me personally. There is something Chris Joyce once said that has always stuck with me: 'The minute you take the pictures just for money is the day that you should put your camera down and walk away from it.' I like to give myself a week on my own to get that head space I like, and find it really exciting coming back with new images."

ADVERTISING AND PROMOTION

Lyttle regards the website, supported by subscribing to various web portfolio services, as the main shop window for the photography business. Says Lyttle, "Lürzer's Archive is very important with senior art directors, who refer to that a lot. Production Paradise is good because you hear about art directors who say that they've come across your work via that site. When it comes to being shortlisted for a job, clients expect first to see a PDF of sample images tailored for the prospective commission. They also want a treatment, which never happened in the old days. However, clients will still expect to see a traditional print book. Art directors are by definition purists, and they like to see how you wanted the picture to be displayed."

FUTURE OF THE INDUSTRY

At the high end, CGI imaging is now good enough to replace a lot of traditional still-life photography. "I don't think it will ever totally replace it, but it will certainly affect a good 90 percent of the market," Lyttle says. "As commissions are driven by budgets, it is inevitable the CGI route will be chosen as an alternative to what would otherwise be too expensive to shoot for real, plus it can be quicker. I think in some areas of the industry, CGI has completely taken over and decimated things like still-life studio and product photography. For example, to photograph bottles of wine a studio photographer would once have been given the task to set up and shoot them for real either on film or digital. Now all you need is a wire frame of the bottle and labels they can UV map onto the bottle. They have some 3D whiz in their bedroom that is doing all the work for them."

Lyttle adds, "Since the recession I see photography grouped into three sections. There is the low end of the market, which handles the PR side of things—the handshakes and business portraits. Then there are the midground people who were doing lots of work for design groups. Then there is the high-end advertising. I think the middle ground is shrinking, which has naturally happened as a consequence of the recession. It's happened for a number of reasons. It's because art directors are now better at Photoshop than we are, quite frankly, and they are now also really good at using cameras and have digital SLRs just like the ones we shoot with. People now know what a good picture is even though they don't necessarily understand the process. Consequently, it's stripped out that whole midsection of the industry, which I don't think will ever come back. The guys doing the handshakes are still doing what they do, and for us guys doing the car brochure work, it's business as usual. But those midlevel photographers can't get work because there just aren't those kinds of briefs coming out of the agencies anymore. They have all ended up diverting their careers a little bit to find something new to do."

As for the future of the industry, Lyttle points out, "I think it is changing and will change radically. Look at the younger generation, who are engrossed in tablets and social media. I don't think any of us know where this is going. That will come out naturally in time, but as a photographer, I think it's really difficult to say right now. Photographers starting out now in the industry have to have firm convictions about what it is they want to achieve. You can't be a jack-of-all-trades. You need to do what you are passionate about and go deep into it as an image maker. And I use that term because photographers now need to know moving images and photography. The days of just being a photographer have gone. You need to be able to shoot and edit video, be aware of sound, social media, how to purpose all of your images to all of these formats, and know about color spaces for web and print production. It's now a much more in-depth process than when I first started out."

Interview with Carl Lyttle.

YOU CAN'T BE A JACK-OF-ALL-TRADES. YOU NEED TO DO WHAT YOU ARE PASSIONATE ABOUT AND GO DEEP INTO IT AS AN IMAGE MAKER.

Carl Lyttle Photography
Carllyttle.com

Moofe
Moofe.com

BOB MARCHANT

SPECIALIZATION: HIGH SPEED LIQUIDS, DRINKS FOR ADVERTISING, AND SUPERYACHT PHOTOGRAPHY

PHOTOGRAPHING LIQUIDS

"I'm not as yet an artist; I'm more a sort of craftsman, a table maker. I make things people can use and solve problems." So says Bob Marchant, who, like Carl Lyttle, came from a traditional photography background and embraced digital technology at an early stage. These days he mostly specializes in creating special effects images, photographing high-speed liquids for advertising clients.

Marchant's photography career started when he got a job at Morgan and Swan, where he assisted two photographers: Angus Forbes, who shot still lifes, and Phil James, who was a beauty and fashion photographer. After eight months he decided to spread his wings and went to the London College of Printing (as it was known then). To cover his living costs he used the college facilities to photograph book covers. Says Marchant, "I photographed all sorts of subjects: dead bodies on train lines, dead bodies in the sea, men on fire. Glasses with bullet holes in them—it was a great grounding in photography. By this time I also had an agent called John Spencer who taught me how it was important to take in everything and feed it into what you do. After leaving college I got a full-time job in a photography studio that did everything, which was a good experience learning how to run a business in someone else's premises."

Finally, in 1974, he set up his own studio in the basement of a pub in World's End, Chelsea. After that he moved to a bigger place in Camden, then back to Chelsea, where he purchased a little old sculptor's studio that he refurbished. As the business grew he began to shoot commercials, which required bigger sets, so Marchant bought 3,500 square feet of industrial space in King's Cross. Says Marchant, "I spent six month's intense work rebuilding and renovating it to turn it into a usable studio and another two years refining it. And then there was a knock at the door from British Rail to say they were going to compulsorily repurchase the studio as part of plans for the Channel Tunnel rail terminal. Four years of litigation followed, by which time I had been working my nose to the grindstone for about 16 years and thought it was time my wife and myself took a sabbatical. We spread our wings and went to California for a while to see what the market was like, especially with moving images, because I knew a guy running a production company there. But then I spotted a little ad in a magazine saying, 'Sail the world: no experience necessary,' which, after some

I'M NOT AS YET AN ARTIST, I'M MORE A SORT OF CRAFTSMAN, A TABLE MAKER. I MAKE THINGS PEOPLE CAN USE AND SOLVE PROBLEMS.

persuasion, my wife and I did. It proved to be a real game changer in working out what really is and isn't important."

Marchant continues, "A year later we went back to LA. This was when the digital thing started kicking in and getting quite interesting. There was an evening class at UCLA in Photoshop and Macromedia Director. I did this course for six months before heading back to the UK full of the joys of digital. Initially I started out renting scanning backs and did all my own Photoshop retouching before buying a second-generation Sinar 23 back with a 6 megapixel chip. Shooting digital these days seems routine, but back then it was a game changer because it gave you much more freedom. Rather than have to wait two hours for the 10 x 8 sheets of film to be processed to see what you had got, you got to see the results immediately, which gave you the chance to experiment. You could get the brief signed off and in the can and had a little bit more time at the end of the day to go wild and do something more exciting, which we did."

SHOOTING DIGITAL THESE DAYS SEEMS ROUTINE, BUT BACK THEN IT WAS A GAME CHANGER BECAUSE IT GAVE YOU MUCH MORE FREEDOM.

THERE IS A CERTAIN
HOMOGENIZATION OF
BRIEFS BECAUSE THEY
GO THROUGH SO MANY
ITERATIONS OF APPROVAL
WITH CLIENTS AND WITH
THE AGENCIES.

As for the work he does now, "the commissions these days come mainly from ad agencies," says Marchant, "but also design groups for drinks shots that are used for packaging. The preproduction can be anything from half a day to two weeks. Even with the smaller jobs, we are finding there can be lots of preproduction meetings now." Given the current financial climate, Marchant finds there is a certain homogenization of briefs because they go through so many iterations of approval with clients and with the agencies. It sometimes takes the edge off what could be a more exciting shoot. And it's our job to then bring it back to what was originally envisaged. The advantage of digital is that you can afford to get that shot done and then push it a little bit further. Not just in the image capture, but also in the postproduction, just to bring a bit more to the table."

Despite this, challenges still crop up. "We just did a shoot for iced tea," says Marchant, "which featured a simple shot of a glass with fruit in it, but once we had read all the storyboards and gone to preproduction meetings it became much more complex. It was actually a whirlpool inside a glass with perfect proportions of fruit. Some were to be in the liquid, some out of it, and all

shown at just the right angle, plus a perfect pour of honey going into the top of the glass. What appeared at first to be a simple brief sort of expanded into something that was hugely complex. The fun of doing photography like this is that just when you think you have got there and got it cracked, there is always the demand for that little bit extra. When those challenges are thrown at you, the answer is to throw everything at it. To pull this off successfully can give you a huge sense of satisfaction."

Regarding image usages, Marchant reckons, "We have had a good run and have a very trusting relationship with our clients. There is always a certain discussion to be had on licensing and buyouts, but we have always retained copyright effectively and licensed images as they are used. It is becoming increasingly difficult for people to do that, but it is the mainstay of lots of photographers' work, and it is the thing that keeps the wheels turning."

COPYRIGHT IS THE MAINSTAY OF LOTS OF PHOTOGRAPHERS' WORK, AND IT IS THE THING THAT KEEPS THE WHEELS TURNING.

STORM IN A BOTTLE

The Talisker whisky shoot is a good example of how every job brings its own little challenges. With this one it was how to create a storm inside a whisky bottle. Says Marchant, "My colleague Chris Gonta and I came out of a pre-production meeting wondering, how the hell are we going to do that? This was after having just assured them it would be absolutely no problem at all. The key was to deconstruct the shot into separate components. We started

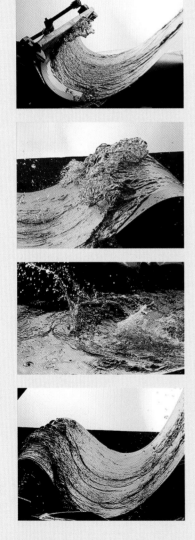

by photographing an empty whisky bottle to get the hero shot. We knew we couldn't get that huge sweeping wave, so we tried things like oil and water in a small tank, but in the end we just went for scale. We built a large retaining pool made out of scaffolding boards and pond liner that was about 12 foot square. We got some sheets of flexible PVC and made formers out of timber to make the shape of the inside of the wave and one the shape of the top of the wave to make that classic curve and then resorted to using buckets of yellow water that was meant to look like whisky and throwing them into the inside of this wave structure. From this we built up a series of shots of curling water." By carrying out all the retouching in the studio they were able to construct the shot as they were shooting it.

As with all projects, it went through several variations. Says Marchant, "We started with a big storm and big waves and smaller waves. We changed the background colors, but we had built up this library of stuff that we knew would work. The cost was minimal in terms of the set building apart from a couple sets of trainers (which are now bright yellow). It's that thing of never having a preconceived idea of what you are going to do. You know you can do it, but you just have to throw lots of stuff at it. We have a little workshop in the studio and I have got one here at home for experimenting. You can just construct stuff as you go along rather than being reliant on one briefing with the model maker."

Marchant has tinkered with CGI effects to see if they can replace "doing it for real." "A year or so ago we shot a wine," says Marchant, "and they wanted to use CGI to form the splashes of the lettering spelling out the name of the wine. They insisted on us using CGI and had a budget to match. So we bought Maya, studied it for a week, and worked out this wasn't where we wanted to go. So we shot the beginning and end frames in the studio and out-sourced the CGI work. It came back perfect, but it was just too perfect and the result wasn't quite there. The client asked if we could add a little more liquid at the end (real liquid) to make it look like it had come out of the box, as it went into the glass. I think by the end of that week we had covered the entire CGI model with splashes of wine that had been shot for real. So we ended up using it more as a frame. I think CGI has a great future, especially for product shots, but what it doesn't have is that ingredient of randomness. It will get there, but for now we are still chucking buckets of water."

LUXURY YACHTS

Another side of Marchant's business is working with his partner, Chris Gonta, photographing luxury yachts. Marchant explains, "There are two distinct markets: the chartered boat market where the boats are intended to be seen and

THE COST WAS MINIMAL IN TERMS OF THE SET BUILDING APART FROM A COUPLE SETS OF TRAINERS (WHICH ARE NOW BRIGHT YELLOW).

CGI HAS A GREAT FUTURE, ESPECIALLY FOR PRODUCT SHOTS, BUT WHAT IT DOESN'T HAVE IS THAT INGREDIENT OF RANDOMNESS.

marketed, and the private boats where client confidentiality is important. We have to be very discreet in the way we work. Some of the boat photos we take will never see the light of day apart from by the yacht designer and the owner. We have to be very careful who we tell and where we are going and what we are shooting, and thankfully, we are trusted in that and it's become a very good market for us."

Marchant and Gonta do get to go to some fabulous locations, but as always, the glamour is not quite as it seems. They sometimes have to spend 12 to 15 hours each day shooting inside the yachts. One of the rewards for this, though, is doing the helicopter chase photography, which means putting a harness on and chasing boats while hanging out a helicopter. Says Marchant, "On a recent shoot we had to photograph a boat at its maximum cruising speed being followed by its own helicopter with two of the tenders, plus jet skiers in the water all at the same time. In the helicopter I had a set of headphones that connected me to the skipper on the boat, a handset to speak to the guys in the tenders, another one to the helicopter to coordinate everything. So you are planning everything in all these dimensions so that one frame comes together, and that's tremendously exciting and loads of fun. The helicopter pilots that we use are not reckless, but they do push the envelope to a certain degree."

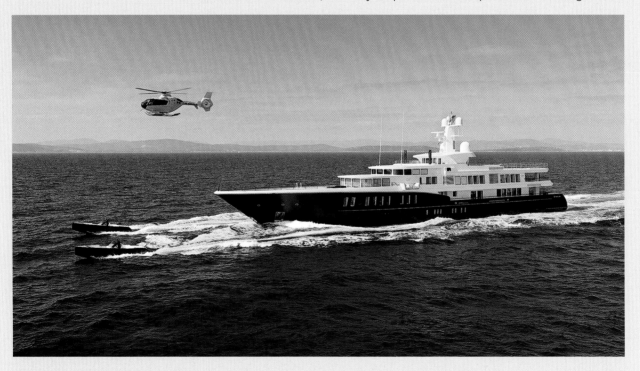

TYPESETTERS OF THE NEW MILLENNIUM

Video interview with Bob Marchant.

Having shot TV commercials in the past, Marchant is now doing more moving image stuff for the drinks market. As for stills photography, "the cynic in me would say we are the typesetters of the new millennium," says Marchant. "More seriously, the issue is the democratization of photography. Everyone says it's not your equipment, it's your eye that counts. I would go beyond that and say it's your eye and the 10,000 hours of experience. But we have to realize that a good 80 percent of the photography that used to be considered professional can now be done reasonably easily with a decent SLR and a couple of weeks' training. It's one of the reasons why it's so important that photographers concentrate on niche markets and distinguish themselves from the crowd. My method of working is something that can't easily be copied by just anyone."

There is no doubt that social media does work and brings in jobs. But you've got to get the balance between the time you spend advertising and the time you spend on photography, your true passion. Says Marchant, "There is an interesting parallel to all this. When I went to the States and worked in LA, I found there, as opposed to the UK, that no matter how good a job you shot you were only as good as knocking on the door the next day and once again getting in a line with everybody else. I feel in some ways that is what is happening here now. Social media tends to bring in just one job at a time. Establishing a long-term working relationship is something that needs to go beyond that. I'm not talking about wining and dining clients but establishing a good working relationship, which in most cases ends up also as a friendship. Delivering the job and not being frightened to say what you think and having a friendly relationship where you can banter about stuff is all for the common good."

YOU HAVE TO BE ABLE TO GO INTO ANY SITUATION AND BE SURE TO COME AWAY WITH THE GOODS.

Marchant's advice to those starting out is that you need more than one string to your bow. "If you are going to do it professionally, it's not just about capturing nice pictures one at a time; you have to be able to go into any situation and be sure to come away with the goods. You can never have too much experience. I can only talk in terms of myself and my market: always keep an open mind as to how you are going to approach anything. Never think you know it even though you think you have got the experience. Always find a new way and get into anything you can. Read lots of books, look at lots of art, and keep the information coming in. On the practical side, the main thing now is to travel light. It's not the be all and end all to own a studio and have a huge staff. This may all change as the economy improves, but right now you have to be adaptable, willing to change, and have passion. Not just a passion for photography, but a passion for life, I suppose, for everything, really. With the stuff I do, the joy is not just in the end product, but in the solving of the problem."

THE JOY IS NOT JUST IN THE END PRODUCT, BUT IN THE SOLVING OF THE PROBLEM.

Bob Marchant Photography
Bobmarchant.com

Marchant & Gonta
Marchantandgonta.com

9
ART PHOTOGRAPHY
EXPLORING THE ART MARKET

FINE ART PHOTOGRAPHY

The commercial photography industry has been radically reshaped by recent events, such as changes to digital technology, rights grabs, and a long period of recession. One sector of the photography industry that hasn't been so badly affected is the fine art market. Here it is in everyone's interest that the photographer retain copyright, and at the top end photographers are commanding high-figure sums for their work. To date, Peter Lik's *Phantom* image is the most expensive ever; in 2014 it fetched $6.5 million, followed by Andreas Gursky's *Rhine II* image, which sold for $3.9 million at Christie's, New York, in 2011, and Cindy Sherman's *Untitled #96*, which also sold for $3.9 million in 2011. When you take into account how even photographs by Mikki the Moscow chimpanzee recently sold for $76,000, you can see why commercial photographers are now looking enviously at the fine art market. If only it were that simple. The fine art world is no less competitive than the commercial one. Regardless of whether you are sympathetic to contemporary styles of photography or not, it is a market in which only a few can hope to climb to the top and achieve success. As with everything else, it is all about the work and effort you have to put in to establish yourself.

Apart from anything else, commercial photography and fine art photography are quite separate disciplines. The working lives of commercial photographers require a fast turnover. Successful photographers working in this medium will often say that they work by intuition and that "you are only as good as your last photograph." Fine art photographers tend to be more introspective about their work and analyze what they do in greater detail. Here it is all about quality rather than quantity.

I wouldn't say commercial photographers are disconnected from the aims of the fine art world. On the contrary, I reckon every photographer I know is passionately interested in the subject, because fundamentally we do all care about art. Interestingly, whenever commercial photographers choose to define themselves as artists, they open themselves up for critical judgment by their peers. Basically, there are good

and bad photographers in every line of work, and just because you saw a fine art exhibition that looked silly and pretentious, it doesn't mean all contemporary art is bad. In the art world, some photographers come from an art background and have always worked exclusively within that environment. But some have come from a commercial background and are now making significant fine art sales, producing work that appeals to galleries and collectors alike. It is this particular section of the photography art market that I have chosen to concentrate on in this chapter.

The debate about photography as art started around the beginning of the last century, with photographers such as Alfred Stieglitz and later Edward Weston, who were instrumental in turning photography into an accepted art form. Their style of photography, described as modernist, was to have a big influence on later generations of photographers, although today we would probably call their style of photography classic or traditional. It was during the '70s and '80s that postmodern styles of photography emerged, which challenged the conventional art photography world. This and antique prints are where the big money is these days. Outside the high church of postmodernism (and now, altermodernism) are other types of photography that continue to sell as art, such as documentary and pop culture. These genres may not always command such high figures, but collectors still have a great interest in them.

Consider the work of Ansel Adams. His photographic career began in the late 1920s, and he went on to make a living selling prints and writing books on photography and collaborated with fellow photographer Fred Archer to create the zone system. Ansel Adams is most often remembered for the photographs he took of Yosemite National Park, and his style of photography continues to influence photographers today. Landscape photography is a subject everyone can relate to, and landscape subjects are accessible to photographers of all skill levels. Documentary photographers tend to come from a background in news reporting. Henri Cartier-Bresson is considered the father of photojournalism, and it was through his commissioned news assignments from around the world that be built up a huge body of work. His photographs and those of many other celebrated Magnum photographers have become icons of modern history. Pop culture covers just about everything else from portraits to fashion, advertising, and music photography. Interest here is just as broad because such photographs have played a dominant role in everyone's lives. As you go back in time, many photographs have increased in price, partly because of their rarity but also because they attract purchasers with more disposable income. For example, people now in their 50s and 60s sometimes like to collect original photographs of bands and artists from their youth and are happy to pay good money for them.

At the same time, the art market is now saturated with images for sale, and this has made it increasingly difficult for artists (established and new) to stand out. You need to take into account the popularity of photography as a hobby and how there are now many more amateur photographers competing for attention. Numerous

PHOTOGRAPHY SCHOOLS

Photography schools vary. Many offer a broad curriculum accommodating different interests from stills to moving images, and most are focused on training photographers commercially. Clearly the fine art market is a significant one, but the high financial rewards are achieved only by the few who make it to the top. The reality is that most photographers who embark on an artistic career won't actually make much money, at least not from their photography. This is something to consider carefully before you enroll in a photography course that is specifically aimed at going into the fine art market. You need to think about the cost-effectiveness of your tuition in terms of how much you are likely to earn eventually. In my view it is important to apply good business principles to whatever line of photography you choose to go into.

websites enable photographers to promote their photographs, and these have become very popular with those looking for ways to sell their work online. Also, with the help of services such as Instagram, people can easily generate instant art from a smartphone. So photography is no longer such a unique craft—just about anyone can claim to be a photographic artist these days.

CREATING CERTIFIED PRINT EDITIONS

PHOTOGRAPHER JOHN PAUL CAPONIGRO CREATES OPEN EDITIONS WHERE THE PRICES ESCALATE WITH EACH PRINT THAT'S SOLD.

Photographs can be sold as standard prints or as part of a limited edition. If you are selling online and using an external print fulfillment service, there is a limit as to how much you can sell such photographs for. The works sold will be unsigned, with no declared limit on the number of prints that can be made. This therefore does not give the prints you sell any rarity value. After all, how much would you be prepared to pay for an unsigned print by another photographer, even a well-known one? A signed print makes it more personal and potentially more valuable. To sell photography as individual art prints, you need to be in full control of the print process and restrict the production to a limited number of prints. Artists may create limited editions of as few as ten or as many as several hundred. It's up to you. Obviously, if you are a relatively unknown artist, you can't expect to command high unit print sales unless you choose a small print edition number. The edition number should be written on either the front or the back of the print showing which number the print is out of how many: for instance, 13/25. Interestingly, photographer John Paul Caponigro creates open editions where the prices escalate with each print that's sold. So for example, the first print may sell for $2,000, the second print for 25 percent more at $2,500, and so on.

Buyers like to see some form of documentation. This can be regarded as a certificate of authenticity from the artist, which shows it is a genuine limited print. Include here as much information as you can, such as the title of the photograph, the paper type and printer used, the ink type, the date printed, and the limited edition size. It is essential you keep to this number and don't change your mind and extend at a later date. A useful tip I picked up from Jeff Schewe is to not use your regular signature when signing your work. In this day and age, where identify theft is a real threat, you want to be careful about using your formal business signature—the signature you use when signing checks. Instead, cultivate a special signature that you'll use when signing your artworks.

Printing your own work

You can either print photographs yourself or contract someone else to provide this service on your behalf. Personally, I reckon it is best to be in full control of the process and make your own prints. At the very minimum you need a suitable,

photo-quality inkjet printer, and ideally you'll also want to work with a calibrated display and a print viewing lightbox. Photo printers are available to print all sizes of prints from 10 x 8 inches upwards. The main inkjet printer manufacturers are Epson, HP, and Canon, and printers designed to suit all budgets are available. Many photographers find the A2 (17" wide) desktop models plenty big enough for most exhibition print needs. These are pretty big devices, though, and will need a desk of their own to support them. For larger prints you can get freestanding printers that print to an A1 size (24" wide) or even bigger.

The main costs of running a photographic printer are the inks and media. The inks are the most expensive consumable, and it is not just the cost of ink that's used when making a print. These devices require head cleaning routines, and some require the swapping of ink cartridges. Even the waste ink reservoir can be costly to replace. Media paper isn't so expensive, but if you intend to supply prints in a variety of finishes and sizes, you'll need to keep a fair amount of paper in stock. When selling fine art prints you will want to ensure the paper used is of a decent weight, such as 250 gsm (grams per square meter) or thicker. One thing to be careful of is that if you print using thicker than normal papers, you may need to create a custom print setting that manually raises the print head clearance. If you don't, the ink may smear badly across the print surface during the printing process. You can't always expect a perfect print first time, so you have to allow for some wastage. Also, don't forget to factor in the cost of maintenance. With the larger printers this will mean getting an engineer to pay a visit. Basically, producing your own prints always costs more than you expect, and it will only be after a year or so of throughput that you'll get a reasonable idea of what your true printing costs are.

External print services can be very good, and the cheaper providers service the consumer and social photography market with decent reasonably priced prints, but this won't do if you are aiming to sell limited editions. To produce and sell fine-quality prints, you'll need to use a company that specializes in handling fine art prints and be prepared to pay an appropriate amount for such services.

OUTLETS FOR SELLING PRINTS

The traditional route is to sell artworks through a commercial gallery. These are commercial dealers who only exhibit work they have approved or vetted first. In order to get an exhibition, you'll need to show a portfolio of images to the gallery owners. If they like your work, they may offer to take you on and include you in a group show, or, if your images are strong enough, give you a solo exhibition.

If a gallery is interested in exhibiting your work, you will be asked to enter into an agreement, where the commission rate will usually be around 40 to 50 percent. Bear in mind there are a number of costs the gallery will have to cover, such as overhead and

THE NOMADIC MUSEUM, USED TO HOST THE *ASHES AND SNOW* EXHIBITION IN SANTA MONICA (2006).

promotional costs, plus selling the work of any artist is unpredictable. If a gallery accepts your work, it will most likely want to represent you exclusively and specify that you can't have your work handled by any other gallery within a certain radius of it.

Another alternative is to rent an exhibition space and manage the promotion and sales yourself. Renting such spaces can be quite expensive. On the other hand, you most likely won't be charged commission on any sales that are made. You can even create your own space in all kinds of locations, including ones that aren't normally used for art exhibitions. One of the most creative examples I saw recently was the *Ashes and Snow* show by the Canadian filmmaker and photographer Gregory Colbert. His work mostly features people interacting with animals. It was a large show in which the photographs and films were displayed in the custom-built Nomadic Museum. It started out at the Arsenale di Venezia in 2002 and from there traveled around the world; it has so far been seen by an estimated 10 million people.

If you use a bit of imagination, lots of other types of locations may be suitable for exhibiting photography. For example, you could choose to put on a small show in a bar or restaurant. There is the potential here to negotiate a reciprocal deal where everyone wins. The premises owner benefits from having attractive pictures on the walls and an extra influx of customers for the opening night. You meanwhile, get your work shown in a public space where it can be seen by more potential buyers. It's an ideal way to get started.

With a one-off solo show your presence is visible only for as long as the exhibition is up and running. With the commercial galleries an artist's work can be more permanently represented. Your work may be displayed in a gallery for longer periods alongside other artworks, plus prints can be archived in drawers, available to show prospective customers. This type of approach can apply to all the different genres of art photography I have mentioned so far, though some galleries will choose to specialize in contemporary, others in more classical works or popular culture. For example, the Proud Gallery in London is well known for its exhibitions of music photography, and Peter Hince, whom I interviewed for this book, had his Queen photographs shown at the Proud Strand gallery.

Only major artists are exhibited in public galleries. These are noncommercial by nature. So although there may be an admission charge made to view the more important shows and sales of associated merchandise, the artwork itself won't be for sale. The reward comes from the acknowledgement and prestige of being associated with a well-known space. There are exceptions, such as the Royal Academy Summer open show, where prizes are awarded to the best entries and artists are actually allowed to sell their work. Overall, the exposure at a prime gallery site will be of immeasurable value to any artist.

Exhibiting in a gallery or public space allows artists to reach a wide group of potential customers, but the number of serious buyers will be limited. It will increase as you exhibit in a major gallery, of course, but this still doesn't allow you to tap

into the full potential of all the different types of art-buying customers. Art fairs, for instance, can broaden your scope. These events have proved very popular with people who are interested in buying art, which can include anyone from ordinary members of the public who are looking to decorate their homes to major corporate buyers. The latter is a very lucrative market to tap into. Corporations and hotels are big purchasers of art. For example, I know one photographer who also happens to run a framing business. He makes big sales to hotel groups who buy his work as a hundred or more framed prints at a time and use these to decorate their hotel rooms. An artist friend of mine, Claire Brewster, was recently commissioned to create an artwork for the lobby area of the Corinthia Hotel, London. As well as being rewarded well financially, she now has her work on permanent view in a central London five-star hotel.

Art fairs are basically a great way to present your work to the public and gauge response. Some are open to all artists, while others are juried, which means work has to be vetted first before you are allowed to exhibit. This is a good thing, as it ensures all the artists who pay to exhibit at the fair are selling work that meets an approved standard. Sellers at art fairs are advised to present their work in a variety of ways. Some of the prints should be mounted in frames and displayed on the walls. Unframed prints can be presented in matte mounts sealed in protective bags, plus you can offer things like greeting cards or postcard sets.

Online print sales are popular, too, though the problem here is that customers who are willing to spend a lot of money are more likely to visit a gallery or art fair where they can actually see what it is they are buying. A number of sites specialize in selling prints, but it is hard to say if these are working well or not for the photographers who sell their work through them. Someone recently mentioned to me how he was doing well using Fineartamerica. I doubt his sales could have been that significant because the print prices on that site are mostly pretty low. But I imagine that's what makes it attractive to buyers. Online galleries such as Saatchiartonline and Newbloodart are clearly targeted at customers who want to spend more money on art, but the Saatchiartonline site in particular is quite saturated. You also have to take into account that these online galleries charge a commission. Saatchiartonline, for example, charges 30 percent.

Another method is to sell work directly via your own photography website. If using a Web portfolio service like PhotoShelter, you can set up your site to manage print sales, which can be fulfilled via a selected online print service provider. There is no sales commission to pay, and you are offering a print service tied to your main web portfolio presence. The problem with this type of approach is, you are passing all control to a third party fulfilling the print order. There is no opportunity for you, the artist, to supervise the print process and carry out the necessary overseeing and quality control of the printing. A straight print run through a color-managed printing service can still look nice but can't compare to a hand-crafted print, and the prices charged should reflect this.

ARTIST'S STATEMENT

Buyers will want to know something about the photographer they are buying from, and for specific projects you'll be expected to provide some background information. This can be a factual account of the subject or series or an explanation of the philosophy behind the making of the photograph. This is your opportunity to communicate with viewers and buyers. It is best to write clearly and explain in your own words what the photographs are about. Critics don't always take kindly to florid "art speak." I remember an artist who once described his work as "about being and not being," to which a critic replied, "How true that is, yet at the same time how false."

ARTIST'S RESALE RIGHT (DROIT DE SUITE)

As individual art sales figures have increased, European Union (EU) legislation has been brought in to help protect artists and guarantee them a share in future resales of their work. The Artist's Resale Right is an EU directive that gives artists the right to receive royalties on their works (calculated using a sliding scale) when these are resold at art auction. This is now law in most EU states, but the minimum sales price varies from country to country. It typically applies to sales of works of art that exceed €1,000, where the resale takes place within three years of the seller having acquired the work directly from the artist. Also, the resale must take place via a professional intermediary, such as an art gallery or auction salesroom. It does not apply to private, individual sales, and there is also an upper limit cap on resales that exceed €2,000,000.

On a related note, copyright legislation makes clear that a purchase of a work of art does not imply ownership of the copyright. Therefore an individual collector, a gallery, or a museum that owns a work of art does not also own the publishing rights. These have to be bought and licensed separately.

BOOK PUBLISHING

It's probably every photographer's dream to have a book published featuring his or her work. Historically, this has been an expensive venture, and from the publisher's point of view a risky one, unless the author is a well-known artist. The fact is, even with some of the bigger-name photographers, the sales volumes will be small compared with those of mainstream books such as novels or nonfiction titles. A monograph book will usually be big in paper size, printed to a high standard, and have a limited print run. All these factors add to the cost of production, which is why the sale price is usually high. Some publishers such as Taschen and Phaidon are experts in the world of art books and publish work only by the best artists. They aren't the only publishers, of course, but everyone you are likely to approach will be very cautious about publishing the work of a new photographer for the first time. If you are

ready to take this step, there is plenty of information out there about how to submit a publishing proposal. Basically, you need to have a plan for your book well mapped out, along with examples of your photography. You need to think carefully about who your audience will be and why people might want to buy your book. Are there competing titles out there, and if so, what would be the unique selling point of your book? The book publishing and especially the fine art book publishing business is a competitive industry, and you'll need more than mere talent to get accepted.

So far I have just considered monograph-type publications, or what might be regarded as high-end coffee table books. There are other ways to get published, as there are lots of photography books that fall outside of the high-end market and are more commercially aimed at the mainstream markets. Here, too, it can be tough to get a book proposal accepted, and you will usually have to incorporate a plan that includes a writer (unless you intend to do the writing yourself).

Self-publishing is also an option, and this can be done through specialist companies, such as Blurb. You can design your book yourself using the supplied software. Or, you can create your own design layout using Adobe InDesign, working from the supplied layout templates, and then upload the PDFs of the final book layout, plus the cover. However, these aren't cheap to produce. To create a large-format monograph-style book in hardback with a high-quality print finish can cost about as much to produce as it would cost to buy a high-quality art book of similar size. Given that the self-publishing alternative involves committing to a large print run (which will be very costly), this is still an economical way to produce your own books. I have used the Blurb book service for several years now and should declare that I have spoken on its behalf at a few photography events, but because I have been very satisfied with the quality of its printing I am happy to recommend it. On their website is a bookstore where book makers can sell their books online. After you have finished uploading a book, you can choose to make the title public and set a sales price, maybe making a small profit for yourself. If someone chooses to order your book, the print fulfillment is all handled by Blurb, and any profits are sent to you as a monthly PayPal payment.

TIM FLACH

SPECIALIZATION: COMMERCIAL AND
FINE ART ANIMAL PHOTOGRAPHY

Tim Flach's studio is located just off a busy main road in Hoxton. Street names like Haberdasher Street, Curtain Road, and Boot Street indicate the area's past connections with the clothing industry. But today it's a popular area for designers, photographers, and artists, with a vibrant nightlife, a rather incongruous setting for Tim's photographic studies of animals. Creatures of all kinds have been photographed here at his studio, from beetles to wolves and even a kangaroo.

The first roll of film Flach ever shot was at London Zoo, while on a foundation course prior to getting his degree. It wasn't till much later, after becoming established as a commercial photographer working for PR and corporate clients, that he returned to photographing animals. His clients now mainly include advertising agencies. He has a secondary career working on book projects and selling limited-edition fine art prints.

For the commercial shoots, he mostly photographs cats and dogs. The intimacy of the basement section of the studio is well-suited for this type of work, as the acoustics are similar to a domestic environment and ideal for putting the animals at their ease. In the UK, dangerous wild animals have to be photographed from behind bars, but this is not always the case when working in the US and the rest of Europe. "Most of the time I am working with a very good team around me," says Flach. "And if they're the people waving the bamboo stick, usually with a piece of meat on the end, the chances are they are doing all the movement and are therefore closer to the animal. I am relatively passive and farther back. So I feel they are taking the risk and not me. But we are not here to be heroes, so you have to think things through carefully." Flach takes care to discuss each project before setting up a photo shoot. "I don't ever feel I am at great risk but am respectful. If I have got a wild animal in front of me, there is always that sense of uncertainty. The trainers have to guide you as to where you should be and where you should move." He will quite often arrange things so that the animal can move onto the set without going through too many stands. This gives the animal and its handlers the mobility to exit the studio easily. "These are all considerations you have to do as a team. You have to discuss the particular animal, and every animal is unique—it might be grumpy one day and good another day."

BOOK COVER: *More Than Human*

EVEN WHEN YOU TAKE THE PICTURES, YOU'VE GOT TO BE INTRIGUED AS TO HOW OTHER PEOPLE MAKE MEANING OF THEM AND HAVE A SENSE OF THE BIG PICTURE.

Even with all the preplanning, you can never be completely sure what to expect. "There is a question of how things reveal themselves on a shoot and how that leads you on to explore other things. With animals you are inviting that uncertainty," Flach explains. "Any project is an inquiry. And I am always of that view that if you go into a shoot, you have to go fishing to catch something. But once you are on the set you mustn't be too wedded or presume what you are going to get. In fact, you have not just got to look but see. I am a great believer that you have got to have a presence, and as things reveal themselves you take that opportunity. With animals that's obviously very true. We all know we can't really control them, but you could argue that you can't ultimately control anything. It's that sense of being in a space and also accepting that even when you take the pictures, you've got to be intrigued as to how other people make meaning of them and have a sense of the big picture."

Flach's *More Than Human* book explores our relationships with animals. As much as the publishers would like illustrated books filled with pretty pictures, Flach felt it important to look at the various issues debated and the different ways we shape meaning around images of the animals. "What I find really interesting is using aesthetics to bring people to something, but then I hopefully introduce them to a new thought or an idea," he says. "For example, the featherless chicken, for me, represents quite a few things. Look at this picture of what looks like a chicken with no feathers, who's prancing like a plump ballerina across the stage and looks back at you. For me it provokes quite a lot of things. I like the idea that it's not a pretty picture, it's not something you would necessarily put on your wall, but what it provokes is this idea of, did he pluck the chicken? Is it genetic engineering? It's actually a naturally occurring mutant. But if you think of the supermarket, there you'll have your packaged chicken without the head on, naked. I like the way those kinds of images operate but accept the fact they will upset people. But maybe they'll provoke questions?

"I do my best to explain the background and context, but quite often it gets detached, and I find that very frustrating. What I want to do now is attach some of that context and meaning within the image. Now here we are in this mechanistic world where for most of us our only contact is with a dog, or a cat, and we are more likely to encounter a chicken in the supermarket than one with its feathers on. That is something I am really interested in. How do we engage with animals? We have somehow been separated. We know animals in a virtual sense better than ever before through the films of [David] Attenborough and such. Yet in actuality, we have never been more separated. So this definitely is something always in the back of my mind."

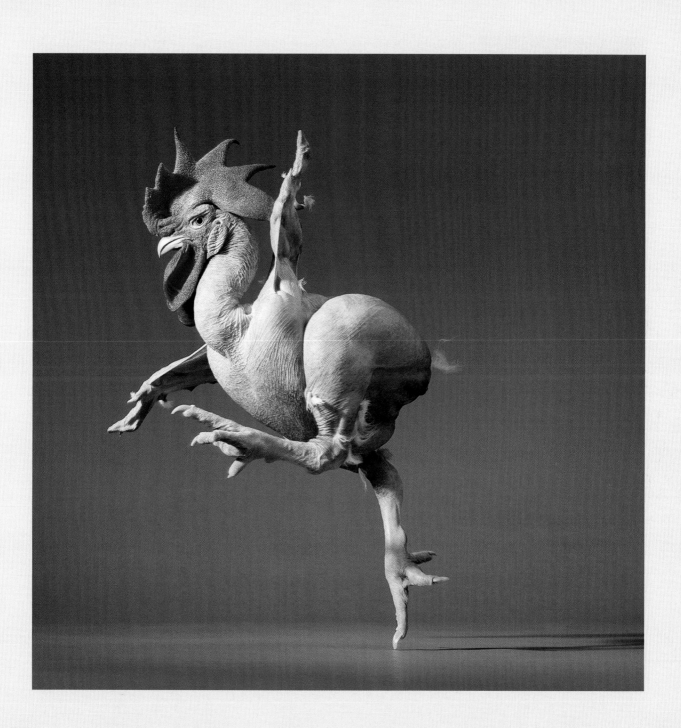

BOOK COVER: *Dogs: Gods*

FRUIT BATS

One of Flach's first series of animal photographs to achieve awards was of fruit bats. His initial idea was to photograph these animals in the studio and somehow comp in a night scene. However, "I discovered that fruit bats are rather big," he says. "They're not very agile and didn't fly very well in the studio. In the break we had them on a perch in the corner. I saw them chatting away with each other and thought, this is very cool, so I asked the handlers if they would bring them back into the studio the next day. When I photographed them on the perch I had a Polaroid of them the wrong way up and thought, this looks cool, so we proceeded to photograph them with the photographs the other way up and I kept that in mind when lighting them. So you have these bats where the eyes are above the feet and you find they become much more figurative.

"One of the things connected with my work is the idea I make things very human. I am very interested in the idea of gaze and also very aware of the way in which we work with cuteness. We have to centralize who we are and relate to things in our terms and that tendency, that anthropocentrism we tend to have, inevitably veils everything we do. I am very conscious of that in the way I manage images of animals and how we make meaning from them."

TONE MANIPULATION

IS THAT CHICKEN REALLY THERE? IS THE DOG THAT LOOKS LIKE A MOP ACTUALLY REAL?

Flach's switch to shooting on a digital medium-format system happened in 2005. This was just before he started work on his *Equus* book. "I took the studio to the animal. I had much more freedom of choice and it put less stress on them. I would say the majority of the work I do now is outside the studio. The use of digital imaging does raise questions as to how much you see in a photograph is real and how much has been manipulated. I have chosen to stylize my work, and as such there is always a suspicion as to what people are looking at. Is that chicken really there? Is the dog that looks like a mop actually real? Has it been sprayed in some way and been suspended?"

Flach asserts that he mainly uses Photoshop to make tonal changes. "I like to shoot everything in camera and go to lengths to do so. I always feel it is a bit tough for me, because it is always assumed there is a degree of construction. But I believe that by making tonal changes alone you can hugely influence the way the eye moves through the space, and that's what I am mostly doing through my work. I'm a great believer that the eye has a tendency to follow certain lines. Compositions that are particularly successful tend to have an entry in the lower left and scoop around. I am not suggesting that all images

share that, but iconic images have certain tendencies within the structure, and I certainly have been very much informed by painting rather than photography in that respect. When I am shooting I am conscious of it. Actually, changing tonal values has a huge impact. I try to avoid adding bits, so you could argue my pictures are more authentic than some less transparent documentary photography. But ironically, they will be perceived as more of a construction because they are stylized."

COMPOSITIONS THAT ARE PARTICULARLY SUCCESSFUL TEND TO HAVE AN ENTRY IN THE LOWER LEFT AND SCOOP AROUND.

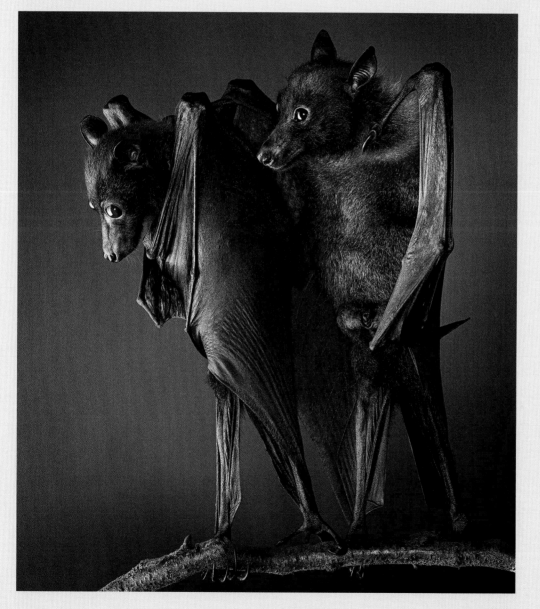

FINE ART SALES

COMMERCIAL ACTIVITY CAN
LESSEN YOUR STANDING AS
AN ARTIST, WHILE BEING
AN ARTIST IMPROVES YOUR
STANDING AS A COMMERCIAL
PHOTOGRAPHER.

Flach's commercial background was in PR, design, and advertising before he got into publishing books. What he never anticipated was the growth in print sales and the positive financial impact this would have on his business. "The art world in photography has gone through such shifts, and the role of photography is now so much more central as a medium. There are many different levels to the art world, from the salon galleries to conceptual galleries, which are more linked to the museum space [just like within the commercial world]." For him it's been a gradual thing, because the amount you command for a print needs to be significant enough so that by the time you've done the print and the gallery has taken its 50 percent, the numbers make sense. "Certainly in recent years it's allowed me a certain amount of freedom," says Flach. "I do my own retouching, and I like that connection, being able to spend time working on individual images. Art prints provide me with that opportunity."

Balancing commercial and fine art careers can be tricky, though. Basically, commercial activity can lessen your standing as an artist, while being an artist improves your standing as a commercial photographer, and you have to carefully balance the two. "I am sure art buyers and art directors like to see something in a supplement discussing an exhibition, but I think in practice their concerns are often, 'Am I actually committed to what I am doing in terms of the commissions?' I would say it can actually undermine you being perceived as someone who might be commissioned. And vice versa: if you are very active in the commercial world, someone buying something to put up on the wall will be suspicious of the integrity of that work. It will almost be seen as being polluted or contaminated by the other side." It's a difficult area. "You find yourself in a situation where what would be relevant, like an award or something in one industry, is irrelevant in the other."

IF I WERE TO DECIDE TO DO A
PANDA BOOK TOMORROW, I AM
SURE THERE WOULD BE LOTS
OF WILLING PUBLISHERS.

As for creating more illustrated books, "these aren't totally finished, but they certainly are a stressed industry. If I were to decide to do a panda book tomorrow, I am sure there would be lots of willing publishers, because cute animals definitely sell. In terms of projects in the future, I want to concentrate on areas like museums where they have a vested interest in communicating and the debates around such projects. I'd like to not just be more involved with the art world, but step outside that and debate about how we handle animals in the human space."

Flach is currently interested in exploring the work of fine art masters and the compositional tricks used to direct the viewer. "I am going to spend time working with scientists to look at the way we seem to navigate certain pictures."

The nature of advertising has changed a lot in recent years. With the growth of Internet advertising and use of digital signage displays, ad campaigns have to accommodate a wide variety of media, which can now combine moving images in ever more inventive ways. "Today we don't know what the format might be. Because of the nature of digital, print, and moving image, it has to be left open. If I am doing something for underground tube stations with some moving images, it's called a tunnel with D6s. If ten years ago I'd been given the brief I got last week, I wouldn't know what was being talked about. When clients talk about things like rich media (which is hugely changing the way we operate), these would have been new words to me a few years back."

The changes in the last few years are profound. As Flach explains, we are in a unique period right now. "There was a statistic bandied about last year that said 10 percent of all photographs that we have ever taken since the beginning of photography were taken in the last 12 months. Apparently mostly of food, but even so, we are becoming more dependent on images than ever. We have had over 150 years of photography, and suddenly we are not dealing with prints anymore, we are dealing with this virtual space. I think it is hugely challenging. Someone of my generation, though fascinated by it, accepts that we have to be much more responsive.

"In the commercial arena I am finding we are in really unusual times again. When I receive a brief it doesn't talk about photographs, it talks about 'assets'—things you can upload and download. What I feel I am doing most of the time is managing the production of bringing these elements into different formats, which could be what we call a skyscraper, which is a very long digital format. It could be a very long banner, or it could be a 96-sheet. But this kind of range of end usage means those in the creative agencies have to know how the elements will be put together according to the demands and media required of them. I myself am at two ends here. I quite like the flexibility of how we can do things in post, which we couldn't do before. I no longer have the traditional idea of a composition that I can see in one go. What I have is the visualization and the flexibility of options that I am offering the client. So on the one hand I am like a banker; I deal in 'assets.' Yet on the other end I am producing prints that are bigger than ever, and I'll spend days finessing them and have the potential to sell them as art prints, where that input will be appreciated."

Flach's main advice to those wishing to become professional photographers is to embrace change and be responsive to it. At the same time, it is important to always remind yourself of the reasons why you chose the medium of photography, the things that touched you and were relevant when you first picked up a camera, and not lose sight of that. Flach hasn't—he first became interested in photography on a day trip to London Zoo and today has successful commercial and fine art careers doing what he loves: photographing animals.

VIDEO INTERVIEW WITH TIM FLACH.

FLACH'S MAIN ADVICE TO THOSE WISHING TO BECOME PROFESSIONAL PHOTOGRAPHERS IS TO EMBRACE CHANGE AND BE RESPONSIVE TO IT.

Tim Flach Photography
Timflach.com

JULIA FULLERTON-BATTEN

SPECIALIZATION: COMMERCIAL AND
FINE ART PHOTOGRAPHY

Julia Fullerton-Batten's work is instantly recognizable, characterized by elaborate tableau scenes and beautifully controlled lighting. Her early success as a commercial photographer followed a five-year period spent as an assistant, working for various London photographers before eventually taking a month off to travel to Vietnam with her boyfriend. It was during this time she had the opportunity to start taking photographs of things that interested her, which provided the impetus to go solo as a photographer in her own right. Fullerton-Batten's style of work was particularly well-suited to advertising. Following her commercial success, she has since applied her commercial, high-production, and technical skills to producing self-funded fine art series, which she has done for almost 15 years now, releasing at least two major new series each year.

EARLY PROJECTS

AS A FEMALE PHOTOGRAPHER, DAUGHTER, AND NOW MOTHER, I OBVIOUSLY RELATE TO THE SCENARIOS DEVELOPED IN THESE STORIES AND ADMIT TO THERE BEING A FAIR AMOUNT OF AUTOBIOGRAPHICAL MATERIAL CONTAINED IN THEM.

Fullerton-Batten's first solo exhibition in London was in 2000. Subsequent exhibitions were held in New York in 2002 and Brussels in April 2005. Her first big venture into fine art photography, which helped establish her as an artist, was the *Teenage Stories* series, which she produced in 2005. "I had shot a series of images involving teenagers beforehand, but I think the major breakthrough came when I realized that I wanted to tell an authentic story, and not just shoot disparate scenes," says Fullerton-Batten. "*Teenage Stories* narrates the transition of a pubescent girl to womanhood. Here I showed that adolescence is a complex and sensitive age when teenage girls start seeing themselves in the context of society and question their identity. For them, it marks a time of important physical, emotional, and psychological change. It's a time of unease and expectation, as well as of hoped-for pending, unrestrained freedom. My next projects followed this teenager through more advanced stages of her transition. These include *In Between, 2009/2010* and *Awkward, 2011*, and concluded with *Mothers and Daughters, 2012* and *A Testament to Love, 2013*. The latter two illustrate stories of women's experiences in adulthood as mothers and lovers. As a female photographer, daughter, and now mother, I obviously relate to the scenarios developed in these stories and admit to there being a fair amount of autobiographical material contained in them."

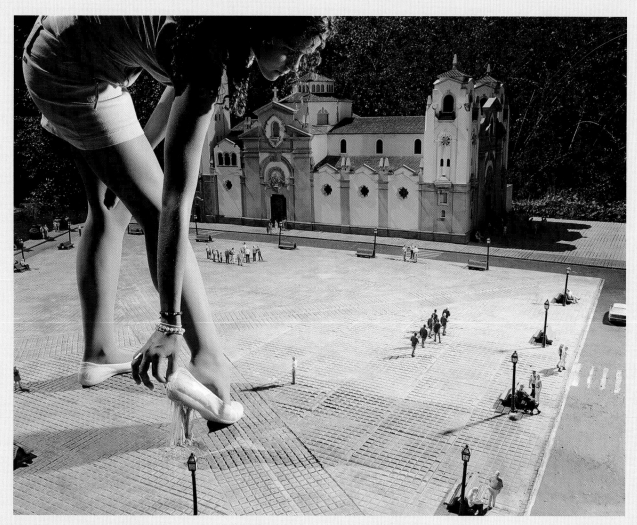

FROM THE *TEENAGE STORIES*
SERIES (2005).

Clearly a lot of work and preparation goes into the creation of the photographs that appear in these series. Fullerton-Batten is hands-on throughout each stage of the production, single-handedly coordinating the preproduction and calling on resources as needed. She will, for example, visit and book locations and cast the models herself, choosing the style and colors of their clothing. She also sources the locations, prop finders, clothes stylists, camera crew, and assistants and takes care of all the production details including hiring lighting and arranging transport and overnight accommodation. "I plan everything thoroughly so that on the day of the shoot I know when, where, who, and how everything will fall into place," says Fullerton-Batten. "Over the years my lighting has got increasingly more complicated, and my team has increased

I PLAN EVERYTHING
THOROUGHLY SO THAT ON THE
DAY OF THE SHOOT I KNOW
WHEN, WHERE, WHO, AND
HOW EVERYTHING WILL FALL
INTO PLACE.

THE APPEAL TO ME OF
STREET-CAST MODELS IS THEIR
NATURALNESS AND OCCASIONAL
NAIVETY.

with every shoot for that reason. On the other hand, since I converted from shooting film to digital my workflow has improved, and my average camera crew is now about eight people."

Fullerton-Batten prefers to street-cast the models she chooses to work with. "I have only occasionally used professional models," says Fullerton-Batten. "The appeal to me of street-cast models is their naturalness and occasional naivety. It has given the touch that I needed in many of my shoots. I can't say amateur models are easier to work with than professional ones, but certainly each requires a different approach. Of course, in the *Teenage Stories* and subsequent stories I was effectively asking the models to play themselves, so there it was easy to get the naturalness that I wanted."

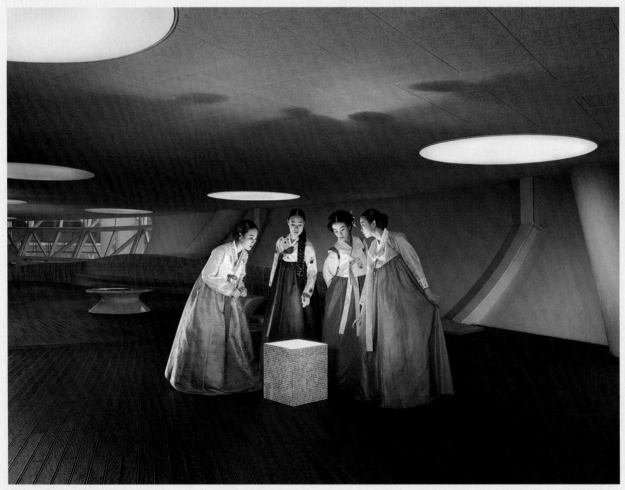

FROM THE *KOREA* SERIES (2013).

There have been occasions where a shoot has gone wrong, which is perhaps only amusing after the event. Says Fullerton-Batten, "In one instance I was doing an underwater shoot for a magazine. We hired the only permanently filled underwater stage in London, which is a large pool in Pinewood Studios in London, where many of the James Bond films were shot. The pool had a platform for lights, windows to light through, and had a viewing window for me to shoot through. My assistant set up a flash light to illuminate the scene through the window but left the modeling light on. This got very hot and started to melt the plastic window. Another minute and the window would have collapsed, sending gallons of water through the studio, flooding all the lights, and possibly electrocuting our model! That was a very complicated insurance claim, as Pinewood Studios threatened they would have to empty the pool, close it for a week to install a new window, and lose lots of valuable business."

KOREA

One of Fullerton-Batten's most recent projects is *Korea*. This came about following a visit she made to the Dong Gang International Photography Festival in South Korea, where she was due to give a talk. The aim of this series was to illustrate aspects of Korea's tradition and turbulent history set against the backdrop of modern-day Seoul. As Fullerton-Batten explains, "Korea was invaded by Japan many times before it was finally officially annexed by that country in 1910. This occupation lasted until the end of World War II in 1945. Koreans were victims of brutalities by the Japanese throughout the occupation. At the end of the war the country was artificially divided along ideological grounds into South and North Korea. Since then, tension has existed between the two nations. North Korean forces invaded South Korea on 25 June, 1950, and a bloody war started that lasted more than three years and involved more than 20 countries."

The shoot itself was prepared in great detail over a period of several months, in which Fullerton-Batten did a lot of background research on the location and potential themes. Says Fullerton-Batten, "Again I decided to concentrate on female models and themes that combined the tradition and history of South Korea set against the backdrop of Seoul's modern and somewhat austere architecture. The girls were dressed in the very beautiful hanbok, a traditional costume for women. It is quite simple in design but is very colorful and has lovely flowing lines. The contrast of the hanbok against the modern architecture gives the images a stunningly bold graphic look that is further enhanced by the beauty of the models. The more tranquil scenes involve historical and traditional aspects such as collecting kindling for the home fire, harvesting

ANOTHER MINUTE AND THE WINDOW WOULD HAVE COLLAPSED, SENDING GALLONS OF WATER THROUGH THE STUDIO, FLOODING ALL THE LIGHTS, AND POSSIBLY ELECTROCUTING OUR MODEL!

tea, the tea ceremony itself, carrying sacks of grain, the popular sport of bad-minton, etcetera. I also incorporated the help of native South Koreans living in Seoul. The only thing that I could not prepare for was the date of the shoot, as this was determined by the timing of the exhibition. This unfortunately coincided with the monsoon season there, which turned out to be physically unpleasant."

Despite scheduling around the rainy weather and discomfort of the high humidity, it proved to be a very successful shoot. However, some South Kore-ans did react negatively, complaining that Fullerton-Batten's images did not represent their culture at all. "That disappointed me," says Fullerton-Batten, "as I had hoped to achieve the exact opposite. The people who provided me with the input for the shoot and the models themselves were very complimen-tary, as have been remarks from many other South Koreans. So it does seem as though there are many diverse viewpoints. I want viewers to form an opin-ion on my work. It can be negative as well as positive, but I was surprised and rather sad at some of the comments I got towards this project."

IN SERVICE

I WAS ESPECIALLY INTERESTED IN THE REASONS WHY PEOPLE ELECTED TO GO INTO SERVICE AND WHAT HAPPENED TO THEM WHEN THEY DID.

Another recent project, *In Service*, focused on the lives of people who worked in service during the late Victorian and Edwardian times. Fullerton-Batten explains, "For this project I carefully researched the background of this par-ticular era as far as the social environment of that time was concerned. I was especially interested in the reasons why people elected to go into service and what happened to them when they did. Undoubtedly many of those entering service did end up in the beatifically presented portrayals as shown in *Down-ton Abbey* on our TV screens. *In Service* is my portrayal of those who didn't end up in *Downton Abbey*, but suffered exploitation at the hands of their employers, something that appears to have been quite common during that laissez-faire period in our country's history."

POSTPRODUCTION

Everything about Fullerton-Batten's work is finely controlled, and shooting digital makes the process that much more effortless. Says Fullerton-Batten, "I didn't convert from film to digital for a very long time. Not until I was sure I could achieve the same or better results with digital. Even when I shot with film, the next step in the process after development was to digitize the result, so I could print the images very large. The major benefit to me of changing to digital has been in the improved workflow and the immediacy of seeing

FROM THE *IN SERVICE* SERIES (2014).

the results straight away. As I use quite complex lighting setups, it was often a prolonged process to be able to determine if the setup was correct from just a Polaroid. All too often several steps were needed before we could get everything right on set. Some think that the major benefit of digital is the post-processing, but that has always been available with film as well. I try to keep retouching to a minimum and control all the steps myself. Many people think I have used extensive retouching in some of my images, but this is not the case. For example, in *Teenage Stories* the scenes were shot on location in model villages. Similarly in my series *In Between, 2009/2010*, I selected models who were dancers, gymnasts, and athletes, and they achieved all the energetic movements seen in the images themselves."

BUILDING A FINE ART CAREER

STARTING OUT IN THE FINE ART MARKET CAN BE A HIGH-RISK VENTURE; ONE CAN INVEST A LOT OF MONEY IN A SHOOT BUT NOT SEE ANY RETURN IF THE IMAGES DO NOT APPEAL TO THE BUYERS.

It has taken a while for Fullerton-Batten to build a career as a fine art photographer. She says, "I have always enjoyed working in a team on commercial assignments, but I found at one stage in my career that I wished to develop the creativity that I felt I had in me to its fullest extent and chose to have the freedom to work on my own ideas as a fine art photographer. Starting out in the fine art market can be a high-risk venture; one can invest a lot of money in a shoot but not see any return if the images do not appeal to the buyers. Fine art photographers frequently get profiled in photographic magazines—although flattering and rewarding for the recognition, not to mention the marketing effect it can give, there aren't any direct financial rewards that come from this." By comparison, when you shoot commercial work you do always have the certainty of being paid, even though the rates may be lower now than was the case in the past. "A further benefit that I gain from working both as a fine art and commercial photographer is that it hones my knowledge and technical base for working in both fields. That's why I enjoy both these aspects of my career. That I am still working as a fine art photographer at the very least indicates that I'm fairly successful in the genre."

At the same time, working as both a commercial and fine art photographer can conflict. "There is a viewpoint that working both as a fine art photographer and a commercial photographer has an impact on how one is viewed by the customer in each genre," says Fullerton-Batten. "Maybe it is only a feeling, but it is sometimes difficult to overcome the suspicion that connoisseurs of fine art photography would rather the photographer had confined himself to that genre. On the other hand, I feel too, that agencies look at fine art photographers as being too remote from the commercial world to be able to produce the goods. Photography is my passion, my raison d'être, whether it is the nitty-gritty of commercial photography or the sophistication of fine art photography. I think I make my contribution successfully in both fields, and enjoy doing so."

Apart from further technological developments, Fullerton-Batten sees two future trends: video and self-publishing. "Video is already a factor for many photographers, especially as nowadays the same equipment can be used both for stills and moving image. Self-published photobooks make photography available to the masses; there is no waiting for an exhibition or regretting that your admirers don't have the money to buy those particular images that they covet. Self-publishing has become cheaper and increasingly more available. It offers a means of getting one's images into the largest possible number of hands. The main hurdles to overcome are the need to get the right quality of

FROM THE *IN BETWEEN* SERIES, (2009/2010).

paper, print, and text. These aspects will hold back many photographers for a time, but the technology and the possibilities are there, and I think it will become an inevitability for many of us."

Fullerton-Batten offers two bits of advice to photographers wanting to enter the fine art market: "The first is to carry out a thorough self-evaluation of your talent, your passion, your uniqueness, your perseverance, your capacity for hard work, your ability to withstand setbacks and rejection, and, above all, your ability to be aware at all times of your financial situation. The second is to make your own luck by doing, participating, talking, showing, and above all living with photography as your life and passion. Then you may have a chance of succeeding in your career efforts."

Julia Fullerton-Batten
Photography
Juliafullerton-batten.com

CHARLIE WAITE

SPECIALIZATION: LANDSCAPE FINE ART PHOTOGRAPHY

"There is a universal response to beauty that is therapeutic and brings great joy. It is 'wealth'—giving much to each of us each time we access it." These are the words of landscape photographer Charlie Waite in a written introduction to his recent gallery show, *Silent Exchange*, at the National Theatre London. Waite's photographs are held in private and corporate collections around the world, plus he has exhibited in the UK, USA, and Japan and has over 30 books to his name.

Beauty is a word Waite likes to use a lot when describing his work, his influences, plus the experience of photographing outdoors. It is interesting to note that in earlier times our ancestors viewed the countryside from a purely practical perspective. Rivers and mountains were seen as obstacles to travel and hills useful only for grazing sheep. It wasn't until the late Elizabethan period

AUTOIRE, FRANCE.

that the word *landscape* came to be used to describe a view. Appreciation of the landscape as an art form didn't happen till the 17th century. But today, landscape art and landscape photography in particular are among the most popular forms of artistic expression.

Waite's own break as a landscape photographer came about when he and his wife were house hunting in London. As Waite explains, "My wife was an actress and had done really well in a TV show called *The Onedin Line*. I had just completed a course in photography at Salisbury College and got involved with photographing actors' portraits as well as assisting some marvelous London advertising photographers. At the same time I had also been taking a few landscapes with my Nikon FTN. I remember feeling like this could really do something. I took the camera with me on my little jaunts and found myself rather unconsciously responding to what was around me. Anyway, we were looking at a house to buy in Wandsworth, and the owner showed us around. It wasn't quite right, but just as we were leaving he asked, 'What do you do?' Those four words changed my life, because I don't know why, but I said I was a landscape photographer, which was a complete lie, because at the time I was patently not one. And he said, 'Well, that's remarkable, because I am the director of the illustrated books department at Weidenfeld & Nicolson publishers, and we are actually looking for a landscape photographer to illustrate *The National Trust Book of Long Walks*. It was just bonkers the way that happened. I thought, 'Oh my God, just grasp this opportunity.' But he did say, "I'd love to see your portfolio," which was a bit of a shock because I didn't have one. Anyway, the following Monday I managed over the weekend to produce some black-and-white images and took them to show him, and he said, 'This is good, let's meet the author, Adam Nicolson,' which we did. And before I knew it I was commissioned."

And so the relationship with Weidenfeld & Nicolson continued. Says Waite, "Before we had finished the book and the publisher had even seen all the images, he said, 'Right, what do you want to do next?' And on it went for some years. I was able to pretty well determine my own books. I would have an idea and take it to a publisher and they would say yes and kept saying yes. For those early books I had to illustrate people's text and produce images that would satisfy the publisher. When it came to books that were more about celebrating a country, it was very different, really, because I would have carte blanche. In fact, nobody interfered with me at all. I could just simply say, 'I would like to do a landscape book about France,' and they would say, 'Fine, can you do it in a year?' and I would say, 'Yes,' and never had to report to them at all. Oh, except for being asked, 'Have you got a cover?' And eventually I would come back and they would look at them and say, 'Yes, these look jolly nice.' So those days were very different."

I SAID I WAS A LANDSCAPE PHOTOGRAPHER, WHICH WAS A COMPLETE LIE, BECAUSE AT THE TIME I WAS PATENTLY NOT ONE.

CAPPADOCIA, TURKEY.

When photographing these books Waite would always do his research before-hand. "Asking somebody who knows so much more than you is a good bet," says Waite. "I loved topographical maps. I would look for water and look for elevation. I would also look at other images. I may not always have liked the photographs others had done, but they gave me a mild clue to get me going. I saw nothing wrong with that, although obviously I didn't exactly want to put my tripod legs where others had been. I usually built up a dossier of places I would photograph, and having established a very rough area, it was largely down to roaming. This increased the possibility of discovery. Sometimes I even went out without a map. As long as I had a couple of images that were repre-sentational of each area, then I knew I would be all right."

THE FINE ART MARKET

Photography has long been accepted as an art form, with most interest coming from collectors who are based in the US. Says Waite, "I was very fortunate to have once held an exhibition in Carmel, California, and one in New York. I was very nervous at the Carmel one, and the main gallery was subdivided into two galleries, one for photography and one for painting. A man came into the photographic section and he said, 'Oh, these are amazing—do you know where the artist is?' And I said, 'Yes, he is in the gallery next door where they've got some paintings.' And he said 'No, the artist who did these images.' This was in the late '80s, and that was the very first time I had ever heard the word artist being applied to photography. So I was really surprised by that and since then have always heralded it as an art form. Someone asked me ages ago, 'Do you think of yourself as an artist?' and I said, 'No, I don't really. No, I think I'm an interpreter and a responder.' As nice as it is to be called an artist, it seemed to be a better answer. I thought 'an artist' is such a broad term. I like to think I am an interpreter, a discoverer and a revealer. Amazingly, a large number of people agree, and it's jolly nice to read the visitors book where somebody says my work is lovely. I'm really grateful and rather chuffed that people feel that."

The fine art market is still a challenge for photographers to break into. "The fine art photography world or whatever it is right now does not appear to embrace beauty, and that's fine," says Waite. "But it's a very peculiar world. Collectors and curators do not seem to give credence to landscape photography unless it is historical, or has what I call 'intellectual scaffolding' to support the content.

"I think it could be that landscape photography is too literal. I remember meeting somebody years ago in America who said, 'Rocks, seas, and trees are finished,' and I said to myself, 'Oh no they're not.' I know you see Gursky and his agents and others making a great deal of money, and it's not sour grapes. It's kind of a shock, really, where one doesn't quite know how the system and the validators decide what is and is not art. I'm all for looking at images that surprise me, and I give credence to that. Yes, it's not beautiful, but wow, I am affected by that. But where an image has to have an intellectual framework bolted onto it, and you'll never understand it unless you read all about the artist in the statement that goes along with the work—I think the visual media becomes undermined if it needs a whole load of explanation and validation.

"It's difficult for me, because I would quite like the fine art photography world to embrace me more. I remember an American friend of mine who said, 'Charlie, come to live in California, it would be a totally different situation.' I said, 'I can't do that, I'm living in Dorset, and I rather like where I live.' He said, 'Well,

I LIKE TO THINK I AM AN INTERPRETER, A DISCOVERER AND A REVEALER.

I REMEMBER MEETING SOMEBODY YEARS AGO IN AMERICA WHO SAID, 'ROCKS, SEAS, AND TREES ARE FINISHED,' AND I SAID TO MYSELF, 'OH NO THEY'RE NOT.'

you'll just have to live with the difficulties and constraints that the fine art world in northern Europe lays down on you. You would do much better and be much more successful, because here photography is treated as an art form.' I do believe that the vast majority of people who love photography love to look at an image that stirs them in some way and awakens something in their soul that moves them and surprises them. Then there is a small percentage of images that the vast majority of people will not comprehend. So what I produce is a bit like the Volkswagen, 'the people's photography,' and I don't see anything wrong with that. I think it's marvelous and in my view what people rather enjoy."

PROMOTING YOURSELF AS AN ARTIST

As for how aspiring art photographers should promote themselves, Waite reckons this is a tricky topic. "Getting lots of PR and exposure in the photographic magazines is really lovely and terrifically complimentary, but you know the person who walks into the Chris Beetles or Michael Hoppen gallery will probably not have bought a photographic magazine other than maybe *The British Journal of Photography*. So I'd like to say get lots of PR, but within the photographic fraternity photographers rarely buy photography. I like to think I and some of my distinguished landscaper photography chums may be the exception in that I do buy photography, but in my experience most photographers don't."

Above all, you need a lot of determination and personal drive. "I think you need to introduce yourself to try and get exhibitions, because it is the only place to get noticed," says Waite. "Having an amazing website alone doesn't do it. Getting exhibitions in different parts of the world and building up some PR through those is probably the answer. Try approaching a gallery agent so you can nudge your way into that particular world. I remember when I had an exhibition in New York, it was just down to me thinking I would love to go to New York, so I bloody well did it—I wasn't invited. I got myself a map of Manhattan and arranged to see 18 galleries in ten days. Everybody I met was terribly complimentary. They would typically say, 'My God, this is beautiful.' And then there would be this pause, and they would say, 'But we can't show you.' And I remember asking one gallery owner, 'Why?' And she said, 'it's not the kind of work we show.' And they couldn't really put their finger on it and were almost asking themselves why they couldn't. It could be my work wasn't big enough. I mean, those New York Soho galleries were showing no more than 20 images at a time, and they were all massive, five foot wide. It was really quite an eye-opener. But then luckily I did get a gallery. One woman I saw said, 'Yeah, these are lovely,' and so we went ahead and did it."

For any fine art photographer it is important to establish good techniques and practices. As Waite explains, "I do make my own prints. I was always OK in the darkroom, and I really fought to get that right and understand black-and-white printing. Now with digital I find it difficult with black-and-white, but I am very content with the color. I care deeply about that and have printed all my own exhibitions. As for editions, I think an edition is a good thing. It helps to convey photography as an art form and not just a repetitive thing where you can

SAFI, MOROCCO.

I THINK ACTUALLY THE CREATIVE ENDEAVOR WILL ALWAYS BE ACCOMPANIED BY A DEGREE OF INSECURITY, BECAUSE THAT'S THE WHOLE THING ABOUT CREATIVITY. WHAT IS IT WE ARE TRYING TO CONVEY?

just bang them off one after the other. So I do no more than 50 for an edition, although I did do 75 once. I think it is also OK to have an open edition, and that is fine. People do that, too."

Above all, producing art of any kind is an intense and personal process. As Waite says, "I have often thought the photography is a bit of an indulgence and I should do something of greater value. I try and do things for charities and stuff, but sometimes I do start introspecting. I think actually the creative endeavor will always be accompanied by a degree of insecurity, because that's the whole thing about creativity. What is it we are trying to convey? But surprisingly, every now and then you get an image that is suddenly all right, and it's amazing how quickly that melancholy vanishes. So it's a good feeling to go deep and be introspective. When I stand outdoors I think about a sense of place. We are so dislocated from our natural world, and when you are out there looking at the birds and the hares and the clouds, you are right in the zone—you are not disconnected. I know I enjoy the process of photographing and I enjoy the process of discovery, surprise, and reverence, which I think is

MOPTI, MALI.

all part of the process, having a sense of wonder in all those things. And I give it the acclaim it needs in the form of a photograph. I do find it very gratifying when I meet people who were moved as I was at the time. I think that's quite a good mark or a measurement for a photograph. "

IMPACT OF TECHNOLOGY

Waite freely confesses that he is not very good with Photoshop. "I don't even use layers and I know I should. Remember, most of my stuff has been photographed on transparency and drum scanned. If anything I just deal with contrast and maybe the levels and that's probably it. I couldn't sleep at night if I imported a sky from another country, as a friend of mine from America once did. He accompanied me on a trip to Berkshire, and while we were photographing there said the sky was lousy and that 'it didn't look the same as when you did this image, so I'm going to add a sky from the Pacific.' And he did it well, actually, although it did look a bit odd. I don't think he would do that now, though. He has been very successful in the fine art world.

"With some photographers the word *restraint* isn't in their photographic vocabulary. You see some images that are very sexed up, and there are others that have been HDR processed, which look completely bonkers, and you think, 'What's happened there?' If the subtlety and reality aren't evident, the viewers are going to be pretty discerning and say to themselves, 'I'm not having that,' and they'll start to question it, and the relationship between viewer and image is effectively broken, because the engineering of the image has come between the two."

Photography has undoubtedly become more popular in recent years, and this has been reflected in the success of Waite's brainchild, the Take a View: Landscape Photographer of the Year Award, which has been running in the UK every year since 2007 (Waite has also established a USA Landscape Photographer of the Year competition). Says Waite, "I can remember speaking to an American friend who is curator of the Center for Photographic Art in Carmel, California. And I said to him, 'My God, everybody is photographing.' And he replied, 'Charlie, photography is the 'it' media.' And I think that is probably true. Everyone is photographing now. I am pretty confident, though, that the skilled crafted images you see produced by the great photographers will still stand the test of time. Whether it is now or in 20 years' time, the real craft of photography will still surface. And mediocre photography will still go to its rightful place as well. Digital has brought about so much reckless execution of photography, but I don't think the true craft of photography will get diluted, I really don't. There will always be fine work."

TAKE A VIEW

The Take a View: The Landscape Photographer of the Year Award is run in partnership with the *Sunday Times* and is now in its eighth year. Each contest has been accompanied by a book showcasing the best work, as deemed by the judges. There is now also a USA Landscape Photographer of the Year competition, which was launched in 2013.

I COULDN'T SLEEP AT NIGHT IF I IMPORTED A SKY FROM ANOTHER COUNTRY, AS A FRIEND OF MINE FROM AMERICA ONCE DID.

Charlie Waite Photography
Charliewaite.com

Light & Land Workshops
Lightandland.co.uk

Take a View: Landscape Photographer of the Year (UK)
Take-a-view.co.uk

USA Landscape Photographer of the Year
Usalandscapephotographeroftheyear.com

10
NEW MEDIA

NEW WAYS OF WORKING

The photography industry—and indeed all aspects of our lives—has been transformed by the rise of social media and the use of mobile devices and apps. One cannot underestimate the significance of these developments. In the context of this book, mobile capture is still predominantly a consumer activity. It is big business if you provide services like offline printing, but the real question here is, how relevant is all this to the business of professional photography?

I am writing this in 2014, and over the last five years sales of digital cameras in the consumer market have very much declined. The main reason for this has been the rise of smartphone technology and in particular the iPhone. These devices can provide stills and video capture that are plenty good enough for most people's needs. There are now consumer photographers who are developing fine photographic skills and for whom the mobile phone is the primary, if not the only, camera they use. Professionals may disparage the image quality that can be achieved using such devices, but in the not-too-distant future we will see smartphone cameras capable of capturing photographs with improved dynamic range and at faster speeds. This in turn has had a big effect on compact camera sales. Why buy a separate camera when a perfectly good one is built into your phone? Plus, with a smartphone you have immediate access to apps that allow you to edit and share your photos instantly. This has also had a knock-on effect on the way digital images are edited. For example, Photoshop was once considered an affordable alternative to high-end imaging workstations, and for many years it was the program everyone aspired to use. Meanwhile, high-end imaging workstations like the Quantel Paintbox ceased to be developed, and Quantel now mainly concentrates on producing video editing systems. The main interest these days is in apps that you can use to process photos on your phone directly, which are either free or cost just a few dollars.

Sales of digital SLRs have declined, too. Not massively yet, but there does seem to be a downward trend, while mirrorless cameras are now becoming increasingly

popular with the professional market as an alternative to the expensive, bulky, and more noisy dSLR systems. It could be that image quality demands have plateaued. The latest dSLRs may offer higher ISO speeds and more megapixels, but some photographers are seemingly happy to carry on using the digital cameras they already own, rather than upgrade to get what are perceived to be negligible technical improvements. Or, it could all come down to the economic climate.

In terms of the equipment photographers are choosing to shoot with, there does seem to be more divergence between what might be regarded as consumer and professional markets. Consumers like the immediacy of being able to shoot using mobile devices, which has eroded the compact camera market. Meanwhile, the market for high-end digital cameras mainly caters to serious amateurs and professional users, and overall, the middle ground market is shrinking. The Hastalosmegapixeles website recently published an infographic that showed the distribution of cameras that were used by winners of the 2014 World Press Photo awards. A full 66 percent of the cameras used were dSLRs, 9 percent were mirrorless (such as Leica or the Fuji X series), 2 percent were film cameras, and 23 percent had no available data. If you were to analyze other professional photography awards, you would probably find similar results. There have been some examples of professional jobs being carried out using a smartphone. For example, Nick Knight recently shot a Diesel campaign using his iPhone. Guardian photographer Dan Chung photographed the entire London Olympics using his iPhone 4s plus a pair of binoculars. He processed the photos using Snapseed and was able to instantly upload them to the newspaper. These particular examples show that it is possible to achieve publishable images using a smartphone, but these kind of usages aren't typical of how most professional images are captured. Some might regard it as techno snobbery, but within the professional spheres you need to be seen to be using the best equipment if you want to compete at the high end, which for now at least is where the most interesting, or best paid work, is commissioned. It's also a strict requirement when submitting photographs to the major image libraries. Yes, some libraries now accept smartphone photos, but the rewards are no more than a few dollars per sale.

A recurring theme throughout this book is that in order to survive as a professional, you need to be the best at what you do. The moving image industry is the same. At one end of the market you can use a smartphone or cheap video camera to capture decent-looking home movies, and at the consumer level almost everyone has access to the tools needed to create their own video content. Low-quality video clips can become popular on channels such as YouTube and generate a lot of interest. Meanwhile, you'll find that professional users who compete at the high end have to use increasingly sophisticated camera equipment and computer systems, plus they have to acquire the skills needed to operate such kit. So, while good enough capture may be good enough to satisfy most people, it is still the case that high-end commissions require high-end skills and equipment to achieve the desired results.

SOME MIGHT REGARD IT AS TECHNO SNOBBERY, BUT WITHIN THE PROFESSIONAL SPHERES YOU NEED TO BE SEEN TO BE USING THE BEST EQUIPMENT IF YOU WANT TO COMPETE AT THE HIGH END.

OLD MEDIA VS. NEW MEDIA

The way freelance photographers make money from photography hasn't changed that much, really. It's about finding people who are willing to pay you to create photographs for them or to purchase photographs you have already taken, or who will pay to learn from you. With the rise of the Internet and social media in particular, we have all become huge producers and consumers of stills and video images. The open sharing of content is a wonderful idea, but giving away stuff for free doesn't pay the bills. There are undoubtedly those who have shown it is possible to create a business based on shared personal content. But at the same time, social media businesses have also been cannibalistic in the way professionally produced media is often used without permission. For example, many blogs, websites, and social media outlets are successful because they are able to generate large numbers of likes, followers, or hits. This can translate into sales of online advertising for the entrepreneurs who set these up, but at the expense of the creators whose images and videos are being used without permission (and without so much as a credit). The pressure to feed the social media beast has resulted in even the best of us taking shortcuts. Only just recently, a photographer I know came across an unauthorized usage of one of his studio photos on the Facebook page of a high-profile photojournalist. It is unimaginable the photojournalist in question did this knowingly. What most likely happened is an assistant or intern was given the job of feeding the photojournalist's social media pages with content and just didn't know any better.

Fundamentally, most people engage in photography more at the consumer level; the younger generation's focus of interest will clearly be biased toward social media usage. Some signs of new business opportunities have cropped up. The most successful have been the entrepreneur system developers, such as those who created the apps that have helped popularize photography. But there are early signs of people making money from social media. For example, Alamy recently launched Stockimo, a library service that allows smartphone users to upload and tag photos that are then vetted for inclusion on the Alamy website. There are even cases of "social currency," where products or services have been given away in return for posting photos on Twitter.

For the photographers who are using social media, it is interesting to note how "likes" can translate into cash or other tangible rewards. A few have managed to make money in this way. For example, successful videos on YouTube attract advertising, which in turn generate income for the creator. Popular Instagram users have been promoted to Instagram's suggested user list and earned a certain celebrity status. Some have also been approached by brand agencies to promote their products in return for payment. The thing is, this creates a dilemma for artists who become popular through the photos they share via Instagram. They can be accused of selling out if they start using that popularity to make money. It's a tricky balancing act, and such photographers need to choose carefully which brands they are associated

with. However, Amadou Diallo, whom I interview later in this chapter, argues this is not such a big deal for a younger generation. To date, the rewards haven't been that great, except perhaps for a few high-profile individuals. For the most part social media should be regarded as a means to an end rather than an end in itself; at this point being able to build a career exclusively from social media activities is extremely unlikely. For now at least, social media offers tools to support established business competing in traditional media markets. Some clients even take the view that you must have a strong social media presence before they can book you. A photographer was told recently by a potential client, "We like your work but cannot use you unless you have at least 10,000 followers on Facebook or Instagram."

So far all this is looking at the situation from the professional photographers' viewpoint. Clients see things somewhat differently. For example, changes to the terms of use to certain social media sites have now opened the floodgates to allow consumer images to be used commercially. Look also at the way Getty Images is now allowing photos to be used freely on noncommercial websites. And who benefits from this? Not the photographers, of course, but those who control and administer access to the images. It's therefore a good idea to check the terms of use for any social media sites you upload photographs to and monitor future changes. But this does not change the fact that plentiful access to consumer images presents a big challenge. Consumer-generated images are entering the commercial marketplace in lots of ways. People naturally want to engage, and it is now almost second nature to respond directly to a blog post, media article, or news story by sharing content. It could be a request from a TV network to "send us your freak weather pictures from today." Consumers are rewarded by seeing a photo they took appear on TV or go viral on social media. Companies these days know that creating opportunities that encourage consumer participation are just as powerful as regular advertising. Indeed, it's essential today in order to compete for customer attention.

In a world now awash with content, it is harder to sift out the quality information from all the noise. One can argue the best content will generate more likes and therefore naturally stand out. But you still need to be able to evaluate the information and determine whether it is reliable or not. The key to understanding any subject is being able to put things into context. For example, with a book like this, much of the factual information can easily be found on the Internet. But the benefit of having it all contained in a book is the way that information is edited, given context, and presented in a readable format. The same argument applies to the selection of a professional photographer. He or she should be able to provide a strong visual style combined with an understanding of the subject matter and the technical ability to work in different media. Commissioners will continue to hire professional photographers who can provide a packaged service, which they can't supply themselves, where they need the photographer's eye, insight, and ability to edit. In recent years, the quality threshold and expectation have been raised for professional photography and (arguably)

FOR THE MOST PART SOCIAL MEDIA SHOULD BE REGARDED AS A MEANS TO AN END RATHER THAN AN END IN ITSELF.

"THESE DAYS THEY (CLIENTS) WANT A MORE GRUNGE LOOK TO THE PHOTOGRAPHS, SO THAT THEY LOOK MORE LIKE PICTURES THAT MIGHT HAVE BEEN SHOT USING AN IPHONE."

lowered for everything else. The best professionals are still working because they can produce unique images, and clients will hire them for that.

At the same time, consumer photography styles are influencing the way commissioned work is art-directed. One of the attractions of using consumer-generated content is the authenticity that comes from using an image that looks like it was shot by a regular member of the public, rather than as a setup image. For example, when you choose to book a hotel, which information do you trust most—the hotel website or the reviews on TripAdvisor, posted by fellow travelers? We have all become slightly jaded by glossy, superficial advertising imagery, and advertisers have begun to change tack slightly to reflect this desire. A food photographer I spoke to recently told me how social media has influenced the style of photography clients want. "These days they want a more grunge look to the photographs, so that they look more like pictures that might have been shot using an iPhone."

VIDEO

There is nothing new in photographers getting into film and video. Advertising photographers in particular have successfully transferred their skills from stills to directing commercials. Some have even gone on to forge careers in the movie industry. Digital video technology has come a long way in recent years. The Canon 5D MkII camera was the first professional dSLR that would allow you to capture full-frame video and achieve a "movie" look with shallow focus. Vincent Laforet was one of the first pioneers to shoot video on a dSLR, as was Clive Booth, whose interview appears later in this chapter. Interest in video has therefore stemmed from the fact that professional-quality video is now more attainable and clients are requiring it.

The reason for this all comes down to the rise of the Internet. Seventeen years ago I interviewed various advertising people about the future of digital imaging. Back then the Internet was seen as a sideshow to print and TV media. The people I spoke to all told the same story of how limited resources were available for Internet advertising. Today, nearly everyone is connected to the Internet, and people are now more likely to reach for their computer or mobile phone to find what they want rather than read a newspaper, magazine, or book. As the Internet has grown, bandwidth speeds have allowed video to be streamed more easily, and more clients are demanding moving image content to go on their company websites or online magazines. While a certain amount of doom and gloom about the decline of stills photography persists, the demand for moving image content has provided photographers with an opportunity to develop new image-making skills to satisfy this market. In many cases commissions are being offered by the same clients that are commissioning the stills and requesting both as a package. This is one area where photographers who have the technical ability can succeed.

Equipping for video

Professional video is a lot harder to produce than stills. While video-enabled dSLRs offer the potential to capture broadcast quality video, there is much more that you need to consider when embarking on a moving image project. I found this out for myself as I recorded the video interviews for this book. I had to spend a fair amount of time experimenting with the equipment and made a number of mistakes before I was able to achieve acceptable results. For photographers who have gotten used to shooting stills in raw mode and the flexibility that allows, video presents a whole lot of technical challenges. Let's start by looking at the camera options. Many dSLR cameras allow you to shoot video at 1080p HD (1980 x 1080) and at 25 or 30 frames per second, and some can shoot at higher frame rates such as 50 or 60 frames per second. The advantage of shooting with a dSLR is, you have full manual control over things like exposure, white balance, and focus settings, and the size of the sensor means the final video footage can have a more "movie-like" quality with a shallow lens focus. The disadvantage of using a dSLR camera is that the image quality is effectively a series of heavily compressed 8-bit JPEG frames. It is critical you get the exposure and white balance just right, as there won't be much room for maneuvering when you later come to edit the footage, and heavy tone and color corrections will be noticeable. If recording to a CompactFlash or SD card, you can record only clips up to 4GB in file size, and if recording HD quality at 25 frames per second, you'll be limited to about 12 minutes per clip.

Professional video cameras let you capture better-quality video with more bit depth and higher bit rates and without the clip length file-size limitations. Some are able to output uncompressed 10-bit raw data, and the latest cameras are also able to film in 4,096 x 2,160-pixel 4K video (or higher, even). Some cameras are emerging that can shoot 4K, but the biggest limitation here is the bandwidth required to store such large video files. It can be around 30 GB per minute when you shoot at a 4K resolution in raw mode. With such cameras the master files need to be recorded to solid state drives, although you can also write proxy files to an internal SD or CompactFlash card, edit using these, and render a full-resolution video from the master files. Then there is the question of how you are going to edit the footage. At the time of writing, Adobe Premiere has recently been upgraded to support 4K editing. To make this work, you will also need a speedy workstation like one of the latest 12 core Mac Pro computers. Some cameras are now capable of recording raw video using, for example, the CinemaDNG format. Blackmagic Design is the first company to have produced an affordable, large sensor video camera system capable of capturing video in raw or Prores formats. A professional video camera that captures raw data will allow you more freedom to apply fine-tuning corrections. Raw video is now tantalizingly accessible, but the downside is very large video file sizes where everything at the postproduction stage will be magnified in terms of storage and the file processing overhead.

MASKING UNWANTED SOUNDS

A useful tip I was given by a sound recordist is to record a silent audio track at each location you shoot in that just picks up the background noise. You can then use that to create a loop soundtrack of the ambient sounds. Then, when recording voices using a shotgun microphone, you can mix this with the closeup audio track to create a fuller sound that includes the background, but where distracting sounds such as a noisy truck or an overhead airplane can be subdued.

Dealing with the variables

These latest innovations have helped popularize video with photographers, though the learning curve is steep. It should come as no surprise that the biggest difference between shooting stills and video is the fact that you are recording an event that takes place over a period of time and from more than one vantage point. This brings with it the problem of maintaining continuity. To capture professional-looking footage, the exposure should be set manually, and you need to do all you can to control the light to avoid the light levels going up and down. Add to this the need to shoot from different camera angles, which means carefully arranging the lighting to avoid flare or seeing the lights appear in the shot. Then there is the focusing, where the subject may be moving through the frame or change position, or the camera may change position. Focus tracking can be a task in itself. The white balance needs to be set before filming and, if shooting with a multicamera setup, balanced for each camera. This, too, can fluctuate over a period of time. To give you an example of what I mean, the movies that accompany this book were recorded running three or four cameras. Each had to have matching white balance settings and the exposure set individually. It was also critical to ensure sharp focus on each camera.

Just as important as the image quality is the quality of the audio. A poor audio track can spoil an otherwise good movie, so you'll need to use something better than the built-in microphone on the camera. One solution is to add an external microphone designed for use with dSLRs, such as a shotgun microphone that attaches to the camera hotshoe, and plug this into the audio socket of the camera. Or, you can buy an audio mixer that accepts XLR inputs from external microphones, mixes the sound, and records direct to the camera. The advantage of this approach is the audio input replaces the internal camera microphone recording and you end up with a better quality, synchronized audio track. The downside is the audio quality will be compromised when you do this. Recording directly to a video file audio track will not give you as good a quality sound as when you record to a professional audio recording device and are able to save this as a separate .WAV file. When recording this way, you can synchronize the audio by using a clapper board or a hand clap at the beginning of each take and use this to match the audio track to the video. This is fairly easy to do at the postproduction stage. You'll also need to monitor the audio recording for continuity of sound levels, which you can do using a decent pair of headphones, and make sure the recording levels are typically around -12 dB. This should ideally be managed by a separate audio person, who can watch out and compensate for fluctuating sound levels as well as pick up on little things like distracting background noises or crackling sounds when someone brushes against a lapel microphone.

The movie interviews that accompany this book were all produced on a tight budget with me mostly using just one cameraman assistant. The main kit consisted of lights and three dSLR cameras plus lenses (four cameras were used on some of the interviews). The audio was recorded to a Zoom H4n recorder using two lavalier lapel mikes plus the recorder's omni microphones. This gave me four audio tracks to mix from. Everything was set up so that one of the cameras could be controlled remotely and monitored via a CamRanger device linked to an iPad and the other two were within easy reach of my cameraman. The clips were then edited using Adobe Premiere and exported for Web viewing at a 1280 x 720 resolution.

So, taking all this into account, you can see why it is often necessary to have a crew of experienced people working on a video production, where each takes responsibility for a different aspect of the filming. When you have a team of people like this working together, you have more chance of keeping the variables under control and a production can proceed more smoothly. Most photographers are used to operating on their own, and working with moving images is quite a leap for them to make. After being accustomed to controlling everything themselves, they have to adjust to handing responsibility over to a team of workers and that can be quite tricky, especially when it involves communicating with and building trust with a team of people.

This shows a typical setup used to film the video interviews for this book. Shown here is a snapshot of the set used when I interviewed Bob Marchant.

CLIVE BOOTH

SPECIALIZATION: VIDEO, FASHION AND PORTRAIT PHOTOGRAPHY

WORKING IN MOVING IMAGES

Ever since the Canon 5D MkII camera appeared on the scene in 2008, photographers have been enticed by the idea of working with moving images, though few have been as successful as Clive Booth at making the transition from stills to video. In fact, Booth had worked in moving images before, creating documentaries for the BBC. Says Booth, "I began with moving image in the early '90s. They were interesting times when I predominantly filmed adventure stuff, such as filming on the Eiger in Switzerland for BBC TV's *Blue Peter*, or in the Arctic filming polar bears on an environmental research expedition. Back then we were shooting with Betacam SP and compact Hi8 pro Super VHS cameras. It taught me how to compose and how to work with the moving image and how to work with people like editors."

Before all that, Booth had trained and worked as a graphic designer. "I've always loved photography," he says. "It's been my first love even as a designer. I studied graphic design with a very strong emphasis on photography. In fact, none of my work was illustrative. It all used to be about photography." Fifteen years ago he started working more as a photographer, though, when one of his clients, Moët & Chandon Champagne, would commission him to photograph events. One of these was to celebrate the then-25-year career of legendary fashion photographer Nick Knight. Knight liked the photographs so much that he invited Booth to collaborate on other projects through the ShowStudio site, which helped his career as a stills photographer grow. Says Booth, "It's kind of hard to explain to people now, but in the mid-'80s you were a specialist. Now it's kind of like a Renaissance period. I can be a graphic designer, I can write, I can shoot pictures, I can make films, and nobody even thinks that's an issue. So, whilst I would like to have been a photographer early on when I first started out, I didn't have the confidence to become one back then. I actually love design and still love it today. I love typography and still get commissioned to work on design projects. The next step, I hope, is to combine all of these skills into one package, which is moving image. I am looking to develop more work with After Effects artists, other designers, and typographers to bring all the skills together into one, which would be wonderful, so moving image could be more illustrative."

> NOW IT'S KIND OF LIKE A RENAISSANCE PERIOD. I CAN BE A GRAPHIC DESIGNER, I CAN WRITE, I CAN SHOOT PICTURES, I CAN MAKE FILMS AND NOBODY EVEN THINKS THAT'S AN ISSUE.

A good example of the kind of thing Booth has in mind here are the title graphics you see produced for TV shows and movies. "Look at how they made the titles for *True Detective*," he says. "It's a movie in its own right. Another good example is *The Girl with the Dragon Tattoo*—it's really beautiful. What you've got is live action mixed with a form of illustration. It's layering the skills of graphic design, photography, filmmaking, and typography and pulling them all together. *True Detective* is right up there at the top in terms of title graphics and what I aspire to be doing myself."

A turning point for Booth was the arrival of the aforementioned Canon 5D MkII camera. "I remember seeing *Reverie*, Vincent Laforet's first movie shot with a Canon 5D MkII," he says. "Everyone was amazed by this. At the time I had been doing a lot of stuff with several fashion designers around London. A friend of mine called me and said, 'Clive, you've got to get your hands on one of these Canon 5D MkII cameras.' I had been working with Canon for a short while at that time forming a collaborative partnership. I also knew it was not enough to have the camera. I needed a project. So I looked around at people I was working with, and Roksanda Ilincic was doing a show at the Raphael Gallery at the Victoria & Albert Museum, which is the most incredible location you can imagine. With the help of Frankie Jim at Canon UK, I put together a proposal to Canon Europe, and two days later a preproduction 5D MkII arrived at my agent's office in Putney. I took it to the fashion show along with all my lenses and a monopod and basically was shooting in very low light with single light sources bouncing the lights off these beautiful Raphael paintings creating this incredible light. Of course I had very beautiful girls in amazing Roksanda Ilincic outfits, beautiful art in the background, plus these ballerina dancers who were part of the show. To give you an example of how early this all was, the models

Still frame from Booth's film of the Roksanda Ilincic fashion show.

WHEN I GOT TO LOOK
AT THE RUSHES I HAD A
CROWD OF PEOPLE OF
MAYBE 20 OR 30 AROUND
THE LAPTOP AS THE
FOOTAGE WAS COMING OFF.

didn't even know I was shooting moving image because at the time they hadn't seen a stills camera being used to shoot video. When I got to look at the rushes I had a crowd of people of maybe 20 or 30 around the laptop as the footage was coming off. There was also a director I have worked with quite a lot who has been in filmmaking for a long time, and her reaction was fantastic. I then worked with an editor I had worked with in New York for MAC Cosmetics and said, 'How do you fancy collaborating on a 30-second piece?' He said, 'Sure,' and we edited everything together using After Effects. It had an incredible magic, and the funny thing is that this was a personal project and the 5D MkII wasn't even out at that time, but after that all my clients wanted moving image. Almost every single one, all as a result of this single 30-second film."

Moving portraits

Booth's recent video work has involved the creation of a series of short films that he likes to describe as moving portraits. This all started with a commission from Intel and Asus to create a series of short videos of photographer Don McCullin at work as he produced individual photographs for Intel. Booth took what might initially have been regarded as a "making of" type of brief and added his own distinctive touch. From that evolved the idea of the moving portrait, with the aim to encapsulate the personality of a person using movement. Says Booth, "One we've completed recently is of fashion designer Henry Holland. We interviewed him for an hour and a half and asked him some searching, pertinent questions. He was great. He gave some very honest answers and held nothing back whatsoever. For example, he talked about

Don McCullin (2011)

being bullied at school for being gay from when he was 14 years old and how this impacted him in later life. I was interested in all those aspects of him and somehow wanted to visualize that. And that's what we do with the moving portrait. We interview people and then collaborate with them and try and dig beneath the skin a little bit and maybe have a narrative, or maybe not. What I like about the moving portrait project is how I'm now trying to extend it to collaborate with After Effects artists as well as illustrators and typographers. I want to try and mix it up a bit on the personal work and hopefully with the commissioned work, too."

Still frame from a moving portrait of fashion designer, Henry Holland.

The challenges of moving images

I asked Booth about the common mistakes photographers make when first working in moving images. "It sounds really ridiculous," he says, "but you need movement. I recently saw some interviews where you could see it was done by a photographer. It was beautifully lit but it was all very static. I made a conscious decision early on that I was going to use the medium, because the medium allows you to. So I think initially one of the difficulties can be not injecting enough movement. Of course, you can also put in too much movement.

"Moving on from that, I think editing is very difficult just as it is for a photographer. I mean, how many great photographers are great editors? Very few. Also, one of the biggest challenges I found is handing your camera over to somebody else. That's probably the single biggest challenge, because you're so used

I'VE HAD PEOPLE COME IN FROM FILM SCHOOL WHO ARE JUST TOO REGIMENTED. THEY DON'T TAKE ENOUGH CHANCES OR TAKE RISKS.

IT'S VERY EASY FOR US TO CONCENTRATE TOO MUCH ON THE VISUAL ASPECT OF FILMMAKING AND NEGLECT BOTH THE PERFORMANCES AND THE NARRATIVE.

to being the person in control. I trust the people behind each camera. And sometimes the people that I bring in to shoot for me have no background in photography or film at all. Other times I've had people come in from film school who are just too regimented. They don't take enough chances or take risks. So I like the people who work with me to experiment. I think it's really important. You know I often say, and I know some people don't believe this, but I like to think I'm the least talented person on the set. And what I mean by that is that I just want to surround myself by very talented people. And not just talented people, but people I can get on with. Because whether you're making films or even shooting stills, it's really important, and the longer you work together the easier it gets. When I work with these people it's like telepathy. I just walk in and everything's ready, because we all know how we work. It's very easy for us to concentrate too much on the visual aspect of filmmaking and neglect both the performances and the narrative, and so we must be prepared to trust others who share our own vision to take on some of that responsibility."

Interestingly, when you work with moving images, it involves a lot of writing. Says Booth, "So much of my time is spent writing. If you want to be director or make your own films you have to write. It's as simple as that. For example, when I'm approached to direct a commercial or a short film, the agency will give me a storyboard, and then I will have to write a film treatment of my version of the storyboard and how I see it, and we'll have a conference call or a meeting. That process can take anything from three to five days, just sitting here conceiving ideas, then writing them down and using imagery to reference ideas." From the planning of a moving image shoot, it's not uncommon to have long shot lists that go into double figures, where Booth will have to do a setup for each one of those shots. "When we did the moving portrait project with Henry Holland, we actually used a plan of the studio to split the studio up for each separate little cameo so we knew where we were going to be," says Booth. "These types of shoots can also involve working with large numbers of crew. On the most recent project I did for Intel and Asus, we had quite a big crew. There were maybe 40 people involved. And that sounds huge, but my immediate crew is probably just half a dozen people. By the time you add hair and makeup, set builders, clients, art director, and producers, etcetera, all of a sudden there will be lots of people on the set. But when you take all these people out of the equation I have a pretty small crew and like it that way."

STILLS WORK

Booth shoots stills commissions for editorial and advertising, specializing in portraits and fashion work. One of his favorite series came out of a commission from *You* magazine to photograph the cast of *Downton Abbey*, shooting a cover

and seven-page spread. Unfortunately, the moment he was scheduled to arrive on set and start shooting, the crew all wrapped for the day. Says Booth, "For me personally, I wanted to deliver—I wanted to come away with good shots. When else could I get the opportunity to shoot on this wonderful set at Highclere Castle with this incredible light and tremendous actors? So I spoke with the head of PR. She saw my point of view and we got access to the three girls who play the daughters, plus some of the other actors. Working with the natural light, I photographed what I still consider now to be some of my best portrait work shot on a TV set. The thing is that after all this work and effort they never published the portraits! The magazine just wanted the behind-the-scenes stuff."

Jessica Brown Findlay as Lady Sybil Crawley in *Downton Abbey*, photographed for *You* magazine.

TERENCE STAMP VIDEO

The full story of how Clive Booth met and photographed Terence Stamp can be viewed on the book website.

Sometimes you have to make your own opportunities, a case in point being the time Booth spotted the actor Terence Stamp in a tearoom in Soho. As Booth explains, "As a photographer and a filmmaker you have to read people and you have to use your intuition, and my intuition was telling me that he was receptive. As it happened I made a complete cock of myself in front of him. This is the guy, right, who has worked with Fellini and Steven Soderbergh. What did I say to him? I said, 'I thought you looked great on the Alan Titchmarsh Show', because I had seen him on the show the week before and for some reason that was fresh in my mind. He just looked at me and didn't say a word, and then I said, 'You're a portrait waiting to be taken,' and then he thought I was some kind of paparazzo. So it just went from bad to worse. Stamp left later, but before he left he came over and said goodbye, which I thought was great." It could have ended there, but Booth decided to persist and chased him down Berwick Street, explaining that he would like to take his picture and how his agent, Mark George, used to represent Terence Donovan, and that was it. "That was the key that unlocked the door to Terence Stamp," says Booth. "He said, 'Donovan took the best picture that's ever been taken of me,' and 'How about tomorrow 11:30 here at the tearoom?' And then walked off. And I guess that's how things were done in the '60s." Sure enough, the next day Stamp did turn up and Booth was able to photograph him in the tearoom. He also got him to walk across Soho to a friend's flat on Frith Street,

where he was able to control the lighting more. Says Booth, "I asked, 'What do you think is your most distinctive feature? What have you got that is unique?' and to my surprise he said, 'My voice,' and I said, 'I can understand that, but visually it's your eyes, you have this incredible presence.' He is very present minded, which means that when he talks to you he is giving everything, and when you are taking pictures of him he is like General Zod; he's peering straight through the camera and into the back of your brain."

COMBINED PRODUCTION SERVICE

According to Booth, "The industry has for a while now been in a state of turmoil or flux. I think there are many photographers who haven't embraced moving image and probably now thinking, 'Where's the work gone?' Because you only have to look at your mobile phone and iPad. Everything now involves movement. Even with shop fronts and point-of-purchase, which is why I've been working with 4K. Because 4K gives you ultrahigh definition. Apparently the boffins say 8K is indistinguishable from true reality, but 4K is still pretty impressive."

Booth's clients have recognized his ability to shoot stills and moving image and now often commission him to do both. Says Booth, "Historically what happened is the director would write the treatment and shoot the commercial, and a photographer would shoot the stills campaign. Well, of course, now there are a lot of people like me who are coming from photography to filmmaking and who have developed their skills as filmmakers and hope to do the two. Don't get me wrong, it's not easy; it takes a huge amount of preparation, but it can be done. It's a contentious subject, but in future, the stills will come from the moving image capture. There is definitely a future in that, and it's the ability to have under one roof one production company that can now offer all of this. To write the film treatment, direct the commercial, and have the stills shot at the same time the commercial is shot. We've been able to pull very acceptable stills from 4K, and I am talking here about 35 MB to 50 MB TIFF files, and printed them up big. There's a synergy between the moving image and the still image, which has now become a really big selling point with the production company that represents me."

Speaking with Booth, it is clear to see how the dSLR video revolution that started in the late noughties continues to have a profound effect on our industry. As Booth says, "I'm an early adopter of this stuff, and understanding how to use these new technologies is very important. But so is the collaboration, mixing it up with great sound design, great typography, and great After Effects artists, bringing as many skills together as you can. People in the music industry have been doing it for years, reinventing themselves all the time."

WHEN YOU ARE TAKING PICTURES OF HIM HE IS LIKE GENERAL ZOD; HE'S PEERING STRAIGHT THROUGH THE CAMERA AND INTO THE BACK OF YOUR BRAIN.

THERE'S A SYNERGY BETWEEN THE MOVING IMAGE AND THE STILL IMAGE, WHICH HAS NOW BECOME A REALLY BIG SELLING POINT WITH THE PRODUCTION COMPANY THAT REPRESENTS ME.

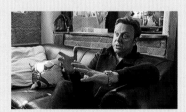

Video interview with Clive Booth.

Clive Booth
Clivebooth.com

AMADOU DIALLO

SPECIALIZATION: TECHNOLOGY JOURNALIST, DIGITAL PRINT MAKING AND TEACHING

SMARTPHONE PHOTOGRAPHY

Amadou Diallo has always worked creatively; his first career was as a jazz musician and composer. "Both of those disciplines had big influences on my approach to photography," says Diallo. "I was initially drawn to landscape photography, hiking through remote areas with a large-format camera, several lenses, and a bunch of film. I've always loved traveling, and photography has been a way for me to explore and document the world around me." By 2011 he had written two books on photography and taught digital imaging and printing fairly regularly in New York City at the International Center of Photography. Says Diallo, "I had also been running my own boutique digital printing studio where we used large-format inkjet printers to produce prints for exhibiting photographers and visual artists. After closing the print studio I moved to Seattle, where I worked for two years as a staff writer at DPreview, churning out camera reviews at a pretty incessant rate."

IT'S ONLY AFTER SHOOTING WITH THE SAME EQUIPMENT FOR MONTHS AND MONTHS THAT YOU REALLY COME TO GRIPS WITH IT AS AN ARTISTIC TOOL.

Since then Diallo has returned to New York City, where he works now as a writer and is a freelance technology journalist at *Forbes*. In a recent article, "The iPhone Replaced My DSLR," he described how in 2012 he packed away his dSLR and for the next 365 days opted to photograph every day using his iPhone 5, posting the results to his Instagram account. "As a tech lover, the obvious perk of being a camera reviewer was that you always got to shoot with the latest gear," says Diallo. "But, as a photographer, the challenge was that I never got to stick with one camera long enough to let both its strengths and weaknesses fully inform my photographic vision. You can learn a lot about a camera in a few weeks while writing a review, but it's only after shooting with the same equipment for months and months that you really come to grips with it as an artistic tool. So the idea of shooting with an iPhone came about, because in the midst of having to shoot with all of these various cameras for work, I wanted to photograph using the same camera day in and day out. The iPhone was a convenient option since I was carrying it with me anyway. And the image quality had crossed a threshold where it was superior in many ways to entry-level point-and-shoot cameras. The iPhone has obvious weaknesses and requires certain conditions to perform its best, but during the year of shooting daily with it, I felt connected to the iPhone as a photographic tool in the same way that I had with my dSLR and large-format cameras."

"The added pressure of posting the shots on social media provided great motivation to push on through the dreary days when it seems like there's nothing interesting to shoot. The reality is, you can always make an interesting picture if you look for one. Of course there are situations and subjects that call for a more specialized camera than the one in your smartphone. But the cameras are just tools. You can make an amazing photograph with your iPhone and a horrible image with your dSLR. It's not the camera. It's you."

IMAGE QUALITY

If you photograph with a smartphone, you are currently limited to capturing an image with a fixed lens and limited image quality. Will smartphones continue to improve? Most likely. For example, some of the latest devices are starting to feature raw capture. According to Diallo, "The speed with which smartphones caught up in image quality to entry-level standalone cameras makes it clear the technology will continue to improve. Nokia has put out a 41 MP smartphone, and there's talk now of dual-sensor cameras that can combine two simultaneous exposures, one for the shadows, the other for the highlights. Improvements in low-light shooting and expansion of dynamic range are two very welcome advancements we'll likely see in the coming years."

THE ADDED PRESSURE OF POSTING THE SHOTS ON SOCIAL MEDIA PROVIDED GREAT MOTIVATION TO PUSH ON THROUGH THE DREARY DAYS WHEN IT SEEMS LIKE THERE'S NOTHING INTERESTING TO SHOOT.

The success of smartphones has certainly dented the consumer camera market, though. "It's a disaster," says Diallo. "Nobody's buying at the low end because smartphones are so good. The lack of a zoom lens is not the barrier that camera company executives had hoped it would be. As a result, we've seen camera companies turn their attention back to the 'serious' photographer who wants a full frame or APS-C sensor and good-performing lenses to go with it. Remember when there were only two full frame dSLRs? And they were something like $8,000? Now, photo enthusiasts have some amazing choices available, at reasonable prices. That's the good news. The bad news is that there aren't enough enthusiasts to make up for the loss of sales to millions of point-and-shoot buyers around the world. So companies are going to have to adjust to this new reality in order to survive. I talk to many commercial, fashion, and wedding photographers who love these small mirrorless cameras with APS-C and full-frame sensors and fast lenses. But none of them can show up with those on a gig, at least not as their primary camera. Based on years and years of seeing photographers with big cameras draped around their necks, most clients associate quality with a large dSLR or medium-format back."

SMARTPHONES USED COMMERCIALLY

COMPANIES ARE SEARCHING FOR A DIALOG WITH THEIR CUSTOMERS THAT'S MORE INTIMATE THAN THE PASSIVE TV COMMERCIAL OR MAGAZINE AD.

Even so, there are examples of smartphones being used on commercial shoots. As Diallo explains, "An iPhone shoot for a fashion client that's trying to stay one step ahead of youth culture may be more of a novelty than anything else. I don't see it as a growing trend. Advertising is going through big changes. There's no doubt of that, and every brand now has a social media community manager. When you're trying to reach customers through Twitter and Facebook, you're competing for attention with status updates from a user's friends. And companies are searching for a dialog with their customers that's more intimate than the passive TV commercial or magazine ad. So ad campaigns that are interactive are becoming popular now."

There have also been examples of Instagram's high-profile users who have been approached to endorse brands, or who've gained attention on Instagram and then gotten paying commercial gigs. Says Diallo, "I recently interviewed one photographer whose interest in photography was born via Instagram and his iPhone. Within one month of buying his first pro camera, he got hired to shoot a holiday gift guide for Gap. He came to their attention through his Instagram feed. Even veteran commercial photographers are sharing their work on Instagram. It's become a useful marketing tool and, just as importantly, a way for the photographer to build her own brand."

There have been recent examples of Instagram photographers being approached to endorse products in return for payment. However, are there limitations to this approach? How much can one be seen to endorse a brand and get paid to do so without being perceived as selling out? Says Diallo, "For better or worse, I don't think 'selling out' even exists as a concept for the social media generation. Companies sponsor music concerts, museum exhibitions, and film shorts. Bob Dylan recently did a Cadillac commercial for the Super Bowl. Photography is no different. Photographers can no longer depend on streams of income from stock photography, for example. Full-time staff positions continue to be eliminated. And with the magazine industry in such bad shape, the opportunities for good-paying editorial work have shrunk considerably. The reality is that artists today must establish and continually grow their personal brands. The days of not wanting to sully oneself by working closely with commercial brands are over. For those who've grown up with it, social media is a deeply rooted aspect of their lives that they literally can't imagine not having. I think they have a much less conflicted view of self-promotion than you or I may. Young photographers know that they have to engage an audience via Twitter and/or Instagram. They view them as platforms not only to reach their followers but to attract the attention of industry players as well. If you make great images and have 100,000 followers on Instagram or Twitter,

THE DAYS OF NOT WANTING TO SULLY ONESELF BY WORKING CLOSELY WITH COMMERCIAL BRANDS ARE OVER.

PHOTOGRAPHY WAS NEVER
THE EASIEST WAY TO MAKE
A LIVING IN THE FIRST
PLACE. IT'S PROBABLY
GOING TO GET WORSE
BEFORE IT GETS BETTER.

you're more appealing than a similarly talented photographer with no social media presence. That's the reality."

"The upside of all this social media frenzy is that many photographers have built real and supportive communities on Instagram. Tinker Street, for example, is a photo agency collective for mobile photographers that has negotiated commissioned work for its members for brands like Adidas and Mercedes-Benz. Are they making Annie Leibovitz money? No way. But they have developed at least the beginnings of an alternative entry into the photography industry. Photography was never the easiest way to make a living in the first place. It's probably going to get worse before it gets better. The main problem, of course, is that people have gotten accustomed to using images for free. A related problem is that with so much photography being used for online-only purposes, the equipment barrier to produce usable images simply doesn't exist anymore. You can make a fantastic-looking 1000 x 800 pixel image with any smartphone. Images have become ubiquitous and thereby devalued. One result of the difficulty in earning a living from photography is that many amateurs, with other sources of income, have turned to photography part-time. For a growing number, it's a hobby that simply breaks even as opposed to a career that puts food on the table and pays the mortgage."

Amadou Diallo
Amadoud.com

INDEX

IPSwitch for PC, 192

Kickstarter, 43

Lüerzers Archive, 33

MailChimp, 34

managing, 30

marketing, 29

Mileage Log+ app, 149

One Eyeland, 33

Photographer's Ephemeris app, 153

PLUS Coalition, 112

Production Paradise, 33

Pro-Imaging organization, 41

promotion resources, 32

SendEmails, 34

Sun Seeker app, 171

skill, evaluating, 7–8

SMART (Self-Monitoring Analysis and Reporting Technology System), 193

social media. *See also* new media

Facebook, 38

Google+, 38

LinkedIn, 38

Social Security tax, paying, 51

soft proofing, 202

software. *See* computer software

sole proprietor/sole trader, 45–46

Sony World Photography Awards, 41

special effects, 223

SSDs (solid state drives), reliability of, 193

St. Maur Sheil, Mike, 156

state sales tax, paying in US, 48

stills, 284–287

Stock Artists Alliance, 18

stock photo photographers, 17–18

street photography, 114

striping drives, 193–194

Strobist site, 29

studio

efficient usage, 222–223

equipping, 220–221

financing, 215

hire alternative, 221–222

making work, 220

renting vs. buying, 214

safety, 220

special effects, 223

style. *See* photographic style

subjects, choosing, 27

sun angle, tracking, 153

Sun Seeker app, 171

supplier problems, 93–94

T

Talisker whisky shoot, 236

tax audits, 51–52

taxes, paying, 48–49. *See also* employee taxes

team, building, 40–41. *See also* crew

technical requirements, camera systems, 180–182. *See also* computer software

technology, reliance on, 196–198

*Teenage Stori*es series, 257

terms and conditions, 77–78

theft, limiting exposure to, 56

TIFF file format, 197–198

tone manipulation, 252–253

training, getting for use of equipment, 199

travel photography

advice for newcomers, 169

business setup, 167–168

personal work, 168–169

shooting on location, 164–167

travel planning

accommodation, 150

air travel, 149–150

ATA carnets, 150

customs and carnets, 150–151

data cards, 155

gaining access, 154

getting on with crew, 157

Google Earth, 152

keeping safe, 155–156

liability insurance, 162

LightTrac, 152

location services, 154

preparing for unpredictable, 156

research, 151–153

road travel, 149

working abroad, 162

Truth & Lies, 137

Truth and Reconciliation hearings, 137–138

Tumblr blog, 29

U

UK, number of businesses in, 45

UK Association of Photographers Awards, 41–42

UK council tax, paying, 49

UK tax, paying, 49

UK's Association of Photographers, 18

underwater photography, 99–101

unpaid debts, chasing, 89

Untitled #96, 240

upgrading equipment, 52, 196

US property tax, paying, 49

US sales tax, paying, 48